Contemporary Art

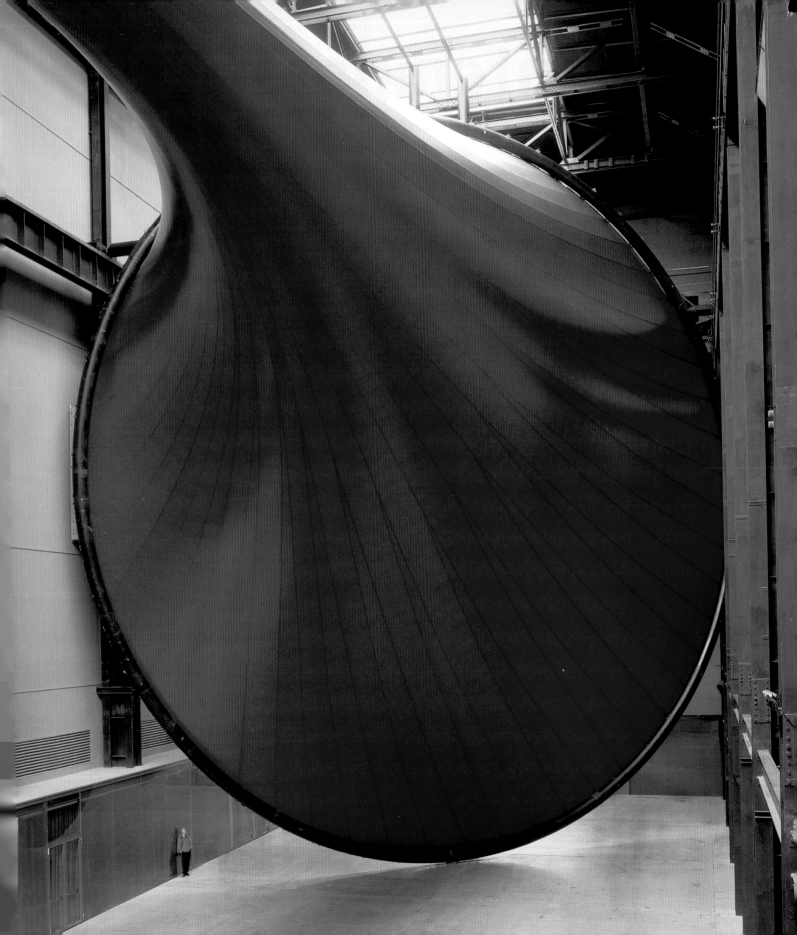

Contemporary Art

Art Since 1970

Brandon Taylor

PEARSON

Prentice
Hall

Upper Saddle River, NJ 07458

Library of Congress Cataloging-in-Publication Data

Taylor, Brandon.
 Contemporary art : art since 1970 / Brandon Taylor.
 p. cm.
 Includes index.
 ISBN 0-13-183729-X (paper) -- ISBN 0-13-118174-2 (case)
 1. Art, Modern--20th century. I. Title.

N6490.T36523 2005
709'.04--dc22

2004046514

Editorial Director: Charlyce Jones Owen
Editor in Chief: Sarah Touborg
Editorial Assistant: Sasha Anderson
Manufacturing Buyer: Sherry Lewis
Executive Marketing Manager: Sheryl Adams

Pearson Education LTD.
Pearson Education Australia PTY, Limited
Pearson Education Singapore, Pte. Ltd
Pearson Education North Asia Ltd

Pearson Education, Canada, Ltd
Pearson Educación de Mexico, S.A. de C.V.
Pearson Education–Japan
Pearson Education Malaysia, Pte. Ltd

This book was designed and produced by
Laurence King Publishing Ltd, London
www.laurenceking.co.uk

Every effort has been made to contact the copyright holders, but should there be any errors or
omissions, Laurence King Publishing Ltd would be pleased to insert the appropriate
acknowledgment in any subsequent printing of this publication.

Editor: Robert Shore
Picture Researcher: Emma Brown
Design & Typesetting: Roger Fawcett-Tang of Struktur Design

Front cover: Daniel Buren, *Ce lieu d'où...* (detail), work in situ, in "Gewald," Ghent, 1984,
© D.B.–ADAGP

Frontispiece: Anish Kapoor, *Marsyas*, installation at Tate Modern, London, 2003,
© Tate, London 2003

10 9 8 7 6 5 4 3 2 1
ISBN 0-13-183729-X

Contents

Preface

Few observers can deny that the visual arts in recent years have attracted enthusiasm and opprobrium in more or less equal degree. Critics of new art have often complained that the formal legacy of the great artistic traditions of the past have become all but invisible in the hectic, competitive, and sometimes mystifying practices with which younger artists are routinely associated. But these voices too often ignore how modern art in the sense we mean today was invented well over a century ago, and still pursues a vigorous experimental agenda with an energy and momentum seldom before seen in public culture, sparking furious debate and rousing hostile passions on every side. Principled opponents of contemporary art also fail to see how the experimental agenda of modern art has deep roots in a far older philosophical mission of art, to provoke demanding questions and hazard risky answers about the pressing moral questions of the day. In the last quarter of the twentieth century and the opening years of the twenty-first, the most difficult new art has often had provocative things to say about the role of the art museum, the legitimacy of the market, the identity and meaning of the artwork, and the place and function of the artist within a technically developed, broadly democratic consumer society.

From the 1960s until the turn of the twenty-first century, new art has at the same time proved adept at distinguishing itself from the surrounding culture of films, advertisements, and commercial images, with which it enjoys an oblique, if critical, proximity. Despite a tide of academic writing that has often sought to subsume it within this larger continuum of images—the "turn" to the visual that some believe now typifies our Postmodernist world—the newest visual art demands more sustained attention, prompts more demanding critical writing, and seeks out more elevated registers of awareness than was ever hoped for by advertising men, TV moguls, and the graphic arts. For today's critic, the field of international contemporary art has become too crowded and energetic for every significant artist, grouping, or exhibition to be reviewed exhaustively, and so I have tried instead to take the measure of recent activity by treating symptomatic examples, by looking at geographical regions, and by examining critical schools. The project has its origins in a detailed revision of an earlier (1995) book. The selection in turn has been guided by lessons learnt in two other parts of my work as an art historian: in museology, and in the art of Central and Eastern Europe respectively. From the first comes the broad principle that the cognitive gains of new art reach their highest level only in the light of sustained inquiry into the curatorial conditions under which a work was brought to exhibition—into the spaces of viewing opened for us in today's spectacular new museums of art. From the second comes the conviction that the geopolitics of American and West European art have

been changing rapidly since the fall of the Communist bloc and the end of the Cold War, under pressure from the expansion of the electronic media and the breakdown of national, linguistic, and cultural barriers. The proliferation of a formerly bounded North Atlantic culture into what promises (or threatens) to become a unified global network is perhaps only the latest of the paradoxes and challenges that face the contemporary visual arts tomorrow and today.

My intellectual debts are to those artists, critics, and curators across many continents whose imaginative adventures have provided the subject matter for this book. I must also thank several individuals and organizations for their cooperation, among them Marion Busch of the Museum Boymans-Van Beuningen, Rotterdam; Richard Francis of the Museum of Contemporary Art, Chicago; Victoria Henry of the Canadian Museum of Civilization, Ottawa; Wolfram Kiepe of the Berlinische Galerie, Berlin; Sophie Grieg and Honey Luard of White Cube Gallery, London; Portland McCormick of the Museum of Contemporary Art, Los Angeles; Matthew Slotover of *Frieze* magazine, London; Karin Stengel of the Documenta Archiv, Kassel; Andreas Hapgemayer of Museion, Bolzano; Dr. Jan Kříž of the Czech Museum of Fine Arts, Prague; Dr. Alexander Borovsky of the State Russian Museum, St. Petersburg; the Ronald Feldman Gallery, New York; the Andrea Rosen Gallery, New York; the Sidney Janis Gallery, New York; the Galerie Gerald Piltzer, Paris; the Gallery Sties, Kronberg; the Neue Galerie am Landesmuseum, Graz; the Martin-Gropius-Bau, Berlin; and the patient staff of the Hyman Kreitman Research Centre, Tate Gallery, London. A number of artists were generous enough to enter into detailed correspondence in response to questions, among them Laurie Parsons, Susan Smith, Tehching Hsieh, Malcolm Le Grice, Cynthia Carlson, and Oleg Kulik. For practical matters I am indebted to the photographer Mike Halliwell of the University of Southampton, to the critic Lucy Cotter, and to my research assistants Liz Atkinson and Frances Taylor. My editor, Robert Shore, and picture researcher, Emma Brown, at Laurence King Publishing have shown friendly cooperation throughout. The text was read in part by Marko Daniel, who instructed me in the art of contemporary China and Taiwan. I am finally grateful to the American reviewers of the manuscript, who lent a series of useful perspectives to the work: Erika Doss, University of Colorado; Jelena Stojanovic, Ithaca College; Joy Sperling, Denison University; Blake Stimson, University of California at Davis; Howard Risatti, Virginia Commonwealth University; Bill Anthes, University of Memphis; Paul Ivey, University of Arizona; and Karl Fugelso, Towson University. The remaining emphases and omissions are my own.

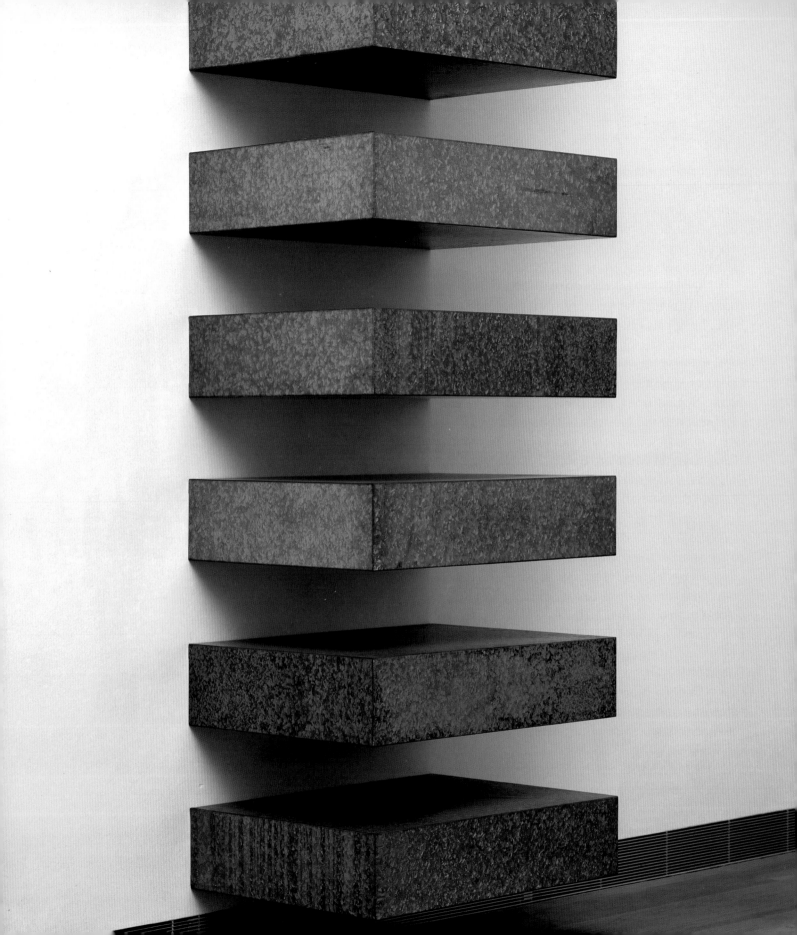

1
Alternatives to Modernism

In the Western nations during the last thirty or so years art objects have come to exist that bear no resemblance to the art of former times, presenting experiences of puzzlement, disorder, and in some cases disappointment to the ordinary viewer in search of imaginative stimulation. Paintings that are blank or disorganized; sculptures that lie on the floor or fill a room with clutter; performances that seem to direct violence against the body or enact apparently meaningless communication; films or works in video that are repetitive, ritualized, or focused upon some arcane obsession of the artist—these are all descriptions that could be applied to works presented as "contemporary" by those who run our galleries and museums, as well as by artists themselves. The degraded formal condition of new art sits uneasily, however, alongside the splendor of the new spaces that have sprung up recently for its display. New museums and galleries for contemporary art have appeared everywhere—to the point where no Western city even of modest size can boast of its modernity, its civic awareness, without the presence of some gleaming piece of new architecture in which cutting-edge culture can be explored.

Willful obscurity in the artwork, then, combined with a massive expansion in the infrastructure of contemporary art—this may be taken as the defining contradiction that has animated and in some cases helped to generate much of the art of our time. Flattered by the new museum with its restaurants and bookshops, yet confronted at every turn by violence and stuttering in the artwork: today's viewer appears to seek a form of intellectual risk whose outcomes can never be predicted. Yet that same viewer understands, perhaps, that the new popularity of contemporary art is in some way due to its origins in the later 1960s and early 1970s, when advanced or "avant-garde" artists sought out new forms of subjectivity, new appearances for art— that on one level contributed to an impression of turmoil in the wider culture, while on

another level giving form to widespread dissatisfaction at the violence issuing from war, capitalism, and sexual and racial inequality. Artistic experiment, then, understood as a kind of record of a society undergoing rapid change: this book is about important developments in the visual arts between that earlier time and now.

Already in the later 1950s, artists who could be called avant-garde in Europe and America had begun to challenge Abstract Expressionist painting and the so-called Modernist critical framework in terms of which it was often understood. That framework may be summarized by two or three statements that together form a particular, and historically durable, way of responding to modern art. As long ago as 1939 the American critic Clement Greenberg observed with unease that "one and the same civilization produces simultaneously two such different things as a poem by T.S. Eliot and a Tin Pan Alley song, or a painting by Braque and a *Saturday Evening Post* cover." Markets have since expanded the popular taste for mass culture—which has continuously threatened the preserves of what Greenberg in the parlance of the day called "high" culture. "It is not enough," he wrote, "in a country like ours, to have an inclination towards the latter; one must have a true passion for it that will give him [note Greenberg's pronoun] the power to resist the faked article that surrounds and presses in on him from the moment he is old enough to look at the funny papers." To that disenchantment with a rampant popular culture must be added a second principle: that the truly vital art of the twentieth century, beginning with Cubism, early abstract art, and Surrealism, evolved following an internal historical logic that gave no place to the social world or to the larger political processes of the day. Internally self-defining and self-referring, "Modernist" painting since Impressionism, said Greenberg—this was in 1961— had learnt the lesson of eliminating from itself "any and every effect that might conceivably be borrowed from or by the medium of any other art." And the third principle of this Modernist art was that it should be viewed silently, and with the eyes alone, against a neutral white gallery wall, once more bracketing off the social environment and even the viewer's own gendered body in order to

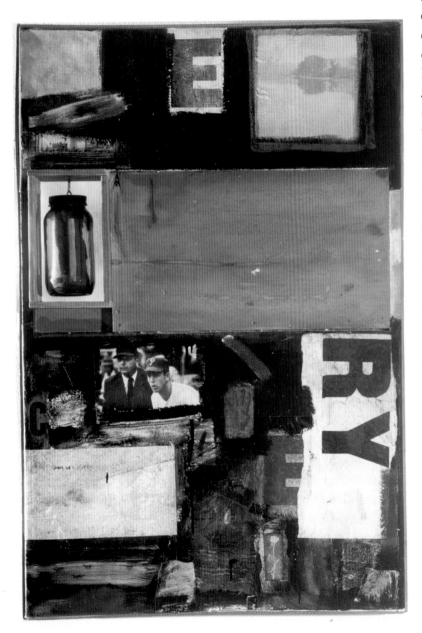

1.1 Robert Rauschenberg
Talisman, 1958
Oil, paper, wood, glass, and metal
42⅛ x 28" (107 x 71.1 cm)

intensify the work's effects, to release its aesthetic value. According to Greenberg, it was the work of a generation of New York abstract painters (among them Jackson Pollock and the later Morris Louis and Kenneth Noland) and an abstract sculptor (David Smith) that best showed the newer forms of Modernism to be the true successors of the Cubist masters.

Yet by the mid-1950s, this powerful New York-centered orthodoxy had already met resistance from several quarters. In America, Robert Rauschenberg, Jasper Johns, and Larry Rivers provocatively introduced into their work mass-cultural signs or icons, vernacular materials or slogans, that parodied the "heroic" gestural freedoms of Abstract Expressionist art. Rauschenberg's "combine" paintings, the first made in 1954, mixed materials and marks of manufacture in ways designed to cut across any adherence to the purity of the painting medium [Fig. 1.1]. British counterparts such as Peter Blake and Richard Hamilton developed informal, collage-like discontinuities that likewise celebrated mass-media imagery, thus openly acknowledging the plethora of popular graphic types (Blake) or photographic surfaces (Hamilton) that made up the artists' and viewers' immediate visual world. At the same time, in the later 1950s, the move into performance, Happenings, and installation by American artists Allan Kaprow, Jim Dine, and Claes Oldenburg helped inspire the European-centered Fluxus movement, whose most prominent member, the German artist Joseph Beuys, pronounced a virtual moratorium on painting, while making a specialty of installations and performance events in which he would manipulate objects and perform actions that seemed more typical of a primitive shaman than of a contemporary visual artist. One such event involved the artist playing the piano, rising to tie a dead hare to a blackboard, then tracing a length of string from the hare to two soft clay mounds on the closed piano: Beuys's small and select audience would be expected to understand the nature symbolism of the sun and stars, the mystic animal sacrifice, and the suggestion of an Eastern mysticism that posed challenges to the rational and heavily technicized West. Meanwhile in Central and Eastern Europe, artists living under the yoke of Communism, while increasingly aware of Fluxus and similar events further west, made dissenting gestures signifying their complete alienation from the political process and their determination to offer templates for new forms of social interaction. The "ceremonies" and "demonstrations" of the Czech artist Milan Knížák, staged in Prague from 1962, demonstrated the latent vitality of a whole generation in revolt. Whether in the form of Yoko Ono's gentle instruction pieces in New York in the early 1960s, or of the Swiss artist Ben Vautier's placing of himself in a gallery window for a week in London, or the bloody performances of the Vienna Actionists, or the political provocations of Jerzy Berés in Poland in the same years—signs were multiplying that the grand assumptions of Modernist theory as manufactured and sustained in New York were under radical review, that the processes and struggles of the wider culture were demanding vociferously to be heard.

Even further east, in countries drastically damaged in World War II and conscious of the need to modernize, artists also contested the automatic dominance of

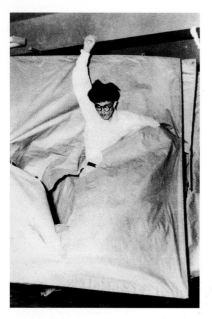

1.2 Saburo Murakami
Breaking Through Paper performance, 1955
Photograph

1.3 Piero Manzoni
Linea Lunga Metri 11.60, 1959
Ink on paper in cylindrical cardboard
container
7 ¾ x 2 ⅓" (20 x 6 cm)

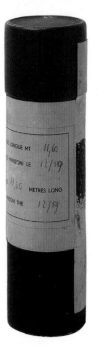

painting as the superior medium of art. The Gutai group, founded in Tokyo in 1954, complained of the "fraud" with which paint, metal, clay, and marble are "loaded with false significance, so that, instead of just presenting their own material self, they take on the appearance of something else." The words are from Jirō Yoshihara's manifesto of 1956, in which he went on to say that "Gutai art [Gutai means 'concrete'] does not falsify material: it brings it to life… If one leaves the material as it is, presenting it just as material, then it starts to tell us something and speaks with a mighty voice." At the same time, the young painter Kazuo Shiraga echoed the bodily energies of New York abstract painting by painting with his feet or writing on his stomach in a pool of mud; Saburo Murakami threw his body through paper screens [Fig. 1.2]; Shōzō Shimamoto smashed paint bottles over canvas to produce explosive patterns of energy: Gutai exhibitions vigorously evoked what the manifesto called "a tremendous scream in the material itself." Though Gutai painting was broadly aligned with 1950s French *art informel* (informal art) as well as the New York manner, Yoshihara remained adamant that the comparisons were only superficial, and that other apparent affinities, such as to European Dada, also missed the originality of the new Japanese investigation into the dynamics and energies of material.

Similar forms of rebellion ignited all over Europe. In Italy, the pioneering dissenter Piero Manzoni was protesting the dominance of painting as the mainstay of modern visual art by producing what he called *Achromes* (they were mostly white), from which the sensuous rewards of color had been removed, leaving the affronted spectator with only the bare form of the work. That was in 1957. By the next year Manzoni had further corrupted the display conventions of "Modernist" art by producing works comprising painted or drawn lines, which were then rolled up and placed in a tube so that they could not be seen [Fig. 1.3]. The only visible element was a standardized printed label bearing the words "Contains a line … metres long, made by Piero Manzoni …" the gaps in which would be filled in by the artist himself with the line's length and date in each case. Manzoni complained of contemporary gestural painting: "A surface with limitless possibilities has been reduced to a sort of receptacle in which inauthentic colours, artificial expressions, press against each other. Why not empty the receptacle, liberate this surface?… Why worry about the position of a line in space? Why determine this space? Why limit it?… A line can only be drawn long, to the infinite; beyond all problems of compositions, or of dimensions. There are no dimensions in total space."

A later and mostly Italian formation, *arte povera*, or "poor art," arose from an exhibition in Genoa in 1967 around the artists Jannis Kounellis, Mario Merz, Michelangelo Pistoletto, Giovanni Anselmo, Alighiero Boetti, Emilio Prini, and Gilberto Zorio. Curated by the ambitious young critic Germano Celant, who devised the category, *arte povera* grouped artists who favored natural forms and biologically organic materials over the industrially produced or anonymously manufactured surfaces of West European Pop art. "The artist-alchemist organises living and vegetable matter into magic things," Celant wrote in a text for a 1969 exhibition in

Milan, "working to discover the root of things, in order to re-find them and extol them. His work includes in its scope the use of the simplest material and natural elements (copper, zinc, earth, water, rivers, land, snow, fire, grass, air, stone, electricity, uranium, sky, weight, gravity, height, growth, etc) for a description or representation of nature. What interests him is the discovery, the exposition, the insurrection of the magic and marvellous use of natural elements." In practice, artists grouped in the *arte povera* camp came from a wide international spectrum, united in their search for the contingencies of growth and decay within everyday life and politics alike. That impulse came from an attitude "that tends towards deculturization, regression, primitiveness and repression, towards the pre-logical and pre-iconographic stage, towards elements and spontaneous politics, towards the basic elements in nature… in life, and in behaviour." For example, the particular interpretation given to "povera" by Mario Merz was to rediscover the numerical systems unearthed by the twelfth-century mathematician Leonardo Fibonacci which applied to plant growth, seashells, and the skin structure of reptiles (1, 1, 2, 3, 5, 8, 13…), then to align these

1.4 Mario Merz
Igloo, 1972
Metal tubes, wire mesh, neon, transformer
o-clamps
Diameter 6'6 ¾" (2.00 m)

growth patterns with the political and economic multiplications of modern capitalism: Merz's favored format required building quasi-technological igloos made of steel, mesh, or glass as an image of nomadic survival undergoing rapid cultural change [Fig. 1.4]. More typical of Giovanni Anselmo or Jannis Kounellis was the use of initially fresh vegetables that might alter the shape of a structure as they decayed (Anselmo), or the introduction of live animals such as birds or horses into the exhibition (Kounellis)—the latter artist's installations have always been demonstrations on a physically impressive scale. Quite evidently, the "poverty" of Celant's categorization was sometimes more apparent than real.

Further examples could be adduced to show that a sort of demonstrative freedom from Modernist dogmatism was the first consideration of young artists fresh upon the international scene after the end of the 1950s. Never far from the burgeoning counter-culture of hedonism and dissent already vigorously manifested in the new pop music or at street level in fashion, hallucinogenic drugs, and political protest, those experiments in the visual arts had consequences that are still important today—both in the observance and in the breach. At that time several arenas of wider

political culture, after all, were in turmoil. Kennedy's assassination in 1963 was followed by Civil Rights marches in America's capital, race riots in Los Angeles, and the beginning of the disastrous US military campaign in Vietnam. The Middle East was on the brink of war. China was undergoing "cultural revolution" under the strict Communist injunctions of Mao Tse-tung. In what we crudely refer to as "the West," the most important experimental artists were seldom far from the centers of youthful political debate.

As the counter-culture took root in America, two developments in the visual arts had effects of special relevance to this book. In the early 1960s artists soon to be known as Minimalists began to enact a different kind of escape from the proscriptions of orthodox Modernism by constructing simple geometrical objects that were characterized by formal symmetry, absence of traditional composition, and monochrome color. Stemming indirectly from the flat-banded paintings of Frank Stella and experiments with wooden blocks by Carl Andre in the later 1950s, a 1963 exhibition at New York's Green Gallery by the then thirty-three-year-old Robert Morris had a series of gray-painted plywood volumes placed directly in the gallery space, where they leaned against the walls, rested on the floor, or hung in space. Similar to theater props for avant-garde dance pieces (Morris had already been involved in dance), these objects presented no compositional complexity, no tonal variation, no clear line of demarcation between the literal space of the gallery and the viewer's own. And this was only the beginning. Soon, Morris was focused entirely on floor-based symmetry and the production of industrially formed shapes in fiberglass [Fig. 1.5], while simultaneously preparing theoretical writings on the condition of sculpture for *Artforum*, at that time the most widely read theoretical journal of the avant-garde community. In the early sections of his now celebrated "Notes on Sculpture," published in parts between February 1966 and April 1969, Morris begins by suggesting that sculpture occupies a quite different experiential territory to that of Modernist painting. Sculpture never having been involved with illusionism, he wrote, its "basic facts of space, light, and materials have always functioned concretely and literally. Its allusions or references have not been commensurate with the indicating sensibilities of painting… Clearer distinctions between sculpture's essentially tactile nature and the optical sensibilities involved in painting need to be made." Training his attention on the qualities of very simple "gestalts" or "wholes," Morris argued that the intensification of the simplest shapes and the elimination of all non-essential sculptural attributes, such as inflection and relationships, "establishes both a new limit and a new freedom for sculpture." As these passages suggest,

1.5 Robert Morris
Untitled, 1965–66
Fiberglass and fluorescent lights
2 x 8' (0.6 x 2.8 m)
Dallas Museum of Fine Arts

"Much work is made outside the studio," Morris wrote in 1966. "Specialized factories and shapes are used—much the same as sculpture has always utilized special craftsmen and processes… Such work, which has the feel and look of openness, extendibility, accessibility, publicness, repeatability, equanimity, directness, immediacy, and has been formed by clear decision rather than groping craft, would seem to have a few social implications, none of which are negative. Such work would undoubtedly be boring to those who long for access to an exclusive specialness, the experience of which reassures their superior perception."

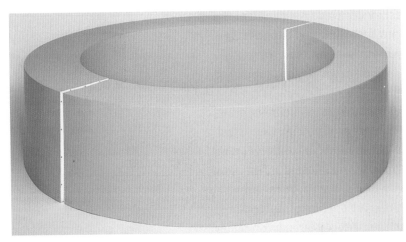

moreover, Morris was urging a description of Minimalist structures that included their effects on the spectator.

Meanwhile another group of young sculptors was also showing elementary sculptural volumes directly in the gallery space. Carl Andre took standard mass-produced bricks and stacked them in rectilinear arrays on the plane of the floor: the notorious *Equivalent VIII* of 1966, for example, which could almost be mistaken for the base upon which a traditional sculpture rested, now became the art object in its own naked and elementary right—it provoked a storm of protest among conservatives when it was purchased by London's Tate Gallery in 1973. By the time Donald Judd published his no less important "Specific Objects" article in 1965, he himself was exhibiting simple boxlike structures, made anonymously and defiantly resisting both orthodox Modernist description as well as the entire aesthetic superstructure of the European tradition in fine art [Fig. 1.6]. "Half or more of the best new work in the last few years has been neither painting nor sculpture," Judd wrote, but "three-dimensional work." In such work, "the whole thing is made according to complex purposes, and these are not scattered but asserted by one form. It isn't necessary for work to have a lot of things to look at, to compare, to analyse one by one, to contemplate. The thing as a whole, its quality as a whole, is what is interesting."

Judd's and Morris's first exhibitions, together with their articulate writings, prompted a series of allegiances and disagreements that were important in what was to follow. The affinities between their work and the 1960s paintings of Frank Stella and Kenneth Noland, which countered the compositional and relational aesthetics of what they identified as European art, spread to other New York artists in the years before about 1967 and marked their work as having a no-nonsense confidence that to Europeans seemed quintessentially transatlantic—as well as assertively masculine. The most important hostile response, on the other hand, came from the American critic Michael Fried, who had been close to Clement Greenberg in the early 1960s and who now, in the summer of 1967, launched an attack on Judd and Morris in which he complained that their Minimalism—also known as ABC Art or Primary Structures (the latter was the title of a Jewish Museum show the previous year)—suffered from "objecthood," or what Fried called "literalness," which essentialized the work's presence in front of the viewer, as well as the viewer's presence in front of it. Fried argued that literalness was antithetical to Modernist critical standards, because in requiring the presence of the viewer it resembled something happening in a theater or on a stage: "the literalist espousal of objecthood," he wrote, "amounts to nothing other than a plea for a new genre of theater; and theater is the negation of art." Turning at the end of his essay to defend the sculpture of David Smith and Anthony Caro, Fried claimed that "it is as though one's experience of the latter has no duration… It is this continuous and entire presentness, amounting, as it were, to the perpetual creation of itself, that one experiences as a kind of *instantaneousness*—as though if only time were infinitely more acute, a single infinitely brief instant would be long enough to see

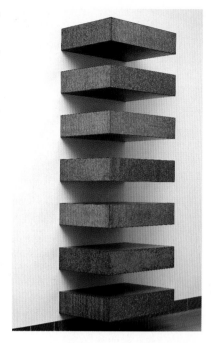

1.6 Donald Judd
Untitled, 1970
Galvanized iron
7 units, each 9 x 40 x 30" (23 x 101.6 x 76.2 cm), with 9" (23 cm) intervals
Moderna Museet, Stockholm

1.7 Anthony Caro
Red Splash, 1966
Painted steel
45.5 x 69 x 41" (115.5 x 175.5 x 140 cm)

everything, to experience the work in all its depth and fullness, to be forever convinced by it" [Fig. 1.7]. Minimalist art commanded only *attention*, Fried suggested; Modernist painting and sculpture compelled *conviction*.

But the times were changing fast. Even as Fried was launching his defense of Modernist painting and sculpture in 1967, America's adventure in Vietnam was escalating, student unrest was fomenting both in the USA and Europe, and freedom from authoritarian cultural principles was being asserted by left-wing political groups from San Francisco to Prague. Rock music was underpinning a mood of euphoric rebelliousness throughout the West. As if in resonance, the mood of younger artists by 1968 was in favor of progressively dematerializing the art object so as to make it no longer an object that could be purchased and traded on the market, no longer the kind of thing that could be displayed in a conventional gallery setting, no longer an entity that could be described in conventional terms. In practice, their new artefacts embodied a potent mixture of refusals, gestures, and non-events, arranged in non-orthodox physical arrangements and drawing upon a motley of resources including found objects and urban detritus, treated with the bad manners and extravagant nihilism of a disaffected minority culture.

Interestingly, it was the older Robert Morris, recently concerned for the detailed sensory phenomenology of the sculptural object, who now proposed to reduce the primary structure still further in the direction of a complete absence of form. By 1968 and the publication of another landmark essay, "Anti-Form," Morris was arguing for

absence of determinate shape, absence of durability, absence even of outline or silhouette: works composed of felt cuts, felt piles, roomfuls of shapeless cotton thread waste, or even steam blowing randomly in the wind were all exhibited to intense critical and spectatorial scrutiny. By 1969 Morris was manually scattering and manipulating matter in a performance-like manner without regard to cleanliness, coherence, or predictable outcome. Pure physical immersion in stuff, rather than stuff as material to be looked at, was now seemingly the objective of his art.

The same shift from object to process was evident in a host of other artistic projects that arose at the apogee of the counter-culture's most revolutionary energies. We can illustrate only representative examples here. Anthony Caro's presence as a teacher at Saint Martins School of Art in London prompted allegiance, but also violent opposition. When a young student named Richard Long was asked by Caro about some sticks he had arranged on a studio floor, Long replied that it was half a work of art: the other half was on top of a mountain in Scotland, some four hundred miles to the north. This was more than a studio joke: a generation who were antipathetic to working in welded steel were now giving singing performances in which they became their own sculptures (Gilbert and George), poured sand into heaps (Barry Flanagan), or went on country walks to collect sticks, perhaps arranging them later in a gallery space (Long). Although Long had his first international exhibition with Conrad Fischer in Düsseldorf while still at Saint Martins—an important example of how a younger generation of curators were endorsing experimental art—his most concise early work, also from his student years, involved not even the collecting of sticks, but rather a walk back and forth across a suburban patch of meadow until a line was formed in the grass that could then be photographed in anticipation of a later gallery show. The work in question, *A Line Made by Walking* of 1967 [Fig. 1.8], constituted for Long as well as his teachers a provocative rejection of traditional fine-art drawing on paper and an assertion that lines could be found anywhere, even in the movement through nature of the artist's own body. Second, the documentation of the walk, from a position at eye height on the line of the walk itself, cleverly resulted in a vertical mark down the photographic print that could be read as echoing both the singularity of a strip in the geometrical paintings of Barnett Newman, and a line inside one of Manzoni's boxes—both of which we assume Long knew. And third, at least in the eyes of American observers, Long's walks came to signal a resumption of the English Romantic tradition of journeying to rural places to take pleasure in the countryside.

Even more fundamentally, perhaps, this and similar excursions into the land, such as those by the Americans Michael Heizer and Dennis Oppenheim, were forcing a dramatic separation between some outdoor event taking place often miles from any gallery, and the subsequent display of its documentation to an art

1.8 Richard Long
A Line Made by Walking, 1967
Photograph

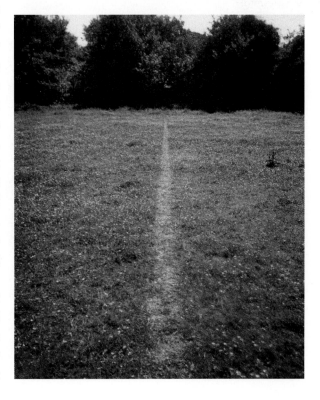

1.9 Michael Heizer
Double Negative, 1969
1500 x 50 x 30' (457 x 15.2 x 9.1 m)
Mormon Mesa, Nevada

"I work outside because it's the only place where I can displace mass," said Heizer in an interview. "I like the scale—that's certainly one difference between working in a gallery and working outdoors. I'm not trying to compete in size with any natural phenomenon, because it's technically impossible."

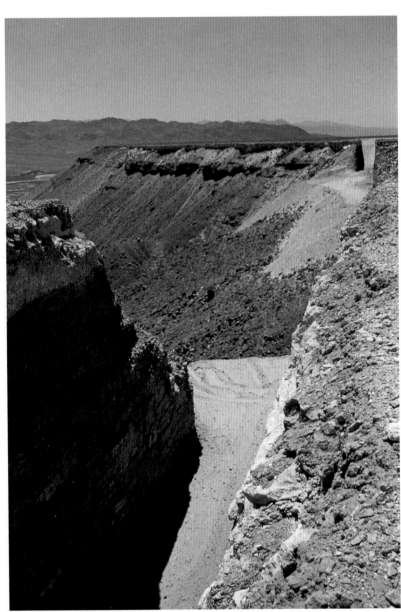

audience indoors. For example, Michael Heizer's monumentally scaled *Double Negative* of 1969, formed by instructing earth-moving engineers to cut a swathe through a mountain in the remote Nevada Desert, resulted in a discontinuous but spectacular void in a natural site [Fig. 1.9]. As the artist has pointed out, hundreds of people have visited the site, but for most, the artwork was only likely to be experienced in the form of photographs in a far-off gallery, or as descriptions in a book. Either way, an assertion was being made of the artist's much sought-after independence from the commercial gallery system, as well as marking the work's lingering dependence upon it.

We are only a short step away from an area of experimentation in which a plan to execute an action, or its record, or some form of written speculation on a possible future event, would alone be sufficient to certify that art was being made. Conceptual art, which shifted the balance of production from material to idea, from event to concept, was not of course completely free of material—but the place of that material within the system of viewing, buying, selling, and conserving art was for a time, roughly between 1966 and 1972, radically at odds with prevailing assumptions about the aesthetic encounter. Sol LeWitt captured one definition of Conceptual art when he wrote in an article in *Artforum* in 1967 that "when an artist uses a conceptual form of art, it means that all of the planning and decisions are made beforehand and the execution is a perfunctory affair… it is the objective of the artist who is concerned with conceptual art to make his work interesting to the spectator, and therefore he would want it to become emotionally dry." Determined to avoid displays of subjectivity or decision-making, LeWitt's own work was characterized by repetition and permutation—in 1968 he began formulating proposals for wall drawings of closely positioned regular straight lines to be executed by a team of draftsmen according to his instructions. But LeWitt also stresses that while "what the work looks like isn't too important (it has to look like something if it has physical form)," a few decisions still have to be made to determine the scale, size, and positioning of the final product. What is important is the

communication of an idea: "Conceptual art is only good when the idea is good."

A potent mixture of provocation and mild absurdity is to be found in most works proclaimed as Conceptual. Sol LeWitt himself added another term, economy, that intersects with both of the above: "Any idea that is better stated in two dimensions should not be in three," he said. "Ideas may also be stated with numbers, photographs, or words or any way the artist chooses, the form being unimportant." ("I dislike the term 'work of art,'" he adds teasingly, "because I am not in favour of work and the term sounds pretentious.")

Accordingly, an artist like Robert Barry, trained as a painter, gave up painting when he found that his works looked different in different light settings; he made installations with thin wire filaments, but gave those up too when he found they were invisible. Barry's shows thenceforward consisted of radio waves, ultrasonic sound, microwaves, and radiation; he would announce their ethereal existence, but nothing more. In another sense, Barry's works can be seen as attempts to dissolve the distinction between art material and the whole environment. His *Inert Gas Series* of 1969 consisted of releasing 2 cubic feet of helium into the open spaces of the Mojave Desert and photographing the invisible result [Fig. 1.10], a work that could function as a metaphor for the dissolution of finite art into infinite life as well as triggering a reflection on the nature of photographic evidence—and the visual world. To provoke an audience philosophically was a regular tactic of Barry's in those extraordinary years. For an important London exhibition in 1969—the first in that city to bring Conceptual art out of the private galleries and into the publicly funded arena—Barry sent an instruction to the organizer Charles Harrison to print a specification for a piece of art that was no more visible than inert gas, indeed that could lie in the future: "THERE IS SOMETHING VERY CLOSE IN PLACE AND TIME, BUT NOT YET KNOWN TO ME." Readers of this text, which was included in the seminal *Live in Your Head* exhibition at the Institute of Contemporary Arts, would have had to undertake only a little mental work to register Barry's interest in what he described as "things intangible and immeasurable, physical yet metaphysical in their effect."

The intuition that art and life are inextricably bound up with one another—and could somehow merge—provided a strong motivation for the Italian-born Vito Acconci, who early in his career was a poet; with the difference that Acconci took to extremes LeWitt's concept of pre-planning and repetition as basic determinants of the work. First, Acconci selected an organizing formula, such as "Choosing a person at random, in the street, any location, each day for 23 days. Following him wherever he goes, however long or far he travels. The activity ends when he enters a private place,

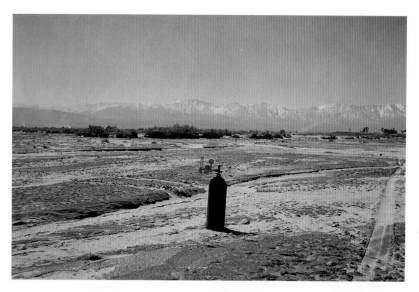

1.10 Robert Barry
Inert Gas Series: Helium. From a Measured Volume to Indefinite Expansion. Sometime During the Morning of March 5th, 1969, 2 Cubic Feet of Helium Was Released into the Atmosphere

"Inert gas is a material that is imperceivable—it does not combine with any other element. When released it goes 'from a measured volume to indefinite expansion,' as it says on my poster… It continues to expand forever in the atmosphere, constantly changing, and it does all this without anybody being able to see it" (Robert Barry).

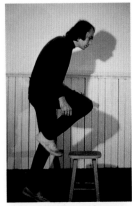
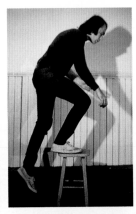
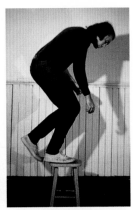
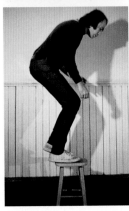
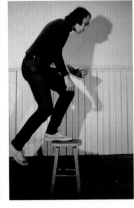
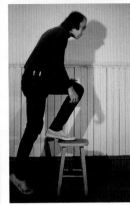

1.11 Vito Acconci
Step Piece (Steps: Stepping-Off Place), 1970
Performance
Four months, varying times each day

his home, office etc." This indeed was the format applied in *Following Piece*, 1969, documented in the true Conceptualist style by a photographer who followed Acconci and recorded in crude snapshot pictures the near-meaningless actions of the artist and his prey. In this and similar works the artist was effectively the only material; yet it was the insignificance of his actions that in the end translated their structure into the content of the work of art. Likewise Acconci's *Step Piece* of 1970, in which an 18-inch (46-cm) stool was set up in his apartment and used as a step: "Each morning, during the designated months, I step up and down the stool at the rate of 30 steps a minute... the activity lasts as long as I can perform it without stopping—the times are then recorded" [Fig. 1.11]. In England, by contrast, one approach was to engage in arcane speculation on the origins and nature of art itself. In a series of texts and documents written in imitation of the dry prose style of linguistic philosophy, the Art-Language group published from 1969 a journal bearing their name which contained no images and promised none, attending instead to conceptual problems of definition of when and how and why the art object had traditionally existed at all.

"The studio is again becoming a study," wrote Lucy Lippard and John Chandler in an article entitled "The Dematerialization of Art" in *Art International* for February 1968—a matter of days before student riots and trades-union demonstrations erupted across Europe and the USA. To Lippard and Chandler, the connection between the dematerialization of the art object and the effervescent rise of the counter-culture was more or less clear. "Involved with opening up rather than narrowing down," they observed, "the newer work offers a curious kind of Utopianism which should not be confused with Nihilism except that, like all Utopias, it indirectly advocates a tabula rasa; like most Utopias, it has no concrete expression." Further observing that the kind of humor present in Conceptual art is really wit, they pointed out that "wit" once meant "mind" or the powers of reasoning or thinking. "One of the word's meanings is 'the mental faculties in their normal conditions of sanity'... the word gradually came to designate 'the ability to make clever, ironic or satirical remarks usually by perceiving the incongruous and expressing it in a surprising or epigrammatic manner.'" Recalling the vital part played in this revival by the French Dadaist Marcel Duchamp, who until his death in 1968 lived in New York and had inspired several younger Conceptualists, Lippard and Chandler's emphases on utopianism and humor also

opened the discussion to the nature of the audience for Conceptualism's most provocative works. The strategy can be described as exchanging one art audience for a better (or at least another) one. When Robert Barry revealed that an exhibition planned for Amsterdam in December 1969 would consist of the gallery staff locking the door and posting an announcement that read "For the exhibition the gallery will be closed," he no doubt intended to divide his audience into those merely affronted by the inconvenience of a "closed" exhibition and those who would more astutely register that the sign could also mean that the exhibition and the closed gallery were one and the same. When Vito Acconci stated in the documentation of the first *Step Piece* event that a second version would be open "to the public, who can see the activity performed, in my apartment, any time during the performance-month" at 8 a.m. each day, he was surely aware that few readers would know where he lived or be prepared to get up early to watch him stepping on and off his ordinary stool.

Conceptual artists "have set critic and viewer thinking about what they see rather than simply weighing the formal or emotive impact," Lippard and Chandler wrote observantly in their piece. And yet—as we shall find in the following chapter— the minor revolution implied in that statement would turn out to have multiple consequences. Lippard's own perspective would shortly change in favor of an open sympathy toward a group so far marginalized by male-dominated Minimalist and Conceptual art. Feminism was little by little attracting support within the wider culture, but was achieving particular gains within the world of the arts. The painter Carolee Schneemann had been fired by her experience of reading Simone de Beauvoir's 1949 book *The Second Sex* and Wilhelm Reich's theories on the relationship between sexuality and freedom, and as early as 1963 had devised photographic representations of her own body in which a far older goddess imagery came to the surface—literally so,

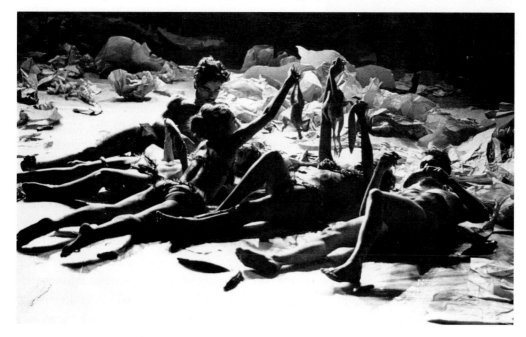

1.12 Carolee Schneemann
Meat Joy, 1964
Raw fish, chicken, sausages, wet paint, plastic, rope, paper, scrap
Performance photograph

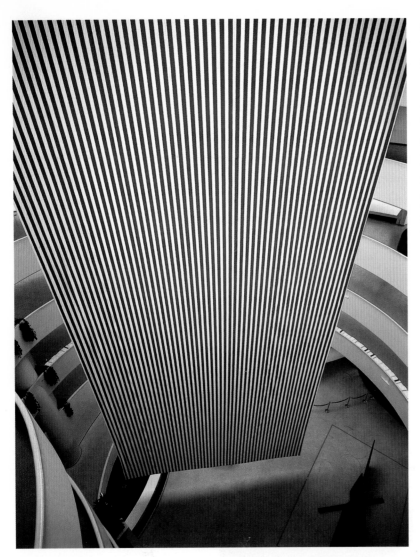

1.13 Daniel Buren
Inside (Center of Guggenheim), 1971.
Acrylic on cloth
65'7 ½" x 29'9 ¾" (20 x 9.1 m)
Installed at the Solomon R. Guggenheim
International Exhibition, 1971, for one day
before the opening
Collection of the artist

as the artist emphasized the skin itself as bearer of the painted mark. But this was only a prelude. Schneemann's landmark performance *Meat Joy* [Fig. 1.12], first performed in Paris with Jean-Jacques Lebel at the Festival de la Libre Expression (Festival of Free Expression) in May 1964 and subsequently at the Judson Memorial Church, New York, was a self-consciously eroticized event in which the participants undressed each other, plucked chicken feathers, and rolled ecstatically near-naked on the floor in a celebration of flesh, blood, and paint. Along with a revival of the performance tradition in Europe—by Wolf Vostell, Yves Klein, Piero Manzoni, and others—*Meat Joy* clearly implied that art need no longer be a durable commodity, witnessed in reverential silence in the off-putting spaces of a dealer's salon. Chance, randomness, unrepeatability, and a carefully calibrated disregard for the sensitivities of taste were the new paradigms of the counter-culture's most experimental art.

The second major impact of the dematerialization of art was upon the politics of the administration of the museum. While some entrepreneurs had begun to welcome new art into the private galleries (increasingly with the active collaboration of artists), the larger institutions financed from the public purse were accused of political conservatism, covert commercial entanglement, and the active discouragement of ethnic minorities, the working classes, and women. Early in 1969 an ad-hoc group calling itself the Art Workers' Coalition (AWC), whose members included Robert Morris, Carl Andre, and Lucy Lippard, presented to the Trustees of the Museum of Modern Art a list of "13 Demands." These included longer opening hours, the widening of participation to encompass blacks and Puerto Ricans, involvement in the housing and welfare of artists, recognition of ecological damage, and recognition of an artist's rights to ownership and control over the destiny, alteration, or exhibition of his or her work. A different kind of controversy erupted early in 1971, at New York's Guggenheim Museum, when the French artist Daniel Buren found himself in confrontation with the museum authorities over the impact of his work on the prestigious gallery space. Buren had issued a declaration two years before, committing himself to a renunciation of "composed" painting and to producing instead stripes of equal width in alternating regular color pairs (red and white, blue and white) as a demonstration of complete

freedom from the tradition. Now responding to an invitation to join a large international survey exhibition at the Guggenheim, Buren devised a plan for two stripe-covered canvases, the largest of which, at nearly 66 by 30 ft (20 x 9 m), would hang in Frank Lloyd Wright's spacious central bowl, while the smaller canvas would be hung across 88th Street outside [Fig. 1.13]. Buren's idea was that the viewer would see the interior piece from multiple positions during an ascent of the Guggenheim ramp—transposing the work, in effect, into a three-dimensional mobile while implicitly reorganizing the function of the ramp itself. "One of the characteristics of the proposition," said Buren, "is to reveal the 'container' in which it is sheltered." Other participating artists immediately complained that Buren's demonstration compromised and endangered the visibility of their own work, and although Buren's response was that the work, "placed in the centre of the museum, irreversibly laid bare the building's secret function of subordinating everything to its narcissistic architecture," the authorities had the larger canvas removed. The museum, said Buren—he might have been speaking about any museum—"unfolds an absolute power which irremediably subjugates anything that gets caught/shown in it."

No more than a few weeks later, the German-born artist Hans Haacke, having been promised a one-person show at the Guggenheim, had several works refused by the museum's director, Thomas Messer, on grounds of allegedly "inappropriate" content. Haacke had latterly begun to explore the intersection of social and institutional "systems" and especially the processes of power. His new work, *Shapolsky et al. Manhattan Real Estate Holdings, a Real-Time Social System, as of May 1, 1971*, comprised 142 deadpan photos of building façades, taken from street level, surmounting type-written statements containing carefully researched data on property tycoon Harry Shapolsky's mortgages, rent deals, and tax agreements on each of his properties in Harlem and the Lower East Side over a twenty-year period [Fig. 1.14]. Potentially incriminating references to rent-gouging, insider deals, and prison sentences relating to Shapolsky were meticulously withheld. Meanwhile Haacke described his works as having the quality of a "system" for which "the range of outside factors influencing it, as well as its own radius of action, reach beyond the space it materially occupies." He fully intended that such effects would place the viewer in a new relationship to the work—"not permitting him to assume his traditional role of being the master of the work's meaning; rather the viewer now becomes a witness." A system "is not imagined," wrote Haacke, "it is real." Yet the museum was quick to condemn *Shapolsky et al.* as a muck-raking venture that compromised the Guggenheim's charter obligation of "pursuing aesthetic and educational motives that are self-sufficient and without ulterior motives": it was an "alien substance that had entered the art museum organism" and that had to be excised. The short-term result was a protest by over one hundred artists inside the museum, and the signing of a pledge "not to exhibit at the Guggenheim until the policy of art censorship and its advocates are changed." With the exhibition's curator Edward Fry dismissed for defending Haacke's work, the longer-term result was the igniting of a wider debate on

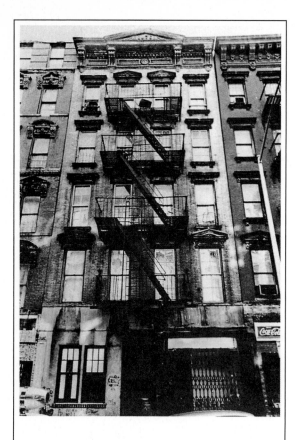

228 E 3 St.
Block 385 Lot 19
24 x 105' 5 story walk-up old law tenement

Owned by Harpmel Realty Inc. 608 E 11 St. NYC
Contracts signed by Harry J. Shapolsky, President('63)
 Martin Shapolsky, President('64)
Acquired from John The Baptist Foundation
c/o The Bank of New York, 48 Wall St. NYC
for $237 000.- (also 5 other properties) , 8-21-1963
$150 000.- mortgage (also on 5 other properties) at 6%
interest as of 8-19-1963 due 8-19-1968
held by The Ministers and Missionaries Benefit Board of
The American Baptist Convention, 475 Riverside Dr. NYC

Assessed land value $8 000.- total $28 000.-(1971)

how art museums might display work that posed critical questions about the values of the museum itself.

Haacke would later polemicize about how art museums were compromised by their business methods, management techniques, public relations, and corporate investments—a "consciousness industry" in effect only superficially cloaked in concern for individual expression, education, and the "spiritual" life. The art historian Carol Duncan would also later co-author with Alan Wallach an analysis of the generic modern art museum, a "ritual architecture" structured through texts, visitor pathways, and information panels to tell a narrative of art leading from earlier beginnings to later apotheoses (the "script" of New York's Museum of Modern Art ascended gradually to Abstract Expressionism as a "triumph" of spirit over matter). Disputing the hermetic sealing of the museum from wider issues of politics and society, Haacke, Duncan, and others kept alive a debate that had started in the counter-culture and that would become one of the signal motifs of the intelligent discussion of art for generations to come.

Almost forty years on, we can see how the later 1960s provided a moment of absolute contradiction between the claims of traditional institutional power to exercise legitimate judgment over art, and the counter-propositions of a generation of artists radicalized by a new awareness of corporate crime, social injustice, and war. An outbreak of artistic experiment was part and parcel of that atmosphere of dissent. The demonstrating workers and students who manned the barricades in Paris in May 1968, or the protesting students shot by military police at Kent State University in 1971, have passed into history as symbols of their era. Art functions as a counterweight to power throughout the period covered by this book.

1.14 Hans Haacke
Shapolsky et al. Manhattan Real Estate Holdings, a Real-Time Social System, as of May 1, 1971 (detail), 1971
One photograph and typewritten sheet

The Guggenheim Museum's rejection of this work revealed the challenge of the radical assumption that "anything could be art," as well as the capacity of Haacke's tableaux, deployed in different contexts thereafter, to unmask the links between culture and power.

Contemporary Voices

Robert Barry, "Interview with Ursula Meyer" (1969), in U. Meyer, *Conceptual Art*, New York: Dutton and Co., 1972, p. 35.

"The most beautiful thing about modern art is that it has built into its own potential the capacity for destroying itself. Nothing keeps renewing itself the way art does. The fundamental beliefs in art are constantly threatened and as a result it is constantly changing; and so art and anti-art are really the same thing."

Lucy Lippard, "Interview with Ursula Meyer" (1969), in L. Lippard and J. Chandler, *Six Years: The Dematerialisation of the Art Object*, New York and London: Studio Vista, 1973, p. 8.

"It becomes clear that today everything, even art, exists in a political situation. I don't mean that art itself has to be seen in political terms or look political, but the way artists handle their art, where they make it, the chances they get to make it, how they are going to let it out, and to whom—it's all part of a life style and a political situation. It becomes a matter of artists' power, of artists achieving enough solidarity so they aren't at the mercy of a society that doesn't understand what they are doing."

Unattributed.

"If you can remember the Sixties—then, man, you weren't there."

2
Victory and Decline: The 1970s

The early 1970s was a time when the prospects for avant-garde art looked bright indeed throughout the Western world. Particularly for younger artists caught up in the mood of opposition to established culture in the decade just ended, it seemed that the victories won against more orthodox readings of modern painting and sculpture held the key to many practical and theoretical possibilities. Thoroughly symptomatic of these ambitions was the first full-scale international exhibition to endorse the artistic values of the counter-culture, the legendary 1972 *Documenta 5* in Kassel, selected by the young curator Harald Szeemann. *Documenta* had been a four- or five-yearly event since 1955, when it was launched by Arnold Bode as part of an effort to show the vitality of German and West European Modernism after the ravages of war, and as a counterweight to the institutional power of New York. Szeemann's selection was nothing if not "alternative." Although a complete account of the event would mention rooms devoted to kitsch, to religious imagery, to children's games, to science-fiction illustrations, to advertising and other marginal aesthetic forms—and not forgetting that a form of "Photorealism" was briefly current around 1972—the main appeal of *Documenta 5* was to the new dispersal of experimentation across the photographic, Conceptual, and time-based arts. *Arte povera* artists (Boetti, Anselmo, Merz) were seen in close proximity to Actionists (Brus, Nitsch, Schwarzkogler), alongside those working wholly or partly in film (Jonas, Serra) or photography (Boltanski, Rainer, Ruscha, Fulton), installation (Kienholz, Thek, Ono, Oppenheim), and performance (Acconci, Beuys, Gilbert and George, Horn, Graham, Hesse), to name only a representative few. Yet by the end of the 1970s the mood was very different. Not only had the artistic radicalism of the counter-culture visibly waned, but a new set of priorities had come to occupy center stage, so as to make that radicalism seem exhausted, misplaced, or at best utopian. But between the experience of hope and the perception of exhaustion lay

Opposite
Chris Welsby
Seven Days (detail), 1974
See fig. 2.19

an expanse of artistic experiment. This chapter is about the attempts that were made throughout the decade to propagate and extend a mood of experimentation, at a time when the pull of the wider culture was often in a contrary direction.

The Demands of Feminism

Of all the major realignments in visual culture of the last thirty or so years, perhaps the most significant has resulted from a sustained reflection on questions of gender. In the early 1970s the crisis of confidence in Modernist male culture was deepest among women artists allied to feminism in its then current variations. Prefigured by the activities of West Coast artists of the 1960s such as Miriam Schapiro and Judy Chicago, women's groups had also been active in New York, where the Art Workers' Coalition included among its "13 Demands" in 1970 the insistence "that museums should encourage female artists to overcome centuries of damage done to the image of the female as an artist by establishing equal representation of the sexes in exhibitions, museum purchases, and on selection committees." In February of that year, so she tells us, the black painter Faith Ringgold, already concerned about black visibility and the identity of black art, became a feminist. "It happened the day I decided to launch a protest against an exhibition, to be held at the School of Visual Arts in New York, protesting the US policy of war, repression, racism, and sexism—an exhibition that itself was all male. I declared that if the organizers didn't include fifty percent women, there would be 'war.' Robert Morris, the organizer, agreed to open the show to women." Soon the critic Lucy Lippard teamed up with Ringgold and the pressure group Women Artists in Revolution (WAR) to protest that the Whitney Annual exhibitions discriminated against women; they agitated for increasing women's participation from around 7 to nearer 50 percent—with less than total success. They and others took steps to organize their own shows and run their own galleries.

Within this atmosphere of protest and debate, a number of key critical ideas about women's art emerged, the most notable being those of Linda Nochlin's lengthy essay "Why Have There Been No Great Women Artists?" published in *Art News* in 1971, and Lucy Lippard's catalogue for the show *26 Contemporary Women Artists* in the same year, of which she was the curator for the Aldrich Museum in Connecticut. Nochlin addressed the much-debated question whether there was a distinctive feminine sensitivity or essence in women's art. She argued forcibly that there was not, nor was there likely to be. She agreed that there were no "great" women artists in the mold of Michelangelo or Manet, but suggested that the reasons lay in male-dominated educational and institutional structures that suppressed women's values. "When the right questions are asked about the conditions for producing art, of which the production of great art is a sub-topic," wrote Nochlin, "there will no doubt have to be some discussion of the situational concomitants of intelligence and talent generally, not merely of artistic genius… art is not a free, autonomous activity of a super-

endowed individual… rather, the total situation of art making… is mediated and determined by specialized definable social institutions, be they art academies, systems of patronage, mythologies of the divine creator, artist as he-man or social outcast." Nochlin's powerful case was that since concepts of "genius," "mastery," and "talent" had been devised by men to apply to men, it was remarkable that women had achieved as much as they had.

Lippard's approach to the question was very different indeed. "I have no clear picture of what, if anything, constitutes 'women's art,'" she wrote, "although I am convinced that there is a latent difference in sensibility… I have heard suggestions that the common factor is a vague 'earthiness,' 'organic images,' 'curved lines' and, most convincingly, a centralized focus." Referring to Georgia O'Keeffe's early efforts to illuminate the essences of female identity, Lippard wrote that "there is now evidence that many women artists have defined a central orifice whose formal organization is often a metaphor for a woman's body." By 1973 Lippard had identified a more generalized range of female imagery, comprising "a unifying density, an overall texture, often sensuously tactile and often repetitive to the point of obsession; the preponderance of circular forms and central focus (sometimes contradicting the first aspect); a ubiquitous linear 'bag' or parabolic form that turns in upon itself; layers, or strata; an indefinable looseness or flexibility of handling; a new fondness for the pinks and pastels and the ephemeral cloud-colors that used to be taboo." The critic Lawrence Alloway, refuting the idea that women's art could be defined in relation to ancient symbolism or ritual, offered the mildly patronizing rebuke that "a plethora of soft sculpture, fetishes and simulated shelters is generationally rather than sexually attributable. Such work is largely produced by young artists motivated by an optimistic belief in a non-specialized technology and a primitivist ideal that we can live on our personal resources."

Alloway's argument was surely addressed in part to the work of the California-based artist Lynda Benglis, whose brightly colored floor pieces of the late 1960s and early 1970s were designed to disrupt the appearance of male-dominated Minimalism, with its multiple technological and mathematical references. First came a series of poured latex forms adhering to the plane of the floor; then she experimented with a new technique of mixing pigment and resin, before adding a catalyst that (augmented by water) produced foaming polyurethane that could be poured over pre-built structures in a variety of shapes that could only just be controlled [Fig. 2.1]. For the artist, these spumous, organic volumes had to be performed rather than made part by part: sometimes the public would be invited to witness the complex event. "I found," said Benglis, "approaching organic form, that it was quite necessary to know about the change of the matter and the timing and the flow of the

2.1 Lynda Benglis
For Carl Andre, 1971
Pigmented polyurethane foam
56¼ x 53½ x 46½" (143 x 136 x 118 cm)
Museum of Modern Art, Fort Worth, Texas

"Most of my work has that kind of feeling of movement in physicality, in that it suggests the body or brings up bodily responses… [for example] the polyurethane pieces which suggest wave formations or viscerals in some way… feelings that are in some way known to the viewer, that are of nature… in other words, prehistoric. Though the forms are not specifically recognizable, the feelings are" (Lynda Benglis).

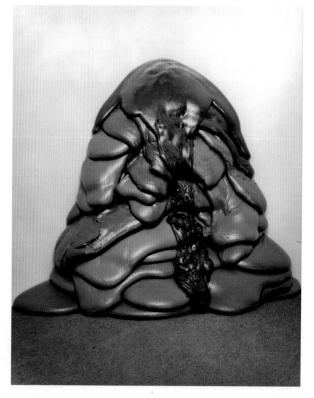

material. I felt I wanted to define for myself the organic phenomena; what nature itself would suggest… I wanted it to be very suggestive but not too specific; very iconographic but also very open." Nevertheless, Benglis continued to feel underrepresented in an art system run predominantly by men (one critic complained that the latex pieces were "theatrical"). In a notorious gesture of 1974 she confronted this male ethos by taking out a series of advertisements for her own work, in which she parodied men's view of women by posing as a pin-up or, in the final advert, wearing nothing but sunglasses and a giant latex dildo [Fig. 2.2]. The latter, placed in *Artforum* for November 1974, in fact evolved out of a collaboration with the sculptor Robert Morris, with whom Benglis had already worked in the field of video. Benglis felt she needed to parody the kind of publicity given to film stars in Hollywood, a type of image too often close in technique to those produced by the porn industry. Benglis recounts how the collaboration worked: "Morris came with me to buy the dildo and he had been involved in playing with me, involved with taking photographs of himself in different poses in Polaroid and I had him play with me with the dildo, so there was a question of maybe doing a large male and female pin-up." Benglis eventually found her answer: for her, the dildo "was a kind of double statement; it was the ideal thing to use, it was both male and female, so I didn't really need a male and it was a statement I really wanted to make totally by myself." Meanwhile, Morris was taking out an *Artforum* ad for a show of his own at Castelli-Sonnabend, showing himself wearing only dark glasses, a helmet, and a spiked dog collar suggestive of S/M practices.

At the same time Judy Chicago, also in California, was painting controversial pictures that explored the symbolic meanings available within the centered, often circular, or radiating forms of the vagina: "centralized focus" was a term of her own devising. Chicago had started the first women's art program at California State

2.2 Lynda Benglis
Artforum ad, November 1974

"The *Artforum* ad was in a way a kind of mocking of both sexes… I was encouraged to do it by the critic Pincus-Witten and the artist Robert Morris. They kind of gave me permission and I paid *Artforum* $3000 for the space" (Lynda Benglis).

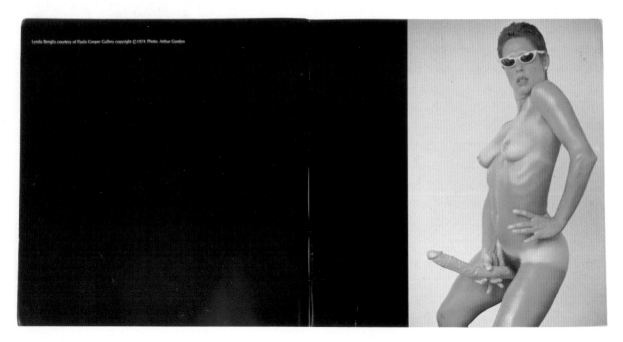

University back in the 1960s, and had followed it with projects such as the *Woman-Space Art Gallery* (1972) and the *Woman's Building* (1974) in Los Angeles. It was in 1974 that Chicago embarked on the largest and most celebrated of her projects, *The Dinner Party*. This involved the close collaboration of ceramicists and needleworkers to help her realize a large dinner table placed upon a "Heritage Floor" dedicated to the histories of 999 women of achievement in symbolic form. Chicago had spent years learning to paint on china—she quickly realized the extent to which artistic skills had been developed and transmitted by women for generations without due reward, either in status or money. *The Dinner Party*, finally finished in 1979, celebrated the achievements as well as the burdens of women's work. "The place settings are placed on three long tables which form an equilateral triangle," Chicago explained; "they are covered with linen tablecloths. Each plate is set on a sewn runner in a place setting that provides a context for the woman or goddess represented. The plate is aggrandized by and contained within that place setting, which includes a goblet, flatware, and a napkin. The runner in many instances incorporates the needlework of the time in which the woman lived, and illuminates another level of women's heritage. On the corners of the table are embroidered altar cloths carrying the triangular sign of the Goddess. The tables rest on a porcelain floor composed of over 2,300 hand-cast tiles, upon which are written the names of 999 women" [Fig. 2.3]. The logic and the form of the ensemble Chicago also made clear: "According to their achievements, their life situations, their places of origin, or their experiences, the women on the Heritage Floor are grouped around one of the women on the table."

Simultaneously with Chicago's epic (and epochal) collaborative work, a diversity of other women's art activity reflected on the body, and on salient differences between male and female identity. Photo pieces exploring gender and identity by artists such as Martha Wilson, Rita Myers, and Kitty La Rocca contrasted formally and materially with the hard technological Minimalism of a Donald Judd or a Carl Andre. Variations upon, or parodies of, the new floor conventions of "anti-form" sculpture by men (sparseness, economy, repetition) became the strategy of choice among feminists— one that had the virtue of speaking a common form-language as well as establishing difference in unequivocally visual terms.

A comparable strategy could be discerned in work by European female artists, in so far as they questioned the tendency of male Minimalist art to involve the viewer in a set of reflective relationships to the artwork. Diverting attention away from the

2.3 Judy Chicago
The Dinner Party, 1979
Mixed media
48 x 42 x 3′ (14.6 x 12.8 x 0.91 m)
The Brooklyn Museum of Art

"My goal with *The Dinner Party* was to forge a new kind of art expressing women's experience; and to find a way to make that art accessible to a large audience… since most of the world is illiterate in terms of women's history and contributions to culture, it seemed appropriate to relate our history though art, particularly through techniques traditionally associated with women" (Judy Chicago).

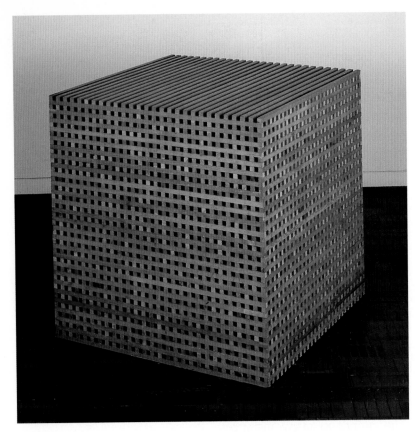

2.4 Jackie Winsor
Fifty-Fifty, 1975
Wood and nails
40 x 40 x 40" (102 x 102 x 102 cm)
Private collection, New York

Constructed by a laborious process of nailing thin strips of wood to each other, Winsor's boxes contain autobiographical references to house-building with wood and nails for her father. Such "human" references were anathema to the male Minimalists, whose concern with geometry and repetition these works nevertheless share.

artwork as an invitation to philosophical speculation and refocusing it as an appeal to physical and human empathy, the Belgian artist Marie-Jo Lafontaine, who subsequently worked in video, painting, and installation, took the cotton of canvas before it was woven and dyed it black. Woven back into material and hung as a series of monochrome canvases, the resulting works stood as an eloquent testimony to women's craft, to repetitive and exhausting labor (the artist's own), yet also to an ongoing refusal to adorn a pre-existing surface with composed forms. In America, Jackie Winsor incorporated labor-intensive repetitions of binding, tying, and nailing, often using twine, rope, and cut trees, to reflect her childhood on the bleak Newfoundland coast. Winsor's elaborately made boxes of the mid-1970s display a fondness for detail *within* or *upon* the cube, and provide an elegant instance of a feminine variation on, and a challenge to, a male aesthetic paradigm [Fig. 2.4].

The work of the German-born sculptor Eva Hesse, who had studied at Yale and knew most of the American Minimalists, stands in the background of much of the new freedom with materials that the feminists were now exploring. Hesse had died tragically young, in 1970; but she had already pioneered for her generation the use of diaphanous or flexible materials such as card, string, rope, and wax, and in doing so had done most, perhaps, to unfix the geometric regularity of male Minimalist art. Inspired by Simone de Beauvoir's *The Second Sex*, Hesse had struggled with feelings of self-doubt, from which she managed to distill an aesthetic of what she liked to refer to as honesty, integrity, process, and the absence of rules—the least pretentious of means with the given resources [Fig. 2.5]. Her containers and vessels, grouped in clusters in the gallery space, read as wonky, lop-sided forms celebrating the unevenness and contingency that we know matter to enjoy. Above all, we find her in her rare statements and interviews reaching for a reduction of form to its absence, in spite of itself. She described some of her late structures reluctantly, but revealingly:

> *they are tight and formal but very ethereal. sensitive. fragile.*
> *seen through mostly.*
> *not painting, not sculpture. it's there though.*
> *I remember I wanted to get to non art, non connotive,*
> *non anthropomorphic, non geometric, non, nothing,*
> *everything, but of another vision, sort.*
> *from a total other reference point. is it possible?*

A kind of homage to the new conventions and a glance back to Eva Hesse can be found in Rosemary Castoro's epoxy, fiberglass, and steel installation sculpture, *Symphony*, of 1974 [Fig. 2.6]. It too is suggestive of physical movement and the organic body. Several of Castoro's pieces refer to the imagery of dance: she studied choreography and worked occasionally with the experimental dancer and filmmaker Yvonne Rainer. Such works demonstrated not merely the latent vitality to be found in heterodox materials and combinations, but that the tendency in American male aesthetics— to deny the body and its references, as feminists read them, at least—was on no account to be followed.

New art of the early 1970s by American women was significant for several reasons. It constituted the first phase of committed philosophical engagement by female artists with questions of how feminist concerns, debates, and discoveries could be embodied in form. It also took up the issue of how women could use the body or body image to explore female identity without inviting the accusation that they were playing to the same kinds of voyeuristic responses that male-centered culture had always been ready to provide. Gradually, collaborations and discussions among women artists began to permeate the institutional frameworks of education, exhibitions, and art criticism. Projects such as Judy Chicago's *Womanhouse* at the California Institute of the Arts in 1971 and 1972 (a vast environmental sculpture made by and for women), or the 1973 New York Cultural Center exhibition *Women Choose Women*, or the founding of *Heresies* magazine in New York (planned from 1975 and first published early in 1977), could be taken as suggesting that art could get along nicely without men. Important art-historical revisions such as Carol Duncan's essay "Virility and Domination in Early 20th-Century Vanguard Painting," published in *Artforum* early in 1974, sounded a note of skepticism toward art-historical accounts of modern art (written by and about men), most of which still foregrounded obsolete notions of the male artist as a "genius" who dominated his materials in often explicitly sexualized ways.

Other women took directly to the land. Alice Aycock took the forms of Minimalism into or under the ground, building caves and subterranean structures that could be interpreted as metaphors for seeking, interiority, or for an atavistic, self-burying impulse. Mary Miss's major work *Untitled* necessitated a laborious journey to view it on a vacant landfill site along the Hudson River in New York City. To Lucy Lippard it gave rise to a blank and "vaguely disappointing" experience until the

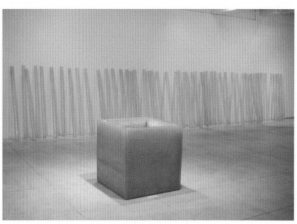

2.5 Eva Hesse
Installation view of *Eva Hesse: Chain Polymers* exhibition at the Fischbach Gallery, New York, 1968. Foreground: *Accession III* (1968); background: *Accretion* (1968)

2.6 Rosemary Castoro
Symphony, 1974
Pigmented epoxy and fiberglass over styrofoam and steel rods
6'4" x 9' x 24' (1.93 x 3.2 x 8.4 m)

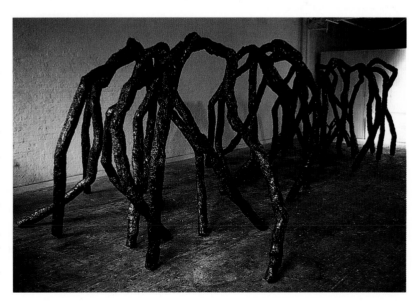

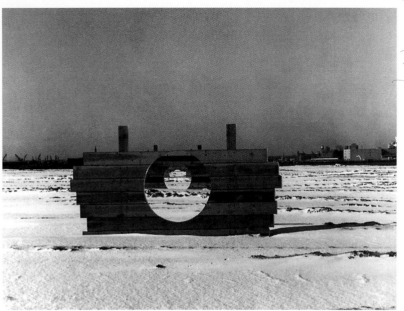

whose greater than parts

moment when its ever more deeply buried circles were aligned to reveal a vast negative volume far greater than any physical construction could enclose [Fig. 2.7]. Other resonances with the expansive landscape were integral to the work. The spaces between the planks of *Untitled* were sealed with black tar, whose lines echoed the structure of the empty landscape. But otherwise the planks functioned only as a false façade. "If certain pieces take on a geometrical aspect," the artist said, eager to rebut any association with Minimalism, "it is not from any interest in this particular form. Though there is a very physical basis to my sculpture, the desired result is not to make an object." *process*

In the sense that much American women's art of the 1970s cut across the tensions between Modernist painting and sculpture and the anti-Modernist postures of Minimalist art—both art forms produced and critically fought over by men—the challenge for feminism was to avoid contesting the rules of practice on exactly the same theoretical terrain: a parody of that practice was for some a more attractive answer. At the same time, as many of these examples show, women artists shared with men some general concerns about the languages of representation, the control of institutional structures such as galleries and museums, and the place of artist-workers within class-divided capitalist societies. And it is here, perhaps, that we encounter feminism's more daunting and important challenge. Only a very few radical women artists were much exercised by theoretical Marxism, whose traditional emphasis on the relationship between the means of production and the formation of social class seemed largely to overlook the concerns of women. And yet, in the words of the British feminist critic Griselda Pollock, "the nature of societies in which art has been produced has been not only… feudal or capitalist, but patriarchal and sexist." What then was also required was a binding together of feminism with reformulated Marxist ideas. A related difficulty for feminism was the hallowed notion of "avant-garde." Not only had utopian or revolutionary thought often been negligent of the contribution of women, but "avant-garde" could begin to seem like yet another "outsider" position from which to mount an assault on traditional bases of power and class. And not only had this position been occupied since its origins in Romanticism largely by men, but feminists could point to the fact that women had always been outsiders anyway. If anything, they needed to establish a powerful position *within* the mainstream. Yet the difficulty here was that "mainstream" was (and remains) an almost impossible position to identify, bound up as it is with the question of who legitimizes the choices, and why. And at the same time that feminists complained of the "mainstream," their contribution to multiplicity and difference helped dissolve it

2.7 Mary Miss
Untitled, 1973
Wood
6 x 12' (1.8 x 3.6 m) sections at 50' (17.5 m) intervals
Battery Park, New York City

The holes of *Untitled* "expand into an immense interior space," said the critic Lucy Lippard, "like a hall of mirrors or a column of air descending into the ground… you are drawn into its central focus, your perspective aggrandizing magically."

anyway. Today, the term is seldom heard; in fact, and thanks in large part to feminism, the 1970s could be described as the decade of its irreversible decline.

No account of the period would be complete without reference to two artists who launched powerful new positions in the 1970s, and whose careers have achieved longevity since then. Among Martha Rosler's earliest works using photography was a series of collages that mixed images of the Vietnam War with contemporary scenes of domestic America. Called *Bringing the War Home: House Beautiful* (1967–72), these collages appeared in the alternative art press in the early 1970s and were Rosler's response to the distance implied by news reporting in *Life* magazine and elsewhere between the actuality of war and the personal responsibility of citizens at home. Next, her photographic series entitled *The Bowery: In Two Inadequate Descriptive Systems* (1974–75) made over into visual form some key concerns not about social or political issues *per se*, but about the tools and techniques of representation that structure all our speaking, writing, and image-making in whatever medium. *The Bowery* paired photos of depopulated derelict store fronts with a range of verbal idioms used to describe drinkers and drunkenness—the expressions ranged from vulgar to obscure, while the images themselves prompted reflections on the photographic conventions of the genre: the implication was that both verbal and visual conventions were "inadequate," and perhaps inevitably so [Fig. 2.8]. On another level, Rosler's *Bowery* can be seen as a work sensitive to the structuralist thinking of the French anthropologist Claude Lévi-Strauss, much discussed and debated at the time. Like structuralist analysis in other fields, Rosler's images sought to shift the viewer's attention from the thing represented to the representing systems themselves. Pitting her work against what she saw as the "victim photography" of standard documentary journalism, which "insists on the tangible reality of generalized poverty and despair" but in which the "victims" of the camera are often docile, Rosler relocated the problem of social deprivation within the politics of the image itself. In her own account: "The words begin outside the world of skid row and slide into it, as people are thought to

2.8 Martha Rosler
The Bowery: In Two Inadequate Descriptive Systems (detail), 1974–75
45 black-and-white photographs

The artist has said that "the photos here are radical metonymy, with a setting implying the condition [of inebriation] itself… If impoverishment is a subject here, it is more centrally the impoverishment of representational strategies tottering about alone than that of a mode of surviving."

comatose unconscious

passed out knocked out

laid out

out of the picture

out like a light

2.9 Mary Kelly
Post-Partum Document, Document I, 1974
Mixed media
28 units, each 14 x 11" (35.6 x 28 cm)
Art Gallery of Ontario, Canada

slide into alcoholism and skid to the bottom of the row... [The project is] a work of refusal. It is not defiant antihumanism. It is meant as an act of criticism: the text you are reading now runs on the parallel track of another descriptive system. There are no stolen images [of drunks]... what could you learn from them that you didn't already know?"

Attention to the form as well as to the "content" of representational systems can be also seen in the work of the American-born (but British-based) artist Mary Kelly. The 165 separate panels of Kelly's *Post-Partum Document* [Fig. 2.9] depict the growth and socialization of a male child (her own)—but not by conventionally picturing the child or his parents, rather by periodically reproducing the child's bodily imprint on various types of matter, from diapers to writing paper. Below these imprints appears a record of Kelly's anxieties about her son, and a section of her diary that records her work as an artist in relation to her role as mother. Several kinds of discourse around the growing child's activities are represented in particular typefaces, carefully arranged to be read, as well as for visual effect; an example of what Kelly calls the "scripto-visual" manner. Borrowing from literary theory, feminism, psychoanalysis, and anthropological sources in order to compile a theoretical commentary, Kelly used scripto-visualism to range over questions of the formation of gender, the child as a fetish, and the division of labor within capitalist society. The larger philosophical significance of *Post-Partum Document* lay in its attempt to fuse two perceptions of female subjectivity, one derived from the writings of Freud (on narcissism), the other from Lacan (on Freud). The work was also intended as a commentary on the steps through which maternal "femininity" is constructed within the mother–child relationship, and the process by which the identity of a child is gradually formed through engagement with, and eventual entry into, the symbolic order which is language. Not only was the immediate topic of *Post-Partum Document* groundbreaking, but its form and theoretical sophistication outstripped anything previously achieved by a European feminist artist dealing with a directly feminist concern.

The two latter projects suggest a tentative generalization: that whereas American women's art in the Conceptual manner tended in the 1970s to the empirical, the positivist, and the descriptive, its European equivalent tended to the psychoanalytically based, the private, and the subjective. Both Rosler and Kelly, however, represent positions of powerful theoretical engagement within a field of alternative practice that was widely perceived as avant-garde. In offering models or modes of representation that contested the comfortable norms of the patriarchy, both can be seen as having forged a kind of union between sexual politics and visual art at a time when their possible connections had been barely understood.

Performance Art

Performance art by its nature—both by women and men—provided further examples during the 1970s of how feminist or other radical content could be embodied in alternative forms and media. Deriving at some distance from Dada and from the Happenings movement of the 1960s, performance art resisted being treated as a commodity (it could be neither bought nor sold) by replacing the normal materials of art with little more than the actions of the artist's own body. Performance art throughout the later 1960s and 1970s attracted small but influential art-world audiences, but resonates vividly today both in recollection, in photo-documentation, and in the recorded eyewitness account. In hindsight, certain projects—significant too for purposes of comparison between Europe and America—stand out as exemplary.

It became immediately clear to Lucy Lippard, for example, that European performance art took on different characteristics from the American. To her, European practice seemed more abrasive, more physically challenging, more dangerously sited in relation to pain, wounding, rape, and disease than the relatively celebratory North American type. A comparison yields pointers to the different social and philosophical traditions, as well as their contemporary crises, on the two continents.

In the United States, Carolee Schneemann continued to evolve the performances that she had begun in 1963. At that earlier time Schneemann had defended the performance over static collage, assemblage, or paintings by pointing to the very different viewing conditions applicable to the two categories. "The force of a performance," she had written, "is necessarily more aggressive and immediate in its effect—*it* is projective"—pointing to the essentially reassuring effect of a painting as a stable entity within the field of vision, over which, in consequence, the viewer can gradually achieve cognitive mastery. "The steady exploration and repeated viewing which the eye is required to make with my paintings," she wrote, "is reversed in the performance situation where the spectator is overwhelmed with changing recognitions, carried emotionally by a flux of evocative actions and led or held by the specified time sequence which marks the duration of a performance." And evocative her performances proved to be. In *Interior Scroll* of 1975 [Fig. 2.10] Schneemann used her own body as a "stripped-down, undecorated, human object." As she described the work: "I approached the table dressed and carrying two sheets. I undressed, wrapped myself in one sheet, spread the other over the table and told the audience I would read from *Cézanne, She Was a Great Painter* [a text written by the artist in 1974]. I dropped the covering sheet and standing there

2.10 Carolee Schneemann
Interior Scroll, 1975
Performance

Interior Scroll was first performed in 1975 before an audience of women artists in Long Island. "The reading was done on top of the table, taking a series of life model 'action poses,' the book balanced in one hand," said Schneemann. "At the conclusion I dropped the book and stood upright on the table. The scroll was slowly extracted as I read from it, inch by inch."

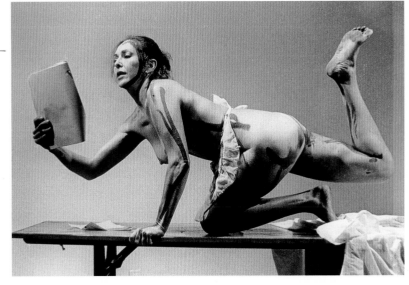

painted large strokes defining the contours of my body and face." The performance culminated in Schneemann reading a selection of texts that had been secreted in her vagina and were slowly extracted amidst waves of audience anxiety and surprise. The metaphor of the work was clear: the concept of interior knowledge seemed to Schneemann "to have to do with the power and possession of naming—the movement from interior thought to external signification, and the reference to an uncoiling serpent, to actual information (like a ticker tape, torah in the ark, chalice, choir loft, plumb line, bell tower, the umbilicus and tongue)." The body in this way becomes a source of self-knowledge and truth. "I assumed," says Schneemann, "that the carved figurines and incised female shapes of Palaeolithic, Mesolithic artefacts were carved by women ... that the experience and complexity of her personal body was the source of conceptualizing or interacting with materials, of imagining the world and composing its images." Above and beyond such metaphors, Schneemann's reflections on the altered position of the viewer apply in more general terms. "During a theatre piece, the audience may become more active *physically* than when viewing a painting or assemblage… they may have to do things, to assist some activity, to get out of the way, to dodge or catch objects falling: they enlarge their kinaesthetic field of participation: their attention is required by a varied span of actions, some of which may threaten to encroach on the integrity of their positions in space." By the time of *Interior Scroll*, Schneemann had also reached forthrightly optimistic conclusions about the future of women and their art education. "By the year 2000," she wrote then, "no young woman artist will meet the determined resistance and constant undermining that I endured as a student… She will not go into the 'art world,' gracing or disgracing a pervading stud club of artists, historians, teachers, museum directors, magazine editors, gallery dealers—all male, or committed to masculine preserves. By the year 2000 feminist archaeologists, etymologists, Egyptologists, biologists, sociologists, will have established beyond question my contention that women determined the forms of the sacred and the functional—the divine properties of material, its religious and practical formation; that she evolved pottery, sculpture, fresco, architecture, astronomy and the laws of agriculture—all of which belonged implicitly to the female realms of transformation and production."

In America, Chris Burden in California stands out among male artists for whom the vulnerable body was the first and in some cases the only signifier of his art. There is little doubt that Burden incorporated something of the daredevil or frontiersman into his work. For the so-called *Shoot* piece of 1971 Burden turned the culture's violence back upon himself and his audience as he arranged for a friend to graze his arm by firing at him from a controlled distance, so testing the boundary between success and failure in an atmosphere of heightened drama. The fact that the bullet wounded Burden seriously (the most painful form of failure) only served to accentuate the dilemma that the audience were already in—caught between the "distance" required for traditional drama and the obligation to share responsibility for the events in front of them. Most of Burden's early performances involved exposing his body to real

physical risk. Some of these actions, particularly if they failed to attract an audience, would be committed to 16 mm documentary film. Others survive only in Burden's sparse descriptions, resembling as they do something like a recipe, instruction book, or formula—for instance *Through the Night Softly*: "Main Street, Los Angeles, 12 September 1973. Holding my hands behind my back, I crawled through fifty feet of broken glass. There were very few spectators, most of them passers-by." Bullets, kerosene, broken glass, live electrical wiring—these were Burden's self-damaging implements of choice in the early years, even if like other Conceptualists he was obviously aware that the survival of the events lay not in popular memory but in the prose descriptions and photographs they spawned. For example, the documentation of Burden's performance *Kunst Kick* at the 1974 Basel Art Fair [Fig. 2.11] reads: "At the public opening [of the Art Fair] ... at twelve noon, I laid down at the top of two flights of stairs in the Mustermesse. Charles Hill repeatedly kicked my body down the stairs, two or three steps at a time." The description suggests how the artist reduced himself to an object to be violated by stress or mistreatment, again inducing a tension between guilt and disengagement in his small yet voyeuristic audience. Burden's deadpan prose voice also suggests a level of irony or pseudo-science in the project, as it reaches effectively for a parody of the reification of the human subject in advanced technological society.

2.11 Chris Burden
Kunst Kick, June 19, 1974
Performance at the Basel Art Fair, Switzerland

Even a male European writer can see the justice of Schneemann's verdict that American feminists of her generation were "crippled and isolated" by the dearth of support; that "a belief and dedication to a feminine istory of art [Schneemann point-edly omits the 'h'] was designed by those who might have taught it, and considered heretical and false by those who should have taught it; that our deepest energies were nurtured in secret, with precedents we kept secret." He can also relate that in Europe as well as America, feminist artists like Urs Lüthi (Vienna) and Katherina Sieverding (Düsseldorf), Annette Messager (Paris), and Renate Weh (Germany), aligned as they were with revolutionary personal and political agendas, enacted postures and attitudes in front of the camera that deliberately proposed a resignification of the body and an exposure of its acculturation under the codes of masculine art. Film and video work by Ulricke Rosenbach (Germany) and Marina Abramović (Yugoslavia) extended the genre to moving images, the latter inviting physical danger in a piece that involved the artist recording her and her audience's reactions as she swallowed pills supposedly designed to cure schizophrenia. Abramović has written of her perfor-mances, many of them done with the German artist Uwe Laysiepen (aka Ulay), whom she met at the De Appel alternative space in Amsterdam in 1975, that they tested the physical limits of the body as the duo explored the balance of female and male energies and the nature and boundaries of non-verbal communication [Fig. 2.12]. Rebecca Horn's films of the mid-1970s, such as *Dreaming Under Water* (1975), featured torture-like contraptions attached to the body—elongated fingers, headdresses, cages, and

harnesses—that were at once menacingly sadistic and tender in appearance. As these examples suggest, in the charged political atmosphere of Europe of the early and mid-1970s, when the utopian hopes of 1968 were being ever more desperately defended, performance art (the category sounds innocuous now, too tame) was the location where much of the violence and hostility of the surrounding culture was examined, and powerfully expressed.

Among Burden's counterparts in Europe since the time of the Vienna Actionists of the previous decade—a group of body-ritualists including Hermann Nitsch, Günter Brus, Otto Mühl, and Rudolf Schwarzkogler—were the younger Arnulf Rainer and Valie Export. While Nitsch and company had drawn upon Nietzsche, Freud, existential philosophy, and arcane religion for their violent forms of libidinous release, the generation who came to prominence in the 1970s began from the dramatic examples of their seniors. Valie Export (born Waltraud Hollinger in provincial Linz before renaming herself in Vienna) entered the circle of Vienna Actionism by compiling a groundbreaking documentation of the movement with the filmmaker Peter Weibel, shortly before announcing her new surname, taken from the Export cigarettes whose name already appeared in commercial signage on the streets. In accordance with a 1972 manifesto commitment that "men have projected their image of women onto social and communication media such as science and

2.12 Marina Abramović
Rest Energy, 1980
Collaboration with Ulay
Performance, ROSC Festival, Dublin

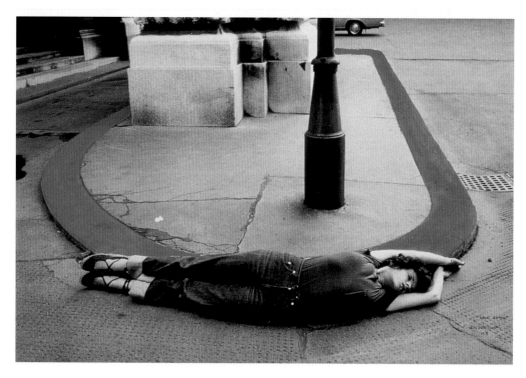

2.13 Valie Export
Einkreisung/Encircle, 1976
Black-and-white photograph, ink
16½ x 24¼" (41.9 x 61.6 cm)
Edition of 3

art, word and image, fashion and architecture... [and hence] gave shape to woman," Export composed her own *Self-Portrait* of 1968–72 out of collaged photographs and cigarette advertisements to launch her signature style of radical reflection on the split identity given to woman by commercial societies. "If reality is a social construction and men its engineers," Export went on to say in her *Women's Art: A Manifesto*, "then we are dealing with a male reality: women have not yet come to themselves, because they have not had a chance to speak insofar as they have had no access to the media." Export's extremely diverse activity in performance, film, and photography throughout the 1970s can best be summarized in the words of the critic Kaja Silverman, who has written recently that "for Export, there is no bodily reality which is not informed by representation, and no corporeal representation which does not have real effects." Hence we find the artist self-consciously fitting her body on to various parts of the urban environment—corners, kerbstones, the flat sidewalk—in a parody of how Modernist design forms not only exclude decoration (as per Adolf Loos's masculinist prohibition on ornament in his classic "Ornament Is Crime" essay of 1908) but force the female body to submit to its spatial and material laws [Fig. 2.13]. The formation of the identity of the female subject in architecture, psychoanalysis, and philosophical reflection has been at the center of Export's work ever since. In particular (and like the American Dan Graham in this respect) Export was among the first experimental artists of her generation to explore the implications of Jacques Lacan's "mirror stage" theory of identity-formation, a concept that, again like Graham, impelled her to work with actual mirrors and with real-time feedback in video, installation, and the manipulation and reconstruction of the gaze.

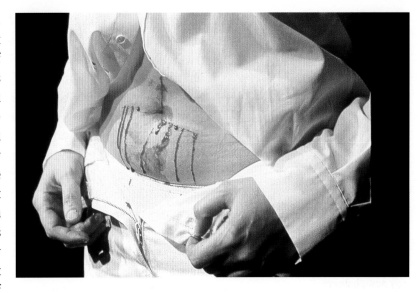

2.14 Gina Pane
Psyche, January 24, 1974
Performance at the Galerie Stadler, Paris

The most controversial European case of a female body artist performing *in extremis* was that of Gina Pane in Paris. From 1968 for the best part of a decade, Pane used her body as the site of her art, cutting and otherwise torturing body parts in front of an audience and the camera [Fig. 2.14]. As she wrote at the time, "to live one's body signifies discovering one's weakness, the tragic and pitiless servitude of its limitations, of its wear and tear and its precariousness; signifies becoming aware of its phantasms, which are none other than the reflection of myths created by society: a society that cannot accept the language of the body without reacting, because it doesn't fit into the automatism necessary to the functioning of its system." The "language" Pane refers to here is in another sense the cutting of one part of the body by another (the hand with the blade), partly to jolt the audience out of its mesmerized state but partly to test the limit of the body's own capacity for self-presence. "The wound is the memory of the body," she later wrote; "it was impossible for me to reconstruct an image of the body

without the flesh being present, without it being placed frontally, without veils and mediations." Readers should bear in mind nevertheless that the audience were never confronted with the self-mutilating Pane directly: the very presence of the photographer Françoise Masson (who was supplied in advance with diagrams and timings to enable her to capture moments of maximum intensity) in the space between the performer and the audience made the event to a degree formal and aesthetic, as if the artist were chiefly concerned with controlling the color, framing, and lighting of the shots that would eventually make her work endure. Pane used the photograph as a witness and as a "logical support" for the body in its self-inflicted travails.

By the mid-1970s the absence of a shared agenda of radical protest within the Western art community had caused the links between European and American art to wear thin. Symptomatic of a desire to address this estrangement was the re-entry into the New York art world in May 1974 of the charismatic German artist Joseph Beuys. Beuys was already well known for his involvement in the Fluxus movement, and had a reputation even in the United States for his messianic teaching style and his shamanistic performances. He had given a speaking performance in a New York gallery in January of that year, developing his message of the need for conscious creativity in all human beings and the necessity to transcend social conditioning. On his second visit in May, Beuys gave a three-day performance at the René Block Gallery in SoHo entitled *I Like America and America Likes Me* [Fig. 2.15], for which he assembled a pile of hay, two lengths of felt, a flashlight, a pair of gloves, a musical triangle, fifty copies of the *Wall Street Journal* (fresh daily), and a hooked walking stick which he used to cajole and signal to a coyote, on hire from an animal farm in New Jersey. Beuys was transported directly to the gallery from the plane, wrapped up all the while in a type of felt similar to that which he claimed had saved him after an alleged crash-landing in the Crimea as a wartime pilot. Each day for three days, Beuys struck the triangle as a signal for a tape recording of loud engine noise to begin, and then excited the coyote by throwing his gloves at it. He wrapped himself again in the felt, which "covered everything but the top of his hat, to become a muffled piece of human sculpture. His walking-stick, hooked like a shepherd's staff, periscoped from the top of the felt like a dousing rod to tune in on the coyote's spirit. Beuys bent and turned according to the actions of the coyote, which… nipped and tugged at the edges of the felt. Beuys passed through a series of chosen positions as if in slow-motion salaam to the animal; when he reached floor level, he lay down, still totally covered." This eyewitness report helps to convey

2.15 Joseph Beuys
I Like America and America Likes Me, 1974
Performance at the René Block Gallery, New York

To Beuys, the presence of the coyote pointed to the Native Americans' history of persecution, as well as to "the whole relationship between the United States and Europe." "I wanted to concentrate only on the coyote. I wanted to isolate myself, insulate myself, see nothing of America other than the coyote… and exchange roles with it."

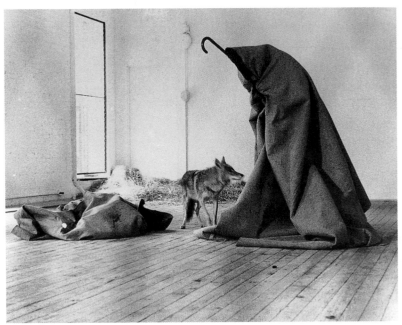

the vivid manner in which a European artist could suggest the notion of a wild and original "nature" that technological and capitalist America now seemed positioned to destroy.

Conceptually, too, such works were built upon radical premises. Like other performance artists on both continents, Beuys aimed to transform the artistic product from a marketable object of exchange to a set of actions consisting entirely of the labor of the artist. Neither theater nor sculpture nor real ritual, such events dramatized a new and important paradox in contemporary visual art: that of the artist attacking the dominant institutions of cultural power in the space of, and with the qualified compliance of, those institutions themselves. The paradox of strained but mutual dependency between the subversive artist and the commercial art system continued throughout the 1970s to be a subject of heated debate among those who saw themselves as transmitters of a politically and aesthetically radical tradition.

Such was the atmosphere of politicized experimentation in the new media during these years that attacks by artists right across Europe and the USA upon entrenched values in the infrastructures of art were multiple, complex, and often compelling. Even in the traditionally undemonstrative London art world, performance art achieved headline status: national boundaries were clearly no longer an obstacle to the spread of radical ideas. Stuart Brisley, for example, developed forms of extended ritual with the body that engaged issues of power versus autonomy, control versus freedom, consumption versus denial. Brisley had been a painter at London's Royal College of Art in the late 1950s, and had subsequently spent time in Germany and the USA, where he witnessed racial segregation and levels of poverty that politicized him to the extent of suggesting the direct form of engagement that performance is. For a work known as *Ten Days*, first performed in Berlin in 1972 and then in London in 1978, Brisley refused food for ten days over the Christmas period while watching the meals ritually served to him slowly rot. In *Survival in Alien Circumstances* [Fig. 2.16], performed at *Documenta 6* in Kassel in 1977, Brisley dug a hole 6 ft (2 m) deep in a location where he encountered rubble, bones from human war victims, and dank water. At the bottom of the hole the artist built a wooden structure in which he lived alone for a fortnight. Indeed, the majority of Brisley's best performances resonated with the smearing and chaos that untutored opinion readily associated with Abstract Expressionism or "action painting"; the latter term is particularly significant in the present context. At another performance early in 1972 known as *ZL656395C* Brisley converted a gallery room into a nightmarish prison or asylum cell, the walls and floors of which were covered with dirty water, fecal matter (in appearance at least), and decaying furniture. In this space Brisley sat swaying in the chair or crawled around, in a state of dereliction and dejection, for a full two weeks, while visitors inspected the depressing scene through a peephole—a mode of access that acted as a powerful

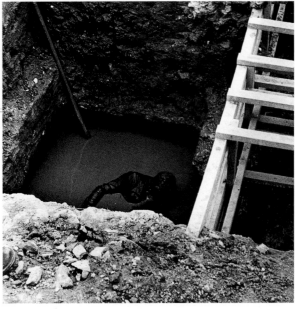

2.16 Stuart Brisley
Survival in Alien Circumstances, 1977
With Christopher Gericke
Performance at *Documenta 6*, Kassel

Ever sensitive to displays of conspicuous waste, Brisley moved his performance from the center of Kassel on hearing of the project of the American Conceptual artist Walter de Maria to drill a hole half a mile (1 km) deep in the Friedrichsplatz, at an alleged cost to an American sponsor of $300,000. Brisley is seen here at work with his young German collaborator Christopher Gericke.

metaphor for their own implied dejection and for the Beckettian alienation of human beings from each other in a confining commercial society.

Theoretical Marxists call this condition reification: the conversion into an immovable solid thing of the relations obtaining between individuals in an accelerating capitalist economy. Most radical experimental art in the 1970s claimed Marxist derivation under some interpretation of that term. A large number of projects were aligned with one or another form of feminism, and a smaller number with psychoanalysis—both the classical forms of the early and middle Freud, as well as later revisions by Lacan, or by charismatic psychiatrist-writers such as R.D. Laing. Inventive instability of both practice and theory was a characteristic of those years—alongside, it should be said, the survival of some not inconsiderable achievements in painting and sculpture. The split, perhaps, was precisely between the self-conscious cultivation of theory within the varieties of radical practice, and the perpetuation of the more conventional artistic forms.

Film and Video

The rapid rise of commercial TV and film in America, combined with the desire of younger artists to explore beyond the traditional limits of painting and sculpture, gave birth to an important new genre that had lain more or less dormant since the film experiments of Duchamp, Man Ray, Hans Richter, and Fernand Léger in France and Germany in the 1920s. The wholesale recasting of "painting" as various types of wall-mounted documentary activity, or of "sculpture" as the dispersal of matter on the ground, or in the landscape, or as performance, was echoed in the way that visual artists, persuaded by the need to dematerialize art, migrated to the moving black-and-white image as a parody of mainstream cinematic experience. Indeed, the broad category of Conceptual art and that of film were as naturally associated as were Conceptual art and photography, or photography and performance: the photographic image was central to them all. The landmark *Documenta 5* in Kassel in 1972, to take the prominent case, included an entire section devoted to 16 mm film and video, and included such early experimental pieces as Richard Serra's *Hands Catching Lead* and *Hands Tied* (both 1969), Vito Acconci's *Remote Control* (1971), Joseph Beuys's *Filz-TV* (1970), Stanley Brouwn's *One Step* (1971), and Yoko Ono's *Fly* (1970).

In most artists' films of those years the dominant strategy was to make film or TV look at itself: to install a self-reflexivity within the moving image that would call the viewer's attention to the way it had been made, out of what materials, and with the aid of what machines or devices of staging. Only in this way, it was argued, could the power of the most transparent of all fictional media (and perhaps the nearest to that of the dream) be brought to accountability. Such materialist concerns formed many of the radical agendas of 1970s art. What appears remarkable now is just how many of those who had been trained in the traditional media wanted to stage a critique of TV or

film—often in the form of a compromise with the medium in which they had once trained.

In the case of the Canadian artist Michael Snow, this compromise was between the moving image and sculpture. A work first shown in Ottawa in 1971, *De Là* [Fig. 2.17], comprised a hydraulic steel structure fitted out with a revolving arm at the end of which a TV camera could film in every direction without interruption, vary the movements and angles of the camera, even attempt to look back upon itself. The resulting picture was relayed to each of four monitors, grouped symmetrically like mute observers around the central machine. A clear extension of earlier Snow pieces like *Authorization* (1969), in which Snow photographed himself photographing a mirror, or *Venetian Blind* (1970), in which he again shows himself being photographed, *De Là* is in fact about the structure of TV production itself. As Snow explained, the piece "has to do with seeing the machine make what you see; the TV image is magic, even though it is in real time. Simultaneously it is a ghost of the actual events which one is, in this case, part of. The machine that is orchestrating these events is never seen in them" (even though the TV monitors themselves occasionally are). As may be understood from this description, Snow's piece was a physical installation (though the word was scarcely in use at the time) in the actual room in which the viewer also moved; in another sense, the machine and the TV monitors proposed a correspondence with human scale and position that echoed the concerns of sculpture throughout the ages.

In common with other film and video artists of his day, Snow has willingly entertained the idea that his constructions were, in effect, sculpture: *De Là* "is a sculpture and it's really important that you see how the machine moves and how beautiful it is," he has suggested. The sound of the film machinery was a further element of its physical, real-time existence: "The sound is an essential part of the concreteness of the machine." So too in the early work of the vanguard British filmmaker Malcolm Le Grice, the very materiality of the film machinery with its spools, motors, and lights was to be an element of the display on an equal sensory footing with the fictive projected image. Le Grice, trained as a painter and with an interest in jazz, had turned his improvisatory skills in the late 1960s to the construction of a film-printing machine that allowed the artist an unprecedented degree of control over the production of filmic sequences and their effects, such as the manipulation of light, framing, montage, and image quality: "As modern painters established the materiality of the canvas, colour and pigment to counteract illusion, a filmmaker can establish a similar materiality for the film medium by showing and using the celluloid, scratches, dirt and sprockets, and by transforming the image through printing." Of course, one of

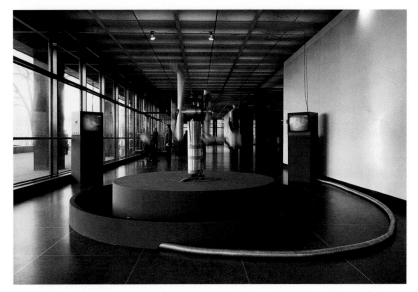

2.17 Michael Snow
De Là, 1969–72
Aluminum and steel mechanical sculpture with television camera, electronic controls, and four monitors
72 x 56" (182.9 x 142.2 cm) without base,
18 x 96" (45.7 x 243.8 cm) diameter
National Gallery of Canada, Ottawa

"You can follow the movements that are made by the sources of the image [the central machine] as well as the results of those movements on the four screens.... It's a kind of dialogue about perception" (Michael Snow).

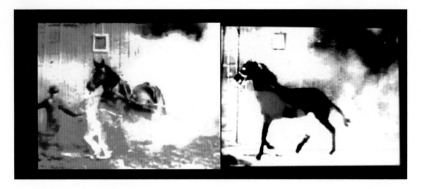

2.18 Malcolm Le Grice
Berlin Horse, 1970
Film by Malcolm Le Grice and sound by
Brian Eno
16 mm film and double projection

the effects of this kind of intervention was to bestow upon the audience a viewing position radically unlike that of cinema or domestic TV. In the former, the viewer is confined to a darkened chamber for the duration of the film, to be drawn into an illusionistic narrative with a storyline proceeding coherently from beginning, through its development, to a final dénouement and closure, a process over which the film producer and distributor retain complete control. Materialist avant-garde film started elsewhere. Le Grice's own films of the mid-1970s were effectively performances "which work directly with the screen, moving projectors, the light beam and shadows cast by the performer." His six-projector *Matrix* of 1973 sought, in its author's words, "to develop an awareness of the screening time and space as the primary reality of cinema." Le Grice's work of 1970 entitled *Berlin Horse* required two up-to-date 16 mm film projectors, projecting film loops of a burning building onto the vertical surface of a vast gallery wall. Turned on together, the clanking and whirring of the projection equipment extended the soundtrack by Brian Eno, having the effect of suffusing the performance with an auditory dimension akin to that of machines "shooting" at a nearby target, while viewers were welcome to walk in and around the gallery space and so imbricate themselves within the duration and physical spaces of the event [Fig. 2.18].

Other young British filmmakers like Chris Welsby, while leaving the context of viewing relatively untouched, emphasized the very process of the film by paying attention to elements of filmmaking that manifested orderly sequence or structure. Structure (the word had begun to enter art practice via the "structuralism" of Claude Lévi-Strauss) was already a key term in photographic artworks that reflected on the relation between exposure-time and print quality, or between developer-time and print quality, and whose favored format of display was frequently the sequence or the grid: to be found in contemporary works such as John Hilliard's *Camera Recording Its Own Condition* (1971) or his *Sixty Seconds of Light* (1972). Structuralist photography, then, in so far as it was concerned with process and time, lent itself immediately to materialist film practice, so that we find in Welsby's *Seven Days* of 1974 a kind of translation of a real temporal passage into the time and space of the film. The work's very title reflects both the content of the work as well as the time taken to film it: the artist located himself on a mountainside in Wales, taking a single-frame shot every ten seconds between sunrise and sunset for a week [Fig. 2.19]. Also crucial to the resulting images was the revolution of the earth against the backdrop of the solar system, and the orientation of a specially designed camera within that process. "The camera was mounted on an equatorial stand," explained Welsby, "which is a piece of equipment used by astronauts to track the stars. In order to remain stationary in relation to the star field the mounting is aligned with the earth's axis and rotates about its axis

approximately once every twenty-four hours. Rotating at the same speed as the earth, the camera is always pointing at either its own shadow or the sun. Selection of image, sky or earth, sun or shadow, was controlled by the extent of cloud coverage. If the sun was out, the camera was turned towards its own shadow. If the sun was in, the camera was turned towards the sun." Viewing these photographic stills as a moving sequence creates a temporal structure of whose origins the viewer becomes gradually aware. Without Welsby's text the film is marvelously abstract. With it, its materialist and structuralist (perhaps cosmic) implications become plain.

Yet simultaneously with these investigations into structure, another issue demanded to be faced. The appearance on the market of the affordable hand-held video camera, launched around 1973–74 by the Sony Corporation, provided the pretext and the tools for an extremely extensive critique of the spectatorial regimes of American commercial TV, at that time (and subsequently) perhaps the most directly exploitative low-quality television in the world. Indeed, so rapid was the uptake of the new camera that by 1975 or 1976—a watershed moment in the progress of avant-garde artists' film—major contemporary art museums throughout the West were staging compendious surveys of video art practice, while the more adventurous art publishers were bringing out fresh critical writings that attempted to position and evaluate the new work. An impressive number of major artists on both sides of the Atlantic made short video films that undercut or otherwise parodied the procedures of commercial TV, hence opening up a critique of the dominant culture as a whole. Lynda Benglis's *Collage* (1973) and Robert Morris's *Exchange* (1973) in the United States both use the cliché of the cheesy screen image to deprecate a Hollywood manner that attends remorselessly (it does so still) to the on-screen glamor of stars such as Elizabeth Taylor and Richard Burton: they are replaced in Morris's work by two pseudo-celebrities engaged in inane conversation. Richard Serra's six-minute *Television Delivers People* [Fig. 2.20], also of 1973, used a TV monitor to display purely verbal messages having paradoxical, political force: "The project of television is the audience," "Television delivers people to an advertiser," "Mass media means that a medium can deliver masses of people," "Corporations that own networks control them," "Corporations are not responsible to their shareholders" are samples of the step-by-step logic Serra employed. In an interview published not long afterward, Serra

2.19 Chris Welsby
Seven Days, 1974
Film

2.20 Richard Serra
Television Delivers People, 1973
Video film
6 minutes, with sound

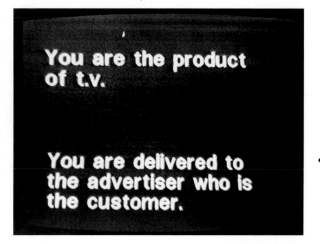

repeated a statement written for a contemporary show: "Technology is a form of toolmaking, body extension... It does not concern itself with the undefined, the inexplicable. It deals with the affirmation of its own making. Technology is what we do to the Black Panthers and the Vietnamese under the guise of advancement in a materialistic theology." He went on: "I think commercial TV is basically show business, and that means show business is used to reflect corporate America's interests. The networks put out programmes that make the viewer feel more secure about his home, city, state—that America is the best place to be... I *know* that TV consciousness was developed in the sixties. And yet, in 1974, people still accept what they see on their TV sets as valid information." Reflecting too on the 1972 election in which "Nixon had the Young Republicans hand-picked to clap on cue with that Sammy Davis handshake," Serra postulated a seamless continuum between the spread of TV to middle America, and more or less covert governmental control.

While Serra showed himself aware, throughout the making of this and subsequent political videos, such as *Prisoner's Dilemma* (1974), of the relation of filmmaking to his own practice as a sculptor, other early video critiques of TV took on a more ludic and spectacular form. A quartet of art and architecture graduates (Chip Lord, Hudson Marquez, Doug Michels, Curtis Schreier) known collectively as Ant Farm began staging public Happenings at the expense of commercial TV in 1971, the year in which a concept was born that initially attracted no institutional support. "The image came out of the subliminal," wrote Ant Farm later; "the idea of stacking up a pile of TV sets in a parking lot and then driving an old car with metal shields over the windscreen through the pile." Sealing off the windscreen and mounting a video camera in a tail fin at the rear of the car, hence steering by means of an interior TV monitor, Ant Farm positioned a 1959 Cadillac at the head of a parking lot in front of 500 invited guests on July 4, 1972. An actor pretending to be John F. Kennedy read a spoof Independence Day address about the addiction of the American people to TV; the national anthem played; and the Cadillac, symbol of prosperous 1950s America, was ritually driven through a mound of forty-two kerosene-soaked TV monitors, while cameras happily documented the conflagration [Fig. 2.21].

Somewhere between the structural and the overtly political film lie the early video works of the American Dan Graham. Graham had come to the attention of an art public with the publication in *Arts Magazine* for December–January 1966–67 of an article entitled "Homes for America," whose text described with deadpan seriousness a history of mass-produced housing in America in the post-war period and the underlying economic limitations determining the final range of

2.21 Ant Farm
Media Burn, 1972
Film/performance

consumer choices, which at the point of sale were dressed up in euphemistic labels suggestive of elegant architectural styles—"Belleplain," "Brooklawn," "Colonia"—while accompanying photos portrayed these single-family houses as geometrically repetitive, formally plain units. "They were not built to satisfy individual needs or tastes," Graham had written; "the owner is completely tangential to the product's completion… his home isn't really possessable in the old sense; it wasn't designed to 'last for generations,' and outside of its immediate 'here and now' context it is useless, designed to be thrown away. Both architecture and craftsmanship as values are subverted by the dependence on simplified and easily duplicated techniques of fabrication and stardardized modular plans." Situating itself somewhere between journalism and art criticism—specifically, criticism of recent Minimalist art—Graham's article found equivalents for political and social structures within the structures and uses of language itself. As Thomas Crow summarized the article's style of address: "Recasting the standard matter of journalistic description much as Flavin reorganised lighting fixtures or Andre reorganised bricks, Graham took up the most radical implications of Minimalism: that art could be made from anything and sited anywhere within a recognisable art context, the pages of a magazine serving just as conveniently as a gallery."

Graham was soon able to transfer his awareness of the relations between language, photograph, and social behavior to the new fields of performance art and film: the special ability of video to relay real-time images, or build in a five- or six-second delay, added some new possibilities to Graham's already strong fascination with feedback and social control. A project called *Two-Room Delay* of 1974 had video TV monitors in adjacent mirrored rooms relaying images of the occupying viewers to monitors in the *other* room, a time-delay acting as a spacer for the viewer's experience as he or she moved next door. "In either room," Graham explained, "an observer sees his present actions reflected in the mirrors; at the same time he will see his past behaviour from the other room projected on the monitor as it is reflected in the opposite mirror." Such works were prescient in so far as they recognized the increasing social implications of video film for police surveillance, for corporate communications, for medical diagnosis, and other forms of information relay. The connection between Graham's work as an artist and those wider social concerns was once again architecture. "The architectural code reflects and helps enforce a code of social behaviour," Graham wrote in a further article of 1974. "As video becomes superimposed upon (replaces) traditional elements or functions in architecture it affects the architectural code… the lives of physically or culturally separated individuals or families can be permanently interlocked through video connections."

Implied already in these descriptions is concern for the fate of a structural element basic to all life in the urban centers of the West, namely the extraordinarily potent function of the mirror—and its articulation of the gaze (hence also of subjectivity) in architecture, shopping, and the ever-problematic distinction between public and private space. Already in the early 1970s Graham had become absorbed in

2.22 Dan Graham
Video piece for *Showcase Windows in Shopping Arcade*, 1976
Two monitors, two cameras, time-delay device installed in two facing and parallel store windows in a modern shopping arcade

writings around film theory, and the implications of the "mirror phase" of infancy so vividly articulated in psychoanalysis by Jacques Lacan. Now, in the mid- and later 1970s, Graham found multiple applications for his fast-evolving ideas. *Showcase Windows in a Shopping Arcade* of 1976 addresses the use of mirrors in a double-sided shopping arcade. For the project, Graham positioned video monitors inside each of two parallel store fronts "so as to provide views of and from inside the opposite showcase (and also from inside the spectator's own showcase, via the view's reflected images from the opposite showcase's mirror)," hence providing "interior front and back perspectives, front and back views of spectators looking at both showcase displays and of spectators in the 'real-world' space of the arcade" [Fig. 2.22]. The conventional showcase display, as Graham points out, "is likely to contain a mirror or mirrored fragments behind the products on view, seductively reflecting fragmented aspects of the spectator's body. The mirror enhances the narcissistic tendencies of the spectator, as well as the alienation of the spectacle from the body-image and from the goods... the spectator feels his perception disturbed if other people are trying to occupy his particular position, or if he becomes too aware of other showcase displays and the people responding to them." But thanks to the multiple reflexivity engendered by the piece, the viewer now becomes suddenly aware of his or her scopic location in the processes of consumption and desire. In like fashion, "the non-equivalence of an employer's view of the employee's work-space with the employee's view of the employer's work-space would be a further instance of the relevance of what film theorists call 'the gaze' to the maintenance of public order." In such situations newly illuminated by video art, says Graham, "the inequality of power is clearly expressed."

The Spread of Radical Art

All revolutionary moments in culture face the same dilemma: how to sustain a level of energy without becoming corrupted by the warm embrace of power. We have mentioned already the fact that, for feminists, the central issue was the relative invisibility of women artists in the larger museum shows and the low status of women artists in education and the gallery system, followed by a struggle to establish alternative formal languages. For men the situation was different; indeed, most forms of male radicalism based on the legacy of Conceptual art soon became endangered by the fact that museums and the commercial art world were becoming quickly converted to their cause. The short-lived but important small-circulation journal *The Fox*, published in New York in the mid-1970s by an offshoot of the English group Art and Language, adopted the rhetorical style of a self-doubting Conceptualism in harness with an increasingly frustrated Marxist analysis of art. *The Fox* trenchantly analyzed the dilemma

whereby even the most radical activity was eventually made subject to capitalist appropriation and the concomitant workings of social power, and, true to this conviction, some of the journal's adherents soon left the field of art altogether to work in education or grass-roots politics. Others were soon to reassemble in Great Britain to pursue the critical practice of, surprisingly, painting in ways the next chapter will soon explore.

Other male artists coming of age in the late 1960s also had to face the unwelcome reality that a degree of impatience was appearing with the more extreme forms of alternative art; that the social landscape would be resistant to new ideas while it was caught up in economic crises that affected everyone, including the artist. Such a figure was Gordon Matta-Clark, who in 1969–72 had discreetly violated buildings left abandoned on New York's waterfront, destabilizing them by cutting out panels or whole walls, making vivid his awareness of inner-city dereliction as well as the inherent impermanence of the architectural (and hence the social) envelope. Up to the time of his tragically early death in 1978 and buoyed up by his belief in the alchemical transmutability of matter, the young Matta-Clark struggled with ill-health to perform a series of major projects in which he continued to "undo" buildings on a vast environmental scale that in retrospect seems to owe as much to the Surrealism of his father, the Communist painter Roberto Matta, as to the anti-form art movements of his immediate forebears in the 1960s. In his punningly titled *Splitting* of 1974 [Fig. 2.23], Matta-Clark cut in half a New Jersey house from which the tenants had recently been evicted to make room for a planned (but never finished) urban-renewal project. Housing became a familiar theme for artists on both continents in the mid-1970s, following crises in property prices, urban planning, and mounting unemployment. The artistic territory that Matta-Clark liked to occupy, on the boundary between urban vandalism, mystic architecture, and subtractive sculpture, represents a kind

2.23 Gordon Matta-Clark
Splitting (in Englewood), 1974
Cibachrome
42 ¼ x 32 ¼" (110 x 80 cm)
Private collection

After visiting the house, the artist Alice Aycock recalled "starting at the bottom of the stairs where the crack was small. You'd go up… it kept widening as you made your way to the top, where the crack was one or two feet wide… you sensed the abyss in a kinaesthetic and psychological way."

of limit to the legal and logistical ambitions that radical artists of the 1970s entertained. The work's longer-term survival as documentation alone was all along (one supposes) intended to constitute an aspect of its real condition.

California artist Michael Asher's project was to elaborate the insights of "situational aesthetics," which proposed that the location in which the artwork found itself was the essential, perhaps unique, component of the work—hence Asher developed a practice that took a museum or gallery as a physical resource and intervened in its palpable, material character in order to suggest a re-reading of the normal processes whereby art was produced, displayed, and commodified. In a project at the Otis Art Institute in Los Angeles in

2.24 Michael Asher
Project at the Claire Copley Gallery,
Los Angeles, 1974

1975, Asher negotiated for the gallery to be closed for the duration of the "show," while in the entrance lobby he positioned a notice saying: "In the present exhibition I am the art" — hence confounding the identity of producer and viewer, as well as utterly frustrating the viewer's expectations of solace and refinement in the gallery space. A year earlier, also in Los Angeles, Asher had taken over a private gallery, removed the partition between gallery and office space, and, by cleaning up any resulting discontinuities in carpeting and decor, made the whole space, now empty of paintings save for those stacked conventionally at the office end, mysteriously one [Fig. 2.24]. The reader can visualize how the result was to deconstruct the distinction between aesthetic experience and commerce. In Asher's words: "Viewers were confronted with the way in which they had become traditionally lulled into viewing art and, simultaneously, the unfolding of the gallery structure and its operational procedure… Without that questioning, a work of art could remain enclosed in its abstracted aesthetic context, creating a situation where a viewer could mystify its actual and historical meaning." Simultaneously, Asher's deconstruction began to shift the authorship of the work from individual (artist) to team (the gallery as commissioner). Henceforward, the compliant curator could be part of his or her chosen artist's work.

Asher's projects cannot be bought or sold and survive only precariously in documentation and critical writing. As an important consequence of this trend, it transpired during the 1970s that several American galleries and museums were able to turn the ephemeral nature of Conceptual art to their own advantage and, by acknowledging and even valuing its characteristic texts, notices, diagrams, instructions, and photographs, make these less demanding formats the pretext for even speedier commercial transactions and less expensive gallery and museum shows. Simple to mount, transport, display, document, and insure, Conceptual art soon risked becoming a ready answer to the dealer's prayer for radical formal novelty combined with material simplicity now reconstituted as aesthetic value.

The same could probably not be said of Conceptualism in the wider international field, where the ambitions of alternative art also took root. For example, several artists newly fluent in the languages of Minimalist and Conceptual art made attempts to accommodate local political anxieties to the new formats. Brian O'Doherty (born in Ballaghaderreen, County Roscommon) had left Ireland for New York in 1957 to launch a career as an influential critic and art administrator. In line with O'Doherty's political convictions, he pursued a parallel career as an artist from 1972 under the nationalist pseudonym Patrick Ireland "until such time as the British military presence is removed from Northern Ireland and all citizens granted their civil rights." For his early land art installation *Rick* (1975), Ireland reconstructed with the help of an artisan builder a traditional Irish turf shelter within an eighteenth-century town

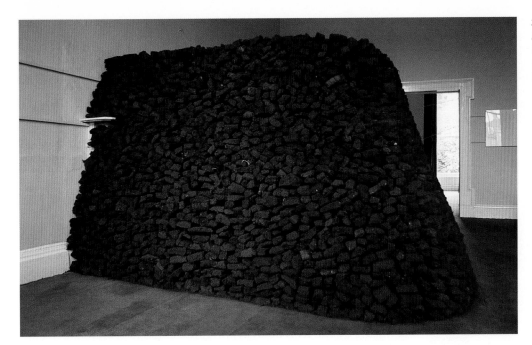

2.25 Patrick Ireland
Rick, 1975
Peat
Dimensions variable
David Hendricks Gallery, Dublin

house doubling as a gallery [Fig. 2.25]. Evoking all too vividly the vernacular peasant structures of rural Ireland and the corbeled architecture of early Irish stone churches, *Rick* established a compelling tension between peasant poverty and the elegant plastered interiors of Georgian Dublin. Here was an early instance of an artwork positioned to raise issues about class society and the colonial past. It should be noted that earlier the same year O'Doherty/Ireland had given a lecture at the Los Angeles County Museum of Art entitled "Inside the White Cube: 1855–1974," which was to become a series of articles in *Artforum* (1976) on the phenomenology and history of the Modernist art museum—a series of articles that set new critical standards for articulating the special demands and prohibitions of that distinctive and (by now) highly typical space.

At the other extremity of the Western art world we see a series of different but related patterns. Not only was the prehistory of the best work produced in Poland, Czechoslovakia, and Russia in the 1970s and 1980s—to take three significant examples—at variance with their counterparts in Western Europe and America, but the support systems and audiences of the Communist bloc countries were scarcely comparable. In such countries the market, which proved so central and so problematic for Western artists, simply did not exist. And yet the fundamental categories of alternative art were quickly absorbed by practitioners with contacts or friendships in the West. The young Zdeněk Beran in Prague, to take an important but untypical example, drew on his experience of a hostile political environment for his epic performance *The Dr. D. Rehabilitation Center*—it refers to the plight of an artist deprived of contact with his public, and is a token of respect for the Czech psychiatrist Stanislav Drvota, who wrote *Personality and Creation*. Beran ritually

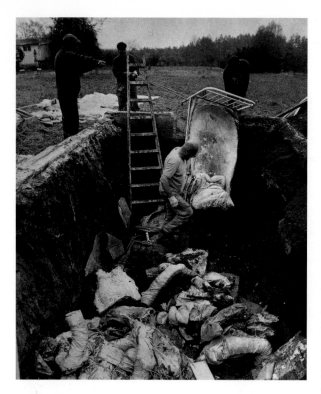

2.26 Zdeněk Beran
The Dr. D. Rehabilitation Center, 1970–2000
7′10 ½″ x 13′2″ x 3′3 ½″ (2.40 x 4.01 x 1.00 m)
National Gallery, Prague

buried the entire contents of his modest studio in a field, attended by a few well-wishers (including at least one photographer) who understood that, even mutilated by time, the work of art would survive suppression and intellectual terror [Fig. 2.26]. For Beran in his struggle with institutional authority, the project amounted to a clear gesture in a society still governed by political censorship and above all intolerant of contemporary art.

In the USSR, state-approved versions of Socialist Realism in the form of images of the glorious march of Communism, the individual's happy subservience to the state, and so on, were by the late 1960s still normal fare. The institutional machinery that regulated the production and display of this work had lain since at least 1945 like a suffocating blanket over all the arts of Eastern Europe. The atmosphere in Moscow in the early 1970s can be judged by the extent to which rare instances of oppositional art still provoked the state authorities to violent overreaction. The infamous bulldozing by the KGB of an avant-garde exhibition in Beljaevo Park in 1974 is the prime example — and yet the publicity generated by this incident paradoxically served to release as much as to constrain the younger generation: with the result that the exhibition was re-staged two weeks later to much-increased popular interest. By this time, Moscow artists had coined the term "Sotsart" (from the Russian *sotsialisticheskii*, or socialist) to denote a bitter-toned Pop-art pastiche of official Soviet realism. The Sotsart work of Vitaly Komar and Aleksandr Melamid, two artists who continue to work together, now in the United States, made use of a mixture of Duchampian, Minimalist, and Pop art ideas learned from Western art magazines, combined with a home-grown cynicism that harks back to an absurdist Russian literary group of the 1920s, Oberiu. One painting by Komar and Melamid, dating from 1972 and representing a kind of Eastern Conceptualism, took an official Communist slogan and reduced each letter to a monochrome rectangle, hence rendering the content of the slogan abstract and unrecognizable [Fig. 2.27]. Here, the blankness of Minimalist painting functioned to characterize the announcement, whatever it was. Official reality became subject to parody within the codes of art — while parody itself, which played subtle games with language and quotation, helped guarantee artists' freedom from the attentions of the generally humorless censor.

For several Soviet artists, unable to travel to the West yet privy to the occasional tidbit of information from New York and elsewhere, the work of certain Western Conceptual artists, land artists, and musicians came to assume almost mythic importance. For example, the group in Moscow around Andrei Monastyrsky known as Collective Actions began in the mid-1970s to adopt and develop the ideas of the radical American composer John Cage concerning the role of chance and randomness in musical composition, as well as Cage's widely imitated tactic of allowing the

environment to flow into the work and even to dictate its phenomenological form. The Russians took their inspiration seriously. Invited witnesses would travel to a destination outside Moscow, where Collective Actions would perform ritualistic actions of an enigmatic nature not announced to anyone in advance. In *Appearance* (1976), for example, two performers emerged from a forest and handed a note to the viewer signifying his or her participation in the event (a good example of the Russian tendency to mix the visual with language). *Lieblich*, of the same year, involved an electric bell that sounded under the snow when the viewer approached: the group's concept of "sounding silence" was also inspired by Cage. In *Third Variant* [Fig. 2.28], characters performed empty actions and self-cleansing gestures like lying in a ditch—a motif found in Carlos Castaneda's *Journey to Ixtlan* and in Samuel Beckett's novel *Molloy*—until the audience drifted away of its own accord. Such actions lay beyond even the conventional tension between official art and its opposition. Merely to travel to these ludic and semi-private events assumed a kind of ritual significance that remained in the cultural memory long after their literal occurrence.

Russian irony in the face of fabled Western art also found expression in the work of a group of Moscow performance artists, Mikhail Roshal, Viktor Skersis, and Gennady Donskoy, who made a document in which they purported to have purchased the soul of Andy Warhol for 100 roubles. Another action by this trio, wittily titled *Underground Art* (1979), took place in the same park as the bulldozed show of five years before. The artists, partially buried in the ground, talked into a microphone about their lives as artists in the USSR while simultaneously drawing with mud on a canvas above their heads. A video recording of the event—a novel form of documentation in Russia in 1979—shows the artists emerging from the hole and asking, "Where is Chris Burden when we need him?" Such self-mocking artworld gestures, many of them barely publicized and sometimes not even successfully recorded, suggest that the pervasive irony of the West European and American avant-garde could be adapted to all manner of distant situations, and function as the new lingua franca of dissenting art.

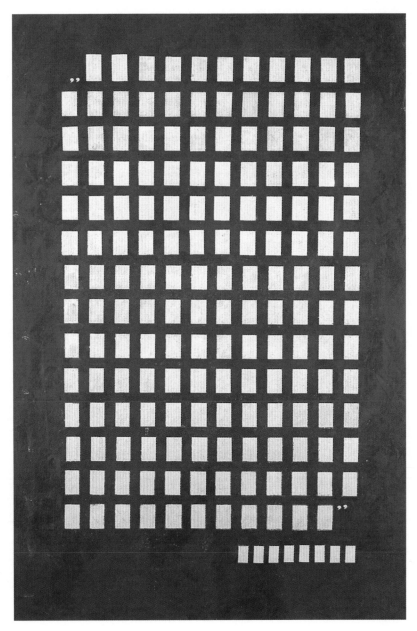

2.27 Vitaly Komar and Aleksandr Melamid
Quotation, 1972
Oil on canvas
46 ½ x 31" (120 x 80 cm)
Private collection

Yet back in the West, it soon began to be suspected that some form of "return" to sensuousness was required to overcome the despondency that enervated much of the art world at the time. The formal conclusion of American involvement in the Vietnam War in 1973 and the Watergate scandal that ended Nixon's presidency had been quickly followed by a series of shocks to the international economy caused by oil-price rises and a sequence of deepening social crises in housing, women's rights, the enfranchisement of ethnic and sexual minorities, as well as in relations between the developed and the developing world. Widespread disenchantment with traditional patriarchal culture was accompanied by a perception that the radical social and artistic alternatives of the 1960s counter-culture could not be indefinitely sustained. The mood of the Western art community toward the end of the 1970s can be described as one of confusion. A New York critic, attempting to summarize the condition of art at the end of the decade, ended her recitation of the key buzzwords of the period—Minimalism, Formalism, Post-Minimalism, Process Art, Scatter Works, Earthworks, Conceptualism, Body Art, Photorealism—with the despairing cry that "after the early 1970s words fail us; the glossary dissolves… there are no more terms that really work." Speaking of "schizophrenia," "dissociation," and "a double bind," she sensed that artists were viewing all the tried alternatives to orthodox Modernism as empty, over-used, exhausted—at the same time feeling uncertain where else they could go.

2.28 Andrei Monastyrsky and Collective Actions
Third Variant, 1978
Performance

In this performance a character dressed in violet emerged from a forest, walked across a space and lay in a ditch. A second character's head (in the form of a balloon) blew up before he, too, lay in the ditch. The characters continued to lie there until the audience wandered away.

Contemporary Voices

From Judy Chicago, *The Dinner Party: A Symbol of Our Heritage*, New York: Anchor Press/ Doubleday, 1979, p. 54.

"*The Dinner Party is not really an adequate representation of feminine history. For that, we would require a new world-view, one that acknowledges the history of both the powerful and the powerless. As I worked on the piece a nagging voice kept reminding me that the women whose plates I was painting, whose runners we were embroidering, whose names we were firing onto the porcelain floor, were primarily women of the ruling classes. History has been written from the point of view of those in power. A true history would allow us to see the mingled efforts of peoples of all colors and sexes, all countries and races, all seeing the universe in their own diverse ways. We do not know the history of humankind.*"

From Vito Acconci, "Biography of Work 1969–1981," in *Documenta 7*, Kassel, 1982, pp. 174–75.

"*A piece is meant to submerge the agent into environment; the agent is lost, no 'thing' exists; a piece functions as a private activity—that private activity, however, exists only so that it can be made public later, like a news event, through reportage or rumour.*"

Malcolm Le Grice, "Statement," *English Art Today 1960–76: Alternative Developments*, Milan: Electra Editrice, 1976, pp. 454–55.

"*I consider the establishment of the materiality of film, its processes and projection event, to be the most fundamental distinction between the premises of avant-garde film practice and those of the mainstream illusionist cinema… Not only is this a fundamental distinction in film thought and form, but I consider its establishment as a premise in the developing avant-garde film culture makes the film work produced from that context more 'modern' and radical in aesthetic, philosophical and political implication than any work produced within the mainstream cinema context. The new work… maintains the time and space of the projection event, introducing illusion, not as a device, but as a problematic to be dealt with in a reflexive-speculative dialectic by the viewer of the film as it develops on the screen.*"

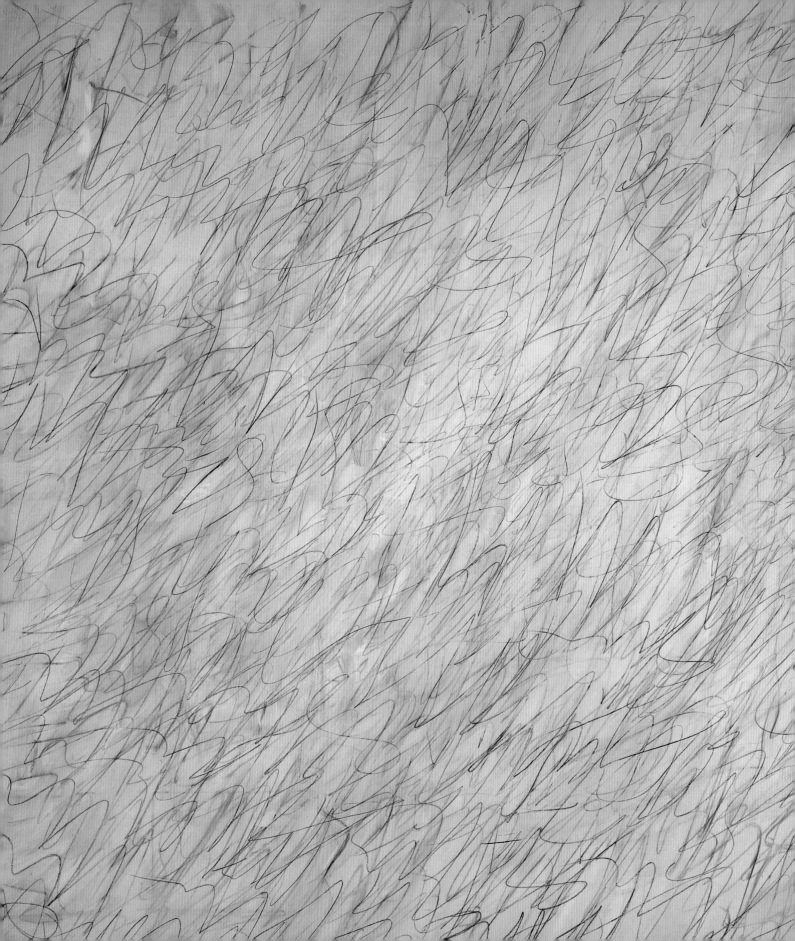

3
The Politics of Painting: 1972–1990

Impermanence, irony, absurdist actions, and repeated gestures of futility and disengagement—this was the currency of the new art as it took its leave of the older forms of modern (and Modernist) painting and sculpture. Painting did not come to a complete halt in the aftermath of the counter-culture, but it did pass through a period of declining confidence during the 1970s as artists devoted themselves instead to video, performance, installation, and Conceptual art. But that decline proved to be short-lived, as artists soon returned to both painting and sculpture as the bearers of modern art's core aesthetic principles, or else retuned their approach to these media after a period in the critical shadows. The dilemmas of that return were acute, and yet ultimately fertile ones for artists seeking a "way back" to the traditional genres. On the one hand, a way out of the growing lethargy surrounding the Conceptualist camp was becoming more and more desirable as the 1970s wore on. Equally, those alive to the hard-won achievements of Conceptual art remained cheerful about the collapse of Modernist critical protocols, and continued to be skeptical of claims that painting would necessarily survive its own demise in all essentials unchanged.

The Survival of Painting and Sculpture

My recollection too is that sculpture in the mid-1970s survived mainly as a residual, even discredited genre. Critical discussion of the ongoing work of Anthony Caro, to take one symptom, sought to explain how the Modernist sculpture project would need to be viewed as politically passive in relation to the radicalized newer media. Caro defended his practice as a sculptor on the basis that "verticality, horizontality, gravity, all of these pertain both to the outside physical world and to the fact that we have

Opposite
Cy Twombly
Nini's Painting (detail), 1971
See fig. 3.3

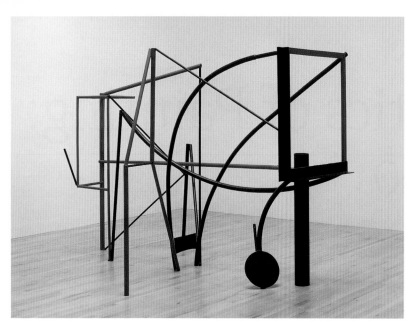

3.1 Anthony Caro
Emma Dipper, 1977
Painted steel
7′ x 5′7″ x 10′6″ (2.13 x 1.70 x 3.20 m)

bodies… depth of human content is what raises art to its most profound level, and human content resides and finds expression within the language of the medium… the language we use in sculpture is the language of sculpture, one that has to do with materials, shapes, intervals and so on. I am a sculptor," Caro would insist, "I try to form meaning out of bits of steel." Asked what the emphatic horizontality of his steel sculptures *meant* in social terms—or their openness, or their lack of interiority [Fig. 3.1]—Caro would rebut any overt connection with the social world of his time, let alone the historical determinants of his identity as an artist. "My job is to make the best sculpture I can," he would assert repeatedly. "My job is not the discussion of social problems." Modernist *painting*, by contrast—or some powerful versions of it—absorbed the lessons of the counter-culture far more easily than did sculpture. Even the far-flung example of the Moscow performance *Underground Art* was in part a nihilistic painting about painting itself.

A particularly potent direction followed by some painters in the West was the further reduction of abstract painting to its minimal conventions—its form, color, and shape, its manner of being apprehended or seen. The already strong tradition of monochrome painting by Ad Reinhardt and Agnes Martin, and some works of Ellsworth Kelly in the 1960s, had concentrated the experience of all the elements of art into the placement of a single hue against a generally white interior—such as only the Modernist art museum could readily supply. In this way the display strategies necessary to monochrome paintings converted them into a kind of performance, quite different from the relatively context-free qualities of figurative or narrative art. And this widening of the conceptual demands upon the viewer's attention proved durable right into, and through, the 1970s, as artists elsewhere took up the baton. The early work of the Swiss artist Rémy Zaugg, for instance, belongs to the critical world of the self-reflective, self-defining, near-monochrome canvas—but with some differences that are too little understood outside his immediate milieu. An avid student of art history and theory, as well as theories of perception, semiology, and phenomenology, Zaugg made Minimalist sculptures and paintings so as to reflect both the conditions of their making as well as (and as part of) their mode of being viewed. Contrary to the Modernist shibboleth that insisted upon each work being autonomous and enduring, a stable perceptual datum that always and everywhere looked the same and maintained its own "value," Zaugg came to believe early in his career that process and becoming were strong determinants of the aesthetic act. "Completion and finiteness," he has said, "are the foundations of closure and separation. They put a seal

on isolation. They call up narcissistic and solipsistic sufficiency." Zaugg describes his own early work by stating that, by contrast, "it aspires to complicity with its setting in the world and claims to be an object of practical use among other objects of practical use; my painting repudiates the frame, this symbol which actualises the mental and behavioural routines of separation." His *Hellblaues, abgeschliffenes, gefundenes Bild* (*Light-Blue, Ground-Down, Found Painting*) (1972–73) presents its light-blue frontal face to the viewer, yet clearly asks to be seen from the side, where marks of previous color-painting (perhaps expressive or gestural—who knows?) are visible as residues of another kind of art, as well as the tacks which hold the canvas in place on the stretcher [Fig. 3.2]. "The idealising strategy of framing is repugnant to my work," says Zaugg. "By masking the vulgar and subaltern lateral sides of the canvas, by making its physical and technical, its domestic or servile constituents disappear, the frame eliminates precisely those elements which are practical objects: it annihilates that which links the painting to everyday objects. The nails holding the tautened canvas on the stretcher belong to the same world as the screws that fix the four metal legs to the table top in my studio… the sides of this canvas have received neither more nor less attention from the author of the painting than did the back of the radiator to my left, under the window, from the house painter." Arguing for a completely redomesticated status for painting, Zaugg wants the work to be as incomplete as possible in order for its position and its appearance to devolve upon and reflect the agency of the humans who hung it, lit it, and photographed it. "The painting can be self-effacing, can make itself small to achieve its one aim: to enable the perceiving subject, who is responsible for his environment and therefore for its appearance, to gain in importance." "The painting knows how to be nothing," Zaugg elaborates, "so that the subject can be everything… the painting calls out to man, and that is its only manifest claim." One might say that Zaugg has joined Minimalist aesthetics to a concept of utilitarian design: a certain kind of Modernist architecture is only a small step away.

By the mid-1970s, certain other painters could be described as pushing the medium to the limits of thought and practice: Sigmar Polke and Gerhard Richter in Germany, America's Robert Ryman, and Cy Twombly, by now living in Rome, whose faint, scribbled abstractions seemed to exhibit the many kinds of uncertainty necessary to painting's contemporary redefinition. Twombly had left New York for Italy in 1957, and had begun to construct his paintings with a range of gestural marks highly heterodox in their associations and

3.2 Rémy Zaugg
Hellblaues, abgeschliffenes, gefundenes Bild
(*Light-Blue, Ground-Down, Found Painting*),
1972–73
Acrylic on canvas
21 ⅔ x 25 ½ x ¾" (55 x 65 x 2 cm)

3.3 Cy Twombly
Nini's Painting, 1971
Oil-based house paint, wax crayon, lead
pencil on canvas
8′6″ x 9′9″ (2.61 x 3 m)

In the autumn of 1971 Twombly painted five
large works in response to the death of Nini
Pirandello: they paradoxically represent
some of his most serene works, which, in the
words of his biographer, Heiner Bastien,
evoke "a remote glaucous colour of sea
between night and day, as slowly churning
as the seasons… [they] achieve a rare
timelessness signifying the respite and
reconciliation possible to the otherwise
eternal dichotomy of art and life."

suggestive references. Inept or untidy handwriting, doodles, numbers, crudely drawn body parts, occasional graffiti-like scratches and gougings all formed part of a brilliant repertoire of disjunctive, randomized markings. Classical references to his new Mediterranean surroundings evoke a historical time and place for his paintings suspended between the ancient and modern worlds [Fig. 3.3]. "It is as if the painting were conducting a fight against culture," the French theorist Roland Barthes said of Twombly's work, "jettisoning its magniloquent discourse and retaining only its beauty." Assimilating Twombly's manner to the anti-individualistic style of Eastern art, Barthes said: "it does not grasp at anything: it is situated, it floats and drifts between the desire which, in subtle fashion, guides the hand, and politeness, which is the discreet refusal of any captivating ambition." Twombly's ethic was to be located, Barthes said, "outside painting, outside the West, outside history, at the very limits of meaning."

A broadly consonant reading of Twombly's project was supplied in a landmark essay written at the end of the 1970s by the American critic Craig Owens. In "The Allegorical Impulse: Towards a Theory of Postmodernism," Owens proposed that Modernist art had ignored the principles of allegory—indeed, that allegory had been proscribed for at least two centuries before making its striking reappearance in the newer art of the Postmodern. Allegory, said Owens, is the doubling of one text within or upon another. The allegorist does not invent images but confiscates them. He or she supplants an antecedent meaning, provides its supplement. Allegory is attracted to, indeed works upon, what is already fragmented, imperfect, incomplete—"an affinity which finds its most comprehensive expression in the ruin, which Walter Benjamin identified as the allegorical emblem par excellence." Allegory is both metaphor and metonymy; it "cuts across and subtends all stylistic categories." And such blatant disregard for aesthetic categories—the very inverse of the Modernist project of purity of medium, of truth to materials—"is nowhere more apparent than in the reciprocity which allegory proposes between the visual and the verbal: words are often treated as purely visual phenomena, while visual images are offered as script to be deciphered." It is the allegorical impulse, Owens proposes, that we should identify in the ruined fragments of Rauschenberg's *Rebus* (1955), in his *Allegory* (1960), or in the ruined graphic provisionalities and quotations of Twombly's art.

But the record would be incomplete if we did not mention a quite different way out of the reductive pull of Minimalist painting toward the blank, uninflected monochrome, namely a directly affirmative practice that reveled in sensuous effects of color, design, and organization—as if nothing had happened in modern painting since the time of Hans Hoffmann in the 1950s, or as if modern painting had only ever been practiced by Matisse. The sensuous color abstractions of Jules Olitski in America or John Hoyland in Britain belong to this type. Yet during the 1970s, supporters of this

work were only able to describe them in the discredited language of celebration, or of human joy—discredited because no art could credibly claim to ignore the pervasive conditions of crisis in the culture as a whole. In regard to such affirmative painting, Theodor Adorno's words rang especially true: "It is barbarous to write poetry after Auschwitz."

It was all the more surprising against such a background that no less a painter than the American Frank Stella in the mid-1970s should now begin to complicate his pictorial surfaces in an explicitly and almost exhibitionistically flamboyant way. Following his own Minimalist black and aluminum stripe paintings of 1958–60, and his development of a type of Cubist wall-relief painting in the early 1970s, Stella now turned in his

3.4 Frank Stella
Bermuda Petrel, 1976
Lacquer and oil on metal
5'1½" x 6'11½" x 1'2" (1.5 m x 2.1 m x 35.5 cm)

The largest of the *Exotic Bird* paintings required factory-made aluminum surfaces treated with ground glass and lacquer that the artist merely directed to be made. "I could make the structural schemes for such paintings, just by sliding templates around the surface [of a drawing]," Stella recalled.

Exotic Bird series [Fig. 3.4] to irregular curves, fervent brushstrokes, and violent color on a vast and assertive scale. At the time, Stella's reputation as one of the most intelligent painters of his generation functioned as a guarantee that the visual procedures of Modernist reductionism were being flouted in a purposeful and even strategic way. But exactly how? To die-hard Conceptualists who still believed that art should be dematerialized in the political meltdown of the time—should be reduced to documents or blank gestures of denial—Stella's new paintings appeared exotic, cumbersome, even Baroque. To his supporters, the term "baroque" would associate the new work with the allegorical impulse, with more complex ways of being seen. Stella's geometrical templates, for example, could easily be seen as an allegory upon Cubist geometry, which was itself already a kind of allegory upon symbolic as well as naturalistic form.

The Debate on the Figure and "Expression"

At around the same time, a thinly concealed case for the restoration of a figurative richness in the visual arts was beginning to surface. In Lucy Lippard's catalogue for the 9th Paris Biennale in 1975, the one-time champion of Conceptual art remarked that women's art might "indicate ways to move back towards a more basic contact between art and real life… By confronting other levels of seeing again, we may be able to come to terms more quickly with that volcanic layer of suppressed imagery so rarely acknowledged today." Though issued on behalf of feminism, her remark proved prescient in a number of ways. Not only would painting's several reinterpretations in the mid-1970s be united by the use of the old-fashioned craft technology of oil or

acrylic on stretched canvas, much of it on a scale approaching that of Abstract Expressionism, but, and more surprisingly, much of the new painting would include the image of the human figure, frequently with an allegorical or narrative intent. But there were hidden problems lurking here as well. For it turned out that the political agenda of the late 1960s and early 1970s was almost entirely forgotten in the painting revival that was to come. Was the art community tired of politics? Of detachment? A further complication was that most of the new figurative art was executed by men.

The question came to a head in London in 1976, when the former Pop artist R.B. Kitaj organized a painting and drawing show entitled *The Human Clay* (the phrase was taken from the poet W.H. Auden: "To me Art's subject is the human clay"). Kitaj included his own work in the show, along with that of Leon Kossoff, Frank Auerbach, Michael Andrews, Lucian Freud, Francis Bacon, and other male painters who were now claimed to constitute a "School of London." Setting his face against what he termed "provincial and orthodox vanguardism," that is, post-Duchampian art, alternative media, the culture of New York, and much else, Kitaj defended figuration in disturbingly traditionalist terms. "The single human figure is a swell thing to draw," Kitaj ventured, referring to the great figurative painters of the past. Wanting not to resurrect but to transform the human image from those earlier roots, Kitaj exalted the manual skill with which the human image is compounded "in the great compositions, enigmas, confessions, prophecies, sacraments, fragments, questions which have been and will be peculiar to the art of painting." "The seam never really gave out," Kitaj said, referring to an alleged tradition of pictures of the human form. "It's not as if an instinct which lies in the race of men from way before Sassetta and Giotto has run its course." Such essentialist claims were of course no more likely to gain credence in 1976 than Kitaj's further claim that a return to figuration was a way of "making common cause with working people." In practice, then, *The Human Clay* remained a traditionalist exercise of men drawing or painting women (less frequently other men). Lucian Freud, for example, who had begun exhibiting in the early 1940s and was regarded as a contemporary painter of great power—a reputation that has increased steadily since then—was hailed by supporters in the 1970s as one who had kept alive a tradition of painting in which the human figure was revealed as candid, classless, and sexually animalistic; in which these revelations were conveyed in and through an encounter with a "masterly" manipulation of paint. In an early text, Freud took pains to describe the special intensity of relationship that has governed his own attitude to the posed figure. "The painter's obsession with his subject is all that he needs to drive him to work," he said. "The subject must be kept under closest observation: if this is done, day and night, the subject—he, she or it—will eventually reveal the all... through some and every facet of their lives or lack of life, through movements and attitudes, through every variation from one moment to another." Published in 1954, the statement evokes the sort of existential encounter between painter and model that was intellectually fashionable then, and that has continued to energize Freud's painting since. In its extreme form, the painter becomes the victim of his own obsession with excluding the

social world, with concentrating on the posed figure for such long periods that the figure may fall asleep or begin to look tired or strained. "A painter's tastes," Freud decreed at that time, "must grow out of what so obsesses him in life that he never has to ask himself what it is suitable for him to do in art" [Fig. 3.5]. To his detractors, Freud has been seen as a fabricator of oddly postured, submissive female images, painted in unpleasant browns and oranges and dominated by the painter's presence, leering down at their prostrate and frequently somnolent bodies from above.

In fact, by the mid-1970s such acts of painterly mastery were seen by progressive critics as irrelevant to experimental art, and the so-called School of London was by such writers summarily relegated to a historical backwater. Nevertheless, public and private interest in painting was encouraged by the construction of some high-profile museum shows. Attention throughout Europe and North America was captured curatorially around 1977 and 1978 by what was presented as an exciting "return" of previously lost possibilities. In Germany and Italy, but also across a wider international spectrum, varieties of painting were now promoted that seemed to resurrect the tradition—but especially those that took up a seemingly knowing, parodic posture in relation to previous historical styles. For example, the painter Georg Baselitz, from Berlin, had for well over a decade been exploring the tension between abstract and figurative art, dispersing fragments over the canvas or, after 1969, taking a photo in his hand and inverting it, then painting the image as if it were "naturally" upside down. Even when they were generated from photos of his wife, Elke Kretzschmar, they were not intended to function as portraits: on the contrary, the marks of the resulting painting come directly from being painted the wrong way up. Baselitz's tactic quickly engaged the puzzled viewer in a dialectic of right and wrong behavior, the license of artistic provocation when faced with the pull of conformity, and ultimately the snares and self-reflections of looking at abstract art itself. Another Berlin painter, Markus Lüpertz, author of the *Dithyrambic Manifesto* of 1966, now daringly played upon feelings of national guilt by his introduction of German military motifs, including helmets, cannon, and incidents from World War II. The Dresden-born A.R. Penck (real name Ralf Winkler) had on account of his isolation in East Germany been frozen out of the Western art system during the 1960s, only latterly to be drawn back in through contacts with Baselitz and the Michael Werner Gallery in Cologne.

The altered atmosphere may be summed up by a comparison of Harald Szeemann's choice of artists for *Documenta 5* in Kassel in 1972, which in retrospect

3.5 Lucian Freud
Small Naked Portrait, 1973–74
Oil on canvas
8 ½ x 10 ½" (22 x 27 cm)
Ashmolean Museum, Oxford

"The painter must give a completely free rein to any feelings or sensations he may have and reject nothing to which he is naturally drawn," Freud said in 1954. "It is just this discipline through which he discards what is inessential to him—so crystallises his tastes."

reads like a compendium of Conceptual art, and Manfred Schneckenburger's choices for *Documenta 6* in 1977. Schneckenburger brought back several painters whom Szeemann had proscribed: Bacon, Baselitz, Lüpertz, and Penck were now placed alongside Nancy Graves, Andy Warhol, Jasper Johns, Frank Stella, Roy Lichtenstein, and Willem de Kooning. At the same time, the work of a number of Italian painters, shortly to be known in their country as a "transavantgarde" (the critic Achile Benito Oliva's term)—Enzo Cucchi, Francesco Clemente, Mimmo Paladino, and Sandro Chia, along with Nicola de Maria, Luigi Ontani, and Ernesto Tatafiori—was shown first at home, then in Switzerland and Germany, and then further afield. Clemente and Chia both exhibited at Sperone Westwater Fischer in New York in 1979, and again at Sperone in 1980 with Enzo Cucchi. Both shows were greeted with rapture and relief by New York dealers and critics who had grown weary of the austerities of Conceptual art and who thrilled to the return of figurative, even pornographic references in Clemente's work. By the time of the Venice Biennale of 1980, it was clear that the curatorial community was wholeheartedly committed to the new painting, which was nevertheless treated with skepticism by those for whom a return to "narrative" and "expression" could only mean a retreat from serious critical engagement with the politics of the image.

The critical divide is well exemplified by the reactions to the high-profile group shows organized in London in 1981 and in Berlin in 1982 by the curatorial team of Norman Rosenthal, exhibitions secretary of the Royal Academy in London, and Christos Joachimedes, the Berlin art critic. The London show, portentously called *A New Spirit in Painting*, showcased artists as diverse as Baselitz, Karl Hödicke, Rainer Fetting, Lüpertz, Polke, and Richter from Germany; Calzolari, Mimmo Paladino, and Chia [Fig. 3.6] from Italy; Brice Marden, Julian Schnabel, and Stella from the United States; and Bacon, Alan Charlton, David Hockney, Howard Hodgkin, and Kitaj from Great Britain. Contributions from already established twentieth-century painters like Picasso, de Kooning, and Roberto Matta served to legitimize the work of the younger generation. The London exhibition embraced paintings by Baselitz [Fig. 3.7], furious sexual impastos from Fetting, eclectic performances from Stella, Picasso in his luminous dotage, Lolita-like figuration from Balthus, and monochrome panels from Charlton, Gotthard Graubner, and Robert Ryman. Confidently paraded as

3.6 Sandro Chia
Smoker with Yellow Glove, 1980
Oil on canvas, 59 x 52" (150 x 130 cm)
Bruno Bischofberger, Zurich

Referring to his studio in Italy as like "the stomach of a whale," Chia described his paintings and sculptures as "like the indigested residues of a former past… I am like a lion-tamer amongst his beasts and I feel close to the heroes of my childhood, close to Michelangelo, Titian and Tintoretto."

including "some of the liveliest and best-known painters in the world today," *A New Spirit* promulgated three main ideas: first, that painting in the 1950s had been dominated by New York, resulting in a marginalization of the European contribution; second, that the ambitions of the 1960s counter-culture needed revision (as Joachimedes put it, "the overemphasis on the idea of autonomy in art which brought about Minimalism and its extreme appendix, Conceptual art, was bound to be self-defeating: soon the avant-garde of the 1970s, with its narrow, puritan approach, devoid of all joy in the senses, lost its creative impetus and began to stagnate"); and third, that despite the continuing importance of abstraction, it was necessary to reassert a figurative tradition. "It is surely unthinkable," wrote the London selectors, "that the representation of human experiences, in other words people and their emotions, landscapes and still lives could forever be excluded from painting." Through a resurrection of what they called "the Northern Expressionist tradition," referring mainly to the early twentieth-century German Expressionism of Ernst Kirchner, Karl Schmidt-Rottluff, and Emil Nolde, artists were now poised to ensure that such themes "must in the long run return to the centre of the argument of painting." An underlying ambition of Joachimedes was to "present a position in art which consciously asserts traditional values, such as individual creativity, accountability, quality." He was bold enough to call the *New Spirit* show—a box-office success—an "act of resistance," a defiant act of recuperation that was "in the true sense progressive."

But there was critical trouble in store. Most damagingly, *A New Spirit in Painting* re-established painting at the beginning of the 1980s as an all-male activity (all thirty-eight artists shown were men) structured around qualities of energy, ambition, sensual celebration, and a return to the craft methods of a hallowed tradition; in the wake of the ambitious feminist incursion into art, the argument simply could not be sustained. Second, the show sought to promote an awareness of so-called national tradition. The Germans were held to be angst-ridden and obsessed in the manner of Northern Expressionism, the Americans were paraded as confident and pluralist, the British were classified as Northern Romantics concerned with the figure, and the Italians were

3.7 Georg Baselitz
Elke, 1976
Oil on canvas
8′2½″ x 6′3″ (2.5 x 1.9 m)
Modern Art Museum, Fort Worth, Texas

Trained in the moribund figurative tradition of East Germany, Baselitz practiced a Surrealist figuration in the early 1960s and began to invert his motifs in 1969 in order to be "delivered of all ballast, delivered from tradition." He now saw himself as German in a wider sense, linked to an expressive tradition stemming from the Gothic and passing through Romanticism.

greeted as having survived the sad episode of *arte povera* to return to even earlier national roots. National stereotyping within a framework of tradition: here were male artists of the NATO alliance bound into the cultural project of "returning" to European values via the trope of the largely expressive painting surface. Meanwhile, Reaganomics in the United States and Thatcherist monetarism in Great Britain were combining to kick-start the international art market after a fallow period following the oil crises and national reversals of the mid-1970s. As part of this new political dispensation, the possession of large, energetic-seeming paintings was held up as the most contemporary cultural investment to be had.

Immediately following the London show, the new European painting became successful with influential dealers across the Atlantic. In the summer and autumn of 1981 the Germans followed the Italians to New York: applause greeted one-man shows by Georg Baselitz, Anselm Kiefer, Markus Lüpertz, Rainer Fetting, and Bernd Zimmer, as well as the scabrous Salomé, who was also involved in performance and music with the band Randy Animals—quickly followed by Jörg Immendorff, A.R. Penck, Franz Hitzler, Troels Wörsel, and others. Influential galleries in Europe, such as Michael Werner in Cologne, the Museum Folkswang in Essen, the Kunsthalle in Hamburg, Gian Enzo Sperone in Rome, and Konrad Fischer in Düsseldorf, showed representatives of the "new spirit" to a substantial tide of both critical endorsement and dismay.

Meanwhile, the 1982 Berlin event entitled *Zeitgeist* (meaning "Spirit of the Times," suggestive of world-historical forces) and with one woman (the American painter Susan Rothenberg) among forty-four German and American men, was put in place in the renamed Martin-Gropius-Bau in Berlin as a counterweight to what Joachimedes called "academically torpid" Minimalist and Conceptual art of the recent past. "Subjectivity, the visionary, myth, suffering and grace have all been rehabilitated," Joachimedes enthused. "A sense of liberating emphasis can be felt," wrote art historian Robert Rosenblum in celebration of the new aesthetic compact between Germany and the USA, "as if a turbulent world of myths, of memory, of molten, ragged shapes and hues had been released from beneath the repressive restraints of the intellect which reigned over the most potent art of the last decade."

The debate that now raged on both sides of the Atlantic about the values and priorities of the new European painting was furious and partisan. To its supporters, it was German painting that provided the strongest way out of what appeared to be the artistic and aesthetic impasse of late-Modernist theory and practice. For one thing, it demonstrated a seeming willingness to engage in artistic "pleasure," while at the same time responding to anxieties of the mid-European mind about its own recent past. Bazon Brock in Germany and Donald Kuspit in America argued for placing the new painting within an avant-garde framework that "compelled us to see the seemingly familiar within our tradition in a totally new way" (Brock), one that showed a complex, forced childishness that in practice was a "political gesture, signalling the helplessness of the individual in the face of social forces beyond his control" (Kuspit). The work of Penck and Jörg Immendorff contained for Kuspit the seeds of a "world-historical art,

a seemingly comprehensive, dominating style, sweeping all before it… beheading and relegating to the dustbin of history the art of the 1960s and 1970s that has up to now seemed royal."

The irony is that, as an American critic, Kuspit knew that his enthusiasm for expressive painting had already been vigorously countered by a series of attacks within the pages of *October*, a theoretical journal published from New York from the spring of 1976 by Rosalind Krauss, Annette Michelson, and Jeremy Gilbert-Rolfe. *October* had staked a claim to interdisciplinarity (painting, sculpture, but also film, photography, and performance) from within a framework that was materialist, intellectually autonomous, and at odds both with the specialist reviews such as *Artforum* and *Film Culture*, with their single focus of interest, and with academic journals such as *Partisan Review* and *Salmagundi* that "sustained a division between critical discourse and significant artistic practice." "Art begins and ends with a recognition of its conventions," announced the first *October* editorial in echo of Russian revolutionary culture before and after 1917. What it called the "pictorial journalism" published elsewhere would be replaced by "critical and theoretical texts" having a direct bearing upon a diverse range of contemporary art. A certain resistance to painting had been implicit in the early *October* writings of Douglas Crimp and Craig Owens on photography. Now, in the spring of 1981, it was the vigorous and articulate criticism of Crimp and Benjamin Buchloh that hit home. "Only a miracle can prevent [painting] from coming to an end," Crimp wrote apropos of the antithesis between the Conceptualist position of Daniel Buren and the contrary claims made by Kuspit and others for the colorful new paintings of Frank Stella. Buchloh for his part elucidated what had been implicit in Buren and Conceptual art generally, namely that "expressive" painting was reactionary in intention and complicit in its support of elite and undemocratic power bases within both art and the wider political process. "If the perceptual conventions of mimetic representation… were re-established, if the credibility of iconic referentiality was reaffirmed, and if the hierarchy of figure-ground relationships on the picture plane was again presented as an 'ontological' condition," Buchloh said of another "return" to painting—that of the early 1920s—"then what other ordering systems outside of aesthetic discourse had to have already been put in place in order to imbue the new visual configurations with historical authenticity?" The implication of Buchloh's question was that the return to figuration of the early 1980s likewise signaled an attack upon robustly avant-garde experiment, which had "great potential for the critical dismantling of the dominant ideology." To a committed left-wing critic of the 1980s, the new German painting was at best apolitical and undialectical; at worst, it underpinned and tacitly endorsed a wider contemporary political and cultural reaction. "In the pathetic force of their repetition-compulsion," Buchloh continued, "the mock avant-garde of contemporary European painters now benefits from the ignorance and arrogance of a racket of cultural *parvenus* who perceive it as their mission to reaffirm the politics of a rigid conservatism through cultural legitimation." *October* was at times implacable. In any event, it maintained a

3.8 Gerhard Richter
Gray (348–3), 1973
Oil on canvas
8′2½″ x 6′6¾″ (2.5 x 2.0 m)

highly selective perception of which painters were worth supporting or even mentioning. The suspicion generated was that painting *per se* could no longer be avant-garde.

Only a few exceptions were permitted to prove the rule. One was Gerhard Richter, who had grown up in Dresden in the former German Democratic Republic and had trained as a painter within an ethos dominated by Socialist Realism before moving to Düsseldorf in 1961, two months before the Berlin Wall divided his country. Richter had been astute enough to see and understand the work of Jackson Pollock and Lucio Fontana at *Documenta 2* in 1959, and after settling in West Germany he worked with Sigmar Polke and Konrad Fischer-Lueg on a manipulation of readymade signs from advertising and urban imagery that they mockingly called "Capitalist Realism." The event was staged in the Berges furniture store in Düsseldorf, and lasted two weeks.

Over the next fifteen years, Richter worked at the edges or limits of representation, between painting and photography, often with a strong implication of wanting to be neither. First came the group of paintings of ordinary snapshot photographs that seemed to bring Richter close to the spirit of Western Pop art—but that Richter himself described very differently. On the contrary, he "wanted to do something that has nothing to do with art, composition, colour, creation, etc." His statements about his art are full of disavowals. "I do not pursue any particular intentions, system or direction," he said of this phase; "I do not have a programme, a style, a course to follow… I like things that are indeterminate and boundless, and I like persistent uncertainty." Then, in 1972 and 1973, Richter painted a series entitled, simply, *Gray*: flat and apparently monochrome surfaces that are not quite identical with each other, and paradoxically so [Fig. 3.8]. "No one [*Gray*] painting is meant to be more beautiful than, or even different from, any other," Richter has said. "Nor is it meant to be like any other… I intended them to look the same, but not be the same, and I intended this to be visible." At the same time this blankness functioned as a clearing device. "In time I noticed differences in quality between the grey surfaces… the pictures started to instruct me… misery became a constructive statement, became relative perfection and beauty, in other words became painting." Then, from about 1978 or 1979, Richter pushed this despairing yet exploratory practice to new limits,

continuing to dispute the culture of "*peinture*" on the grounds of its associations with traditional aesthetics ("*peinture*," Richter said, "stands in the way of all expression that is appropriate to our times") while at the same time producing abstract paintings, by now in color, and more grisaille (gray-only) paintings, this time based on mass-produced imagery such as the snapshot and photo-journalism.

Richter's abstract paintings from these years are produced by the unorthodox method of spreading and dragging relatively simple colors over the surface of the canvas with large spatulas or squeegees so as to blur and imbricate the resulting color patches in unpredictable veils and disclosures. The resulting multiplicity seems to make fun of the very idea of color juxtapositions, while in their random and mechanical mode of production they appear to refute the very idea of painterly composition [Fig. 3.9]. In another group of photo-inspired paintings Richter adopted a similarly perverse authorial position: making it clear that he was knowingly producing the appearance of photographs, but doing so by the wrong means. A notable series from the later 1980s, the fifteen gray paintings entitled *18 Oktober 1977*, originated as responses to journalistic photographs documenting the incarceration and death in the Stammheim prison of Andreas Baader, Gudrun Esslin, and Jan-Carl Raspe, all members of the Baader-Meinhof group of the radical left-wing "Red Army Faction." Richter said that he was not primarily concerned with politics, or with memorializing radical fighters; rather that he was struck by "the public ambitions of these people, their non-private, impersonal, ideological motivation... the tremendous force, the frightening power of one idea to the point of dying for it." While visually replicating photographs right down to their indistinct focus and lack of convincing depth, Richter viewed the resulting paintings, lifesize, as sympathetic meditations on the death, probably by suicide, of the captive terrorists [Fig. 3.10]. They were "victims, not of a specific ideology on the left or right, but of ideological behaviour *per se*."

What is striking in the early critical reception accorded to Richter was its legislative, sometimes dogmatic quality. Buchloh, writing in *October*, saw Richter's strategies as an ironic

3.9 Gerhard Richter
Abstract Painting [576–3], 1985
Oil on canvas
6' x 3'10 ½" (1.8 x 1.2 m)

"Here," says Richter, "I was trying to combine constructive elements in painting with areas which contain destructive elements—a balance between composition and anti-composition." Of a comparable earlier picture he said that "there is something deconstructivist and oddly imbalanced along with something else which is carefully composed."

3.10 Gerhard Richter
Shot Down No. 2, 1988
From the series *18 Oktober 1977*
Oil on canvas
39 x 54 ½" (100 x 140 cm)

attempt to deal with political history in the best avant-gardist manner, that is, by translating significant content into the nuances of painting technique. Yet Richter has insisted that he was not attracted to the Red Army Faction as a political group. "I'm interested in the *raison d'être* of an ideology that sets so much in motion," he said. "Politics just isn't for me, because art has an entirely different function… The reason I don't argue in 'sociological terms' is that I want to produce a picture and not an ideology. It's always its factuality that makes a picture good… call it conservative if you want." Yet Richter recognized that his painting practice was radical vis-à-vis the conventions governing both documentation and artifice. Throughout his long and illustrious career his chief interest has been the idea of representation itself in an age dominated by news photography, and how such photography can be brought within the confines of a painting tradition governed increasingly (and perhaps necessarily) by reflection on its own resources. We need to begin again to see content in form, rather than form as something that *contains* content. "Content has not form (like a dress that you can change)," says Richter, "but is itself form (that cannot be changed)."

Real awareness of the crisis that painting had fallen into during the period of the late 1960s was confined to the most intelligent practitioners—those who could put to good use the opportunities now forced upon them to turn painting into a critical art. Also in Europe, the resourceful French painter Gérard Fromanger has shared with Richter a keen appreciation of the issue of photography, but has treated the photographic image very differently from his German counterpart. Fromanger had been active in the Atelier des Beaux-Arts that produced revolutionary posters during the riots in Paris of May 1968; had visited China in 1974 with the filmmaker Joris Ivens, shortly after France's recognition of the People's Republic; and had thoroughly informed himself about the short-lived American Photorealist movement in painting during the early and mid-1970s (in particular the work of Richard Estes and Robert Cottingham). Importantly, Fromanger won the admiration of contemporary French intellectuals of the order of Jacques Prévert, Michel Foucault, Gilles Deleuze, and Félix Guattari, all of whom would write insightfully about his work.

Fromanger has generally painted in series, as if serial differences rather than unique utterances contained the salient features of the painter's art. But his painting technique was from the beginning determined by an acute awareness of modern media. As Foucault summarized it in a catalogue essay of 1975: "His method of work is significant. First of all, he doesn't take a photograph that will 'make' a painting, but 'any old' photo. For a long time Fromanger used press photographs, but now he has pictures taken on the street, random photos, taken almost blindly, photos that don't fasten onto anything in particular; that have no centred or privileged subject… pictures taken, like a film, of the anonymous flux of events… And then he shuts himself away for hours, with the transparency projected on a screen: he looks, he

contemplates. What is he looking for? Not so much what might have been happening at the moment the photo was taken, but the event which is taking place and which continues endlessly to take place in the image." Dispensing with drawing and applying painting directly to the screen-canvas, Fromanger used sharp alternations of hot and cold color, grisaille or chromatic areas, fast and slow, patterned and plain—only to inspect the result for the first time when the projector is turned off and the painting is revealed to view. Fromanger's subjects—banal street scenes in Paris, snapshots of the new China, or portraits [Fig. 3.11]—then emerge from the studio twilight as extraordinary accounts of the presentness of contemporary life, lacking any personal intention to "express" or "announce" anything beyond a palpable pleasure in the qualities of the image for itself. Gilles Deleuze asked the question: "What is revolutionary in this painting? Perhaps it is the radical absence of bitterness, of the tragic, of anxiety, of all this drivel you get in the fake great painters who are called witnesses to their age... From what is ugly, hateful and hateable Fromanger knows how to bring out the colds and hots which produce a life for tomorrow." There is no politically or aesthetically revolutionary painting, observes Deleuze, "without delight."

3.11 Gérard Fromanger
Jean-Paul Sartre, 1976
Oil on canvas
51 x 38" (130 x 97 cm)

A comparable preoccupation with the conceptual as well as technical resources of painting can be found in the British group Art and Language, whose members throughout the late 1960s and early 1970s concentrated on theoretical discussions but produced few artworks identifiable as such. They also wrote texts, a practice ironically described by two members of their circle as "a type of post-Frankfurt and post-logical atomism... developed into a culture-critical sloganisation with logical detail." By 1978–79 membership of the group had dwindled to just three: the artists Michael Baldwin and Mel Ramsden, and the art historian Charles Harrison, who began to discuss questions of how meaning came to reside in pictures at all—an inquiry that led to the further question of how a picture (any picture) established its various relationships to what it was a picture *of*. One answer, derived from contemporary philosophical analyses of naming, they couched in terms of cause. "No answer to the question of what a picture is *of* can be seen as adequate... so long as it requires a suppression of

3.12 Art and Language
Portrait of V.I. Lenin with Cap, in the Style of Jackson Pollock, I, 1979
Oil and enamel on board mounted on canvas
70 x 50" (170 x 120 cm)
Private collection, Paris

Using stencils for the gestural moments and an official Communist-party icon for the emergent image of Lenin, such paintings play with the annihilation of both "action painting" and *"partiinost,"* upon ground occupied by neither.

information about, or inquiry into, that picture's genesis," they wrote. It seemed to follow that relations of genesis (including the practical resources, and the painterly and theoretical competencies of the artist and the viewer) would stand against and often collide with the indexicality of an image—its direct resemblance to the world—when that indexicality was open and declared.

The opportunity to test the stresses and results of such conceptual and practical collisions was presented by an invitation to exhibit work in the Netherlands in 1980. For this, Art and Language began a series of paintings (in itself both an accommodation to fashionable concerns and an extension of the group's previous researches into art's foundations) generically entitled *Portrait of V.I. Lenin with Cap, in the Style of Jackson Pollock* [Fig. 3.12], which somehow combined a Socialist Realist icon with the abstract striations of Jackson Pollock's drip paintings of the late 1940s. Described in an auto-history of the group as a "monstrous stylistic *détente* between the two supposedly antagonistic parts of a mutually reinforcing cultural pair," the *V.I. Lenin* series purported to show that "expressionistic" pictures could be produced otherwise than by using expressionist technique. Art and Language used drawings and stencils for their "expression-ism," in whose abstract patterns an image of Lenin can sometimes (but only just) be seen. The scandalous compatibility of American abstraction and Soviet Socialist Realism was intended to break open a central taboo of 1950s formalist Modernism, namely that the two styles stood incompatibly opposed. An ironic or even slightly comic effect was the intended result.

As is now clear, a serious and principled revival of painting had already been under way for several artists in the recession-hit 1970s, not all of it aligned with the debatable assumptions of the European (and specifically Italian) trans-avantgarde. Further, Art and Language's work was seeking to contest the premises of Modernist painting on the ground of painting itself, not outside it—as was Richter's. Both Art and Language and Richter claimed that revised conditions for painting were being set. Charles Harrison wrote of the *V.I. Lenin* series: "Now that the possibility of painting as a form of practice had emerged for Art and Language out of the legacy of

Conceptual art... the history of painting itself was open to recovery and revision... The *culture* of painting, it seemed, could now be critically addressed by painting." Harrison was underscoring his and the group's conviction that, after the "end of painting" in the 1960s, painting had to be "second-orderish," not only a reflection on the condition of painting from the outside, but engaged with the nature of painting and its historical and critical condition from within. In the wake of Minimalism and Conceptual art, no artistic decision could be free from what another sympathetic observer, Thomas Crow, has called "the burden of historical and theoretical self-consciousness." Painting in order to continue would have to become, in Harrison's words, "as complex in the receiving and describing as in the making."

Such a version of Modernism-after-Modernism undoubtedly made its strongest appeal to those for whom a restricted number of postwar artists and critics (among them Pollock and Greenberg) were unimpeachably important. For others, especially artists trained away from the clamor of the Anglo-American debate about Modernism, that canon had never existed anyway, at least not in an absolute form. Many women artists cared nothing for a theoretical position that bore the hallmarks of masculine agonizing about the art of other men. Nor was the dry, academic tone of the Modernist debate calculated to appeal to those untrained in philosophical criticism. For such artists and their supporters, the nuances of recuperating a better or more advanced Modernism were an irrelevance, at best.

What then had happened to the ancient connection between painting and the political image? The critique of painting of the later 1960s had made the very notion of figurative art seem outmoded, even nostalgic. Moreover, the cultural and diplomatic stand-off between the Soviet Union and the United States had contributed to making a serious engagement with figurative realism in the West look unlikely. Further, the counter-culture had argued that most paintings were physically redundant objects; a related suspicion was that all figurative styles had already taken place, hence that a revived figuration could at best offer experiences of deep inauthenticity. Had not pioneer Modernists such as Picasso and Duchamp explored the ways in which the very languages of representation could be made self-aware? And in spite of those achievements, had not the very act of painting figures become irredeemably associated with male historical institutions and the wielding of political and personal power—even the socialist tradition of "popular" realism in both East and West? And yet a reinvestment of confidence and energy in such painting could be seen in the work of the American Leon Golub, for whom the possibility of a political figurative art was the central question.

Perhaps a committed political realism could only have emerged from an older artist. Born in 1922, Golub had been a student in figuratively inclined WPA (Works Progress Administration) art classes in the mid-1930s and had exhibited internationally throughout the 1940s and 1950s. He had become engaged in artists' protests against the Vietnam War in the later 1960s (in 1968 he lobbied to have Picasso withdraw *Guernica* from the Museum of Modern Art in New York as a protest against the

3.13 Leon Golub
Mercenaries III, 1980
Acrylic on canvas
10' x 15' (3 x 4.5 m)
Eli Broad Family Foundation, Los Angeles

Golub has said that the mercenaries "are inserted into our space and we're inserted into their space. It's like trying to break down the barriers between depicted and actual space… There is a certain *ressentiment*, an aggressive shoving of these images right back at a society which tolerates these practices."

United States' bombing of Vietnam). Golub's paintings of the following decade eschewed abstraction while addressing the theme of political power struggles: his *Assassins*, from 1972, and his *Mercenaries* series, from 1976, may be taken as referring to social and political violence in general as much as to CIA-sponsored terrorism in General Pinochet's Chile or genocide in Pakistan [Fig. 3.13]. Working against Golub, of course, was the uneasy suspicion that after the detailed recording of the war in Vietnam by television and photography, narrative and political painting of military violence had become a hopeless, though brave, endeavor—a suspicion underpinned by the notion that such painting could at best function as illustration rather than as an aesthetic construction working critically upon the audience's understanding of how illustration works. Careful attention to Golub's large wall-pinned canvases, however, reveals a more subtle strategy. He does not, for example, identify his mercenaries as Cuban, South African, Soviet, etc.; rather he specifies a general scene of violence in which very precise psychological manipulations are in play—in Golub's words, "through specifics of intention, implications of violence, threat, or irregular means, the way they inflict themselves upon us." All the visual qualities of Golub's paintings point, moreover, to a highly self-conscious use of the medium, one that removes them irrevocably from the world of illustration. The faces and gestures of his mercenaries owe something both to Greek and Roman art, but more exactly to characteristics of contemporary media photography, and above all to pornography. "The freeze of a photographic gesture, the fix of an action, how an arm twists, how a smile gets momentarily stabilized or exaggerated," says the highly articulate Golub—"to try to get some of this is important." Having then constructed his figures above lifesize and often (as here) footless in order to entrench them in our visual space, Golub roughens the canvas with scraping or paint-stripper to give it tension and immediacy. "I am trying to retain a raw, brute look so that the events do not become oversynthesized: the paintings attain a porous appearance which is crucial to their impact. What remains is the tooth of the canvas… this is how the canvas breathes." The result of Golub's studio methods is not "realism" in the sense of depicting violent power, but in the more subtle sense of showing it, making its sensory accidents visible. And though not overtly about American military operations, Golub has suggested that the posture and presence of his mercenaries in these guises "represents a magnitude which corresponds to American global presence," what he terms "the irregular use of power."

Something Called Postmodernism

Another kind of painting that attempted to find a way beyond orthodox abstract Modernism leant toward the perceived pluralism and heterogeneity of the mass media. Clement Greenberg had emphasized flatness and a practice of austere self-criticism in the construction of Modernist painting, in "the use of the characteristic methods of a discipline itself—not in order to subvert it, but to entrench it more firmly in its area of competence." Modernism too had presupposed a relatively unified author/artist, a guiding subjectivity that was central to the meaning of the work. What gradually became known as "Postmodernism" now embraced eccentricity, stylistic variation, historical pastiche, and the rejection of high cultural seriousness. Two painters who became prominent in the 1980s for their unconstrained use of mixed and media-derived imagery were the German Sigmar Polke and the American Julian Schnabel.

3.14 Sigmar Polke
Measurement of the Stones in the Wolf's Belly and the Subsequent Grinding of the Stones into Cultural Rubbish, 1980–81
Mixed media on fabric (plaster and/or acrylic modeling paste, acrylic, painting used as paste, iridescent mylar on felt and synthetic fur)
6′ x 3′10 ½″ (1.8 x 1.2 m)
Art Gallery of Ontario, Toronto

Polke had already exhibited in Düsseldorf with Richter in 1963 as part of the Capitalist Realism group. Throughout the later 1960s his paintings had inverted existing consumer images in defiance of the tendency among many German artists to perpetuate versions of Surrealist abstraction or *art informel*, all of which Polke dismissed as a Parisian import. Either by instinct, temperament, or conscious design, Polke came to practice instead a critical reworking of the widest possible range of cultural effects, taking material images from the mass media, film, or historical culture, and degenerating them through deliberate mistreatment, irony, mischievousness, or sheer ambiguity. By the 1970s Polke was using types of painterly surfaces that were later used to scandalous effect by Julian Schnabel—black velvet, leopardskin, and the like—surfaces that travestied the fetishized surfaces of Modernist painting whose supposed optical "purity" he either disliked or did not believe in. Polke has always taken a wry approach when talking about his work, yet beneath the apparent cynicism and despair is a belief in layering imagery, in change, and in the flow of time. "You have to look first… you have to watch [the paintings], take them to bed with you, never let them out of your sight. Caress them, kiss and pray, do anything, you can kick them, beat the daylights out of them. Every picture wants some kind of treatment—no matter what." Yet who can say what narratives are supposed to be read into Polke's juxtaposed images of seventeenth-century art, religious signifiers, doodles, and erasures [Fig. 3.14]? Above all, Polke's strategy of "calculated spoiling" played havoc with all those conventions of painting that had been developed to exclude the contamination of the wider culture. Although in his work of the later 1980s Polke seemed to drift into nature mysticism, by early

in the decade he had already done enough to establish himself as an archetype of the resistant, quizzical, and non-conformist artist—perhaps the quintessential, playful Postmodernist.

The contrast is with Julian Schnabel, who by the early 1980s was encumbered with a large international reputation despite a low, or at least mixed, critical standing in the art press. Schnabel had his first one-person show at the Mary Boone Gallery in New York early in 1979. Later in the same year he exhibited some "plate" paintings—paintings incorporating broken crockery—examples of which were included in both *A New Spirit in Painting* and *Zeitgeist*. Schnabel's paintings of the 1980s, most of them very large, were characterized by a rough-and-ready profusion of sources and styles, and like the plate paintings were derived in some measure from Texas "Funk," a style that Schnabel had absorbed in Houston as a student. At first sight, the new works looked reckless and confusing. They contained, apart from smashed crockery, bits of wood and various other props attached to unconventional surfaces such as velvet, linoleum, carpet, or animal skin: in this way the flatness of the base surface was interrupted by a variety of protruding objects, in this instance deer antlers [Fig. 3.15]. "If we believe we are free to act," Schnabel said to one interviewer in 1983, "then we are not restricted to creating structures that always have a similar appearance (commonly called style), or bound by our own past to always work in the style dictated by that which preceded." In his work, quotations from Old Master paintings rested alongside inconclusive or semi-finished passages that seemed not to cohere. Schnabel's images—made to seem collage-like, banal, sometimes infantile—appeared as challenging "aberrations" in an art world that by the early 1980s was ready for a new and marketable style.

On one level, Schnabel's most controversial paintings served as a focus for an already burgeoning artworld debate about authorial intention. Which of Schnabel's many styles was truly his? The very asking of this question seemed to imply that the unified author in art had died, and with it the coherence of the idea of an "authentic" creative manner. Those who assessed Schnabel's significance in these terms claimed him as a representative of the tendency toward eclecticism and vagrant historicizing that could be called Postmodernism. Others placed him within neo-Expressionism, a late revival (but perhaps a timely one) of an earlier Modernist style. Schnabel himself had admired the mosaics of the Spanish architect Antoni Gaudí (1852–1926) in the Park Güell in Barcelona, and had wished to "make a mosaic also, but one that wasn't decorative." "I liked the agitated surface," he remarked in a 1987 interview; "it sort of

3.15 Julian Schnabel
Prehistory: Glory, Honor, Privilege, Poverty, 1981
Oil and antlers on pony skin
10′3″ x 14′10″ (3.2 x 4.5 m)

The title and scale of this work evoke epic, yet conflicting, narratives of claustrophobic density, which a supportive critic described as "writhing, pulsating images [whose] effect is one of suffocation, excess, and decay."

corresponded to my own taste… These paintings really are not about aggressive surfaces, but about an imagistically focused inarticulateness, which shows itself in agitation." Schnabel spoke too of his "anxiousness… the sense that things aren't right." "I want to put something in the world that can communicate this in a concentrated, shorthand way, that finally becomes explosive." Yet other critics accused Schnabel of sacrificing his art to an overweening personal ambition. They charged him with replaying mass-media effects and Postmodernist juxtapositions without reaching for the critical judgments and priorities that those effects and juxtapositions demanded. For a time, Schnabel was an *enfant terrible* in the New York art world whom nobody could quite pin down.

3.16 Thomas Lawson
Burn, Burn, Burn, 1982
Oil on canvas
48 x 48" (120 x 120 cm)

Discussion about the role of painting in a media age was furious and fast. While Douglas Crimp and the *October* writers were urging the "end" of figurative painting, and while critical attacks on Schnabel and his works mounted, other voices were attempting to locate painting's place in a somewhat different relation to mass culture, specifically in tension with an essentially photographic world. The young painter and critic Thomas Lawson argued in his article "Last Exit: Painting," published in *Artforum* in 1981, that "the work of the pseudo-expressionists [he is referring partly to Schnabel] does play on a sense of contrariness, consistently matching elements and attitudes that do not match, but it goes no further… a *retardataire* mimeticism is presented with expressionist immediacy."

Lawson's brief for photography was part of a more general argument: in preference to abandoning painting wholesale for photographic strategies in ways that could be dismissed as yet another avant-garde gambit, artists could square the circle by allowing painting itself—the medium from which an engagement with photographs was least expected—to trade in the photographic and photo-based image. "It is perfect camouflage," wrote Lawson, whose own paintings of the time looked unswervingly at media images that appeared on the front pages of the *New York Post* [Fig. 3.16]. "We know about the appearance of everything, but from a great distance… Even as photography holds reality distant from us it also makes it seem immediate, by enabling us to catch the moment. Right now a truly conscious practice is concerned above all with the implications of that paradox." The stage was set for a re-evaluation of painting squarely within the context of the appropriated photographic motif.

Lawson's critical appetites extended at least as far as the strategy of the New York painter David Salle, first seen in a solo show in 1980 and again at the Mary Boone Gallery (as it happens, with Julian Schnabel) in 1981. Salle's paintings, Lawson observed, consisted of images placed next to or on top of one another in what seemed like unplanned, disinterested combinations [Fig. 3.17]. They looked immediately stylish, Lawson observed, even if they sometimes sailed close to diversity for its own

3.17 David Salle
Lampwick's Dilemma, 1989
Acrylic and oil on canvas
7'8" x 11'3" (2.4 x 3.4 m)

The "dilemma" of Salle's title seems to refer to the classic children's tale by C. Collodi, in which Pinocchio's errant schoolfriend Lampwick suggests a journey to the Land of Fun, where there are no schools or books and the days are spent in play. Once there, however, they discover that those who engage in endless fun turn into donkeys. In this painting may be seen a "play" of images, including an African figurine, a seventeenth-century figure, pornographic images, and a fragment of a painting by Lucian Freud.

sake. "Yet the images Salle presents this way are emotionally and intellectually disturbing. Often his subjects are naked women, presented as objects. Occasionally they are men. At best these presentations of humanity are cursory, off-hand; at worst they are brutal, disfigured... meaning is intimated but tantalisingly withheld... they are dead, inert representations of the impossibility of passion in a culture that has institutionalised self-expression."

That critical distinction was a sign of a general divide within the ranks of those negotiating mass-media references. On the one hand, appropriation was welcomed as potentially parodic and hence subversive of the mythology of Modernist painting, with its obsessively crafted surfaces and its posture of authenticity. On the other, those still suspicious of something called Postmodernism would want to stop short of ironically celebrating the commercial world—the cost of which might be a descent into vapidity and bad taste. For the latter group, painting in the wake of Conceptualism had to be difficult rather than entertaining, oblique rather than condescending, to one side of already known categories: in Charles Harrison's words, it needed to be "as complex in the receiving and describing as in the making." A corollary—one that dented the critical reputations of Salle and Schnabel alike—was that art that became instantly popular with museums or in the marketplace was unlikely to have substantial critical depth. Painting could afford to adopt an ironic mode—to be painting, but also something else—but it should be wary lest that irony evaporate into sarcasm or mere camp.

The distinction proved vitally important. Camp had been the prevailing hallmark of the Chicago school of "bad" painting led by Ed Paschke and Jim Nutt in the 1970s. Now, in New York, in the years between 1982 and 1985, there was a surge of activity that seemed to revel in heterodoxy, bad taste, and almost any kind of accommodation to street art and life. The East Village (the area south of 10th Street between Broadway and Tompkins Square) had been inhabited by artists before. Quite suddenly, a combination of ethnic restaurants, clubs, small galleries, and exotic retail outlets lent support to a generation of younger artists estranged from the career networks of uptown galleries and magazines, to produce a brief explosion of garish and transgressively styled works that had important implications for what it meant to be Postmodern, and sharpened considerably the discussion of what it could mean to be any longer "avant-garde."

So-called East Village art depended for its appeal directly upon what its most eloquent supporter, Walter Robinson, called "the unique blend of poverty, punk rock, drugs, arson, Hell's Angels, winos, prostitutes and dilapidated housing" that was the

social and economic legacy of a forgotten inner-city neighbourhood. Replaying the profusion and disorder of real street life, East Village artists, supported by cheap-to-run galleries with exotic names— Fun, Civilian Warfare, Nature Morte, New Math, Piezo Electric, and Virtual Garrison—now threw caution to the winds in an orgy of attitudinal and technical excess. Copying and pastiche became their hallmark, in ways that were supposed to signal a hedonistic widening of the sources of pleasure and an irreverent taste for such unfashionable historical styles as psychedelia and Op art. Works by George Condo and Peter Schuyff, shown at Pat Hearn's gallery, recaptured Surrealistic motifs out of Salvador Dalí, René Magritte, and Yves Tanguy. Patti Astor's Fun Gallery, from its beginnings in late 1981, held openings celebrated as "minifestivals of the slum arts," with rap music and break-dancing and works by Jean-Michel Basquiat (a one-time collaborator of Andy Warhol), Fab Five Freddy, Kenny Scharf, Les Quinones, Keith Haring [Fig. 3.18], and others. Nature Morte and Civilian Warfare showed photo-based work (Gretchen Bender, Richard Milani) as well as so-called "expressionistic" painting (Huck Snyder, Judy Glantzman). The Gracie Mansion Gallery was a focal point: the ensembles of Rhonda Zwillinger and Rodney Alan Greenblatt were popular (that is, admired by East Village types), self-parodying, cheap, and self-consciously kitsch. Other such locations abounded.

With the luxury of hindsight we can perhaps say that Mike Bidlo's assault on the concepts and conventions of "authorship" produced the most genuinely paradoxical results. At first sight his transcriptions, which look like copies of poor-quality reproductions of Brancusi, Picasso [Fig. 3.19], Morandi, Kandinsky, Léger, Schnabel,

3.18 Keith Haring
Untitled, 1982
Vinyl paint on vinyl tarp
14 x 14′ (4.27 x 4.27 m)

3.19 Mike Bidlo
Picasso's Women, 1988
Exhibition at the Castelli Gallery, New York

For this show Bidlo worked through most of Picasso's paintings of women, from the Blue Period to Mougins. Since Bidlo's paintings are reinvented from very poor reproductions and hence falsify the registration, color, and textures of the originals (even though painted the same size), they are strictly neither copies nor fakes, but a kind of mimicry.

and Warhol's Factory, done to scale, seem to be little more than low-grade Pop art reveling in wackiness and irony for all it is worth—until one realizes that the very project of copying raises relevant questions about the aura of genius, the relationship of copy to original, and the appetites of the viewer, hence about the wider notion of Modernist originality and its relation to taste and cultural consumption. To Bidlo's critics, however, his works were merely copies of very expensive modern paintings, made with an eye to lucrative profits on the market.

For a while in the mid-1980s, East Village art seemed to promise the final defeat of high Modernist seriousness with its traditional masculine emphases and its pathological fear of playfulness or kitsch. Certainly, the establishment of new exchange networks outside the axes linking uptown museums with established dealers seemed to promise an escape route for young artists starting a career. But the heyday of East Village art was brief. Left-inclined critics complained of its dominant tendency to reduce all urban phenomena (graffiti, debased design, marks of squalor or disorientation) to grounds of celebration and/or indifference. To many, the East Village preoccupation with the media (Kenny Scharf is an example) was already a product of an alienated consciousness that had abandoned any attempt critically to examine the world that had produced it. A third argument was that the East Village avant-garde was part of, rather than an antidote to, the general leveling of sexual, regional, and cultural difference that was fast becoming a symptom of later capitalism's decay. East Village art stood accused of replacing some relevant differences with little more than the culture industry's artificial, mass-produced, generic signifier of "Difference" in a motley of empty diversity and puerilism.

The latter position, published by the *October* critic Craig Owens, is important for implying the existence of a more ambitious and more theoretically strenuous concept of avant-garde, to which most East Village artists and comparable artists elsewhere simply failed to measure up. Owens's argument was that the classic European avant-garde of the earlier part of the century had occupied an ambiguous social position between an educated and cultured middle class, from which many of the avant-garde were deserters, and various subcultures on the city's margins that they did not entirely join. For Daumier, Degas, and Manet in nineteenth-century Paris, the latter had been ragpickers, prostitutes, street entertainers. For Picasso and some Cubists, it had been the circus or the working man's café. In contrast, East Village adventurers had adopted something akin to a fashion posture that was not only self-

3.20 Gérard Garouste
Orion le Classique, Orion l'Indien, 1981–82
Oil on canvas
8'5" x 9'10" (2.5 x 3 m)
Musée National d'Art Moderne, Paris

"Banality interests me," says Garouste. "It's a question of playing with what is called classical painting, as if that were the language of painting. And starting with that language I am writing a novel… I see myself as part of the generation which cut short the whole game of Modernism."

advertising and commercially successful ("a miniature replica of the contemporary art market" was Owens's least flattering description), but was precisely incapable of evoking ethnic or sexual difference as a culturally resistant force. It now fell to *genuinely* avant-garde practice not to replicate but to dislodge an institutionalized, commercially driven impostor.

In any event, the debate about parodic painting in the early and mid-1980s was becoming not just a New York but an international phenomenon. In France, where President François Mitterrand (elected in 1981) embarked upon cultural investment on a grand scale, new painting was well represented by the young Gérard Garouste, who practiced a kind of reproduction Mannerism derived from Picasso, de Chirico, and Tintoretto [Fig. 3.20]. Garouste always emphasized that, after Conceptual art, painting was bound to seem strange at first. "After Buren," he said, "originality no longer existed… We have to return to the original system of our Latin culture and see what comprises the system of painting and invest all the archetypes with new meaning." Quickly absorbed into a rapidly growing international mainstream and with a support base in the German galleries, Garouste drew upon classical narrative painting—a Modernist heresy—but did so unstraightforwardly. "When I make the myth of Orion," says Garouste, "it's not the fact of having taken Orion from Greek mythology that matters, but of drawing on him through mythology that comes from the depths of our culture." The distance between the "primitive" and the inauthentic in Garouste becomes almost nil. Or take East Germany, where the Czech-born Milan Kunc produced works whose deliberate banality was meant to stand for the impossible, absurd interface between West European avant-gardism and the prevalent conditions of cultural collapse in the Communist bloc [Fig. 3.21]. Kunc's cartoonery and nihilism— on a par with the Chicago school of the 1970s or the contemporaneous work of the Dutch artist Rob Scholte—are not to be admired, but read as symptoms of an existential state: his Venus, pictured here, relaxes in a meadow littered with old car tires and weeds. In saying that "modern art was over and done with by 1930," that "art since then has been post-Modern," Kunc meant to signal the inevitable degradation of all styles by repetition and over-use as well as art's corruption by political and social realities. Yet in playing the kitsch gambit straight, Kunc suggested that inauthenticity was now the real measure of experience in a market-dominated world.

At a quite different extreme, Ken Currie from Scotland felt himself impelled to return to explicitly narrative painting in a tradition—that of Soviet Socialist Realism— that had long since become distrusted, by many even despised. The most interesting of a group of Glasgow painters who were heavily touted in the early 1980s, Currie painted

3.21 Milan Kunc
Venus, 1981–82
Oil on canvas
5′3″ x 7′11″ (1.6 x 2.6 m)

3.22 Ken Currie
The People's Palace History Paintings.
Panel 6: Fight or Starve… Wandering
Through the Thirties, 1986
Oil on canvas
7′2″ x 12′6″ (2.2 x 3.8 m)
The People's Palace, Glasgow Museums,
Scotland

scenes of working-class heroism and trades-union solidarity decked out with some old-fashioned pictorial devices such as placards, marching proletarians, and grimly resolute portrait heads. Critically, Currie was greeted (or reviled) as a "realist" attempting to extol the virtues of a traditional, but declining, political culture. Close inspection of Currie's manner however suggests that he too may have been engaging in a kind of historical parody. While some may see in his paintings illusionistic realism of the kind advocated by the Hungarian Marxist critic Georg Lukács, Currie's *People's Palace* murals [Fig. 3.22] have been claimed by others for a Brechtian tradition of contradiction and complexity (they show women in a male political environment, ordinary workers in an international political theater). It is true that their harsh, glaring colors, sulfurous atmospheres, and surly male workers repeat only some aspects of 1930s proletarian realism. Currie has said merely that he wanted his paintings to "speak a democratic language," to make art "about working people for working people," one that is "demystified, popularised and socialised, giving artists the chance to fulfil a useful social function"—language that quickly alienated Currie from those who wanted socialist art to be skeptical and reflective, not instructive and missionary. The argument, which remains an important one for leftist political affiliations in art, turns upon the extent to which the apparent directness of Currie's painting exhausts its ostensible content. Was this a critique of abstract Modernism from within the figurative and popular traditions, a stubborn repetition of an earlier "realist" style, or a finely calibrated (and perhaps ironic) updating of a lost historical manner? Only careful attention to the paintings themselves will enable the critical viewer to tell.

Painting and the Feminine

The more durable reaction to male Modernist art came from the practice of feminist women. Ree Morton came to art late, but established a legendary presence in the mid-1970s before her untimely death in a car crash in 1977. Like other contemporaries, Morton's reaction was to disrupt and parody canonical abstract work painted by men and promoted by male critics. Her early series entitled *Silly Stellas* was designed as three-dimensional paintings that were also floor sculptures: for Morton chose to drive her work in the direction of touchable, physical constructions that went in the opposite direction to prevailing aesthetic taste, racing as she did so through a whole catalogue of sculptural styles and materials—including sticks, branches, bricks, earth, and fabric, assembled in the Eva Hesse manner against a wall or across a floor. It was not until 1974

that Morton discovered a material that was to change her work irreversibly: Celastic, a molding material that is malleable when applied to wet cloth, but dries hard. Armed with this discovery, Morton spent the last three years of her life as an influential art-school teacher, making what we would now call "installations" tabulating the ebb and flow of American cliché. *Signs of Love* (1976) was made after a happy year teaching at the University of California, San Diego, and is a rococo feast of Celastic ladders, ribbons, smaller painted panels,

3.23 Ree Morton
Signs of Love, 1976
Wood, Celastic, and synthetic polymer
Dimensions variable
Whitney Museum of American Art, New York

and hanging swags of plastic, all assembled with unabashed sentimentality and vibrant color [Fig. 3.23]. On the wall surfaces appear words such as "Atmospheres," "Gestures," "Poses," "Moments," somewhat mawkishly (to this viewer) celebrating the overblown, the nostalgic, and the theatrical. Temples, bowers, fantasies are all invoked at a time of deep anxiety within the American women's movement about the politics of both art and life. Morton's exuberance and her interest in decorative artifice in a high-colored, mass-culture idiom would be important for a generation of Californians to follow.

All the same, one's sense at the time was of a certain redundancy in painting that wanted to be exuberant and colorful merely for the sake of change. This judgment (or one very like it) could be applied to a type of women's painting that surfaced internationally toward the end of the 1970s, one known as "Pattern Painting." Celebrated in shows such as the twenty-artist *Pattern Painting* at New York's P.S.1 Gallery in November–December 1977, the style could be said to have answered to a particular appetite for sensuousness at the end of a confining decade. Its appeal was to types of ethnic decorativeness (Celtic, Native American, Islamic), celebrated in ways that did much to restore the relevance of women's traditional preoccupations to the arena of art. Deploying colorful, repeated detail across generally large formats, Pattern Painting unashamedly celebrated craft, decoration, and sensuality in and for itself. Critics who supported it made much of the way it refused the supposedly barren exercises of the Conceptualist turn. "We need an art that will acknowledge Third World and/or those forms traditionally thought of as women's work," wrote the *Artforum* critic John Perrault, "an art that will enliven a sterile environment… Naked surfaces are being filled in." "The grids of Minimal-type painting are being transformed into nets or lattices that are sensuous and have content that goes beyond self-reference."

Similarly Melissa Meyer, an original member of the *Heresies* collective, collaborated with Miriam Schapiro around 1976–77 to uncover why it was that so many women valued collecting, recycling, saving, transforming, and commemorating— practices that had expressed themselves in the wider culture in the making of quilts, embroidery, weaving, scrapbooks, and diaries, all commonplace examples of the kind of "collage" that had already appeared in Modernism in the work of artists like Hannah

3.24 Cynthia Carlson
Wallpaper installation, 1976
Acrylic paint pieces on latex paint,
1500 sq. ft. (139 sq. m.)
Hundred Acres Gallery, New York

3.25 Joyce Kozloff
Tut's Wallpaper, 1979
Three silkscreens on silk, each 8′11″ x 3′7″
(2.7 x 1.1 m), two ceramic pilasters, each 7′7″
x 8″ (2.3 m x 20 cm), grout, and plywood
Metropolitan Museum of Art, New York

"We need an art that offers direct meaning
without sacrificing visual sophistication, an
art that will express something other than
withdrawal, scientism or solipsism," wrote
the critic John Perrault. Kozloff has recently
adapted her method to urban design
schemes for walls, walkways, and piazzas.

Höch and Ann Ryan. Wanting to relocate these types of collage beyond the mainstream, Meyer and Schapiro urged a powerful case for a new aesthetic based upon recognition of their feminine values. "Women have always collected things and saved and recycled them because leftovers yielded nourishment in new forms," they wrote. "The decorative functional objects women made often spoke in a secret language, more a covert imagery. When we read these images in needlework, in paintings, in quilts, rugs and scrapbooks, we sometimes find a cry for help, sometimes an allusion to a secret political alignment, sometimes a moving symbol about the relationships between men and women." They called this waste-not-want-not aesthetic "femmage." Installations such as those of Cynthia Carlson, in which entire gallery environments were submitted to the urge to eclecticism and profusion, functioned as a model-kit for architecture that wanted to renovate its form-language, as much as they claimed to be a contribution to art [Fig. 3.24]. The achievement of Pattern Painting, nevertheless, was to demonstrate the willingness of women painters to work outside the protocols of Modernist critical formulae, and yet within formats ambitious enough to win approval in an art world hungry (as ever) for change. Plundering the canonical art-historical literature for evidence, Joyce Kozloff and Valerie Jaudon wrote a powerful analysis of how decoration had been consistently devalued in Modernism, from Loos to Malevich, from Reinhardt to Greenberg; and how the same bias toward efficiency and functionalism had sidelined African, Oriental, Persian, and Slovakian art, as well as the values of pleasure, chaos, decadence, eroticism, artifice, and ornament. Published in *Heresies* in 1977–78, their provocatively titled "Art Hysterical Notions of Progress and Culture" stands today as a prescient statement of directions that advanced Western art would subsequently and willingly follow. Kozloff's own installations took those principles and made of them a powerful counterstatement to the ubiquitous languages of the "Western white male" [Fig. 3.25].

Given the association of flat easel painting with tradition, with maleness, and with a Modernist history of art, it is perhaps unsurprising that women artists should have sought a way of ending their exclusion from this history by deriving norms of practice from the idea of "the feminine" as such. From the days of the counter-culture onward, this search started from the premise that "the feminine" exists. Yet it went on to propose (for example in the writings of Shirley Kaneda) that feminine abstraction had little or nothing to do with vaginal imagery (Hannah Wilke, Judy Chicago) or with craft

elaborations (Faith Ringgold, Joyce Kozloff). Feminine painting, in this argument, would seek to articulate neglected and even denigrated qualities, but to do so without guilt. It would embrace the tentative and the unstable (feminine), rather than the totalized and balanced (male). It would welcome rather than suffer from traits such as intuitiveness and passivity. It would tie the work's facture to the body (feminine), rather than to the mind alone (male). It would insist upon criteria of judgment that accompany paintings one by one rather than in general. It would tend to the additive rather than the subtractive. It would embrace the sublime through sensuousness (feminine), rather than through reduction, geometry, or negation (all male). It would seldom foreclose or complete. It would indulge in the eccentric or unprincipled (on principle). Finally, it would insist that the production of feminine painting derive not from the gender of the painter, but from the values prevailing in the work itself.

By a similar logic, Philip Taaffe's more recent paintings can be claimed for femininity because they defy the reductive good taste of "male" art and celebrate arbitrariness and decorativeness as values that, so to speak, have no stable value in the male aesthetic [Fig. 3.26]. The delicate grids of Agnes Martin could be claimed for the feminine because they open the authoritarian grid of male Modernist architecture, atomize it, and render it receptive to quietness and the poetic. In a similar vein, the

3.26 Philip Taaffe
Nefta, 1990
Mixed media on canvas
60 x 48" (150 x 120 cm)
Private collection

Taaffe has developed an open yet self-conscious attitude to decoration—the bane of Modernist formalism. He describes his posture as "pluralistic, completely non-authoritarian, and which doesn't overtly exalt the heroic or the masculine." Taaffe has also said that "painters are really the best philosophers of mass culture… it's more of a critical role than an entertainment posture."

3.27 Valerie Jaudon
Ballets Russes, 1993
Oil on canvas
7'6" x 9' (2.3 x 2.7 m)

Jaudon, who practiced Pattern Painting in the later 1970s, went on to explore in her work a series of hieroglyphs that point toward rhythm-within-diversity. She sees this as a social construction and, at the same time, a feminist strategy. "The world is falling apart so rapidly and it is a male-constructed world… it's their bridges that are falling."

3.28 Joyce Pensato
Untitled, 1990
Oil on linen
7′6″ x 6′ (2.3 x 1.8 m)
Collection of the artist

works of Valerie Jaudon superficially resemble Sol LeWitt's structures, but are made in a spirit that seeks out, rather than avoids, subjectivity and taste [Fig. 3.27]. (Interestingly, recent assessments of LeWitt's work have divided male critics who find it reductive and theoretical, from female critics who see in it a staged abandonment of control as it seeks variety, disorder, and even color.)

According to the premise that expressiveness has been a male prerogative, the possibilities open to a self-consciously feminine painting might initially appear to be restricted. Admittedly, male expression was often identified with ambition, and with the philosophical penetration of "nature"—qualities only males could attain. Yet the recent claims of so-called *écriture féminine* (female inscription) of artists such as Térèse Oulton and Joyce Pensato have been able to establish channels of viewing, endorsement, and display that value the feminine, not as another artworld gambit, but on its own terms and for its own sake. The strong claims made for their richly delicate painting surfaces have been to the effect that gender difference *in and of itself* produces distinctive types of marks, distinctive awarenesses of the body, and a distinctive pace and rhythm of perception [Fig. 3.28]. Of course, those critical claims have often encountered the difficulty that wider social structures still largely define culture as masculine, even if in small ways the pattern is slowly changing. To that degree it remains moot to what extent the values of feminine painting under this or some description will succeed in *practically* impressing themselves upon a world plagued by the male propensity for war, ecological aggression, and the lavish misuse of resources. The practical as opposed to the aesthetic demands of *écriture féminine* may sometimes seem to reach beyond what art by itself can sustain; and yet a dialogue of gender upon the very grounds of masculine achievement in art would seem to remain a vital and necessary task.

A dilemma for female and male alike is that, even at the start of the twenty-first century, paint on canvas still seems to constitute a source of aesthetic ambition and value. If it is true that painting remains superior in durability, transportability, and what Walter Benjamin called "aura" to the other media, then it will follow that alternatives to painting will have to retain some awareness of, and respect for, the particular aesthetic qualities of its tradition. This is one reason why painting's controversial "return" after Conceptualism was at its most convincing when informed by the demands of the medium itself. Or to put it differently, the best recent work in the medium has involved a repositioning of painting somewhere between its former self and the demands of its theoretical critics.

Contemporary Voices

Gerhard Richter, entry for March 28, 1986, from "Notes 1966–1990" in *Gerhard Richter*, London: Tate Gallery, 1991, p. 118.

"Art… is a particular mode of our daily dealings with appearance, in which we recognise ourselves and everything that surrounds us. Thus, art is the desire in the manufacture of appearances that are comparable with those of reality, because they are more or less similar to them. Thus, art is a possibility of thinking about everything differently, of recognising appearance as fundamentally inadequate… because of that, art has an educative and therapeutic, comforting and enlightening, exploratory and speculative function, thus, it is not just existential pleasure, but utopia."

Valerie Jaudon and Joyce Kozloff, "Art Hysterical Notions of Progress and Culture," *Heresies* I: 4, winter 1977–88, p. 38.

"As feminists and artists exploring the decorative in our own painting, we were curious about the pejorative use of the work 'decorative' in the contemporary art world. In rereading the basic texts of Modern Art, we came to realize that the prejudice against the decorative has a long history and is based on hierarchies: fine art above decorative art, Western art above non-Western art, men's art above women's art. For focusing on these hierarchies we discovered a disturbing belief system based on the moral superiority of the art of Western civilization."

4
Images and Things: The 1980s

Speaking recently about the condition of sculpture at the start of the twenty-first century, one of America's most powerful critics confessed that "it was proving difficult to imagine what it could be… To actually produce it seems to have become next to impossible." He went on to admit that while some reasons for its demise—even its bankruptcy—were obvious, others remained obscure. "Obvious is that the incessant overproduction of objects of consumption and their perpetually enforced and accelerated obsolescence generate a vernacular violence in the spaces of everyday life which regulates every spatio-temporal order and devalorizes all object relationships." The writer, Benjamin Buchloh, is bemoaning the loss of vivid and open public spaces in the wake of the ever-increasing tendency in contemporary culture to consume, faster and more anxiously, than the survival of community can really tolerate. Where social forms and networks are dominated by spectacle, he believes, art struggles to keep pace, let alone find a point of critical purchase on its origins.

The implacable quality of this judgment is typical of that author. Yet the argument asks to be understood. A real sense of disenchantment with "formal" values, the art of judgment, of delectation, of plastic and spatial relations, can be traced to the powerful but still controversial work of Marcel Duchamp at the beginning of the twentieth century (Duchamp's immediate context was Cubism, with all that that implies). In 1913 Duchamp had taken an ordinary bicycle wheel and mounted it upside down on a domestic stool. In 1914 he purchased and exhibited a rack for drying bottles—the idea of the "readymade" was born. As Duchamp remarked in a later interview, the act of choosing a readymade allowed him "to reduce the idea of aesthetic consideration to the choice of the mind, not to the ability or cleverness of the hand which I objected to in many paintings of my generation." In 1919 he took a cheap photographic reproduction of Leonardo's *Mona Lisa* and added a mustache, a

Opposite
Jeff Wall
Milk (detail), 1984
See fig. 4.11

goatee beard, and a risqué pun, to form a "combination" readymade whose context was now Parisian Dada. All of these objects—like the urinal submitted to a New York exhibition in 1917—Duchamp claimed to be art. In 1942 he moved permanently to the United States alongside other European Dadaists and Surrealists, where he became a celebrated member of the émigré community and an increasingly influential figure among younger artists on both east and west coasts. Robert Lebel's monograph on Duchamp was published in 1959, and in 1963 Duchamp was accorded an important retrospective at the Pasadena Art Museum, California, by the adventurous young curator Walter Hopps. These events formed the springboard for Duchamp's influence upon artists of the 1960s and 1970s worldwide. For them, emphasis was now frequently placed on the Dada-like choosing of existing man-made objects as "art," at the same time elevating the idea-structure of art at the expense of the visual alone. Against that background, Conceptual art of the mid- and later 1960s led to "readymade" practices in at least three areas of art-making between the mid-1970s and about 1990—photography, sculpture, and painting. The camera, of course, already treats as readymade those sections of the world to which it opens its blinking eye. Readymade object-sculpture begins from the premise that an existing object presented in a new fashion can be aesthetically more powerful—given certain assumptions about authorship, originality, and "presence"—than a newly crafted one. And we find that the more adventurous painting of the 1970s and 1980s borrowed images from low culture or the mass media only to relocate them, altered or ironically manipulated, within larger signifying ensembles. All the media of art took existing historical styles, treated them as usable material, and made an issue out of the scandal involved.

Photography as an Art

Black-and-white photography had been widely used in early Conceptual art as documentation of an event taking place beyond the gallery. Much of it had an intentionally amateur quality, and much of it played with its differences from the richly crafted surfaces of the painting tradition. In the later 1970s it took only the subtlest change of attitude to transform photography from a provocative signifier of "not-painting" to a surface of interest and relevance in its own right.

As might be expected, the photograph's unique optical window on reality proved vital to the exercise. In the Netherlands, the work of Stanley Brouwn, Jan Dibbets, and Ger van Elk is representative. In the later 1960s Van Elk had played with dualities: back and front, left and right, presence and absence were woven into works of paradox and surprise. In works like the *Missing Persons* series (1976) he staged photographs that lacked a crucial figure, suggesting the susceptibility of the photographic image to manipulation and falsification—the reverse of what its mechanical contact with reality might suggest [Fig. 4.1]. Van Elk's experiments

4.1 Ger Van Elk
Lunch II
(from the *Missing Persons* series), 1976
Retouched color photograph
31 ½ x 39" (80 x 100 cm)
Tate Gallery, London

can be regarded as prescient—even though the photograph as an objective record had come under pressure from the use of airbrushing techniques in the media. And it was in the 1970s that the US military was researching the digitizing of photography in weapons-related research, particularly reconnaissance and surveillance. In its modest way, then, Van Elk's output can be read as a morbid reflection on developments in public life, while formally it tries to be something else—a reglamorization of the staged color photo as an alternative to the heroic man-made productions of Modernist painting and sculpture.

Van Elk's counterpart in Great Britain, the New Zealand-born Boyd Webb, favored the production of high-gloss color photography having the format of a well-priced painting, in which he staged surreal scenes that appear at once impossible *and* impossibly real. Such works might appear to signal a retreat from the tendency in early Conceptual art to analyze or enumerate—but they can also be seen as a way forward for it too, one that proposed an engagement with obviously fictional or narrative elements. Webb's photo scenes are the result of long preparation with hoists, pulleys, suspended fabrics, light sources, objects disguised— the sheer artifice of the directorial approach which, because of its commercial connotations, had in early Conceptualism been far from politically *de rigueur*. Reality here is in the rig-up, which by most viewers of the finished photograph

4.2 Boyd Webb
Nourish, 1984
Unique color photograph
60 x 48″ (150 x 120 cm)
Southampton City Art Gallery, England

Photo-works such as this effect a contrast between bizarrely improbable events and the "reality" medium of the color photograph, but on the scale of the Modernist oil painting. Increasingly, Webb has touched on issues of human survival. Here, a clothed man "under water" is sucking at the "nipple" of a whale. The whale's "skin" is a mock-up of old rubberized sheeting, while the nipple is an Indian vegetable.

cannot even be inferred [Fig. 4.2]. The colors are garish; the ambience is mawkish, even surreal. In moving that way, both Webb and the Dutch artists were symptomatic of a wider photographic tendency in the later 1970s that became philosophically potent and reflective, ranging from the snapshot to the film still to the magazine cut-out to the found photograph or directorial shot. In the wake of Conceptual art, artists were able to subject photographic categories to a multiplicity of analytical critiques. Photography was reclaiming its status as art.

An important early manifestation of the new investment in photography was the show organized by the *October* critic Douglas Crimp at Artists' Space in New York in 1977 called, simply, *Pictures*. *Pictures* gave the participating artists—Troy Brauntuch, Jack Goldstein, Sherrie Levine, Robert Longo, and Philip Smith—a critical framework that established their distance from idealist versions of Modernism while at the same time placing their work within a set of discourses of the Postmodern. Recent Modernist doctrine, Crimp pointed out, had inveighed against the theatricality of Minimalist (and by implication Conceptual) art on the grounds of its dependence on the unfolding, durable time of the physical spectator, and because of its perverse location between painting and sculpture. Yet theatricality (or staging) and "in-between-ness" were the very qualities that Crimp now came to admire in the work of the *Pictures* group.

Cindy Sherman was not a *Pictures* artist, but was closely allied to those who were. From the late 1970s she presented photographs that, though they looked like stills from classic recent films, were actually staged portraits of herself in various thinly concealed guises [Fig. 4.3]. Notice that the size of Sherman's photographs is exactly that of a film still, while the decor, clothing, and lighting of the scene are beautifully prepared and directed. Meanwhile the title-word, *Untitled*, draws attention to the photographs' very loss of content, to their drained or simulated nature. As a young woman Sherman had experimented with dressing up as different characters, and had been struck by the reactions of her friends. Moving to New York precipitated her move into photography. Yet the critical response was now highly ambiguous. Early feminist readings of Sherman's photos drew enthusiastic attention to ways in which they revealed woman as a cultural construct, a pawn of media inventiveness; even today Sherman is held up as a pioneer investigator into the feminine masque. Yet the artist herself has consistently resisted that interpretation. "A photograph should transcend itself," she has said, "in order to have its own presence. These are pictures of emotions personified, entirely with their own presence—not of me. The issue of the identity of the model is not more interesting than the possible symbolism of any other detail." For Crimp too the question was about the photographic still *per se*. What kind of temporality did this "very special kind of picture" inhabit: the natural continuum of real events, or the constructed context of the fictional film? Crimp argued that its condition is that of the snapshot whose location in the real is subverted by our knowledge of its origins. "The work's sense of narrative," Crimp wrote, "is one of simultaneous presence and absence, a narrative ambience stated but not fulfilled." In a similar vein, Troy Brauntuch, another member of the *Pictures* group, staged historical photo-fragments (Hitler asleep in his Mercedes, photographed from the back, in one example) in such a way as to evoke both desire and its frustration: the desire to know, to complete the meaning of what an image shows, and the frustration that comes with the awareness that photographic fragments from the historical past appear more and more as fetish and display, less and less as historical transparency. "That distance," said Crimp, speaking of the gap between the photographic surface and

4.3 Cindy Sherman
Untitled Film Still, 1978
Black-and-white photograph
10 x 8" (25.4 x 20.3 cm)

4.4 Sherrie Levine
After Walker Evans: 7, 1981
Black-and-white photograph
10 x 8" (25.4 x 20.3 cm)

the historical time-slice that caused it, "is all that these pictures signify." About Sherrie Levine's early works, showing silhouettes of eminent statesmen framing images of a family group, Crimp suggested that they were through and through acts of theft and Postmodernist obfuscation of the question of medium. Both categories of fragment were lifted from other sources: coins on the one hand, magazines on the other, restaged in the form of 35 mm slides, prints, or reproductions of themselves, their true medium remaining all the while unclear.

Levine's work of the early 1980s consisted of re-photographs of works by well-known male photographers such as Edward Weston, Eliot Porter, Aleksandr Rodchenko, and Walker Evans [Fig. 4.4], as well as watercolor copies of El Lissitzky, Joan Miró, Piet Mondrian, and Stuart Davis, and drawings after Kazimir Malevich. "The world is full to suffocating," Levine wrote at this time (she was in fact imitating Roland Barthes's writings on the phemonology of the photograph): "We can only imitate a gesture that is always interior, never original. Succeeding the painter, the plagiarist no longer bears within him passions, humours, feelings, impressions, but rather this immense encyclopaedia from which he draws." In terms of the debate about gender, was this a case of female authorship hiding within a classic male prototype? The complete eradication of the female voice? Or its complete return within the credentials of masculine art? The "after" of Levine's titles induced expectations both of distance (in time) and of absence (in space); yet aren't those expectations confounded, in the act of looking, by the seeming presence of the works themselves? Crimp made the pertinent observation that, due to the importance attached in Postmodernist practice to staging, photo-based artworks, especially simulationist ones, absolutely resist their own photographic reproduction. They demand (and demanded) to be seen.

Yet the requirement of actual visibility was never intended as a return to the "aura" or "presentness" ascribed to some painting surfaces; nor was that visibility to count toward a spiritual witnessing of authorial uniqueness and creative skill. On the contrary, the use of photography by younger artists and/or refugees from painting in the early 1980s was born of a desire precisely to examine (and by examining to bury) the remnants of a predominantly male painting tradition: not only Modernist abstraction, but also the neo-expressionism that was its much-vaunted contemporary replacement.

In other words, the de-masculinization of art suggested by the migration into photography at the start of the 1980s was impelled by the recent circumstances of culture and the visual arts. But it also coincided with, indeed was stimulated by, important developments in the field of photographic theory. Texts like Susan Sontag's *On Photography* (1977) and Roland Barthes's *Camera Lucida* (1981; published in French

as *La Chambre Claire* in 1980), together with periodicals like *Screen* and *October* from the later 1970s, pushed the analysis of the photograph and the representational process generally—including the contribution and so-called creative unity of "the artist"—to new heights of sophistication. Those debates, hand in hand with fruitful re-readings of classical psychoanalytical texts such as Freud's essays on narcissism, fantasy, scopophilia, repetition, and fetishism, now stood in an authoritative relationship to the practice of art in all media, but particularly the photograph. Also very influential at around this juncture were the writings of Michel Foucault, whose *Discipline and Punish: The Birth of the Prison* of 1977 (particularly its celebrated seventh chapter, "Panopticism") propounded a controversial thesis on the relationship between visibility and power. Foucault's argument was that modern institutions, especially of the state, impose surveillance techniques upon their subjects that operate not always by literally observing, but by inducing the belief that observation is under way—hence instilling a passivizing self-consciousness of the subject's own behavior, condition, and place within the established cultural order. It is probably no exaggeration to say that, in those countries where these texts were debated in the early 1980s, art gained a new energy and ambition of a kind that did not separate the conceptualization and the making of art, but made them almost one.

In this regard, too, the writings and work of Victor Burgin have proved seminal. Burgin, who figured prominently in European Conceptual art of the period 1968–73 and had used photography in his parodic visual-verbal "poster" works of the later 1970s, now proposed a radical revaluation of the thus far inconclusive Modernist theory of the photograph—inconclusive because in its wish to exclude mass culture Modernist theory had scarcely attempted to address the nature of the photographic image. "Photography's triumphs and monuments are historical, anecdotal, report-orial," Clement Greenberg had suggested in 1964. "The photograph has to tell a story if it is to work as art, and it is in choosing and accosting his story, or subject, that the artist-photographer makes the decisions crucial to his art." Yet Greenberg's account here had run counter to the wider Modernist doctrine of self-critical reflexiveness in the practice of each medium; and it had strangely bypassed the work of Modernist photo-artists of the order of Alfred Stieglitz, Man Ray, and Rodchenko, each of whom had, in his own manner and local context, attempted to establish photographic practice outside the parameters and institutions of the easel picture. John Szarkowski, Director of Photography at the Museum of Modern Art in New York, had for his part identi-fied "The Thing Itself," "The Detail," "The Frame," "Time," and "The Vantage Point" as aspects of a

4.5 Victor Burgin
The Office at Night, 1985
Mixed media
3 panels, 6 x 8' (1.8 x 2.4 m)

The subservient female office-worker from a 1940 painting by Edward Hopper appears reinscribed in a new network of relations arising from vision itself, including the voyeuristic role of the viewer, the woman's imagined reactions to the gaze, and the inherent fascination exerted by the photo-surface.

formalist understanding of the photographic. For him as for Greenberg, the meanings of the photograph derived largely from the properties of the thing photographed. Burgin for his part went back to the Soviet debate on social photography during the 1920s, while drawing heavily on psychoanalytic theory and semiotics. He complicated Freud's basic analysis of "the look" into active (scopophiliac) and passive (exhibitionist) components, adding to it Jacques Lacan's emphases on the narcissistic mirror-phase (the early moment of identification with the self by a mirror) and on objectification, in which "the look" becomes characteristically gendered (male) and social (a question of power). Burgin's position, published in his influential *Thinking Photography* (1982), was that in so far as a photograph records a moment of looking (that of the photographer) and a moment of being looked at (that of the objects or persons shown), it becomes not only a *representing* surface but a site of multiple relations of empowerment, submission, surveillance, identification, gender, and control. In his *Office at Night* series of the mid-1980s [Fig. 4.5], Burgin mobilized the voyeuristic functions of the photograph at the same time as drawing attention to its very distinctness from other representational systems. He further proposed that other sign-systems, however banal, could function alongside the photograph in such a way as to direct, excuse, and articulate that fetishistic regard.

The use of the photograph to dissect and then restructure the relations of looking—hence of power—was echoed to good effect in the early career of the French artist Sophie Calle. Listless after leaving school and then spending years traveling, Calle turned her sense of dislocation into activities that could be viewed as art. "I felt lost in my own city," she said, "I didn't know anyone, I had no place to go, so I just decided to follow people—anybody—for the pleasure of following them, not because they particularly interested me. I allowed them to determine my route." The semi-fictional narratives that resulted from her having photographed these followings suggest a transfer of identity between the photographer and the photographed: Photography immediately became what she called "a tool of observation" as well as an instrument of identity; it became at once voyeurism, surveillance, even a form of theft. This aspect of her thinking was reflected in a work known as *Hotel* (1983), in which Calle got a job as a hotel chambermaid, but rather than tidy the rooms she took the opportunity to photograph the intimate personal belongings of the guests instead—and in so doing cleverly erased the distinction between public and private, even seeming to rob the guests of the "character" they thought they had created for themselves [Fig. 4.6]. The pure voyeurism of the viewer turns suddenly into the following awkward question: How would I feel if *my* bedside clutter were laid open to view? Calle has subsequently set up situations for the photograph that reanimate this dangerous

4.6 Sophie Calle
The Hotel, Room 47, March 2nd, 1983, 1983
Ektachrome print with text and silver gelatin prints/collage
40 ¼ x 56" (102.2 x 142.2 cm) each panel
Edition of 3

line between private self and public world. In a work of 2000 entitled *The Sleepers* she invited twenty-seven strangers consecutively to sleep next to her in bed, and recorded their impressions afterward in text and image.

Yet not all practices of the photographic "moment" of the early and mid-1980s were as conceptually articulate as Burgin's or as personally provocative as Calle's. While in Europe photographic art tended on the whole to be reflective, allusive, and sensitive to theoretical niceties, in America the immersion of the artist in a fast-moving media environment tended to generate more openly assertive analyses of power.

When Barbara Kruger first came to critical attention in 1981 after a career in graphics and commercial art (she had been an art director at Condé Nast), it was as an artist who addressed large questions—relations between women and the patriarchy, and the alienating blandishments of the consumer world—in ways that required not only voyeuristic identification with aspects of an image, but reflection on a series of verbal messages touching upon gender and power. Kruger openly acknowledges that her background was important: "my 'labor' as a designer became," she said, "with a few adjustments, my 'work' as an artist." Thus in Kruger's *Your Comfort Is My Silence* [Fig. 4.7], the pronouns "your" and "my" mark out gender identifications that the viewer quite self-

4.7 Barbara Kruger
Your Comfort Is My Silence, 1981
Photograph with added text
56 x 40" (140 x 100 cm)
Private collection

consciously has to decode. The main possibilities of course are that the hatted male in the image is speaking to a male or female viewer, or that the viewer (male or female) is speaking back to the image—though there is ample room for slippage and fiction as between the two readings. "The use of the pronoun," Kruger suggested, "really cuts through the grease on a certain level. It's a very economic and forthright invitation to a spectator to enter the discursive and pictorial space of that object." To be sure, the structural simplicity of Kruger's work has made it attractive to publishers and publicity-conscious galleries; yet it recognizes that the viewer needs both politics and a gender in order to confront it at all. The result throughout the 1980s was that Kruger's work became a touchstone for many feminists who looked for direct, no-nonsense politicized art lent legitimacy by an earlier montage tradition, that of the pre-1939 work of the German artists John Heartfield and Hannah Höch.

In the combative Western art world of the early and mid-1980s, however—one that utilized the rampant market mechanism while continuing to indict that market's typical processes and forms—the crucial question was not only *who* was doing critical art, but *how* they were doing it. Were particular appropriations comment-free or essentially interrogative in style? When Hal Foster published his influential collection *The Anti-Aesthetic: Essays in Postmodern Culture* (1983), he drew a distinction that for a while became canonical in discussions of Postmodernist montage or the eclectic mixing and

appropriation of forms: "One may support Postmodernism as populist and attack Modernism as elitist," he proposed, "or, conversely, support Modernism as elitist—as culture proper—and attack Postmodernism as kitsch... In cultural politics today, a basic opposition exists between a Postmodernism which seeks to deconstruct Modernism and resist the status quo and a Postmodernism which repudiates the former to celebrate the latter: a Postmodernism of resistance and a Postmodernism of reaction." Proposing to seek out and delineate what he called a "Postmodernism of resistance [that] arises as a counter-practice not only to the official culture of Modernism but also to the 'false normativity' of reactionary Modernism," Foster and his contributors to *The Anti-Aesthetic* sought to reconnect the aesthetic and the cultural to the wider field of communications, architecture, audiences, and museum culture.

For example, Craig Owens, in his contribution "Feminists and Postmodernism," made a proposal that was already latent in the photographic work of some women artists, and that had itself grown indirectly out of earlier Conceptual art. Bringing together the notion that Postmodernism constituted a crisis of traditional cultural authority with the realization that the traditional viewing subject was generally assumed to be self-possessed, unitary, and masculine, Owens concluded that the feminist critique of patriarchy was precisely the keystone of a Postmodernism of resistance. The assumption that Modernist artistic mastery had usually meant signs of artistic labor—agitated brushwork or sculptural objects in heavy steel, for example—led Owens directly to the further proposition that feminist photographic art was the quintessential Postmodernist form. The early works of Sherman, Kruger, Levine, Martha Rosler, Mary Kelly, and Louise Lawler all suggested a Postmodernist strategy that, in "investigating what representation does to women (for example, the way it invariably positions them as objects of the male gaze)," answered *both* to the demands of gender *and* to the need for a cultural space other than the traditional phallocentric one. "The existence of feminism," Owens wrote, "with its insistence on difference, forces us to reconsider."

And yet if Conceptual art and feminism, or their powerful partnership, had formed a major resource for new radical art of the 1980s, these were not the only discourses being mobilized in the field. A benchmark figure in the wider cultural debate had always been Walter Benjamin, whose 1936 essay "The Work of Art in the Age of Mechanical Reproduction," examining the impact of photo-reproductive methods upon culture, had been widely reprinted and read. Now, however, there was a new and more abstract concern: one arising from the ever renewable image technologies and the ever higher levels of glamor being injected into the commercial and entertainment spaces of the 1980s. In the face of such an onslaught, Western artists might have been forgiven for quitting the scene. But the significance of the new image-rich environment was at this moment being articulated by the influential, if ambivalent, figure of the French sociologist and cultural theorist Jean Baudrillard. Baudrillard's early books, *For a Critique of the Political Economy of the Sign* (1972) and *The Mirror of Production* (1973), had had more impact on academic Marxist theory than

on art. The publication of *Simulations* in 1983, however, placed Baudrillard at the center of the New York art world (he became a contributing editor to *Artforum* the following year). In a section of *Simulations* called "The Precession of Simulacra," he advanced the suggestive but paradoxical thesis of a "hyperreal" that has no "real" beneath it—as if the photographic surface were ubiquitous, inescapable, and backed by nothing. "Abstraction today," wrote Baudrillard in reference to thought and language as much as to art, "is no longer that of the map, the double, the mirror or the concept. Simulation is no longer that of a territory, a referential being or a substance. It is the generation by models of a real without origin or reality: a hyperreal [which is] henceforth sheltered from the imaginary, and from any distinction between the real and the imaginary, leaving room only for the orbital recurrence of models and the simulated generation of difference." The idea of an erosion of priority between the original and the copy—the "precession" of simulacra—Baudrillard explained by analogy. "The territory no longer precedes the map, nor survives it. Henceforth, it is the map that precedes the territory."

Baudrillard's thesis of hyperreality was endlessly discussed. In its weak version, it distantly echoed the German philosopher Immanuel Kant's assertion that objects are unknowable apart from their representations. In its stronger, more interesting, and more contentious form, it said that at a certain stage in civilization objects had entirely collapsed into, had even come to coincide with, their representations. Applied to the contemporary media environment, the thesis was taken to mean that the "real" that supposedly lay behind television and advertising imagery no longer existed. Baudrillard's prose seemed both to diagnose and to promote a bleak acceptance of a kind of ecstatic reduction of experience in the face of a frantically accelerated media and commercial world.

Baudrillard's sense of an imploding reality corresponded to a widespread belief in the art world at the time that saw the mass media as gargantuan and almost out of control. As the New York writer Edit deAk put it in an *Artforum* discussion of 1984: "Reality has long been a shifty bastard, a gigolo, a flash of enchantment, a fairy, a desire, the richest internal lining of the 'nothing' we have been talking about. Let's not pretend we live in terms of it." On another level Baudrillard's writings, and his own not uninteresting practice as a photographer [Fig. 4.8], had the further effect of positioning Europe as the "old" world in which things were still analyzed, pondered, and felt, in distinction to America, especially New York and Los Angeles, which had become centers of specifically cultural "affects" constituting a whole "ecstasy of communication," in which public and private, object and subject, truth and falsehood, had collapsed into what Baudrillard called "a single dimension of information."

4.8 Jean Baudrillard
Venice, California, 1989
Color photograph
Dimensions vary
Edition of 15
Collection of the artist

By aligning the edges and colors of some objects with the overlap and disjunction of others, Baudrillard's photographs throughout the 1980s and early 1990s proposed the visible world as a two-dimensional continuum, constituted as a kind of montage against the pull of its actual three-dimensionality.

What was finally distinctive about simulationist art and its theory—simulation literally copies an antecedent object or image in the same medium—was how closely they were bound together, at least for a time. Simulationist art and photography suited one another because the photograph simulated the real in the act of representing it. The Duchampian readymade suggested how the photograph might function radically as art. Yet for all that, the Baudrillardian version of "simulation" was unable to solve the question of resistant versus reactionary Postmodernism. After all, it took no account of gender, and seemed implacably opposed to any but passive forms of consumption in the later Modernist city. To some, inevitably, Baudrillard's "hyperreality" thesis appeared to be part of the problem, rather than its solution.

At around the same time, a generation of younger photographers came to the question of photography's veracity from a quite different point of view. Replacing the look, position, and aura of traditional large-scale painting with colored surfaces of comparable size and scale, the photo-art of Andreas Gursky in Germany, Clegg and Guttmann and Mike and Doug Starn in the United States, and others, came quickly to reoccupy (but not fundamentally to redefine) the museum and gallery spaces that Conceptual art once aspired radically to reconfigure. For innovative photographic practice since the 1980s—as subsequent chapters of this book will show in greater detail—has been both philosophically important for its re-examination of the medium's potentialities, at the same time as being highly agreeable to the curatorial outlook. It has extended the critique of basic picturing practices that was begun but left undeveloped in earlier Conceptual art.

The Düsseldorf artist Thomas Ruff has cleverly exploited the fascination effect engendered by working at a single, repeated idea: large color photographs of friends or acquaintances (or architecture, or corners of the night sky) which are devoid of formal rhetoric, dramatic lighting, or nuances of arrangement. Reinvesting energy in the lost art of portraiture, but against the grain of glamor photography, advertising, and publicity, Ruff has claimed that "most photos we come across today aren't really authentic any more—they have the authenticity of a manipulated and pre-arranged reality." He says of his own photo-pieces that they "have nothing to do with a person any more... I'm not interested in making a copy of my interpretation of a person." Called simply *Portraits*, they conceal clues to the subjects' status, age, occupation, or character (we know only that they are friends or acquaintances of the artist) while appearing superficially lifelike. The *Portraits* series—and all of Ruff's works are in series—presents the paradox that the increasing stripping-away of portraiture's conventions to reveal the truth of a sitter in practice reveals less and less, not more and more. The corollary, that representing personhood requires formulae and conventions, would have been taken for granted had Ruff's medium been painting. That it appears true for photography as well comes as a surprise in view of the assumed relationship of indexicality between the photograph and the world.

A further instance of Ruff's interest in the defeat or confusion of representation is that he has shown several of his *Portraits* side by side, so that his subjects take on the

look of specimens for classification. In discarding direct representation in favor of a Zen-like repetition of the almost arbitrary, Ruff follows the precedent of his Düsseldorf Kunstakademie teachers Bernd and Hilla Becher. Yet the work of Ruff is to be distinguished from theirs by its more thoroughgoing fetishization and particularization. The Bechers' photographs of old industrial building-types, unlike Ruff's later work, seldom approached the standards of technical perfection found in advertisements for high-priced commodities. But in common with the Bechers and other Conceptualists, Ruff too seeks to demonstrate that the photograph is inexorably a construction and can never achieve the qualities of a neutral sign.

Another of Bernd Becher's Düsseldorf students, Thomas Struth (who began his studies under Gerhard Richter), may also be said to toy with the paradoxes of photographic particularization. Struth's early views of city streets and buildings directed the eye to aspects of the urban scene that to normal, functional perception are invisible: contingent arrangements of parked cars, open and closed windows, architectural perspectives, and conjunctions of street furniture. These urban scenes were seldom populated [Fig. 4.9]: one saw miraculously empty streets whose very ordinariness made the observer almost feel he or she should apologize for being there. Unlike Ruff's photo-portraits, Struth's works seemed to supercharge the photographic surface with the small but (to the urban eye) significant marks of accident and history that only cities can generate and that only the camera can record.

Once cool and minimal, photo-art since the 1980s has become not only visually "hot" and maximal, it has also converted the anti-establishment gestures of 1960s art into a more measured, more visually attractive critique. In the process, the art museum soon became a space, not of contestation, but of speculation about representation and reality. The tendency has been widespread. The work of the French artist Christian Boltanski has been concerned since the early 1970s with the evocative power, not of the thing itself, but the photographic record of the thing as a fallible index of the memory process. Continuously absorbed since his early Conceptualist days by the image of the archive —of personal effects, of ordinary objects enumerated in all their banality—Boltanski has in his best-known work used the installation format to pile up nostalgically charged photo-information arranged in the manner of the forensic laboratory, the detective-agency workroom, or the archive of missing or dead persons. Claiming particular affinity with the projects of Tadeusz Kantor and Anselm Kiefer, Boltanski has said that he bases his work on cultural memory. "I am for an art that is sentimental," Boltanski once admitted. "The task is to create a formal work that is, at the same time,

4.9 Thomas Struth
Düsselstrasse, Düsseldorf, 1979
Black-and-white photograph

recognised by the spectator as a sentimentally charged subject." As with Anselm Kiefer, his subjects have been moments of loss in European history, such as the Holocaust, the artist's own childhood, the exterminations of World War II, but above all the sense of transience conveyed by the photo-archive itself [Fig. 4.10]. Roland Barthes's words of *Camera Lucida* might almost apply. "The life of someone whose existence has somewhat preceded our own encloses in its particularity the very tension of History, its division. History is hysterical: it is constituted only if we consider it, only if we look at it—and in order to look at it, we must be excluded from it… I am the very contrary of History, I am what belies it, destroys it for the sake of my own history." Yet, as Barthes also tried to show, the contemplation of a photograph can seemingly cut across that division and make the historical once again poignant and full of presence.

A not dissimilar preoccupation also exerted its hold on a generation of young photo-artists in Moscow who, working in painful isolation and with inadequate equipment, at the time of the meltdown of the Eastern bloc made plentiful use of found photos, visual jokes, montage techniques, and performances. They deserve wider recognition. Inspired by the work with found snapshots of the Ukrainian Boris Mikhailov, the Russians Vladimir Kupreanov and Alexei Shulgin gathered photographic remnants from the days of the old Communist state (archives, memorabilia, official photos) and crumpled, veiled, parodied, or electronically rotated them in the manner of mischievous children let loose in an overlooked archive. In their case it was the state as origin of the "real" in representation that had to come under stern yet jocular review.

In fact, no technique or tradition of representation has proved immune from revision from within the photographic camp. The most acute of the recent photo-Conceptualists may be the Vancouver-based artists Ian Wallace, Rodney Graham, Ken Lum, and Jeff Wall, the latter of whom came to international attention by creating in meticulous detail events that only happened for the camera, though they have all the look of scenes that the camera just happened to capture, such as incidents in the workplace, accidents on the street, moments of interaction between types from different classes. During the 1980s Wall presented these scenes in the form of large-scale cibachrome transparencies, back-lit in display cases of the kind used in expensive street advertising. They were intended to be a kind of "painting of modern life," an accumulation of compressed yet symptomatic detail from the social mix [Fig. 4.11]. The viewer had to understand that these were not in any sense documentary works. On the contrary, and despite their similarity to film stills, Wall's early photo-works attempted to reprise Baudelaire's project of capturing the fleeting, the contingent, and the ephemeral within the traditions of high art—the joys and fears of capitalism, the ironies and deprivations and casualties of the global economic order. "I'm

4.10 Christian Boltanski

Chases High School: Graduating Class of 1931, 1987
Photographs, metallic boxes, bulbs
Castelgasse, Vienna.

For an installation in Vienna in 1987 of which this is a detail, Boltanski took a photo of Jewish students in the Chases Gymnasium in Vienna in 1931, rephotographed and enlarged details, and mounted them under the glare of a table lamp in the manner of an archive of lost or missing persons. "What I want to do is to make people cry," says Boltanski, against the grain of much contemporary work; "this is difficult to say, but I am for an art that is sentimental."

working within and with a dialectic of capitalism and anti-capitalism," Wall said in one conversation, "both of which have continuous histories within, and as, modernity… The social order itself, when you look at it studiously, never ceases to provide support for a programme of images of subjection and unfreedom, and we need those images, but not exclusively. So I have worked on pictures about resistance, survival, communication and of dialogue, scenes of empathy, and empathetic representations… there is no polar separate distinction between those two streams in what I'm doing." What he was doing above all was to construct photographic scenes as a painter might construct a composition. Thus, in common with the work of Ruff and Struth, the apparently extreme mimeticism of Wall's works has been betrayed, in effect, precisely by that mimeticism: since although the precision of the staging resulted in pictures, they were pictures of a sort that proved dependent on highly complex orderings of the photographic sign in relation to its referents. Wall has said: "it is the overall value of the content of the image, not to mention the sensuous experience of beauty in the image, that validates anything critical in art, anything in art which dissents from the established form of things and their appearances." Going so far as to embody sympathy for a pictorial tradition that predates modern art, Wall's project in the 1980s could be summarized as a resumption of a pictorial tradition through a kind of negation of Conceptual art itself.

4.11 Jeff Wall
Milk, 1984
Cibachrome transparency in lightbox
6'1 ⅔" x 7'6" (1.87 x 2.29 m)

Objects and the Market

The application of terms like "appropriation" and "simulation" to objects, and therefore to sculpture, can be directly compared. To wind back by about a decade: By the mid-1970s it had been recognized that a major shift had occurred in the criteria by which a made three-dimensional entity could be classified as art. Minimalist and Conceptual art had been predicated on the idea of the art object's renegotiation of its privileged sites of display and modes of approval. Despite a minority who still maintained that sculpture should concern itself with direct physical properties of mass, outline, relationship of parts, and volume—that was the Modernist view—it had been argued in Conceptual art that no entity, however apparently random or unpromising, could automatically be disqualified from, or fail actually to be, art: lines worn in the ground, empty boxes, filing cabinets, tables and chairs, even actions and processes of the artist.

But by the end of the 1970s it could be said that the debate was growing repetitive, even sterile. Both Conceptual art and orthodox Modernism were being perceived by younger sculptors as theoretical impasses obstructing the making of new work. A reversion to a level of engagement with mass culture was the obvious way out.

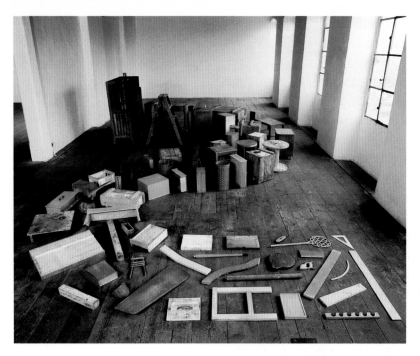

4.12 Tony Cragg
Mesozoic, 1984
Mixed media
Installed at the Ticci Russo Gallery, Turin

"I liked the… unpretentiousness in Minimal art, and the intensity that looking at the work needed," Cragg has said. "But there was too much geometry, too much reliance on the natural material quality, on big natural processes, without new ways of dealing with them. And so the crucial question became one of finding a content… I want to place [materials] and give them meaning."

The crucial change, from materials to real objects, became visible in both Europe and North America in about 1977 or 1978: it occurred first in Europe and surfaced in North America as the working-out of a relationship with the new market in consumer goods.

The vital shift can be described on one level as a reinvesting of the *forms* of Conceptual art with narrative or social meaning. In his student works of the early 1970s, to take a notable case, the British artist Tony Cragg had placed and stacked found materials in formal patterns. After moving in 1977 to Wuppertal in Germany, Cragg made several floor-pieces out of remnants of real-life objects: toy plastic cars, or fragments of plastic picked up on the street, sorted by color and then reorganized as simple images of a socially pertinent kind. Here, Cragg's future as a sculptor could already be discerned. Refusing to equate sculptural creativity with what he called the "heavy-handed dramatics" of work in steel, he focused rather on the experience of plastic itself. Some of the resulting floor- or wall-pieces were openly ideological—notably the wall-pieces in which plastic fragments were used to form massive policemen or riot troops battering demonstrating crowds. Both the content and the manner of this return to iconography can perhaps be related to the British punk revolution of around 1977–79, which utilized unwanted materials in fashion and raw protest sounds in music. "What does it mean to us on a conscious, or perhaps more important, unconscious level, to live amongst these and many other completely new materials?" Cragg asked in a text published for *Documenta 7* in 1982. "We specialise in the production [of plastics], but not in the consumption." Then, by around 1984, he was returning to find more ancient symbols within the forms of modern detritus, organizing obsolescent wooden fragments in the shapes of larger three-dimensional structures depicting ax-head, boat, or horn [Fig. 4.12]. "It is very important," he said, "to have first-order experiences—seeing, touching, smelling, hearing—with objects/images and to let that experience register." Either way, "meanings" were suddenly back as cleverly staged illusion, rather than as exercises in materials alone.

A prescient show of 1981 entitled *Objects and Sculpture*, held simultaneously at the Institute of Contemporary Arts in London and the Arnolfini Gallery in Bristol (featuring Cragg, Bill Woodrow, Edward Allington, Richard Deacon, Antony Gormley, Anish Kapoor, Brian Organ, Peter Randall-Page, and Jean-Luc Vilmouth), had quickly consolidated this novel use of urban materials. It was followed by a display at the British Pavilion at the 1982 Venice Biennale, and a rapid succession of shows in Berne, Lucerne, and elsewhere. Guided in its early stages by the Lisson Gallery in London, the

"new British sculpture" was making a series of aesthetic claims that underpinned its evident curatorial appeal.

A second member of this group, Bill Woodrow, was also a student during the heyday of Conceptual art in the late 1960s and early 1970s, but now produced assemblages of discarded domestic machinery and other objects reassembled according to a montage aesthetic, while still placing his sculptures on the gallery floor in the manner of Modernists (Caro) and anti-Modernists (Morris and Judd) alike. Developing from works such as *Hoover Breakdown* and *Five Objects* of 1979, in which simple domestic objects were taken to pieces, dysfunctionally altered, and disposed on the floor, Woodrow now cut one object out of another in such a way as to supply all parts of the resulting tableaux with references to a lived-in domestic world [Fig. 4.13]. They were made by performing work on remaindered familiar things, themselves suggestive of quotidian wear-and-tear, with a sculptor's analytical skill.

A third member of the Lisson Gallery group, Richard Deacon, also achieved a vivid extension of Modernist syntax in what amounted at times to an almost narrative mode. Deacon's originality as a young sculptor was to use once-outlawed readymade materials such as linoleum, leather, galvanized iron sheeting, and laminated wood (predominantly DIY or high-street products) and to join them by gluing, riveting, or bending in a virtuoso craftsmanly manner. Simultaneously, Deacon enlarged the design of small body parts, such as the eye or the ear, in a manner exactly opposite to

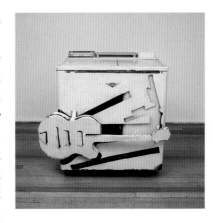

4.13 Bill Woodrow
Twin Tub with Guitar, 1981
Washing machine
30 x 35 x 25" (76 x 89 x 66 cm)
Tate Gallery, London

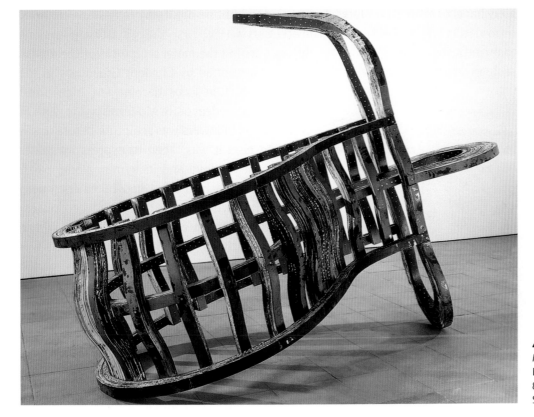

4.14 Richard Deacon
Fish Out of Water, 1987
Laminated hardboard with screws
8' x 11'6" x 6'3" (2.5 x 3.5 x 1.9 m)
Saatchi Collection, London

that of traditional Modernist sculpture, where scale and imagery, always external and public, were generally intended to coincide. Third, like Woodrow and Cragg, Deacon felt no hesitation in enriching his already heterodox materials and techniques with a vein of scatological humor, transgressing Modernist high seriousness with a playful mixing of imagery and forms. Much of Deacon's sculpture "refers" to the human or animal body, yet without courting an unambiguous or non-ironic relation between the sculpture's form and its title. The wayward yet precision-made loops of a work like *Fish Out of Water* [Fig. 4.14], for instance, manage to be narratively and materially complex at the same time as contributing in some more familiar sense to an impeccably sculptural work.

Others members of this generation of artists, such as Jean-Luc Vilmouth, Shirazeh Houshiary, and Richard Wentworth, or the younger Edward Allington, Alison Wilding, and Julian Opie, have, perhaps unfairly, been perceived *en masse* both as the Thatcher period's contribution to European sculpture and as the counterpart of the Scottish painting revival further north.

But what of the new sculpture's critical power? As a generalization, it may be said that Deacon and Cragg were seeking a revised relationship to the image by using existing objects and surfaces—essentially the strategy of Pop. From 1983, for example, Cragg made a series of pieces that exploited the textures and patterns of Formica, plastic, and DIY goods. In these, he joined together tables, bookcases, cupboards, and various material off-cuts, and covered the resulting surreal assemblages with deliberately banal or artificial textures that evoked the culture of kitschy restaurant interiors, retro decor, and deliberately downmarket style [Fig. 4.15]. Cragg's attitude was one that contrasted strikingly with the impetus behind the metal sculptures of the British sculptor Anthony Caro, who after being championed by Clement Greenberg in the 1960s had by the 1980s become the high priest of Modernist endeavor. To Modernists, the work of Caro and his followers was sculpture before it was anything else: it was taken to express its values through the medium and its syntax alone, particularly what Michael Fried had called its "openness and its lowness"—the basis of alleged kinaesthetic "correspondences" to gesture and the human body. The early work of the younger Britons was precisely parodic of such late-Modernist heroics. It pleaded for a wholesale descent from the look and feel of enduring high art to the use of domestic materials and non-legitimate surfaces, and the construction of flimsy, non-permanent structures—a switch from serious to non-serious, from masculine to non-masculine, from Modernist to Postmodernist. One can see in retrospect that

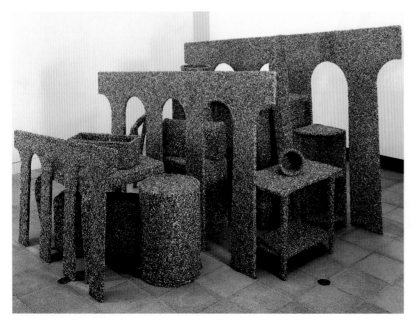

4.15 Tony Cragg
Aqueduct, 1986
Plastic and wood
11′4″ x 11′4″ x 5′5″ (3.5 x 3.5 x 1.7 m)
Installation at the Hayward Gallery, London

"I don't want nostalgia," Cragg has said. "I don't want to make an art that sticks, bogged down, hanging on to a natural world that we've lost our grip on anyway. But equally I don't want to make an art which has a horrible futuristic quality about it." The results resembled a de Chirico painting from his later, derided period—a period that was undergoing critical revaluation at the time.

their attempts to render galvanized iron or commonplace washing machines aesthetically relevant *could* be registered as critical of 1980s economic and social policy that was obsessed with encouraging consumerist attitudes to every object and service. Assigning status to derelict plywood or Formica could be taken as a sort of mischievous play in territory that the new social policy tended to ignore: the forlorn surfaces of public institutions, rubbish heaps, and the neglected spaces of the inner-city street. Cragg said in 1986 that we must learn "to live in a world that has become predominantly artificial and man-made... I would define myself as an extreme materialist... Art has to do with a claiming of new territory out of the non-art world into the art-making world"—

4.16 Haim Steinbach
ultra-lite no. 1, 1987
Mixed-media construction
55 x 78 x 20 ¾" (140 x 198 x 52.7 cm)

In Steinbach's words: "I'm interested in how we perceive objects to be grotesque or fashionable, or, yet, fashionable and grotesque, as in punk; how attraction, revulsion, and compulsion are put into object-forms and rituals. Archeologists dig up the culture of others... I want to capture the picture of the history of the present."

a statement tantamount to claiming, as the Cubists had before him, that all objects, however humble, are suffused with cultural signification.

Yet this interest in neglected objects and surfaces was not confined to Britain alone. On the other side of the Atlantic a group of younger artists was simultaneously working out the terms of deployment of Duchampian concepts in the form of an explicit interest in commercialism, consumerism, and taste.

The Israeli-born New York artist Haim Steinbach, for one, had for some years been purchasing junk-store objects and bringing them into the gallery. His installation at Artists' Space in New York in 1979, entitled *Display No. 7*, had comprised objects arranged on shelves that ran continuously into the gallery from the magazines and brochures displayed at the receptionist's desk. Yet by the mid-1980s Steinbach had evolved a formula for which he became mildly celebrated: the arrangement of newly purchased from-the-store artefacts in duplicate or triplicate on triangular Minimalist shelves [Fig. 4.16].

It is a measure of the speed of change in the New York art world that Steinbach's interests as an artist could be very precisely distinguished from those of the *Pictures* group mentioned in the previous section. The *Pictures* group, especially Sherrie Levine, Troy Brauntuch, and Richard Prince, can be said to have undercut currently standard strategies for reading art images: questions of production and reception had become, for them, the urgent questions to be asked. By contrast Steinbach, to his critics, appeared to be parading a celebratory attitude toward commercially produced objects at a time when the very status and meaning of the commodity was a critically vital issue in the wider culture. Yet in reality and in practice, Steinbach's so-called "shopping sculptures" of the mid-1980s were never about the distinctions between cultivated taste and kitsch, between good objects and bad. Launched upon the same consumer culture from which they derived, from the framework of an international exhibition circuit newly

primed for a critique of object culture, it was the very collapse of those distinctions that formed the primary content of Steinbach's work. At the least, Steinbach was experimenting with the way the viewer/consumer's gaze falls upon the market's useful and useless goods in the time-honored tradition of the still life. "There is a renewed interest in locating one's own desire," said Steinbach in a discussion staged by the magazine *Flash Art* in 1986; "there is a stronger sense of being complicit with the production of desire, what we traditionally call beautiful seductive objects, than being positioned somewhere outside of it. In this sense the idea of criticality in art is… changing."

Steinbach's colleague Ashley Bickerton also opposed the theoretical and political orientation of the *Pictures* group. He described its work (in the language of the media theorist Marshall McLuhan) as a "cool approach to a hot medium." "*Pictures* was after a particular deconstruction or breakdown of the process of the corruption of truth, whereas… we are utilising that process of corruption as a poetic form, a platform or launching-pad for poetic discourse in itself… This work has a somewhat less utopian bent than its predecessor." Hence the surfaces of Bickerton's works feel no guilt about carrying the corporate logos of the companies involved in the various stations of their operational life, from storage and shipping to reproduction and display. "Through the last few decades [the art object] has been ripped off the wall and twisted through every conceivable permutation," Bickerton said at the time, "yet back to the wall it insists on going. So be it, on the wall it shall sit but with aggressive discomfort and complicit defiance." Hence a work like *Le Art* of 1987 [Fig. 4.17] asks to be read as gathering up a series of commercial logos and endorsing the power of corporations in a knowingly politically incorrect way. Referring to the tendency of avant-garde art to end up "above a sofa," Bickerton wrote that his own wall-mounted art "imitates the posture of its own corruption… attempting to forward the question of precisely where conflict exists in this morass of ideal, compromise and duplicity."

To critics of the left, such apparently off-the-peg radicalism brought the condition of the art object perilously close to that of the style accessory. Certainly the realization that shopping sculpture was finding favor with curators and galleries throughout the West came as a blow to those artists who still harbored leftist ambitions amid the conservative cultural politics of the mid-1980s. And it is true that Bickerton's tone all too frequently struck a defeatist note. "We're all riding the monster train and we can't get off," he once said. His and Steinbach's attempts to share rather than deconstruct the consumer's viewpoint can be aligned with the mentality of leverage-broking, asset-merging, and deregulation, of rapid but shallow growth, that typified that dismal time.

4.17 Ashley Bickerton
Le Art, 1987
Silkscreened acrylic, lacquer on plywood with aluminum
34 ½ x 72 x 15" (87 x 180 x 38 cm)

Certainly, the distance of these readymades from the utopian moment of 1967–72 was by now extreme. Or it was worse. Very little writing outside of the *October* journal was proposing a counter-cultural or politically radical posture. There was much talk of the "end of history" (Francis Fukuyama) and the effective collapse of all choices into those of the shopping spree. "Politics is a sort of out-dated notion," said the painter Peter Halley in the same mood; "we are in a post-political situation now."

The critical distinction here is between a theoretically informed left critique of the market, and an attitude of almost theory-free fascination with all its products and forms. Perhaps the most that could be claimed for the new commodity art was that it suggested an acknowledgment of the failure of classical models of socialism, both in Eastern Europe and the West, and a willingness to accept the consumer world as an inevitable and even a pleasurable fact. Indulging in a kind of attitudinal full-immersion in the cornucopia of Western over-production, it reveled in certain kinds of identification and desire, and seemed to announce a moratorium on puritanical abeyances and proscriptions identified more easily with the Marxist left. The gratifications as well as the frustrations of consumption were now to be placed center stage.

Probably no one more willfully invited the disapproval of his specialized or general public in this regard than the New York artist Jeff Koons. Openly embracing a number of attitudes hitherto regarded as virtually taboo, Koons now dramatically extended the operations of the Duchampian readymade to embrace a range of consumer products comprised almost exclusively of kitsch. His earliest works, for example *Inflatable Flower and Bunny* [Fig. 4.18], lent validity to cheap plastic adornments, apparently without embarrassment and certainly without what Brechtian theorists had called estrangement—the corrupting or critical distancing of the image. Mute yet self-announcing, these ephemera were innocently presented during the market years in all their appalling yet fascinating allure.

In the intervening period Koons has sought to "sell" himself as a hustler and salesman type through art-magazine ads, interviews, and published reminiscences about his entrepreneurial past (he was for a time a commodity broker on Wall Street). His posture has quite intentionally been that of a popular entertainer or clown. Commenting on his early work, together with the *Vacuum Cleaner* pieces of 1980–81

4.18 Jeff Koons
Inflatable Flower and Bunny
(Tall Yellow and Pink Bunny), 1978
Plastic, mirrors, and Plexiglas
32 x 25 x 18" (81 x 63 x 45 cm)
Collection Ronny Van De Velde, Belgium

Low-art values have remained important to Koons from the time of these early pieces. "Banality is one of the greatest tools that we have," Koons has said. "It is a great seducer, because one automatically feels above it; and that's how debasement works… I believe banality can bring salvation right now."

4.19 Jeff Koons
One Ball Total Equilibrium Tank, 1985
Glass, steel, sodium-chloride reagent,
distilled water, and basketball
64 ¾ x 30 ¾ x 13 ¼" (160 x 93 x 33.7 cm)
Edition of 2
Collection Dakis Joannou, Greece

4.20 Tony Tasset
Sculpture Bench, 1986–87
Painted wood, leather cushion, Plexiglas
22 x 55 x 19" (55.8 x 139 x 48 cm)

In a variation on the Minimalist aesthetic,
Tasset simulates the bench on which
museum visitors sit. Looking both like and
unlike the bench it almost is, it occupies its
position while both resisting and attracting
the viewer's museal gaze.

and the *Equilibrium Tanks* works of around 1985 [Fig. 4.19], Koons has said that "to me, the issue of being able to capture a general audience and also have the art stay on the highest orders is of great interest. I think anyone can come to my work from the general culture… I don't set up any kind of requirement. Almost like television, I tell a story that is easy for anyone to enter into and on some level enjoy, whether they enjoy just a little glitter of it and get excited by that, or maybe, like with the *Equilibrium Tanks*, they get a kick out of the sensationalism of seeing basketballs just hover… I purposely always try at least to get the mass of people in the door… [but] if they can go further, if they want to deal in an art vocabulary, I hope that that would happen, because by all means I am not trying to exclude high-art vocabulary." He has also interested himself in the personality traits of objects such as basketballs and plastic trivia: "Some of these objects tend to be stronger than we are, and will out-survive us. That's a threatening situation to be confronted with." And Koons has tried to launch his own distinctive iconography: "The basketball refers to its traditional role in lower-class communities of being a vehicle for upward mobility… It took on another meaning when encased in the tanks: it was cellular, womb-like, foetus-like." In speaking of the "sparseness and emptiness" of the work, Koons also claimed a relationship to Minimalist art. Yet despite his efforts at self-promotion (perhaps because of them), his work initially attracted the scorn both of left critics, who either disparaged its complicity with the market as "repulsive" (Rosalind Krauss) or who complained of its uncritical fetishism of the object that "ingratiates rather than disrupts" (Hal Foster), as well as those on the critical right who found Koons's enthusiasm for market values no better than frivolous. As such, Koons succeeded in dividing his artworld public while appealing directly and sensationally to a news-attentive general audience on very much his own terms.

Koons's ability to out-run the gambits of his own critics became evident in 1986 when he took part in two important group shows, *Damaged Goods: Desire and the Economy of the Object* at the New Museum of Contemporary Art in New York and *Endgame: Reference and Simulation in Recent Painting and Sculpture* at the Boston Institute of Contemporary Art, in which he was championed as having posed some unsettling questions. What now seemed to distinguish Koons's work was not the strategy of the Duchampian readymade, nor its interest in kitsch, but rather its evident fascination with the kinds of taste and subject matter identifiable with the low suburban culture that left-inclined culture theorists since Theodor Adorno had tended to ignore, or even revile. Shiny porcelain mantelpiece sculpture, garish evocations of pets, film stars, religious sentimentalia, gawky teenage toys, and the rest—not to mention photo-pieces of carefully staged erotic couplings between Koons and his then wife, the Italian porn star Illone Staller—became rapidly identified with his name. The incorporation of Koons's work on the side of high art, in such shows as MOMA's controversial *High and Low: Modern Art and Popular*

Culture (1990), merely served to compound the dilemmas posed by his graceless yet unavoidably interesting style. Within an art system in which fame was a necessary sign of artistic success, who could deny that Koons's reputation was not a pointer to other anxieties, not least those concerning the relationship of the market to virtually all art?

In general, the critical question was how far objects appropriated from the marketplace could counterpose themselves to the overtly commercial context out of which they came. And the question itself appeared problematic. After all, the notion that the redisplay of consumer objects could provide an effective critique of commodity culture was at best utopian in the market zeal of the 1980s. Aside from the aesthetic arguments, the two sides in such a contest could only be described as grossly unequal in financial and cultural power.

It comes with a sense of relief then to find that the commodity-art genre has proved capable of more abstract formal sophistication. When the Chicago artist Tony Tasset transformed the visitors' stools at the Chicago Museum of Contemporary Art into a wall-relief, as part of a series of works in which elements of museum-viewing— benches, stools, and display cases—were made identical with the art itself, some interesting perplexities arose. In his *Sculpture Bench* of 1986–87 [Fig. 4.20] Tasset devised a paradox: between an object that simultaneously asked to be used but that also required attending to as art. For the bench's Plexiglas cover serves to complicate the sculptural coding of the work by (i) transforming it into a box, Minimalist-art style, by (ii) showing that it is not to be sat upon but looked at, and by (iii) seeming to protect the work in the manner of a museum showcase. How could the artist's collusion in the very museum system he sought to critique be brought to resolution?

A sense of paradox also marks the work of the Swiss artist Sylvie Fleury, who more recently has adopted a very different persona from Bickerton, Steinbach, or Koons—that of the wealthy female shopper who is consumed by, rather than in command of, her desires. For a series of exhibitions of the early 1990s [Fig. 4.21], Fleury literally went shopping for expensive feminine adornments from leading designers in

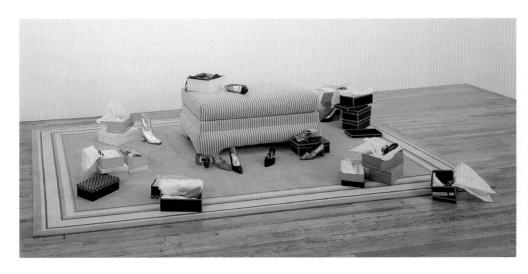

4.21 Sylvie Fleury
Untitled, 1992
Carpet, ottoman, and shoes
2'1" x 11' x 8'9" (0.63 x 3.34 x 2.60 m)

"I think shopping is never complete if you don't buy at least one pair of shoes," says Fleury in the manner of a fashion-conscious consumer. "I use my size," she adds, "in case the sculpture is never sold."

Paris and New York. She frequented elegant hotel lobbies to observe the promenading *haut monde*—what they wore and how they behaved. She then brought her purchases into the gallery and displayed them, in and out of their boxes, in the spirit of a celebration of the shop-to-drop mentality of the rich and alienated. The New York critic Elizabeth Hess summed up Fleury's message nicely: "She suggests that most people don't (or can't) go shopping to buy; they go to fantasize about the shapes of other people's lives. The slippers scattered across the gallery belong to Madonna or Cinderella. If the shoes become metaphors for the invisible body, the imperfect body that we are continually told needs fixing, then the ottoman becomes a psychiatric couch, leading us to consider this massive neurosis. It's a conspiracy against women that is irresistible."

4.22 Jack Goldstein
Untitled, 1983
Acrylic on canvas
96 x 72" (244 x 183 cm)

The author Fulvio Salvatori wrote: "When I discovered the paintings of Jack Goldstein I immediately associated them with the Polyptych of Ghent, the Mystic Lamb of Jan Van Eyck: at first sight two different things. The Mystic Lamb shows the moment just before the outburst of the Apocalypse when time is held back and life is an endless instant."

Painting and Appropriation

Painting was also subject to the pressures and rewards of appropriation, both in Europe and America. The great exemplar of the appropriationist painting attitude was Andy Warhol, whose use of existing commercial and media images in the early 1960s had lit a beacon for others to follow. Artists who learned from Warhol, though from a basis in Conceptual art, included the *Pictures* group member Jack Goldstein, whose acrylic paintings of the early 1980s stepped ingeniously backward to examine a concern of an older tradition, that of the sublime. Goldstein's photographic engagement with the very distant and the very small evoked what one commentator, in reference to the simultaneous intensity and distancing effect of contemporary media, called "a flattening of history, an instantaneous contemporaneity which we experience day by day in the world of electronic information." The source for Goldstein's paintings was generally a photograph: first, of technologically sublime views of airborne fighters or descending parachutists hurtling through space, then of lightning strikes, bomb bursts, or tracer trails [Fig. 4.22]; subsequently, microscopic phenomena that he then painted large-scale in the lurid colors of the newly digitized image.

In an important respect this tendency of Goldstein's is characteristic, for the general aura of pastness in art of the 1980s was often (and paradoxically) attributable to a concern for the recently unfamiliar or else the very new. The kind of abstract painting frequently tagged "Neo-Geo" in the art press of the mid-1980s is another example of the retrospective point of view. Neo-Geo was claimed by its supporters to subject the basic conventions of geometric abstraction—the square, the grid, and the stripe—to

re-readings in which it was thoroughly cleansed of outworn aesthetic concepts such as "inspiration," "nature," and, above all, "metaphysics"—the qualities attached to abstract painting by artists as diverse as Mondrian, Newman, and Agnes Martin. In place of Modernist intensity and spiritual expression, Neo-Geo now offered depersonalized Postmodern allegories embedded in existing languages of form. Thus the work of the New York painter Peter Halley, from the early to mid-1980s, arose out of an attempt to expand Minimalism to a plane of explicitness about social and industrial life.

Impressed above all by Foucault's *Discipline and Punish: The Birth of the Prison*, Halley proposed from the beginning to take geometry quite explicitly as a metaphor for coercion and confinement, rather than for reductive form. In the early 1980s he completed a set of paintings related to the forms of jails or jail-like structures, using a Constructivist or Minimalist idiom. "These are paintings of prisons, cells and walls," he then said; "here, the idealist square becomes the prison. Geometry is revealed as confinement… The paintings are a critique of idealist Modernism. In the 'color field' is placed a jail. The misty space of Rothko is walled up. The cell is a reminder of the apartment house, the hospital bed, the school desk—the isolated end-points of industrial structure…" Mimicking on a large scale the visual spaces found in video games and computer graphics, Halley also deployed bright, commercial colors and a rough, artificial texture: "The stucco texture is reminiscent of motel ceilings. The Day-Glo paint is a signifier of low-budget mysticism."

What was curious about Halley's position is that other examples of his paintings, completed only slightly later (and yet visually the same), have been read as evoking widely divergent aims. Halley himself related how the publication of Baudrillard's *Simulations* in 1983 made possible an extension of Foucauldian theses on power to a very different realm of theory. Halley now saw his paintings as structures that presented in reflective form qualities of urban consciousness in the late-capitalist city. "Conduits supply various resources to the cells," he now said. "Electricity, waste, gas, communication lines and, in some cases, even air, are piped in. The conduits are almost always buried under ground, away from sight. The great networks of transportation give the illusion of tremendous movement and interaction. But the networks of conduits minimise the need to leave the cells. Today… we sign up for bodybuilding at the health club. The prisoner need no longer be confined in the jail. We invest in condominiums. The madman need no longer wander the corridors of the asylum. We cruise the Interstates" [Fig. 4.23]. In this formulation Halley's "enrapture by geometry," his "building of the linear that characterises modernity," is presented as a kind of spatial equivalent of Baudrillard's "hyperrealism." Combining pessimism with elation, a sense of ending with a mood of transcendence, the paintings were now seen as

4.23 Peter Halley
Asynchronous Terminal, 1989
Day-Glo acrylic, acrylic, and Roll-a-Tex on canvas
8'1 ¾" x 6'3" (2.4 x 1.9 m)
Private collection, New York

Of the Abstract Expressionists whose paintings had the scale of his own, Halley said that "they were sure that what they were doing could have meaning on a world philosophical/political stage… the glow in their work, as well as the emptiness of it, relates to social issues."

suggesting ways in which urban consciousness was confining and liberating at the same time. Two decades later, they still serve as potent reminders of how, in the high days of Postmodernism, the ebbing of the idea of a single master narrative (of God, history, or the state) severely eroded the quest for coherence or truth in particular doctrines. What was now termed "theory" became packaged, multivalent, and at worst impressionistic. It could be taken up or put down: mixed, layered, or selectively ignored. Baudrillard's theses on hyperrealism and simulation can be read as theories, but also as symptoms of the media effect; the consequences of urban anxieties turned back upon theory itself. It would be fair to say that, for better or worse, neither Foucault nor Baudrillard is read today with the mesmeric enthusiasm of those years.

The more enduring facet of American painting of that period—and contrary to the claims it made for itself—may turn out to have been its attempt to find a certain relationship to history. As is suggested by the connection of Halley's work to Minimalism and abstraction, much art of the Neo-Geo phase needed a relation to previous painting in order to be read as art at all. Halley himself, writing now in *Arts Magazine* about the work of his friend Ross Bleckner, pointed to a relation with Op Art of the 1960s—less as an act of reverence as in recognition of a short-lived experiment from the period of the artist's youth that history had passed largely by. In Bleckner's work, Halley said, "Op Art is chosen as a telling symbol for the terrible failure of positivism that has occurred in the post-war era, for the transformation of the technological, formalist imperative advanced by the Bauhaus into the ruthless modernity preached and practised by the post-war American corporation, of the transformation of the aesthetic of Mies and Gropius into the Hoola Hoop, the Cadillac

4.24 Ross Bleckner
Architecture of the Sky III, 1988
Oil on canvas
8'10" x 7'8" (2.7 x 2.3 m)
Collection Reinhard Onnasch, Berlin

tailfin, into Tang and Op Art. How did this occur?" But it is also the case that Bleckner doubled his preparedness to learn from bad art (and the bad culture that supported it) with a bizarre investment in the spiritual significance of light—the radiating patterns and shiny surfaces that structure his paintings of the time [Fig. 4.24]. It amounted to saying, as Halley did, that Bleckner was presenting the "disturbing aspect of irony and transcendentalism coexisting in the same body of work."

Sherrie Levine's contribution to Neo-Geo, the stripe, checkerboard, and knot paintings that were first exhibited in New York in late 1985, may be seen as succinctly announcing a move from "appropriation" to "simulation." Following her *Photographs After* series of the early part of the decade, Levine was now making works that could be regarded as copies of Lissitzky, Mondrian, Malevich, and other Modernist masters. "Where as an artist could I situate myself?" Levine wrote. "What I was doing was making explicit how this Oedipal relationship artists have with artists of the past [i.e. wanting to kill them] gets repressed: and how I, as a woman, was only allowed to represent male desire." But a new interest in optical

painting was now emerging. In a work of 1984, Levine reproduced Malevich's epochal *White on White* of 1918 as more like yellow on white: interpretable perhaps as a turn away from idealism and mysticism in the direction of deprecating transcription. Shortly afterward Levine produced plywood panels whose knot-hole plugs were painted gold: not quite transcriptions but references back to older wood-panel paintings embossed with gold from the thirteenth and fourteenth centuries, which in their day had functioned as vital reference-points to shared religious belief—but which now presented little more than a distant echo of that powerful aura. To give the right visual tone Levine used casein instead of oil and framed the panels with glass in the manner of a museum display [Fig. 4.25]. Yet calling the viewer's attention to older art enforced the sense of distance between that time and Levine's own. Like Halley's paintings, the works contain unstable references to art history's past, while draining out the formal and emotional appeal that was normal in the early Renaissance tradition. It is a kind of endgame art. Levine's more recent works in that vein, sculptures that re-present modern masterworks by Brancusi or Duchamp—even Brancusi done after the manner of Duchamp—continue the illusion of repeating Modernist male gestures, but according to a feminizing Postmodernist logic.

4.25 Sherrie Levine
Large Gold Knot: 2, 1987
Metallic paint on plywood
60 x 48" (150 x 120 cm)
Collection Martin Zimmerman, Chicago

Describing these works as "distillations," Levine suggests that, unlike Modernist art, they do not "give you that kind of satisfaction: the closure, balance, harmony. There's that sense of things being all there, all served up, that you get from classic, formalist painting. I wanted the ones I was making to be uneasy. They are about death in a way: the uneasy death of Modernism."

The idea of late-Modernist or Postmodernist painting practice that referred to the great achievements of earlier art took several forms across the international spectrum. In Western Europe, at least, appropriation was seldom addressed to the consumer or media worlds in the New York manner. The Yugoslav artist Braco Dimitrievíc was born in 1948 and raised in Sarajevo in a tolerant multi-ethnic milieu before an education in Zagreb. In 1972 he moved to London at a time of international disobedience in the arts (Fluxus became his milieu), and started to exhibit vast photo-documents of casual passers-by on the streets, made in London, Rome, and other cities. In the same year Dimitrievíc published a book, *Tractatus Post Historicus*, which looked squarely at the situation of art in what he variously called its "post-historical" or "post-formal-evolution" phase. The latter phrases summarize a conviction common among first-generation Conceptualists: that traditions from Duchamp and Malevich came together in Fluxus and Minimalist art, after which culture had somehow had to begin again, at any rate to recover or reinvent itself. Hence Dimitrievíc's "post-historical" triptychs, or *Triptychos*, as they appear in the art museum—and they still do—combine three sorts of object: an old or Modernist masterpiece, an ordinary object such as a piece of furniture, and a vegetable or piece of fruit [Fig. 4.26]. "I did not want to add anything to the accumulation of styles and formal innovation," Dimitrievíc has said, "but to use the museum as a studio." Or as he has insisted, "the Louvre is my studio, the street my museum." The

4.26 Braco Dimitrievič
Triptychos Post Historicus or Repeated Secret, Part I: "The Little Peasant," Amadeo Modigliani, 1919; Part II: Wardrobe Painted by Sarah Moore; Part III: Pumpkin, 1978–85
Mixed media
79 ½ x 36 x 27 ½" (200 x 91.5 x 70 cm)
Tate Gallery, London

challenge to the viewer's attention was immediate: "In the set-up of the *Triptychos* something of the painting's aura reflects on the triviality of objects, pulling them out of anonymity. Instead of looking at them with our usual indifference we start deciphering their meanings or search for layers in their unknown existence—the fate of their producers or one-time owners." In line with structuralist thinking made popular in the 1970s, the *Triptychos* works exemplify a concern for the relativity of judgments of value, a sense that history had come to an end, and that in an age of space exploration man was entering a period of plurality and parallelism. "If one looks down at Earth from the Moon," Dimitrievič has said cryptically, "there is virtually no distance between the Louvre and the Zoo."

If the work of art has no special status—is just one object among others—then (logically at any rate) the aura of painting and sculpture vanishes too. This is the reason why Dimitrievič's deliberate mixing of categories may be placed alongside other post-painting projects of the 1980s from Central and Eastern Europe. By the early part of that decade information was arriving relatively freely in the Soviet Union from America and other points west: neo-Conceptualism, East Village art, and simulationist strategies were being registered and talked about by younger artists, even if their economic and social contexts were not fully understood. In particular it was the East Village example and its aftermath—or the return to montage aesthetics in American Postmodernism more generally—that stimulated the so-called Apt-art concept in Russia.

Apt-art took the form of showing art in private apartments and began in 1982 with a show by the Mukhomory Group and others in the flat of Nikita Alekseev. The participants were not concerned with pure painting: they assembled urban detritus and old posters to produce deliberately kitschy tableaux in parody of the coarse texture of later Soviet life, one of depleted public spaces and cramped, cheerless apartment living. Apt-art became a sort of environmental *bricolage*, dependent upon a "complete saturation of available space" (Sven Gundlakh) or "an avalanche of texts, inscriptions and posters" (Anatoly Zhigalev). Sarcastic and colorful, these crowded installations radically undermined the distinction between art and life, and to thoroughly paradoxical effect. As art was provocatively displaced from the gallery and the museum, a new kind of gallery was created in ordinary domestic space: above the sink, across the ceiling, even in and around the fridge [Fig. 4.27].

Yet Apt-art was neither incantatory nor shamanic, as Collective Actions had been; rather it attended to the social and political. In common with some East Village artists, the Mukhomory Group claimed to have gone beyond mere plagiarism in a spirit of desperate comedy: they claimed mockingly that "the elimination of private property, as Marx argued, signifies a complete emancipation of all human feelings and

characteristics." What lay behind such clowning was the intuition that the extreme and enforced separation between private and public realms in the USSR was leading artists inexorably to a posture of comment-free quotation of existing mass culture, rather than any sort of strategic engagement with it. At the time, such despairing quotation was perhaps enough. Apt-art was denounced by the authorities for being "anti-Soviet" and "pornographic," whence its organizers switched briefly to outdoor events (Apt-art *en plein air*) before the experiment folded completely.

Yet the impulse to Duchampian quotation remained. Yurii Albert, who took part in many Apt-art events, demonstrated one version of Soviet appropriation aesthetics in his 1981 painting *I Am Not Jasper Johns* [Fig. 4.28], which stylistically duplicated a painting by Johns, but with the letters of its title in Cyrillic. The work is in a clear sense duplicitous: In deploying the style of Jasper Johns to say that its author is not Jasper Johns, it takes a detached look at language only to play with the viewer's recognition of the double-bind that the artist has proposed. Having absorbed most varieties of Western Conceptual art and theory, Albert claimed to be making paintings "about possible 'conceptual' art-works in the spirit of early Art and Language." "Imagine," he said, "a member of Art and Language who, instead of doing serious work, tells everyone he is getting ready to do it, but who never brings his proposals to fruition. Instead, he stops halfway, gets out of it with jokes, and in the final analysis doesn't really understand the problems he is trying to solve... As soon as the possibility of serious research arises, I stop." Albert holds both that "our entire activity is nothing but ritual gestures, metaphors, hints, and winking at each other around art," and that "this may be regarded, if you like, as the emancipation of art, liberation from causes and effects, just as man in the secularised world makes an ethical choice, expecting neither salvation nor punishment." Positioning his art within the tradition of Russian

Below left
4.27 The Mukhomory Group
First Apt-art Exhibition, 1982
Apartment of Nikita Alekseev, Moscow

The exhibition comprised seventeen artists from four principal groups: the Mukhomory (Sven Gundlakh, Aleksis Kamensky, Konstantin Zvezdochetov, Sergei and Vladimir Mironenko), the group known as S/Z (Vadim Zakharov and Viktor Skersis), the husband-and-wife team of Anatoly Zhigalev and Natalia Abalakova, and the K/D (Kollektivnye Deistvia) members, including Andrei Monastyrsky. The exhibition was reconstructed by Viktor Tupitsyn at the New Museum of Contemporary Art, New York, in 1986.

4.28 Yurii Albert
I Am Not Jasper Johns, 1981
Oil and collage on canvas
31½ x 31½" (80 x 80 cm)
Private collection, Philadelphia

4.29 Avdei Ter-Oganyan
Some Questions of Contemporary Art Restoration, 1993

Like other performances of the Russian avant-garde, Ter Oganyan's constructions present caustic reflections on the Modernist past, though with an apparent indifference to the vagaries of international artworld attention. In this epitaph to Conceptual art's vicissitudes, an object similar to Marcel Duchamp's urinal of 1917 was smashed and then repaired with glue.

formalism, Albert compares more recent canonical works (such as those by Jasper Johns) to points in three-dimensional space, with traditions, analogies, and "influences" conceived as the multiple connecting lines between them. "These connections are more important than the works themselves," Albert has said. "I immediately try to draw lines, and not to distribute more points. My latest works are only a positioning in artistic space; outside of it they have no value."

Like several other artists across the international spectrum both at the time and since—Bertrand Lavier from France or Andreas Slominski from Germany might be mentioned—the East Europeans demonstrated that not everything that could be called quotation or appropriation necessarily fell into the pit of complicity with those forms of economic organization that enslave us and bind our desires. In the years of so-called "perestroika" (reconstruction) after 1985, and even more after the collapse of the Soviet empire in 1991, the work of younger artists "coincided with the loss of legitimate application of the category Soviet and the possibility of escaping this identity" (the critic Ekaterina Degot). Appropriation and quotation remained strategies of loss, even of mourning. With artists perceiving themselves to have failed to enter an international system of contemporary art, the making of paintings and sculptures in Russia had been replaced by the early 1990s by "actions" that were mostly nihilistic with respect to ambitions of wide visibility, durability, or international fame. I myself remember a series of "actions" by the Georgian artist Avdei Ter-Oganyan that drew heavily on appropriation aesthetics nevertheless: bringing vagrants from Moscow's Kurskaya railway terminus and putting them on gallery display; drinking himself into a stupor (already a daily routine) as an art event; restaging the *0.10 Exhibition* of 1915 in the form of photocopies; or breaking and mis-repairing a disused Duchampian urinal [Fig. 4.29]—a potent reminder of the changing relevance of Duchamp's work over time. In the East as in the West, the replaying and quotation of existing art found a certain temporary freedom from that pressure for originality that an unflinching Modernism had wanted to call its own. Replacing "expression" with sophisticated coding in the hope of engendering self-reflexiveness in the viewer, single or multiple references to other representational codes became for a time the lifeblood of advanced thinking in art. And this was further evidence that shifting to a meta-language has often been a necessary condition of a contemporary avant-garde.

Contemporary Voices

Jeff Koons, "From Full Fathom Five," *Parkett* 19 (1989), p. 45.

"The bourgeoisie right now can feel relieved of their sense of guilt and shame, from their own moral crisis and the things they respond to. The bourgeoisie respond to really dislocated imagery, and this is their rallying call: it's all right to have a sense of openness and emptiness in your life. Don't try to strive for some ideal other than where you are at this moment; embrace this moment and just move forward. I try to leave room for everyone to create their own reality, their own life... My work will use everything that it can to communicate. It will use any trick; it'll do anything — absolutely anything — to communicate and to win the viewer over. Even the most unsophisticated people are not threatened by it; they aren't threatened that this is something they have no understanding of."

Jean Baudrillard, 1976 statement from M. Poster (ed.), *Jean Baudrillard: Selected Writings*, Cambridge: Polity Press, 1988, p. 144.

"The secret of Surrealism was that the most banal reality could become surreal, but only at privileged moments, which still derived from art and the imaginary. Now the whole of everyday political, social, historical, economic reality is incorporated into the simulative dimension of hyperrealism; we already live out the 'aesthetic' hallucination of reality. The old saying, 'reality is stranger than fiction,' which belonged to the Surrealist phase of the aestheticization of life, has been surpassed. There is no longer a fiction that life can confront, even in order to surpass it; reality has passed over into the play of reality, radically disenchanted, the 'cool' cybernetic phase supplanting the 'hot' and phantasmic."

5
In and Beyond the Museum: 1984–1998

Two phenomena are especially revealing of the cultural dynamics of the later 1980s, a time of renewed confidence in free enterprise and market culture throughout Europe and the USA. The first was a massive expansion in the infrastructure of art in the Western nations: the elevation of the curator-showman-impresario figure, the expansion of the business agenda, and, most importantly, the building of dozens of new and architecturally adventurous museums of contemporary art. Even a selective list is a long one. The Museum of Modern Art in New York was expanded in 1984. Great Britain had new spaces at the Whitechapel and the Saatchi Gallery, both in London (and both 1985), and at the Liverpool Tate (1988). New museums opened in Los Angeles—the Temporary Contemporary (1983) and the Museum of Contemporary Art (1986)—in Tokyo (1987), and in Madrid (1990). In France, after the opening of the Pompidou Center in Paris (1977), well-appointed provincial centers opened at Bordeaux (1984, extended 1990), Grenoble (1986), and Nîmes (1993), plus a series of *"grands projets"* including the remodeling of the Louvre and the rebuilding of the Orsay rail terminus as an exhibition space in Paris, with a total of 400 museums either built or renovated in France during the years of François Mitterrand's presidency (1981–95). While private galleries boomed and then bust toward the end of the decade, the public museums were simultaneously to encourage and to meet a growing demand for exhibitions of contemporary art. High-profile curators commanding large exhibition budgets, often bolstered by corporate sponsorship, rose to become professionally elite figures with considerable national fame and commensurate international power. The question was whether the counter-cultural impulse of the post-1960s avant-garde could survive its own rapid institutionalization.

 The second factor was the surviving Conceptualist and Marxist traditions in Europe, both of which, from different directions, continued to uphold an avant-gardist

Opposite
Thomas Hirschhorn
Otto Freundlich-Altar (detail), 1998
See fig. 5.26

outlook that insisted that art continue to contest the expanded institutional network even as it used and was used by it. We have already seen how the question of whether painting could complicate the *reception* of art seemed alive in the work of Gerhard Richter and Sigmar Polke, among others. In sculpture, a key issue was whether the pioneering steps taken by Beuys or Manzoni or Duchamp might somehow be resumed in the face of a newly buoyant market culture. If the danger for adventurous painting had been uncritical versions of neo-expressionism, sculpture's difficulties arose from an unstable boom in the art market that reflected the morality of the trading practices and the consumption lifestyles publicly encouraged during the Reagan and Thatcher years. By the mid-1980s the critical reception of that work had already split into two camps, at least. Dealers and museum people were generally delighted with the reappearance of art-as-goods and of goods-as-art; on the other hand, left-inclined critics saw in most forms of "appropriation" art varying degrees of accommodation to the combined forces of alienation and Mammon. This is consistent with the verdict that the critically most acute work that reflected market culture—Burgin, Tasset, Fleury, Levine—treated that accommodation with sensitivity and caution. And yet the necessarily latent tension between advanced art and the expanded museum infrastructure found its most elaborate articulation in a vein of work that took its very presence in the museum as part and parcel of its significance—the topic to be examined here.

Art Itself as the Subject

An important example of a revived Marxist aesthetics of the later 1980s was the successful excavation and revalidation of the Situationist International, an organization that had been founded in France in 1957 and that had published the journal *Internationale Situationiste* between 1958 and 1969 before being finally dissolved in 1972. The Situationist International had included among its members, at different times and on different footings, Guy Debord, Asger Jorn, Ralph Rumney, and T.J. Clark. Debord's book *The Society of the Spectacle* (1967, first English-language edition 1970) had claimed that "the spectacle is the moment when the commodity has attained the 'total occupation' of social life… it is the self-portrait of power in the epoch of its totalitarian management of the conditions of existence." Situationism went beyond an analysis of the commodity-as-fetish and its artistic counterpart, the Duchampian readymade, to embrace a *refusal* of concepts of art and the museum in any but their most evacuated and scurrilous forms. Derived ultimately from Dada and Surrealism, Situationism was in effect an attempt to destabilize and make strange existing culture by means of ironic graphics and cartoons that sought to rupture totalities and destroy the coherence of accepted social signs. Its two major concepts were *détournement*, the theft and revitalization of pre-existing aesthetic elements, and *dérive*, defined as "a mode of experimental behaviour linked to the

conditions of urban society, a technique of transient passage through varied ambiences," implying an attitude of openness to urban contexts structured by solo or collective passage through the city's attractive or repulsive places. Situationism's affinities and offshoots had included not only Fluxus, but anarchist affiliations such as the Dutch Provos, the American Yippies, Punks, Mail Art groups, and a later Canadian variant termed Neoism. "The SI is a very special kind of movement," Debord had written in an earlier text, "of a nature different from preceding artistic avant-gardes. Within culture the SI can be likened to a research laboratory, for example, or to a party in which we are Situationists but nothing that we do is Situationist. This is not a disavowal for anyone. We are partisans of a certain future of culture, of life. Situationist activity is a definite craft which we are not yet practicing."

The revival of Situationism as a museum phenomenon around 1989 invited the inevitable accusation that the original anti-aesthetics of the movement had by now reached its terminal phase—one of recollection and/or nostalgia. Yet the SI's revival was timely: in large measure it re-evoked the spirit of protest after a twenty-year interval, keeping alive the possibility of a critical reading of cultural institutions such as the exhibition and the museum itself. It is an attitude of sympathy for this critique that has distinguished the work of a number of artists who, while never Situationists themselves, have had some contact with original Situationist activity: among them, Daniel Buren, Marcel Broodthaers, Mario Merz, and Art and Language.

Daniel Buren has committed himself to a strategy of repeating the same 3 ½ in (8.7 cm) wide bands of alternating white and colored paint or paper since the beginning of his career in the avant-garde, back around 1969: his provocation lies in *not* expressing, *not* composing, *not* deciding how the internal order of the work should be arranged. Buren strove to maintain his radical posture in the face of the general de-politicization of art during the 1980s, in the course of which his work was often accused of declining into a signature, into a mere style of radical behavior. Yet his projects, though now often highly decorative, continued to demand of the viewer a subtle form of reflection on art's relationship to its institutional setting. Of a construction made in 1984 for a site in Ghent in Belgium [Fig. 5.1], Buren offered the following negations: "Though all the elements of the piece are in fact elements of traditional painting, it is

5.1 Daniel Buren
Ce lieu d'où (*This Place Whence*), work *in situ* (detail), in "Gewald," Ghent, 1984
Wood, striped linen

"Most art produced today is totally reactionary and reinforces social reaction," Buren said in an interview in 1987. Yet the artist saw his work as having adapted to this change rather than capitulated to it. Still all but unavailable to public or private collectors, it continues to defy easy description or categorization.

5.2 Niele Toroni
Exhibition at the Galerie Buchmann,
Basel, 1990
Foreground: 3 hanging papers in blue, green,
and yellow, 10'2" x 14 ¾" (3.1 m x 37.5 cm);
rear: 2 canvases painted in red acrylic, 9'8" x
6'6" (3 x 2 m), on a wall painted in red acrylic;
all No. 50 brush at 11 ¾" (30 cm) intervals.

not possible to say that what we are talking about here is painting. Further, although all of these elements are built to stand in a site, we still cannot say that what we are talking about here is sculpture. And if all these elements create new visions of and volumes for a space, we still cannot say that this is architecture. And even though the entire apparatus can be approached as a decor that reveals both sides of itself depending on the movements and positions of visitors, so that they become actors in a play without words, this nevertheless does not allow us to say that what we are talking about here is theatre… what the work *does* have to do with is what it does."

The final tautology of Buren's statement will be taken by some readers as symptomatic of the difficulty in preserving radicalism from an almost unstoppable descent into style. Yet compare Niele Toroni, whose elegant and reductive painting-installations have for nearly three decades consisted of even-spaced dashes of paint as a means of "bringing painting to view" [Fig. 5.2]. In a similar way to Buren, since 1967 each one of Toroni's installations has been done by applying patches of paint with a No. 50 brush at 11 ¾-inch (30-cm) intervals according to the dictionary definition of the word *application*: "to put one thing on another so that it covers it, sticks to it or leaves a mark on it." An early statement issued by Toroni (with Buren, Olivier Mosset, and Michel Parmentier) stressed that "because painting is a game, because painting is the application (consciously or otherwise) of the rules of composition, because painting is the representation (or interpretation or appropriation or disputation or presentation) of objects, because painting is a springboard for the imagination, because painting is spiritual illustration… because to paint is to give aesthetic value to flowers, women, eroticism, the daily environment, art, Dadaism, psychoanalysis and the war in Vietnam… *we are not painters.*" Toroni has more recently said that "my job is not to displace, but to paint; to try to do paintings without a state of mind… and to hell with fashions!" As with Buren, such affirmations make use of repetition—it has continued now for some three decades—in order to avoid the embrace of the cultural structures and institutions that the work originally sought to critique. Indeed, the device of repetition is intended to *be* that critique.

Reference might be also made here to the British artist Alan Charlton, whose gray-colored paintings have followed the working-out over more than three decades of the logic of an idea first developed in the late 1960s. Like other painters of his generation with whom he has exhibited—Buren, Robert Ryman, Brice Marden, and Agnes Martin—Charlton determined early in his career to make paintings that were private, personal, "where somebody couldn't tell you what to do… that's when I

decided that I had to make my own rules up. I found I could make a painting which nobody could tell me was right and nobody could tell me was wrong… from the beginning I knew all the things that I didn't want in the painting." Those things have included internal composition, color, and what Charlton calls "intricacies of craftsmanship." He has produced paintings with slots, square holes, channels; in series, teams, or parts; equal, rectangular, and gray, so that the work incorporates and even summarizes, in effect, the processes of its own making. A formula once set down is followed remorselessly [Fig. 5.3]. Taking standard-width timber he builds outward from its sizes and proportions toward the intended context of display. "Many of my conditions or rules were not just unique to

5.3 Alan Charlton
"Corner" Painting, 1986
Acrylic on cotton duck
10 parts, each 7'9" x 26" x 1¾" (2 m x 67.5 m x 4.5 cm) with 1¾" (4.5 cm) spaces between
Musée Saint Pierre Art Contemporain, Lyon

how to make a painting," Charlton has said; "they were in a sense a foundation for how I was going to live my life and the paintings in a way just followed those foundations… [they were] about equality and the equality sometimes happens in the way I think about making the art… from the concept of making the painting, to building the painting, to painting the painting, to packing the painting, to seeing to the transport of the painting, to seeing how the layout of the catalogue is, to seeing to the day-to-day activities of the studio: all those qualities for me are completely equal."

There is a sort of affinity between the austerity of Charlton's project and the series of works made during the 1980s by the German artist Gerhard Merz, which are best described as environments: monochrome color-field paintings with vast, overbearing frames positioned as if they were part of, rather than merely installed in, particular gallery or museum spaces [Fig. 5.4]. Normally requiring whole suites of rooms, Merz's environments relate formally to Constructivist, Suprematist, and Minimalist predecessors while casting a degree of visual doubt—imparted by a

5.4 Gerhard Merz
Where Memory Is (Room 3), 1986
Installation at the Munich Kunstverein

Attracted always to the nostalgic but critical projects of de Chirico and Ezra Pound, Merz's Postmodern incunabula resonate with the forgotten violence of European history. For Merz's Munich project, a suite of oppressively colored rooms stage images of death from the Renaissance to the Holocaust. A silk-screened version of de Conegliano's *St. Sebastian* here functions similarly to a chapel altarpiece.

generally arid format—upon their containing spaces. While Merz's works of the early 1980s took the form of installations interwoven into the texture of existing art-historical museums, later works have taken the architectural format of the Modernist gallery as their point of reference. Thus, for the *Where Memory Is* project at the Munich Kunstverein in 1986, Merz took a silk-screened image of a Renaissance *St. Sebastian*, Otto Freundlich's sculpture *The New Man*, pilloried by the Nazis in their carefully stage-managed *Degenerate Art* exhibition in Munich in 1937, and an image of bones and skulls, and placed them in what then became a series of oppressively empty memorial chambers, perfectly symmetrical and tomb-like. In such a work, the pompous architectural style of authoritarian culture is Merz's immediate concern. His installations insert themselves into those spaces as a disruption and critique of the privileged historical knowledges they purvey, suggesting as they do so that the relation between modern memory (the museum) and authority is to be kept under vigilant review.

A direct attempt to address the culture of the museum itself was made by the Art and Language group between 1985 and 1988 with the series of paintings known as *Index: Incidents in a Museum*, a number of which were first shown together in Brussels in 1987. Art and Language continued to have the strong support of the critic and art historian Charles Harrison, who was by now virtually a spokesperson for the two remaining artists of the group, Michael Baldwin and Mel Ramsden. The three had persistently raised questions about the managerial and curatorial aspects of the "Story of Modern Art," but had not previously pointed to the space of the archetypal Modernist art museum as in any way problematic. In the *Index* paintings, however, the austere undecorated rooms of Marcel Breuer's Whitney Museum of American Art on Madison Avenue, New York, appear quite explicitly as tokens of their Modernist type. The *Index* paintings are characterized by visual and conceptual paradoxes, mostly unresolvable. For while the colors of *Incident VIII* [Fig. 5.5] are (strangely) those of analytical Cubism, the text is a murder mystery derived from an opera libretto, written earlier by the group, about Victorine Meurend, the model Manet used for his *Olympia* of 1863. Much of the force of the painting springs from a distinction between the spectator *in* the painting (whose notional presence is implied by the painting) and the spectator *of* the painting. Incompatibilities of scale, size, support surface, perspective, and mode of address unsettle even the minimally inquisitive viewer. And yet becoming unsettled is not the whole story. Harrison wrote that "it is arguable that… competently to view *Incident VIII* is to be able to become, in imagination, the reader of the text on a museum wall—and not simply the reader

5.5 Art and Language
Index: Incident in a Museum VIII, 1986
Oil and alogram on canvas
5'9" x 8'11" (1.7 x 2.7 m)
Private collection, Belgium

The *Incident* paintings, in Charles Harrison's words, "represent in allegorical form the spectator's activity as structured within the imaginary museum… Shifts of size and scale open the processes of reading to a dialogue of values and competence…
As a reader of the text which *Incident VIII* presents [the murder story], the spectator in the painting is caught up in a drama of conflicting significations."

of the text on the surface of the painting… What is read *in* the painting threatens to disqualify that which the painting is seen *as*, while the conditions of the painting's being viewed as painting tend to remainder the findings of the imaginary reader." He further proposed that "what is required if the spectator is to be critically engaged is that reflection upon the uncertainty involved be at some level a form of reflection upon the culture of the Modern. In so far as the paintings succeed… the conditions of consumption and distribution of modern artistic culture are taken into them and reflected back as formal effects… Unreassuringly, the painting works on the viewer."

All of the projects presented so far in this section could be said to want to dislodge the orthodox certainties of the producer and more especially the viewer of art. They want the viewer's own certainties to be placed under some kind of critical doubt. To consider the work of the theorist, painter, and object-maker Terry Atkinson is to begin to make a wider statement about a dominant European way with materials and its relation to cultural seriousness. At various times close to Art and Language, Atkinson's work has veered more to the mischievously askance, even to the disarmingly evasive, than to the theoretically correct. In a little-noticed show entitled *Mute* that toured Copenhagen, Derry (Northern Ireland), and London in 1988, Atkinson made some works that included the oily substance of their generic title, *Grease*. These Atkinson presented as contributions to an investigation into concepts of disaffirmation and negation that had been proposed as necessary to inventive new practice by the art historian T.J. Clark. "By 'practice of negation' [in the visual arts]," Clark had written a few years before, "I mean some form of decisive innovation, in method or materials or imagery, whereby a previously established set of skills or frame of reference — skills and references which up till then had been taken as essential to art-making of any seriousness — are deliberately avoided or travestied, in such a way as to imply that only *by* such incompetence or obscurity will genuine picturing get done." Clark had gone on to give a list of the types of negation — which he has more recently revised — that characterized key moments of Modernism: "deliberate displays of painterly awkwardness, or facility in kinds of painting that were not supposed to be worth perfecting; the use of degenerate or trivial or 'inartistic' materials; denial of full conscious control over the artefact; automatic or aleatory ways of doing things; a taste for the vestiges and margins of social life; a wish to celebrate the 'insignificant' or disreputable in modernity; the rejection of painting's narrative conventions; the false reproduction of painting's established genres; the parody of previously powerful styles." In just this spirit Atkinson had sought to produce art "that had mistakes, feints, gaps in it." The *Grease* paintings were disaffirmatively sarcastic about grease, but also about themselves. Among the grease analogies assembled by Atkinson we find: "Using grease: (1) The material of the avant-garde greasers, (2) Grease — the new material, (3) Grease as the repository of the potentially oppositional… (4) Grease as a disaffirming material — will it ever dry?" Pointing both downward to the world of the car mechanic and upward to the "oiling of careers, the greasing of art," Atkinson's grease metaphor

transformed art-objects from a set of worthy, abstract expressions into a mordant joke at the expense of art from the inside.

It was in Germany alone, perhaps, that the theoretical lessons of Conceptual art became infused with portentous historical themes. Like other artists whose origins lie in the later 1960s, Anselm Kiefer has over a long and illustrious career built on those foundations an art of epic ambition and complexity. Often identified (wrongly) with the German painting revival of the late 1970s and early 1980s, Kiefer can be more tellingly viewed as a maker of objects and environments: books, particularly, have concerned him since controversy first surrounded his *Occupations* documentation of 1969, in which he presented photos of himself in a number of architecturally symbolic locations producing parodies of a Nazi salute. In *Occupations* lay a key to a preoccupation of Kiefer's that he has elaborated since: namely, the nature of historical memory and the troubled European past. Yet the artist has denied a primary interest in history painting or its revival. He begins rather with Minimalism and Conceptual art—two impulses that he says "need completion with content"—and with a concept of history that sees it as "like burning coal… it is material… a warehouse of energy." Unlike the work of most other contemporary artists, ancient history and symbolism come together for Kiefer in a single contemporaneous temporality. "History is for me synchronous," he says, "whether it is the Sumerians with the *Epic of Gilgamesh* or German mythology." In a major book project of the mid-1980s, Kiefer made a massively heavy library out of some two hundred lead books, filled with evocative images from geology, architecture, landscape, skies, modern industry, and much more. Though the form was Minimalist in shape (the shelving) and Conceptual in its process (the enumeration of parts), the material itself was laden with ancient lore [Fig. 5.6]. "Lead has always been a material for ideas," Kiefer said. "In alchemy, it was the bottom level among the metals in the process of extracting gold. On the one hand, lead is dense and linked with Saturn, but on the other it contains silver, and alludes to… a spiritual plane." Determinedly averse to the usual types of artworld publicity, Kiefer has repeatedly indicated that his concerns are mythical, synthetic, even Gnostic. The lead library of *High Priestess (Land of Two Rivers)*—its secondary title refers to the two rivers Tigris and Euphrates of ancient Mesopotamia—presents itself as a massively durable record of secret and modern knowledge, a fund of humankind's hopes and failures.

The high moral tone of Kiefer's literally and symbolically weighty reflections exceeds by an impressive margin the limits normally imposed upon seriousness within the more conventional

5.6 Anselm Kiefer
High Priestess (Land of Two Rivers),
begun in 1985
Approximately 200 lead books in two steel bookcases, with glass and copper wire
14 x 26 x 3′ (4.2 x 9.6 x 1.1 m)

Too heavy to lift or manipulate by a mortal viewer, the elements of Kiefer's library remain largely mute as to their contents. In fact they contain photo-images of clouds, desolate landscapes, rivers, deserts, industrial waste: also human hair and dried peas, as well as blank pages. Both the material of the work and its allusive contents can be read as elements of a contemporary alchemical experiment.

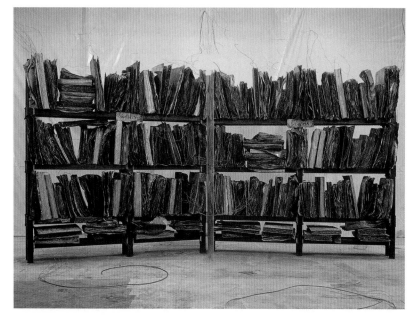

ranks of avant-garde art. What Clark had called "genuine picturing" has more often been approached through a kind of disrespectful play with the orthodoxies of Modernist art and with the sensations of modern history. So let me mention a couple more projects that address a kind of archeological concern within the frame of the modern museum: they are both by women.

The motif of interrogating the museum-space directly has proved persistent in Louise Lawler's photo-work (we are back in America once more), which has looked skeptically at the aura of Old Master and Modernist works and has tried to displace that aura with views that focus not upon the "masterpiece" but upon its supposed epiphenomena—its manner of placing, the character of the gallery setting, and so forth. In the early 1980s Lawler took high-definition photos of picture edges, frames, and captions to give a new shape and articulation to the viewer's attention. "I am showing what they are showing," Lawler said of such works. "Painting, sculpture, pictures, glasses and words on painted walls are furnishing the same material experience: my work is to exchange the positions of exposition and voyeurism." In one work, Lawler photographed a painting by Joan Miró reflected in the polished seating benches of the gallery; in another, the subtle linkage between a Jackson Pollock painting and a delicate French tureen on the sideboard of a wealthy collector; in a third, a painting by Philip Guston seen through the Perspex vitrine encasing Robert Rauschenberg's *Monogram* of 1955–59; in a fourth, an archetypal Frank Stella painting of his *Protractor* series, not as you see it on the museum wall, but as it appears reflected in the polyurethane varnish of the expensive wooden floor beneath [Fig. 5.7]. Reading beyond what was for a time called "institutional critique," we can say that Lawler's photographs turn minor events in the viewer's consciousness into poignant, and legitimate, museal effects.

When we come to the abstract paintings made by the New York artist Susan Smith, by contrast, we notice references to Modernist traditions of abstraction (Mondrian, Reinhardt) but we see that Smith has taken scraps of building material from local inner-city building sites (metal sheets, masonry, plaster-board, steel I-beams, moldings, and so forth) and sensitively recomposed them as in a Minimalist artwork, as well as engaging in a kind of Conceptual play with material references. She seems to be seeking out a more complex dialogue between the resonances of the artistic surface and those of non-art, or waste [Fig. 5.8]. Can spectators of the work follow the aesthetic guidelines of Piet Mondrian or Ad Reinhardt and enter the mentality of the bricoleur, even a Duchampian, at the same time? Can spectators

5.7 Louise Lawler
How Many Pictures, 1989
Cibachrome
61 ⅞ x 48 ⅟₁₆" (157 x 122 cm)

5.8 Susan Smith
Green Metal with Red and Orange, 1987
Oil on canvas with found metal
53½ x 49¾" (1.3 x 1.2 m)

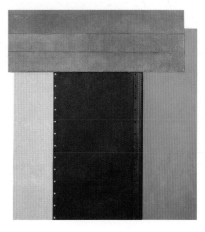

reconcile their instinctive reverence for the sensitively brushed monochrome surface with the uncomfortable presence of a piece of discarded Masonite found on a street corner? This kind of modern archeology brings the fabric of the rapid-obsolescence city right into the museum, whose very role, Smith seems to imply, is too often simply to forget.

Installation as Decay

I think it is possible to deduce from these examples that, within the larger project of engendering self-consciousness in the viewing subject, avant-garde art frequently seeks out anti-formality, awkwardness, humor, and (in a spirit of self-mockery) a carefully calculated absence of poise. Advanced European sculpture, to take an overlapping category, tended in the later 1980s toward the broken, the bathetic, and the reduced: sculpture of a certain kind seemed to enjoy wallowing in its own material condition. Perhaps other factors were helping to keep alive a culture-critique in Europe based on concepts of decay. One was the *arte povera* inheritance of recovering and hence aestheticizing materials discarded by nature or manufacture: wood and metal, junk and mass-media fragments. A second was the Fluxus aesthetic of the scandalous negation of art. A third was the survival of the spirit of European existentialism of the 1940s and 1950s: moods of cynicism and despair, and their conversion into a quest for revolutionary seizures that might just reanimate the spirit of past conflagrations: those of 1789, 1848, 1917, and 1968.

A position somewhere between the United States and Europe is represented by the painter and sculptor John Armleder, who was born in Switzerland but works in both Europe and New York. Armleder's roots as an artist lie in Fluxus, in the work of John Cage, and in performance. Armleder came to attention in the early 1980s with abstract paintings done with appropriated circles and grids from earlier Modernist art—and then, to more powerful critical effect, with a new category of so-called "furniture-sculpture" in which items of second-hand furniture were scavenged from the street, assembled in tableaux, and painted with Suprematist forms before being returned to the street after the show [Fig. 5.9]. "There was a large sofa sawn in two halves by its aged owner," said Armleder about one project, "which enabled us to get it up easily [to the second floor], the gallery being at that time in the apartment where its owner, John Gibson, was living. He was very grey-faced at having to live in the company of this

5.9 John Armleder
Furniture-Sculpture 60, 1984
Three seats, wax, and acrylic on cloth
31 x 74 x 35" (80 x 180 x 90 cm)
Collection Daniel Newburg, New York

For his first New York show, Armleder scoured the pavements and thrift stores of Manhattan and Brooklyn for pieces of found furniture, only to return many pieces to the street after the show. The re-representation of obsolete furniture styles with Minimalist or Suprematist painting here constitutes a triptych, with "spots of increasing diameter painted in the centre of each seat, the same series inverted on the backs."

rotting furniture for the duration of the show." In formal terms Armleder's tableaux looked like a conventional migration of paintings into real space. Armleder's Fluxus inheritance had prompted him to adopt a strategy of "playing at being a decorator" in the spirit of what he called a "cynical devaluation of the enterprise [of art]."

In claiming to dissolve the distinction between rubbish and art, Armleder mobilized an aesthetic gambit that has become central for many artists of this tendency: an exploitation of the disused and overlooked as a springboard for philosophical and aesthetic speculation. The gambit runs from the "presentation" of rejected objects and artefacts at one extreme through to full-blown installation art—as it became called— at the other. The latter tendency is the one that

5.10 Reinhard Mucha
Calor, 1986
Work made *in situ* for an exhibition at the
Centre Georges Pompidou, Paris

we shall examine now. Formally, the shift involved significant complication of the materials of art, generally from minimal to maximal expression. Another shift was from specialist to generalist attitudes to art's traditional hierarchies and media. Though the word "installation" refers primarily to the importation and arrangement of matter, its aesthetic implications range further and wider still. In each case, the project has been one of severely problematizing what it means for a cultural space such as a gallery or museum to be perceived as a container for art.

A group of post-Fluxus artists in Germany in the later 1980s exemplified this posture precisely. Variously dubbed "model-makers," "scene-setters," and "presenta-tion artists," they were preoccupied with a post-Constructivist assemblage aesthetic, taking everyday objects or fragments and positioning them offhandedly in real space, that is, in the untheatricalized empty space of the museum. Hubert Kiecol and Klaus Jung have taken their cues from architecture. Wolfgang Luy and Reinhard Mucha, in Düsseldorf, have manipulated materials according to the particularities of a chosen site. In Mucha's work of the period a mixture of useless showcases, ladders, and *passé* office-furnishings culled from the environs of the exhibition site ended up as make-shift structures in real space [Fig. 5.10], but without coalescing into a good gestalt (compare in this respect Woodrow and Cragg). Mucha's pieces have been both utterly ordinary and nightmarishly complex; yet they are not illustrative, and seem not to point beyond their own origins and resources. Mucha's "staging the stage" (to use his own phrase) can be seen as an extension of the founding impulse of modern sculp-ture from Brancusi onward, tinged with nihilism and a radical desire for impermanence.

No less anti-artistic in the tradition of Beuysian philosophy were the contemporaneous works of a group of seven artists—Gisbert Huelsheger, Wolfgang Koethe, Jan Kotik, Raimund Kummer, Wolf Pause, Hermann Pitz, and Rudolf

5.11 Fritz Rahmann
Lützowstrasse Situation 13, 1979
Wall paint, remains of Situations 1–12, water

5.12 Hermann Pitz
Out of Infancy, 1989
Nine resin casts, aluminum, lamp, caddie
38 x 40 x 23" (90 x 100 x 60 cm)
Collection of the artist

Pitz takes non-cultural objects and parades them provocatively in a new setting. Particularly unsettling is the position of this tableau on its own wheels, suggesting a breach of perhaps the oldest convention of sculpture, that it does not move.

Valenta—who for their exhibition *Spaces* in 1979 rearticulated the spaces of a disused Berlin warehouse using nothing other than the building itself and the disordered debris and garbage that they found there. "No one can say where the art begins," wrote Pitz of the arbitrary-seeming ensembles inside. "Who did that scribbling on the wall? An artist? Who drove these nails into that particular order on this wall? An artist? Who broke the window over there? Who painted the line on the floor? Who is it here who's looking out of the window?" The show gave expression to a manifesto statement that "the art object alone is no longer important. The object can document an attitude." The group, which then concretized as Büro Berlin in 1980 under the guidance of Kummer, Pitz, and Fritz Rahmann—joined on occasion by Tony Cragg and others—extended this Brechtian attitude to all manner of urban detritus, however marginal or unpromising. It took to another kind of limit the idea that "the quality of a work of art consists... in the structure of its realization not being concealed," to quote Büro Berlin's essay "dick, dünn" ("Thick, Thin") of 1986. Fritz Rahmann's project for the *Lützowstrasse Situation* exhibition in 1979 remains exemplary of Büro Berlin's important and (still largely unrecognized) contribution to advanced European art of the time [Fig. 5.11]. He collected up the debris of twelve other projects and disposed the pieces frankly yet informally like the set of disused fragments they were. Restaging the material remnants of the exhibition site directly as the work itself, Büro Berlin predicated itself through the early and mid-1980s on precisely *not* being the "neue wilder" expressionist grouping of Fetting, Middendorf, and Salomé. Anarchic and sometimes scarcely recognizable as artists, Büro Berlin evaded, and were in turn usually evaded by, the promotional machinery at work on their more marketable neighbors. Though the group was formally dissolved in 1986, most of the artists have continued to work interestingly on their own [Fig. 5.12].

The desolate forms taken by much of the work of this German generation, many of them born near the end of World War II and reared in a period of rapidly increasing

material prosperity, can be related once more to Adorno's remark that to write poetry was "barbarous" after Auschwitz. Far from associating itself with the tortured angst of an Expressionist past, the best work of these younger Germans was art precisely in not being art, aesthetic only in not performing aesthetically, pleasurable only in comprehensively renouncing pleasure (compare the ever-influential Gerhard Richter).

Thus Joseph Beuys's pupil from Düsseldorf, Imi Knoebel, moved from devising Dada-like gestures in the later 1960s and 1970s to making installations of low-grade wooden panels that were painted (frequently face down), stacked, or disposed on wall and floor surfaces according to the atmosphere and character of an existing room. Some of Knoebel's works echo childhood incidents: a series of triangular plywood panels from the mid-1980s recalls the window through which he watched the burning of Dresden as a five-year-old boy. A 1980 room installation for a Ghent museum, reinstalled subsequently in several other galleries, combined order, chaos, geometry, and informality in an arrangement that manages to stop short of completeness or finality [Fig. 5.13]. Storage, accumulation, deference to pioneer Modernists, and a refusal of sensuous declaration all inhabit Knoebel's work. "Beuys showed Knoebel a way to free non-objectivity from design," a supportive critic wrote in an essay of 1987; "the look of an art… is far from its whole story."

What was also distinctive about Germany in the later 1980s (as before) was the existence of several artistic centers, each with its own cultural traditions, its own mechanisms of influence and power, and its own network of galleries and museums. One of these was Cologne. In the 1950s Cologne had been the home of a kind of abstract painting, associated with Ernst Wilhelm Nay and Georg Meistermann, that had attempted to break free of National Socialist proscriptions on modern art. Subsequently associated with Fluxus, experimental music (John Cage, Nam June Paik, Karlheinz Stockhausen, and David Tudor) and the *dé/collage* aesthetics of Wolf Vostell, the Cologne art community had by the later 1980s begun to codify its differences from other cities and to command international attention. The stance of the original Mülheimer Freiheit artists is a case in point. Walter Dahn now began to describe his earlier activity as "playing" with Expressionism, rather than—as was loudly proclaimed at the time—plumbing spiritual depths. Jiri Georg Dokoupil, too, swayed by the childlike, cerebral, and distanced posture of a precursor like Sigmar Polke (who frequently exhibited in the city), came to view the much-vaunted neo-expressionism of the early 1980s as a strictly bad-faith, role-playing product.

5.13 Imi Knoebel
Ghent Room, 1980
Lacquer on plywood
459 parts in varying sizes
Installation, Dia Center for the Arts, New York, 1987–88

Originally shown in Ghent in 1980, this room installation has been reconstructed in Kassel, Winterthur, Bonn, New York, and Maastricht. Varied according to the dictates of each space, the stacked and hung panels resonated with echoes of founding Modernism—from Malevich to Marden—under the aegis of a deceptive informality learnt from Beuys.

5.14 Albert Oehlen
Fn 20, 1990
Oil on canvas
7′ x 9′ (2.1 x 2.8 m)

Hence a more ironic and complex attitude came to engage Cologne artists like Martin Kippenberger, Werner Büttner, and the painters Markus and Albert Oehlen. In his shows toward the end of the decade, Albert Oehlen confronted a dilemma that at the time seemed central to any avant-garde: how to "go on" with an art that had been ritually pronounced dead many times; how to reconstitute painting at that moment as more than a nihilistic or repetitive fetish. "The main reason why I made the decision to paint," said Oehlen, "is that I think this is the real centre of art. And to pursue formally new directions—video or performance or whatever—or to do nothing at all, would only limit one's expressive options. It would all be overshadowed by technical issues, by the novelty." What emerged, then, was not *belle peinture*, but scurrilous and defeatist mark-making that knew that the power of painting to make descriptive images was by then a substantially lost cause [Fig. 5.14]. Adopting a despairing attitude to questions surrounding the social function of painting—and particularly deriding the work of Otto Dix—Oehlen has also opposed the work of Hans Haacke and Louise Lawler (for example) as overly litigious, overly concerned with costs, values, markets, and ownership. Art cannot be political in that way, Oehlen insists: "I try for example to force the concept 'mess' or 'crap' or 'out of focus' or 'fog' onto the observer. My goal is to see that he can't help having the word 'mess' in his head." Provisional and mute, his works speak of irresolution on a grand and attractive scale. For it is the making plain of that irresolution within the painted surface that marks Oehlen's as an aesthetic, rather than a merely nihilistic, project. Kippenberger, meanwhile, Oehlen's colleague from Hamburg, made objects, sculptures, and installations, wrote a novel, collected others' works, and ran a bar: he played an animating role that led him to exhibit occasionally, teach, proselytize, and give interviews—lying to one side of the conventions of avant-garde culture, but all the more necessarily part of its ambition. "I'm not a 'proper' painter, a 'proper' sculptor," said Kippenberger; "I only look at all this from the outside, I make an occasional intervention, try to do my bit as best I can."

In German constructed sculpture of the period a sense of chaotic aggression was conveyed by the installations of the Berlin-trained Olaf Metzel. For example, Metzel's contribution to the *Skulpturenboulevard* show in Berlin in 1987 consisted of a pile of police crash barriers heaped up at a major junction of the Kurfürstendamm, steadied by concrete blocks at its base, and with a supermarket trolley hanging teeteringly near its top [Fig. 5.15]. Generally deploying an iconography of wreckage, of ruined machinery and apparatus, of violent rupture and collapse, Metzel—who has since

lived and worked in Munich—has come close to converting *bricolage* into overt political symbolism.

The rise in importance of German art of the period, though grounded in individual achievement, is from another point of view to be placed within the context of the modernization of the whole infrastructure of art—which in turn arose out of German economic expansionism in the period. Such developments customarily go together; and it is no contradiction that an interest in wreckage and decay should be the counterpart of economic success. Accordingly, the German art world evolved its own machinery of publicity in the form of house journals such as *Art* and *Kunstforum International*, as well as experiencing a massive proliferation of museum-building for the display of contemporary art. In the train of Philip Johnson's Kunst-halle at Bielefeld (1966) and Mies van der Rohe's Neue National-galerie in Berlin (1968), there followed the Wilhelm-Hack Museum Ludwigshafen (1979), the Städtische Museum Mönchengladbach (1982), the Städtische Kunsthalle Mannheim (1983), the Museum Bochum and the Staatsgalerie Stuttgart (1984), the Kunstsammlung Nord-rhein-Westfalen Düsseldorf, the Ludwig Museum Cologne (1986) and MOMA Frankfurt (1991), to name only the more prominent [Fig. 5.16]. In Hans Hollein's MOMA Frankfurt, designed to accommodate both a fine permanent collection as well as temporary shows, we find the wedge-shaped site elegantly exploited to provide a set of very small and medium-sized pockets of interior space whose muted articulations themselves appear as objects of an almost aesthetic order. Here as elsewhere, the contemporary museum becomes a fascinating receptable, or stage, for multimedia artistic work across the widest possible range. No longer designed for "painting" or "sculpture" alone, the contemporary art museum has encouraged protocols of making and viewing that are altogether new.

5.15 Olaf Metzel
13.4.1981, 1987
Steel, chromium, concrete
37'7" x 29'5" x 22'9" (11 x 9 x 7 m)
Installation at the Kurfürstendamm/
Joachimstaler Strasse, Berlin

5.16 Hans Hollein
Museum of Modern Art, Frankfurt am Main,
completed 1991
Main entrance, southwest façade

The Curator's Part

Alongside the new museum architecture we encounter the figure of the "new" curator: the impresario capable of assembling concepts and groupings that more or less convincingly thematize a tendency, a generation, a stylistic change. "Concept" exhibitions comprising small numbers of works by dozens of artists have made the contemporary art museum a showcase and a spectacle, yet one in which the individual philosophy can become obscured by the wider and more marketable agenda.

A case in point was *Metropolis*, a huge showcase of German and American trends of the 1980s mounted at the Martin-Gropius-Bau in Berlin in 1991 by Christos Joachimedes and Norman Rosenthal, two of those who had promoted the much-advertised "return" to painting of 1981. Now, it was painting that was in retreat: *Metropolis* claimed that Warhol, Beuys, and Duchamp—a judicious blend of American, German, and French progenitors—were the vital figures. "A feature of art in this century is the imaginary pendulum swinging between Picasso and Duchamp," Joachimedes suggested; "if 1981 was Picasso's hour [the artist had died in 1973], Duchamp's time has come in 1991." The important geographical proposition was that "in the image of art presented today, there are two obvious points of culmination drawing events to themselves like magnets: New York, and the area around Cologne." And yet, as in other mega-projects of the recent past, the curatorial eye remained fixated on male artists of already secure reputation, stimulating the international dealer network without burdening it with local differences, questions of gender, inconsistencies of aspiration or allegiance. Curatorially molded for rapid projection into the space of art journals, criticism, and even tourism, *Metropolis* postulated a seamless international continuum of a far simpler kind linking Europe (even Eastern Europe) and America.

The relation of Rosemarie Trockel's paintings and objects to those of the Warhol–Beuys–Duchamp axis is at least partly clear. Trockel had trained at the Werkkunstschule in Cologne in the late 1970s and had had contact with the ironic tendencies of the Mülheimer Freiheit group of painters in that city—Walter Dahn, Jiri Georg Dokoupil, Pieter Bommels, and others—who had combined historical and social referents with a series of eclectic, quotational styles. The critically most celebrated result of this background was Trockel's computer-knitted paintings and objects of the mid-1980s, which by incorporating heavily loaded motifs such as the hammer and sickle, the swastika, the Playboy symbol, the Wool-mark, and other commercial signifiers, managed at once to load an immediately gendered surface with a menacing sense of the familiar gone askew. Showing a strong interest in the work of the French *Documents*

5.17 Rosemarie Trockel
Untitled, 1991
Enameled steel and four hotplates
39⅓ x 39⅓ x 4¾" (100 x 100 x 12 cm)

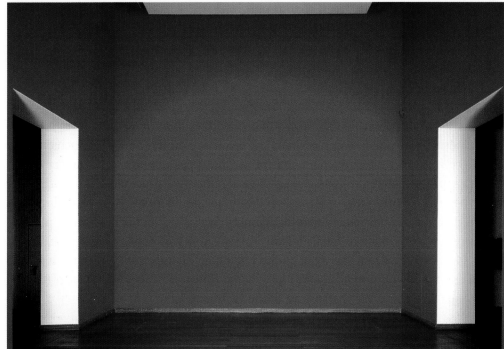

5.18 Katharina Fritsch
Red Room with Howling Chimney, 1991
Color, sound from tape
Installation at the *Metropolis* show, Martin-Gropius-Bau, Berlin

Though her early projects had the appearance of Duchampian or Beuysian readymades, Fritsch has made it clear that she "never exhibits readymades." She likes to free objects from their usual significances, working instead with a sculptor's attention to exact dimensions and placing. Asked about the evacuation of content, Fritsch replied: "My works are neither icy nor cold, just precise."

group of the later 1920s (Georges Bataille, Michel Leiris, and others), Trockel toward the end of the 1980s resumed an appetite for a kind of ethnographical Surrealism in which objects with social, sexual, and magical connotations were placed tantalizingly in vitrines (a format perfected by Beuys). For *Metropolis* itself Trockel contributed a series of works that extended a dialogue with Minimalism by enriching an elementary geometrical format with the shiny forms of a cooker surface, complete with four circular hotplates, the whole being raised from the horizontal to the vertical in a distant but nevertheless amusing parody of the Cubist still-life picture [Fig. 5.17]. A Duchampian readymade joke, a Warholian play with the banal, and often a Beuysian fascination for the atavistic are also to be found in such work.

On the other hand, Katharina Fritsch had already made it clear that she wanted "to have nothing to do with the ideas of Beuys or with Warhol's Factory." Fritsch had already scandalized the good citizens of Münster in Westphalia by exhibiting a six-foot-tall, yellow, plastic Madonna in the center of the town's pedestrian precinct in 1987. In the same year, she exhibited a lifesize green elephant mounted on a large oval pedestal in the Krefeld Museum. "I don't aim for expressiveness," she says. "That is a concept that I find too spongy, too vague… I don't want to force myself onto things but to let them grow on me and show me the clarity of the things themselves." She generally makes objects from molds, implying repeatability. "You will find that my works are always symmetrical… it's very important that they be exact." For *Metropolis*, Fritsch showed *Red Room with Howling Chimney*, a monochrome space in which chimney sounds could be heard [Fig. 5.18]. Concerned less with iconography than with symmetry and precision, her installations eliminate emotional resonances

and particular associations, as if their significance consisted in their sculptural values alone—what Fritsch calls "exemplary form without ideological meaning."

Functioning simultaneously as a showcase for advanced tendencies in art at the beginning of the 1990s and as a simplifying, banalizing account of them, *Metropolis*—which included work by Knoebel, Oehlen, Metzel, Armleder, and Mucha, but not Rahmann, Kippenberger, or Pitz—demonstrated several paradoxes of the latest visual art on an international scale that have still not been resolved and perhaps can never be satisfactorily overcome. Perceived bias, the tendency on the part of particular high-profile curators to omit or over-emphasize certain types of work, must be set within the larger problematic that there can be no final or truthful representation of a culture that does not at the same time undermine its claims to finality by revealing local commitments and relevant short-term agendas. We arrive immediately at a paradox that is also a truth: namely, that no global perspective can hope to exist in an age of many perspectives. From the 1980s to the beginning of the twenty-first century, the rise of curatorial ambition has had to accept that universalism and the local often pull in opposite directions. We shall return to this difficulty later.

And yet the attractions as well as the obscurities of the newest visual art continue to exert strong demands upon the competence and sophistication of its viewers, and appeal to an understanding of large globalizing agendas in social theory, aesthetics, and the theory of art—in this way the universal and local inform one another. Many of the major museum exhibitions of contemporary art in the later 1980s showed evidence of wrestling with both sides of this difficult paradox. Shows like *Bi-National: American and German Art of the Late '80s*, which exchanged work between Düsseldorf and Boston in 1988–89, or *Magiciens de la Terre* (Magicians of the Earth) in Paris in 1989, not to mention the continuing *Documenta* series in Kassel, or the Venice Biennales, all vigorously assert the possibility of international (even global) representation while bowing to critical tendencies that marshal necessarily selective arguments and merely convenient resources. And no amount of juggling with the claims of other constituencies such as minority cultures, geographically remote groups, emergent power bases, and critically experimental genres is likely ever to perfect the ways in which art is represented in a world of multinational commercial interests, image-enhancement sponsorship, and competitive governments. This is to say that the ways of cultural power will remain as elusive as they are important. On one side of the equation will be a continued attempt to maintain a "high" visual culture that does not fall back into commerce or the lowest values of mass entertainment. On the other, important misrepresentations look likely to occur. What the cases of Trockel and Fritsch point to is not just that neglect of women's art in the period continued to be endemic—*Metropolis* contained men to women in proportion of 93 to 7 per cent and quickly acquired the tag "Machopolis"—but that radical art could enter public visibility (of course it still does), often on condition of being unwittingly misdescribed and misunderstood.

It is in that sense that it becomes pertinent to ask whether the new German

avant-garde did not encounter the danger of becoming co-opted by the very values that its work at some level wanted to resist: the pursuit of art as recreational pleasure, the construction and elaboration of a bogus national culture, and the entrenchment of patriarchal management. There is an old implication here: that an avant-garde both needs, but needs to resist, the art-historical and managerial competencies of the manager or curator (even those of the humble writer). But in whose interests do curators act? On behalf of what gender, class, and ethnic constituencies does cultural management function? The problem is one of first identifying the steps by which each party to the relationship performs its elaborate, ritual-like negotiations with the ideals and aspirations of the other.

Some Counter-Monuments

It is merely an extension of this paradox to say that some of the most critically effective artworks of the period were staged outside the gallery, away from the museum, and in that sense found a different relationship to them. The tendency to work outside, in urban spaces, will recall to some readers the counter-culture's strategy of working in remote deserts, fields, landscapes, anywhere in fact that does not play directly into the hands of curatorial power. A "counter-monument" is a particular project of this kind. Focused on public buildings or memorial spaces, several recent counter-monuments have commanded widespread attention and have generated intense public discussion. Krzysztof Wodiczko was educated at the Warsaw Academy of Fine Arts in a Contructivist and Bauhaus tradition, then taught in Poland until moving to New York in 1977. His technique during the 1980s of taking a public monument, building, or urban site and projecting onto it images that displace its customary public meanings (military commemoration, monument to culture, or business honor) forms a prominent and much-admired exemplar. Projecting the hand of Ronald Reagan across the chest of the AT&T building in 1984, or a swastika onto the center of the classical pediment at South Africa House in London in 1985, or proposing in 1986 that the Lincoln statue in Union Square, New York, carry a crutch, are representative. The artist has said in relation to these Public Projections (capitalized for emphasis by the artist) that "in today's contemporary real-estate city, the mercilessly dynamic space of uneven economic development makes it extremely difficult for city-dwellers and nomads to communicate through and in front of the city's symbolic forms… Not to speak through the city monuments is to abandon them and to abandon ourselves, losing both a sense of history and the present." "Public Projection involves questioning both the function and the ownership of this property," Wodiczko has written; "In defending the public as the communal against the public as the private, the projection reveals and is affected by the political contradictions of the culture of capitalism… The attack must be unexpected, frontal, and must come at night when the building, undisturbed by its daily functions, is asleep and when its

body dreams of itself, when the architecture has its nightmares." Of course, the formidable complexities of commission and permission that precede Wodiczko's Projections are to be counted among their intended meanings. It is also telling that the museum of art itself, in its role of storehouse, support base, and filter of older and contemporary culture, should sometimes have become a target for Wodiczko's works [Fig. 5.19].

"Taking art to the streets" may sound romantic, even utopian. Yet as the dismal recent debate about "public art" suggests and as Wodiczko's projects demonstrate, there can be no such category that does not at the same time launch wider questions about the public space, about the posture and politics of audiences, and about the kinds of controversy that avant-garde art itself is scheduled to provoke. "The aim of the memorial projection is not to 'bring life to' or 'enliven' the memorial nor to support the happy, uncritical, bureaucratic 'socialisation' of its site," Wodiczko has also said, "but to reveal and expose to the public the contemporary deadly life of the memorial. The strategy of the memorial projection is to attack the memorial by surprise, using slide warfare, or to take part in and infiltrate the official cultural programmes taking place on its site." The desire of architects or city administrators to embellish otherwise unappealing buildings is also anathema to the most challenging public art.

To the contrary, the most vital recent projects in city environments have been designed to challenge habitual urban behavior, even to promote counter-thinking about the fabric of the city itself. A classic example must now be mentioned. From the later 1960s the American sculptor Richard Serra has been working both in the studio and the gallery with extremely heavy lead and steel plates propped against each other,

5.19 Krzysztof Wodiczko
Projection on the Hirschhorn Museum,
Washington, D.C., October 1988
Hal Bromm Gallery, New York

Wodiczko's technique of using xenon-arc projectors to re-signify public monuments takes the museum as its inevitable extension. The images projected onto the Hirschhorn Museum present a contradiction in three parts: a candle that shines in the dark and thus illuminates, a gun that threatens, and a microphone-bank that speaks both of publicity and power.

precipitously juxtaposed, or shaped in geometrically complex volumes and shapes. As Serra has said in interviews, the aesthetic function of such pieces, though deriving formally from Minimalism, has been to reflect attention upon the nature of the physical spaces that they occupy. "What I'm interested in is revealing the structure and content and character of a space and a place by defining a physical structure through the elements that I use… it has more to do with a field force that's being generated, so that the space is discerned physically rather than optically." "Sculpture," said Serra in 1980, "if it has any potential at all, has the potential to create its own place and space, and to work in contradiction to the spaces and places where it is created. I am interested in work where the artist is a maker of an "anti-environment" which takes its own place or makes its own situation, or divides or declares its own area." Applied to the city arena, that statement may easily be related to Serra's *Tilted Arc*, commissioned in 1979 and installed in 1981 in New York's downtown legal and administrative center, Federal Plaza [Fig. 5.20]. Following its installation, a conservative New York judge, Edward Re, immediately whipped up public controversy over the piece until, at a public hearing in 1985 led by the Government Services Agency's New York administrator William Diamond, polarizing statements were made in a public hearing both for and against *Tilted Arc*'s removal on the grounds that it disrupted the "normal" functioning of the plaza. Though non-specialist opinion was ranged against the sculpture at the time (it was "the ugliest outdoor work of art in the city," according to the *New York Times*), persuasive support was adduced by the city's artistic and intellectual community. The already prominent art critic Rosalind Krauss pointed out the sculpture's capacity to externalize vision: *Tilted Arc*, she said, was "constantly mapping a kind of projectile of the gaze that… like the embodiment of the concept of visual perspective, maps the path across the plaza that the spectator will take. In this sweep which is simultaneously visual and corporeal, *Tilted Arc* describes the body's relation to forward motion, to the fact that if we move ahead it is because our eyes have already reached out in order to connect us with the place to which we intend to go." Benjamin Buchloh pointed out that Serra's work was in the historical line of Picasso, Brancusi, Schwitters, Tatlin, and Lissitsky, all of whom were once vilified by the Nazis but whose works were now installed at the Museum of Modern Art—that *Tilted Arc*'s intended philistine desecration was an example of "mob rule in culture." Douglas Crimp argued that Judge Re's complaint of loss of efficient security surveillance demonstrated that at the root of the GSA's arguments were fears that the social life of the plaza would become suddenly unstable and uncontrolled. Notwithstanding, the hearing panel voted four to one to relocate the sculpture, and despite a flurry of lawsuits from the sculptor, the work was dismantled during the night of March 15, 1989 and removed unceremoniously to a government parking lot in Brooklyn.

The example of *Tilted Arc*'s prominence and demise has provided a touchstone for younger sculptors since. For example, the very concept of the counter-monument has animated the much younger British sculptor Rachel Whiteread, whose reputation

5.20 Richard Serra
Tilted Arc, 1981
Cor-ten steel
12′ x 120′ x 2½″ (3.6 m x 36 m x 5.1 cm)
Federal Plaza, New York City (removed)

5.21 Rachel Whiteread
Untitled (House), 1992
Metal armature and concrete
Grove Road, East London (demolished 1994)

5.22 Rachel Whiteread
Vienna Judenplatz Holocaust Memorial, 1997
Vienna

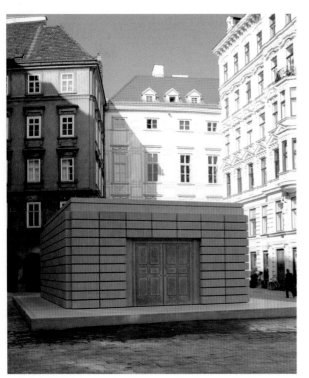

until recently rested upon a series of gallery pieces consisting of paradoxical negative volumes formed by reproducing in wax or plaster the spaces between or behind objects: the volume behind a cupboard, beneath a chair, or inside a bath. Her much-discussed 1992 project *House*, formed by pouring concrete into a condemned house in East London in advance of the building shell's removal, thus stood out from the surrounding wasteland both as a monument to the interior life that it once enclosed, and as a telling symbol of the violence done to communities by unpopular and bureaucratic planning [Fig. 5.21]. *House* survived for a few weeks after the destruction of its immediate neighborhood until it, too, was ritually destroyed by local political interests amid a roar of conflicting publicity.

It would be only a further three years before Whiteread again entered the stage of high-profile controversy with her design for a Holocaust Memorial in the center of Vienna's Judenplatz [Fig. 5.22]. Austria's relation to its Nazi past had heretofore been politely submerged, despite local awareness that the Judenplatz itself had witnessed dozens of anti-Semitic persecutions, from the pogrom of 1421 through successive purges of the banking and commercial fraternities of Austria's capital city. For this design, Whiteread conceived the idea of a library of books, linked to Jewish intellectual traditions as well as to the book-burning ceremonies of the Nazis. The second premise was again the idea of the void as a presence—exploited effectively both in Berlin's Bebelplatz by the Israeli-born Conceptual artist Misha Ullman, as well as, subsequently, in the dramatic interior design of Daniel Libeskind's Jewish Museum (2000). For the Vienna Judenplatz, Whiteread proposed a white stone cube whose exterior surface modeled the spaces between the books and above and below the shelves. Winning the competition against proposals from the likes of Ilya Kabakov, Zvi Hecker, and Peter Eisenman, Whiteread's design soon attracted controversy from residents concerned about parking, and from shopkeepers anxious about a decline in trade. Stalemate soon followed, until in 1998 the Vienna authorities announced that it would proceed after all with a project that met almost perfectly the competition brief of a monument that "would combine dignity with reserve and spark an aesthetic dialogue with the past in a place that is replete with history."

Like Wodiczko, Serra, and latterly Whiteread, the German artist Jochen Gerz has risked negative publicity with a series of monuments in public places that, like the ill-fated *Tilted Arc* and Whiteread's *House*, relocate the thought processes of the studio in the spotlight of journalistic and public awareness. Gerz had been a poet, a Conceptual artist, and a prolific producer of photo-and-text pieces during the 1970s—a genre he continues today. But in 1984, for the city of Hamburg, Gerz was commissioned with his Jewish wife Esther Shalev-Gerz to produce the *Monument Against Fascism, War, and Violence, and for Peace and Human Rights*, finally completed in 1986. From the outset

it was clear that the piece could not be a mere message or propaganda image: instead, the artists devised a 40-foot (14.6-m) hollow aluminum pillar covered with lead, on whose lower section passers-by could make an inscription with a steel point. Periodically the bottom part of the pillar was lowered into the ground and a new surface exposed, until by the end of 1993 the entire structure was buried except for its top surface. In the process, the column was covered with graffiti of all shades, including erasures, complaints, messages of hope and desperation. The *Hamburger Rundschau* newspaper characterized the resulting marks of "approval, hatred, anger, and stupidity" as "a fingerprint of our city applied to the column." In a further project conceived at the interface "between the real and its reproduction," Gerz executed with the help of students from the École des Beaux-Arts in Saarebrücken a *Monument Against Racism*. It consisted of names of Jewish cemeteries inscribed on the undersides of the paved cobbles of an ordinary square [Fig. 5.23]. The monument was lent added trenchancy by being situated below Saarebrücken Castle, once a Gestapo headquarters but now a local museum. In both *Monument Against Fascism* and *Monument Against Racism* Gerz withholds representation as such—or rather buries it. He enumerates by naming; yet he also wants to perpetuate the "violence of naming" as a function of the public monument. Insisting at Saarebrücken on both horizontality and on the absence of presence—both hallmarks of much Conceptualist artwork—Gerz and his counter-monument attracted fierce political controversy before the work became a kind of tourist site despite itself.

5.23 Jochen Gerz
2146 Stones—Monument Against Racism, Saarebrücken, 1990–93
Photograph by Esther Shalev-Gerz

By night, Gerz and his students lifted cobbles in small batches, replacing them with fakes while the real ones were inscribed with the names of cemeteries, to a total of over two thousand. Carried out clandestinely, the work was nevertheless officially sanctioned after a debate in the local parliament, while the square itself was renamed "Square of the Invisible Monument."

A heavy dependence on both writing and horizontality has also been a pre-occupation of the American artist Jenny Holzer. Holzer came to public art after a brief phase as an abstract painter, though she remembers reading *The Fox* as a student and realizing that not all art need be heroic, or sublime, or an object. Enrolling in the Whitney Museum's Independent Study Program in 1976–77, Holzer recalls how she was handed a voluminous booklist—unreadable through its sheer size—that stimulated the production of a series of one-line written statements hovering somewhere between philosophical profundity and folksy wisdom that she came to call Truisms: "A LITTLE KNOWLEDGE CAN GO A LONG WAY," "CHILDREN ARE THE CRUELLEST OF ALL," "ABUSE OF POWER COMES AS NO SURPRISE," and the like, which she ordered alphabetically and paraded anonymously on posters throughout New York. Courting affinities with advertising and public-service announcements, in a tone both effort-lessly pragmatic and frighteningly official, the series launched a welter of further projects in which Holzer, like other Conceptualists before her, forged images principally out of words.

5.24 Jenny Holzer
Venice Installation, American Pavilion,
Venice Biennale, 1990
Photograph by David Regan

Like most public artists who found themselves working out of Conceptual art, Holzer has migrated from the urban space to the gallery and back, as if only thus could contact with an avant-gardist crucible or testing ground be sustained in practice. In a sequence of messages beamed from a Spectacolor board in Times Square, New York, in 1982, suggestive truths such as "FATHERS OFTEN USE TOO MUCH FORCE" or "TORTURE IS BARBARIC" were purveyed to an extensive, if transient, audience. For the American pavilion at the 1990 Venice Biennale, Holzer designed a series of rooms clad sumptuously in marble, in which flanking benches, also in marble, carried inscriptions, while LED (light-emitting diode) displays on the walls summoned up in several languages the aura of a quiet devotional space for a minority celebrant clientele [Fig. 5.24]. Despite enormous media attention and an apparently eclectic audience for her signs, what has been at issue in the more specialized critical appraisal of Holzer's work has been the extent of her familiarity with the traditions and possibilities of epigraphy. The critic Stephen Bann has compared Holzer unfavorably with the California painter Ed Ruscha and the Scottish sculptor Ian Hamilton Finlay, and has questioned the extent to which the spread of her epigrammatic style to T-shirts, limited-edition LED sign boards, and inscribed sarcophagi in effect undermines and banalizes the ambitious reanimation of public space promoted by her better works. What cannot be denied, however, is that the range of Holzer's syntax has been considerable, veering from the terse philosophical one-liner to the vernacular throwaway, from the authoritative-sounding public announcement to commercial signage, from headline journalism to gossip. In this sense if in no other, her projects have drawn attention to the anecdotal power of language as a ubiquitous feature of the contemporary public realm.

Two very different counter-monuments from Europe will complete this short review. I did not know the work of the German sculptor Isa Genzken before seeing her exhibition *Holiday* at the Frankfurter Kunstverein in 2000, and further work by her at the Kassel *Documenta* in 2002. For the former, Genzken had made ten smallish and squarish sculptures that she called *Beach Houses for Changing*: pedestal-mounted some four feet above the floor and arranged in sequence, these light-hearted evocations of colorful temporary structures seemed nicely to capture the atmosphere of gaiety and pleasure on holiday while expressing the individuality of their owner, the cost and size of the beach houses, and the colors and materials typical of the scene. Shells and pebbles added a note of playful mimicry to some of the interiors. One quickly understood, however, that far more serious concerns underlay Genzken's project as a sculptor. A hint of this was contained in the view from the Kunstverein

window, as, turning from the beach houses, one saw the reality of the modern architect's idiom in a coarse collection of shapes and office buildings outside. Genzken's work as a sculptor comes out of precisely this awareness. Educated at the Academy of Arts in Düsseldorf in the 1970s, she came to know Bernd and Hilla Becher's serial photographs of nineteenth-century architectural structures that set out not only to turn architecture into photography—hence to refuse the need to make anything in material form—but to point to the functionalism and repetitiveness of industrial and commercial architecture at the dawn of modern consciousness. Genzken quickly developed a method of caricaturing as well as mildly celebrating the scale and monumentality of the modern architectural idiom, specifically the concrete-and-glass business monoliths of American and European cities, from the anonymous industrialized skyscraper to the utopian masterworks of celebrated auteurs such as Gropius, Saarinen, Meyer, and Loos. Seriality and a mocking reverence became essential to Genzken's sculptural work. The work pictured here, *Corridor* (1986), standing no more than 33 in (83 cm) high atop a chest-high metal plinth, evokes the vast ambitions as well as the material brutality, the social rationalism, of the late twentieth-century's alienated urban centers [Fig. 5.25].

Thomas Hirschhorn's "altars" and "monuments" meanwhile take the ambition to evade the system to a more extreme limit. They have attracted attention nevertheless from the very curators, editors, and managers from whom Hirschhorn otherwise wishes to escape (not really). It is a complex but effective posture. The Swiss-born Hirschhorn, who works in Paris, first made a series of "altars" to revered figures, including Mondrian, Ingeborg Bachman, and Otto Freundlich, but he did so in the form of sculpture having no visible connection to a spectacular space or a convenient viewing posture. On nondescript pavements, at road junctions, at the edges of unremarkable public piazzas, Hirschhorn would assemble photos, books, discarded electrical goods, small kitschy mementos, or marks of popular endearment, and dispose them in a semi-ordered "scatter" style reminiscent of a pavement tradesperson's display or even a tramp's temporary home, the whole being ringed off from too easy a public contact by red-and-white tape of a kind normally used to screen roadworks or a building site. In this way Hirschhorn has found a mode of sculptural production that defies not only the languages of gallery Minimalism but virtually every other paradigm of object construction of the last thirty or more years. In no sense "popular" art, this aesthetic strategy Hirschhorn describes starkly in terms of energy, audiences, and value. "I want to work without volume, I want to make a non-hierarchical work and I want to work without the will to intimidate," he has said. "The sculptures that people make to be held up in political marches, in trades union demonstrations, in gay-parades or

5.25 Isa Genzken
Corridor, 1986
Concrete
16 x 12 x 32 ½" (41 x 30 x 83 cm)

5.26 Thomas Hirschhorn
Otto Freundlich-Altar, 1998
Shown in Basel and Berlin

carnival floats, have an explosive energy. They are made with engagement, careless of aesthetics. They are beautiful sculptures. They consider the human scale, either enlarged or reduced, in order to express a project or a thought... I can't and won't inscribe my work somewhere specific, and I don't care where my work is inscribed in the history of sculpture... I only want the spectator to be confronted with my work... Energy yes, quality no." Thus, in the *Otto Freundlich-Altar* (1998)—Freundlich was a German modern sculptor vilified by the Nazis—we saw on a Berlin street corner crudely drawn memorial messages ("Thank You, Otto!"), flowers, candles, and photocopied images of Freundlich's sculptures, including the *New Man* to which the Nazis took particular exception—quite as if Freundlich had been run over at that road junction and local people who knew him had spontaneously participated in a moment of respect [Fig. 5.26]. Hirschhorn explains: "I don't make institutional art. I work within the volume of space that is given to me: I assert the autonomy of art... I want to reflect, assert, share, and at the same time I want to do what I feel to be profoundly worthwhile." In further defiance of conventional sculptural frameworks, Hirschhorn makes sure that no permanence inheres in anything he does beyond the recollection and the documentation of the piece. As Benjamin Buchloh has summarized it, the notion of participation in Hirschhorn's sculptures "not only solicits vandalism, small-time barter and acquisition, but it inevitably also entices forms of petty theft, the clandestine removal or addition of small parts (like candles or bricolage objects of all kinds), hence it undermines the assumption that sculpture as a discourse on the condition of object experience... could still be constituted within registers of autonomous objects and spaces, exempt from the universally enforced banality of private property and the terror of controlled space." In his *Monuments* to Spinoza, Deleuze, Bataille, and Gramsci, Hirschhorn has constructed (often with the aid of youth clubs and local residents) temporary pavilions whose relationship to the usual commemorative building has been no less radical or inspired.

Certainly, the idea of the counter-monument as examined here gives the lie to the notion that late 1960s radicalism has withered and died. The most fundamental impulses of Conceptual art—namely, to keep one step ahead of the acquisitive hand of power and to resist becoming the mere good taste of the culture industry—have been successful in animating this work, if not as a counter-culture, then as a critically effective "intervention" in the spaces of contemporary debate. And yet, in the meantime, another shift had begun to occur that posed challenges to all forms of art claiming legitimacy from the Western avant-garde. This took the form of an unexpected turn away from context and "form," toward overt reference, iconography, and symbolism. From the mid-1980s to the millennium and beyond, artists have reattuned themselves directly to issues of race, ethnicity, and the body that once lay beyond the institutional setting and materials of art. This work—for which "narrative" may well be the most accurate term—has placed the counter-culture's radical legacy under pressures of an altogether unexpected kind.

Contemporary Voices

Krzysztof Wodiczko, "Public Projection," *Canadian Journal of Political and Social Theory*, 7: 1–2, winter/spring 1983; reprinted in C. Harrison and P. Wood, *Art in Theory 1900–2000: An Anthology of Changing Ideas*, Oxford: Blackwell, 2003.

"In the process of our socialization, the very first contact with a public building is no less important than the moment of social confrontation with the father, through which our sexual role and place in society is constructed… the spirit of the father never dies, continuously living as it does in the building which was, is, and will be embodying, structuring, mastering, representing, and reproducing his 'eternal' and 'universal' presence as a patriarchal wisdom-body of power… The attack must be unexpected, frontal, and must come at night when the building, undisturbed by its daily functions, is asleep and when its body dreams of itself, when the architecture has its nightmares."

Louise Lawler, "Statements," 1986–87, *Projects: Louise Lawler*, New York: Museum of Modern Art, 1987.

"The effort of my work is to show the habits and conventions of looking at art by taking on aspects of the system to make it visible… I am showing what they are showing: painting, sculpture, pictures, glasses and words on painted walls furnishing the same material experience; my work is to exchange the positions of exposition and voyeurism. You are standing in your own shoes."

"Albert Oehlen in Conversation with Wilfred Dickhoff and Martin Prinzhorn," *Kunst Heute* 7, Cologne 1991; in English in C. Harrison and P. Wood, *Art in Theory 1900–2000: An Anthology of Changing Ideas*, Oxford: Blackwell, 2003.

"I think the main thing as an artist is that you realize that art leads a life of its own, that is, quite independently of the reality of social life, or work, etc. And realise that art cannot intervene in life, irrespective of whatever heroic ideals you may entertain… [T]o pretend that art itself can make life better is a lie. And this lie is useful to certain ideologies, and is indeed required by them. So you pretend that if we could all go out and do a lot of painting then the world would be a better place. The reality is that if the world were a better place, then we wouldn't need to do such senseless things as painting pictures, making pottery, that sort of thing. Absolute utopia is a world without art because living itself would be the art: a liberated form of work, a liberated form of life. If you want to try and imagine pure happiness, art wouldn't have any place there any more."

6
Marks of Identity: 1985–2000

The perplexing change that came over the visual arts in the later 1980s or early 1990s was the reintroduction of the image into made forms. This may sound uncontentious. Since all art is at one level image, what significance could its reappearance really have? The change might be called an iconographic turn: requiring the reinstatement of the image and a commensurate diminution of the compositional, material organization of the work—even an illusion of theater in which the spectator may be involved. Narrativity, its other name, has delivered virtually unanswerable challenges to the founding principles of modern art, in particular to its languages of form. For narrativity overflows with speech-like activities such as telling, indicating, suggesting, even explaining. On the face of it, such art has its origins in mass culture, and has then taken its battery of connotations to the fields of bodily experience, personal and racial identity, to the stories, questions and "issues" that so much art today tries to address. Anathema to Modernists, especially Modernists of the formalist kind, this art has upset the applecart of criticism in ways whose effects are still impossible to foresee.

Narrating the Body

A late-1980s floor-positioned work by the American Robert Gober, for example, though taking a Minimalist, generally circular form, solicited the observer's attention in ways that bristle with signification and counter-signification, both to the readymade and to the real [Fig. 6.1]. There is a dog basket, an absent dog, a sheet on which images of a sleeping white man and a hanged black man appear. The white basket itself is homely and familiar, some three-and-a-half feet (111 cm) across, suggesting a large and perhaps unfriendly occupant. Far from sparking

Opposite
Vanessa Beecroft
VB 35 (detail), 1998
See fig. 6.9

6.1 Robert Gober
Untitled, 1988
Rattan, flannel, enamel, and fabric paints
10 x 38 x 44" (25 x 96 x 111 cm)
Collection Jacob and Ruth Bloom,
Los Angeles

Gober says: "It's such a good image, I think, because it yields so many different responses about what's happening. And then something's literally missing in the story, if you look at it as a story—and you kind of have to. You have to supply that: what was the crime, what really happened, what's the relationship between these two men."

off a discourse about art as a category, or the museum, or sculpture's past, Gober's work framed rapidly available associations with violence, race, America, domesticity, and perhaps death, in what amounted to a calculated rejection of earlier Minimalist strategies of reduction and abstraction. On hearing that words like "homely" and "homespun" were being applied to his work (intended moreover as derogatory, feminized words), Gober pointed out that this was exactly his purpose. He cited an entire generation of American women as supposedly his mentors: Cindy Sherman, Jenny Holzer, Barbara Kruger, Sherrie Levine. Their work is "meaty yet popular, enjoyable yet erudite," he said in their defense. In terms of behavior, self-image, and mode of address—let alone in terms of "content"— most male artists provided poor examples for Gober to follow.

Gober's deliberate "feminizing" of art through the incorporation of iconography points ineluctably to the fact that a key to the concept of "narrative" in late-1980s art lay in the sensibility and self-image of the male gay artistic community. It is too seldom noticed that so-called Postmodernist traditions in America and elsewhere—kick-started in the later 1950s by Johns, Rauschenberg, and Warhol—were based not simply on differences of lifestyle, but upon an emphatic rejection of male, heterosexual Modernist aesthetics and the various concepts of "expression" associated with it. Pop art provided the first camouflage for this feminized Postmodernism, and it was Pop art that staunchly heterosexual Modernist critics roundly condemned. Clement Greenberg, for example, condemned in 1967 what he called "Novelty Art" (the term included Assemblage, Op, Environmental Art, and Neo-Realism) for being "rather easy stuff… much closer to the middlebrow than to the highbrow, genuinely avant-garde thing." A year later, the year of student riots and workers' rebellions across the developed world, Greenberg was suggesting that "Pop was slowing to a halt… suffice to say that it goes down like candy… it's not *bad* art, but art on a low level, and fun on a low level too." Proto-Pop, by which he meant Johns and Rauschenberg, represented a culmination of Abstract Expressionism at the same time as a "canceling of its vision" (Greenberg's own words) in favor of the debased glories of mass culture and even kitsch. Greenberg did not notice, nor could he given his critical priorities, that mass culture had a gendered appeal and even an erotic one. As far back as 1968, Leo Steinberg had said of the "flat-bed" or "all-purpose picture plane" of Rauschenberg and Warhol, with its photo-journalist images and its suggestively narrative bent, that it had "made the course of art once again non-linear and unpredictable." It had implied "a change in the relationship between artist and image, image and viewer" that was

"part of a shake-up which contaminates all purified categories" — he meant the stable Modernist categories articulated by Greenberg and Michael Fried.

Although prefigured in the 1970s and even before, the moment of the early 1980s can be seen in terms both of the flowering of a feminized Postmodernism, and of the further problematization of artistic consciousness itself. Some of the critical terms of this emancipation were captured in a panel discussion that followed the *Extended Sensibilities* exhibition in New York at the end of 1982. In that discussion Bertha Harris, author of *Confessions of Cherubino*, *Catching Saradove*, and *Lover*, accused the "heterosexual appetite for usefulness" of persistently reinforcing "connections with history, inheritance, antecedents, friends, neighbours, tribes, and so forth, and in so doing giving us the illusion that a future exists." The singular privilege of the homosexual sensibility was "to make things stop happening." Harris suggested that the gay artist or writer cleaves to two principles: "first, that reality is interesting only when it is distorted, and second, that reality lacks interest because it is controlled by usefulness which is pertinent only to the heterosexual continuum. The positive decision our hypothetical artist makes is to attach himself or herself to the inexpedient and impertinent." Edmund White, author of *A Boy's Own Story* and *The Beautiful Room Is Empty*, though denying that "gay" was an ahistorical or trans-social construct, sought to define heterosexual tastes in terms of understatement mixed with control, of preachiness combined with a tendency to conformity. Affluent, white, male gay taste he characterized in terms of ornamentation, an interest in the luxurious proliferation of detail, an oblique angle of vision, fantasy, theatricality, and "in terms of content, an interest in, and an identification with, the underdog."

The irony of such ambitious generalizations lay in the fact that in 1982 their claims were just about to undergo a tragic and irreversible change of resonance. The emergence of AIDS in San Francisco, Los Angeles, and New York in 1981, its official recognition in 1982, and its rapid spread thereafter, meant that several members of the American art community were forced to reconsider the relation between art and its content in a new light. Harris's identification of "a human as well as an aesthetic need for risk" in gay and lesbian artists suddenly assumed particular and unwanted meanings. A new mood of activism suddenly prevailed. The New York art community, eloquently championed by the critic Douglas Crimp, called for education programs, non-discriminatory advertising, medical and social support agencies, and a recognition of the ways in which gay men and women had become progressively displaced as audiences for art. Not only was the interface between politics and art now rapidly changing, but the identification and description of gender within art-political discussion was evolving quickly too.

A further consequence of the AIDS crisis in America (it did not devastate the European art community in anything like the same degree) was a desire, for the most part unstated or merely implied, to put the prescriptions of left-wing and Conceptualist theory, identified as male, academic, white, and heterosexual, to one side. The experiences and images of the body, as opposed to the materials and devices

6.2 Robert Mapplethorpe
Man in Polyester Suit, 1980
Photograph

6.3 Robert Gober
Untitled, 1991–93
Wood, wax, human hair, fabric, fabric paint, shoes
11 x 17 x 44 ½" (28 x 43 x 113 cm)
Museum für Moderne Kunst, Frankfurt

of representation, became, in such circumstances, perhaps the dominant general concern among younger artists at the time

The spectrum of work identified with the gay community and its desire for non-stereotypical visibility now ranged from Robert Mapplethorpe's celebratory photo-works of the portrait head or the male anatomy, often staged in starkly sexual ways [Fig. 6.2] — work described by Edmund White as having "ended the invisibility of blacks" — to Robert Gober's more recent pieces simulating body parts in beeswax and placed in unexpected positions within the gallery space [Fig. 6.3]. Frequently decorated with candles or impregnated with plastic drains, such pieces resonated with a sense of the body's vulnerable, prostrate, and potentially hospitalized condition. "There was the butt with music, the butt with drains and the butt with candles," Gober said recently, "and they seemed to present a trinity of possibilities from pleasure to disaster to resuscitation." It comes as little surprise that Gober and Mapplethorpe's work — but particularly Mapplethorpe's — was regularly identified by illiberal, homophobic, or conservative critics (sometimes all three) as symptomatic of cultural backsliding or even catastrophe. Contrary to the tenor of Mapplethorpe's own remark that "I don't think there's much difference between a photograph of a fist up someone's arse and a photograph of carnations in a bowl," these critics complained of the display of "loathsome" or "bizarre" images, of pandering to sexual fantasies surrounding the black body, of the collapse of "decency" in American life and art. US Republican Congressman Jesse Helms led a campaign to indict Mapplethorpe for pornography. The far more subtle relationship between photography and sculpture, or between photographic texture and form in Mapplethorpe's work, was generally overlooked.

Before his death from AIDS in 1992, the artist and writer David Wojnarowicz became identified with a defiant dismantling of dominant images of gays as libertines or corpses, and with a vociferous opposition to government inactivity in the face of the epidemic. In *Untitled* (1992), Wojnarowicz directly identified the bandaged outstretched hands of a beggar with those of a crippled and hence marginalized AIDS-infected artist in need of care [Fig. 6.4]. The covering text, from the chapter "Spiral" in Wojnarowicz's book *Memories That Smell Like Gasoline*, ends: "I am shouting my invisible words. I am getting so weary. I am growing tired, I am waving to you from here. I am crawling and looking for the aperture of complete and final emptiness. I am vibrating in isolation among you. I am screaming but it comes out like pieces of clear ice. I am signalling that the volume of all this is too high. I am waving. I am waving my hands. I am disappearing. I am disappearing but not fast enough." Like Gober's,

6.4 David Wojnarowicz
Untitled, 1992
Silkscreen on silver print
38 x 26" (96.5 x 66 cm)
Edition of 4

The text on this work begins: "Sometimes I come to hate people because they can't see where I am. I've gone empty, completely empty and all they see is the visual form, my arms and legs, my face, my height and posture, the sounds that come from my throat. But I'm fucking empty. The person I was just one year ago no longer exists; drifts spinning slowly into the ether somewhere way back there."

Wojnarowicz's art was unashamed about narrative, imagery, and the signified, and is prepared to mobilize sign systems explicitly in order to comment directly on prominent issues of the day.

The approach taken by the Cuban-born artist Felix Gonzales-Torres was formally very different. He had attended the well-known Whitney Museum Independent Study Program in 1983, then joined the collective Group Material, and exhibited with them in the later 1980s and early 1990s. True to the theoretical sophistication of the students in the Whitney program, Gonzales-Torres made several quite distinct bodies of work without attempting to give them the appearance of a coherent whole. There were text pieces, light-strings somewhat after the example of Dan Flavin, photographs, and stacks of paper on which a phrase was mechanically printed, set in the gallery space without any pretence of durability or even finality of form. The latter Gonzales-Torres construed as a metaphor of human frailty at the time of his lover's decline toward AIDS-related death in 1991: viewers were invited to remove a sheet, hence making the stacks quite poetically disappear. "I wanted to do something that would disappear completely," said Gonzales-Torres. "It was also about trying to be a threat to the art-marketing system, and about being generous to a certain extent… Freud said that we rehearse our fears in order to lessen them… [so] this refusal to make a static form, a monolithic sculpture, in favour of a disappearing, changing, unstable and fragile form was an attempt on my part to rehearse my fears of having Ross disappear day by day right in front of my eyes" [Fig. 6.5]. As Gonzales-Torres was quick to understand, the stacks were a sort of reprise of Minimal art as well: a highly formal art now reinvested with several other meanings. Until Gonzales-Torres himself succumbed to AIDS in 1996, he was a closely followed representative of a new political, racial, and gender awareness in an art world long dominated by unimpeachably canonical figures.

The supposed theoretical rigor and formal purity of Minimalist art was a tempting target for several artists during the time of the gender wars in New York. In the *Ecstasy* series [Fig. 6.6], for example, Aimee Morgana (née Rankin) set up a Judd-like series of wall-boxes with peepholes that reveal highly charged sensuous or erotic scenes on the themes of Perversity, Possession, Sadness, Sex, Fear, Suffocation, Attraction, Bliss, and Fury. Protesting against male theory but equally seeking a position related to that theory, Morgana observed that "the system of logic which models our thinking process is showing signs of wear and tear." "Sometimes discourse fucks me nicely and I don't begrudge myself the pleasure," she

6.5 Felix Gonzalez-Torres
Untitled (Loverboy), 1990
Blue paper, endless copies
7 ½ (at ideal height) x 29 x 23"
(19 x 73.7 x 58.4 cm)

6.6 Aimee Morgana
The *Ecstasy* series, 1986–87
Installation view at Postmasters Gallery,
New York

continued provocatively. "Sometimes I like to use it to fuck it back—discourse as a sort of strap-on prosthetic dick." To vary the metaphor only slightly, her stated preference has been for "an exuberant orgy of mental gymnastics that would encourage a fluid interchange of meaning… the pleasurable rubbing of one idea against another to see what sparks fly."

When Morgana speaks of the "revolutionary power of women's laughter," one begins to understand the motivations that animate her own and others' modifications to the male Minimalist cube. Debby Davis has made cubes that are anything but pure: they are cast from the forms of compressed, dead animals. Extending Jackie Winsor's original feminist Minimalism [see Fig. 2.4], Liz Larner has exploited cubic and rectangular forms as containers of phials of disease or as lead-and-steel boxes covered with corrosive chemicals used in the manufacture of bombs. The art historian Anna Chave has proposed of male Minimalism that it embodies a rhetoric of power that in some of its more unwholesome manifestations aligns it with the social psychology of fascism. Spurning the strictures of leftist critics and Modernist theory alike, these protests called for the reintroduction of iconography, the social self, and the body into the framework of innovative contemporary art.

An equally urgent narrativizing agenda has also been followed, and again internationally, in relation to the concept of the "abject" body. Made articulate on a theoretical level by the publication in English of Julia Kristeva's *The Powers of Horror: An Essay on Abjection* (1982) and of a collection of writings by Georges Bataille in *Visions of Excess: Selected Writings 1927–1939* (1985), the term connotes anything that contaminates or defiles, anything that is surplus, ejected, or base, anything which evokes psychological trauma or threatens the stability of the body image. Mike Kelley has spoken of the prevalent "intense fear of death and anything that shows the body as a machine that has waste products or that wears down." John Miller's coprophile sculptures of the period [Fig. 6.7] set out to organize contradictions between the ubiquitous hygiene of the gallery and evidence of the "extreme" body of a kind seldom seen since the self-immolating performances of Hermann Nitsch, Stuart Brisley, or Gina Pane in the 1960s and early 1970s, or the even earlier coprophile installations by Sam Goodman and Boris Lurie of the No! Group in America during the years 1959–64.

The presence of bodily fluids—shit, piss, vomit, milk, sperm, and blood—in the work of the New York artist Kiki Smith has brought into focus, through narrative or iconographic vocabulary, the baleful hierarchy of the civilized body, which elevates the rational and functional while it represses the instinctual and emotive. Smith emphasizes that our bodies are constantly "stolen from us… we have this split where we say the intellect is more important than the physical: we have this hatred of the physical." She speaks of "reclaiming one's own vehicle of being here," of "integrating the spirit and soul and physical and intellect in a kind of healing and nurturing way, even if it should mean attending to those things that the body won't easily contain."

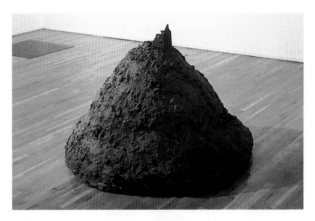

6.7 John Miller
Untitled, 1988
Styrofoam, wood, papier mâché, modeling paste, acrylic
34 ¼ x 48 x 42" (86 x 121 x 106 cm)

The sculpture depicts houses, tenements, and other buildings smeared with a brown substance, atop a fetid excremental pile. Its brute disregard of traditional languages of Modernist sculpture points to Miller's equally stern disregard for "art" in its more glamorous manifestations.

6.8 Sue Williams
Your Bland Essence, 1992
Acrylic and enamel on canvas
60" x 68" (150 x 170 cm)
Regen Projects, Los Angeles

Emphasizing that "women's experience is much more acutely through the body," Smith then reads that experience as a powerful social metaphor. "You're constantly changing, with a fluidity that's not to be lost," says Smith. "You're a flexible thing, not this inert definition."

In a related register, women artists have been refusing what they perceive as the over-cerebral tendencies of Conceptual art in order to articulate feelings of rage and frustration, particularly as (and on behalf of) victims of rape, sexual stereotyping, and homophobia. Sue Williams's painting style to begin with could be likened to that of badly drawn pictures and messages scrawled in desperation in public toilets. No longer comic or ironic but embodying the bitter voice of a rape victim in trauma, Williams's painting was for most of the 1990s a no-nonsense protest art that used the public arena of the gallery as its billboard. She used a faux-naïf graphic style to propagate a range of feminist concerns: the attitudes prevalent among men toward the women they profess to love, the confusions of the porn/anti-porn debate, the censorship of sexually explicit art in America by the National Endowment for the Arts (NEA), and other topical causes of disquiet [Fig. 6.8]. It was also determinedly ugly, as painting goes. But the issue was not whether its ugliness disqualified it as art—on the contrary, a commitment to certain kinds of ugliness has often been a precondition of art—but

whether the venom of its attack would sustain Williams's art enough to prevent it from sliding back into well-mannered style. It so happens that Williams has since developed a sort of decorative abstract style made up of long tube-like shapes resembling snakes, or the shapes of prosthetic phalluses. Her moment of rage was effective, but brief. Or else the demands of painting over "content" came to predominate once more.

A very different kind of bodily politics is to be seen in the recent projects of Vanessa Beecroft, who, like museum-aware Conceptualists before her—Buren, Charlton, Lawler, or Andrea Fraser with her pseudo-museum tours—has sought to engage the very dynamics of the space in which she works. Brought up in Italy amid the splendors of Renaissance paintings of naked and near-naked bodies, amid the conventions of looking at bodies that the old traditions of figure-drawing required, then trained in architecture, painting, and scenography, Beecroft in the later 1980s took the radical step of dispensing entirely with drawing to introduce the live model directly into the experience of the viewer. Signaling her difference from the auto-performances of the 1960s and early 1970s (Gilbert and George, Carolee Schneemann) in which the artist him- or herself would take to the gallery stage, Beecroft now hired groups of half-dressed young fashion models to stand, sit, assemble, or just vacantly exist in the gallery space for a designated time. Against the backdrop of a European tradition in which the female body is objectified in the gaze of the male patron of art, the near-naked presence of these defiantly lounging female groups was an immediate trigger of predictable anxieties in the hapless (even if critical) viewer: for looking was here being invited, but in the same instant cruelly repelled. Just what sort of attention was the viewer supposed to provide? The apex of Beecroft's work in the genre took place with *VB 35* (all her works are numbered) at the Guggenheim Museum—that space again—on Thursday, April 23, 1998 [Fig. 6.9]. Here, a group of fashionably slim models, "dressed by designer Tom Ford of Gucci" in expensive bikinis and high heels—a few without the bikinis—stood more or less motionless, staring vacantly ahead of them as those present looked on from the foyer or the lower stages of the Guggenheim ramp. The sense of occasion bestowed by the aura of Frank Lloyd Wright's museum, combined with the discernible whiff of scandal and celebrity

6.9 Vanessa Beecroft
VB 35, 1998
Performance at the Guggenheim Museum, New York, on April 23, 1998.

that animated the invitation-only event, had the effect of heightening the models' presence and nicely dramatizing the often-disputed power relations between viewer and viewed. One was *not* allowed to speak to the models, walk among them, or infiltrate their space. Any viewer aware of the phenomenological conventions established in Minimalist art, in which the viewer's own presence became relevant to the frame of what could be experienced, would have been quick to reflect that Beecroft had employed essentially the same device—but with a sexual charge. It was a form of self-awareness that tended to reflect rather poorly perhaps on the male viewer's self-possession. The critic Dave Hickey found the words to express what many of the rest of us truly felt: "We found ourselves

6.10 Kara Walker
Insurrection! (Our Tools Were Rudimentary, Yet We Pressed On), 2000
Cut paper and projection on wall
11'9 ¾" x 21' x 32'10" x 10'9" (3.6 x 6.4 x 10 x 3.28 m)
Installation view
Collection of Solomon R. Guggenheim Museum, New York

unkempt and slovenly in our clothing, confronted with the cool authority of art's nakedness, and we had no role to play. Neither worldly enough to stare—to reimpose the distanced logic of the gaze—nor innocent enough to accept the world in its nakedness and opacity, we drifted and loitered." The additional and critically remarkable fact that the ancient terracotta figurines of the army of the Chinese emperor Qin Shihuangdi were on show elsewhere in the Guggenheim succeeded in lending to Beecroft's nonchalant female figures a modishly timeless look.

Deep cultural significance may be read into the fact that—at least until very recently—all of Beecroft's fashion models have been white. For no account of female experience in American art would be complete without reference to the African-American heritage and to the history of slavery in particular. The young black artist Kara Walker, who represented the USA at the São Paolo Biennale in 2002, has acted as a lightning rod for the discussion of racial stereotyping since her debut around a decade ago. She has displayed paper silhouettes of lewd and often horrific narratives that celebrate the African-American tradition at the same time as evoking the prejudice that white America still bears against it. It is not an easy performance to pull off. When Walker first exhibited her stereotypes, older black American artists like Betye Saar protested against their negative, bodily crudity—a controversy upon which Walker has thrived. Generated from books she came across while working as a bookstore assistant in Atlanta—Harlequin romance novels and books on colonial history—Walker's strong signature format exposes viewers to their own confused emotions in front of the image. In a characteristic Walker cut-out (as indebted to Goya's black paintings as they are to the works of her acknowledged heroes Warhol and Basquiat) she performs a virtuoso scissoring of scenes into which the viewer may read many things: sexual dalliance, oppression, excretion, vomiting, violence, and the rampant exhibition of childish desires. In an impressive three-part work first presented in Geneva in 2002 bearing the provocative title *Why I Like White Boys. An Illustrated Novel. By Kara Walker, Negress*, her cut-outs were suffused with colored lights and shapes as well as the silhouettes of gallery visitors themselves. The cut-outs of the section shown here, collectively entitled *Insurrection! (Our Tools Were Rudimentary, Yet We Pressed On)*, suggest a plantation idyll disrupted by images of a slave girl fellating her master, followed by violent revenge in the form of a white man being disemboweled by his kitchen staff in front of three high Gothic windows [Fig. 6.10]. The format, of course, is that of the nineteenth-century silhouette postcard crossed with the Rorschach ink-blot, into whose outline one is invited to "read in"

moments of violence or fantasy. But there are moments of high seduction too. "I really wanted to find a way to make work that could lure viewers out of themselves and into this fantasy," Walker has said. "Seduction and embarrassment and humour all merge at a similar point in the psyche—vulnerability." Other prominent black artists such as Adrian Piper and Carrie Mae Weems have also pushed at the boundaries of contemporary black subjectivity, but it is Walker's bold new fantasies that have really ignited the debate.

West Coast Postmodernism

Another kind of identity politics in the visual arts may be charted with respect to whole geographic regions. The Los Angeles area has developed very distinctive cultural manners—distinctive enough for international status and ambitious enough to warrant recognition even in far-off New York, as well as further afield. At least since the early 1950s—when Los Angeles artists trained under the generous allowances of the GI Bill (1946) and when the likes of Wallace Berman, George Herms, and Wally Hedrick made decisive contributions to "Beat" culture and when Ed Kienholz and (later) Bruce Conner, John Baldessari, and Ed Ruscha began to develop a wry Conceptualism unique to their milieu, Los Angeles and its northern sister San Francisco have pioneered a kind of hedonistic but skeptical regard for mass culture that is unmatched throughout the world. The international regionalism of Chicago might well be compared.

We shall begin with an articulate painter who exemplifies many of the best qualities of south Californian art since the 1980s. Lari Pittman was a student at UCLA from 1970 to 1973 before moving to the California Institute of the Arts (CalArts), where under the influence of artists such as Elizabeth Murray and Ree Morton [see Fig. 3.23] he developed a vividly polymorphous style. Ostensibly based on decoration and pattern, his painting manner is in fact rich and internally contradictory, and devoted entirely to issues of taste and gender identity in a culturally highly

6.11 Lari Pittman
This Wholesomeness, Beloved and Despised, Continues Regardless, 1989–90
Acrylic and enamel on two mahogany panels
10'8" x 8' (3.25 x 2.44 m)
Los Angeles County Museum of Art

self-conscious register. Exchanging the traditional methods of oil on a canvas support for acrylic on a wood panel—and addressed flat on a table rather than upright—Pittman constructs what he calls "simultaneities," rapid and usually garish contrasts of suffering and relief, pleasure and pain, fast and slow, left and right. Pittman is interested in all the icons and symbols that should not be allowed to exist in fine art, and puts them in unashamedly: ejaculations, blood, sexual invitations or expletives, entreaties to the viewer, foul geometries, and banal patterns, all circulating polymorphously (as he would say) before the viewer's astonished gaze [Fig. 6.11]. About his paintings he has said that he wants the viewer to be polymorphous too, to feel ambiguous about the work, even to feel sorry for its tasteless iconography and arch patterns. He "wants to make the world a junkier place," to recast the high moral discourse of heterosexual Modernist art on the plane of utterly explicit contradiction and excess. In a work of 1991, *Transubstantial and Needy*, by writing the words "Get Out!" on the painting surface, Pittman supplies an injunction that recognizes the work's sensory overload and scandalizes the Modernist canon simultaneously.

6.12 Nancy Rubins
Topanga Tree & Mr. Huffman's Airplane Parts, 1987–89
6000 lb (3000 kg) of airplane parts, steel
Approx 40′ (12.2 m) high
Installation in Topanga, California

The viewer can escape whenever he or she wants to. In reference to his ethnic identity Pittman has drawn attention to the hybrid quality that perhaps underlies his entire creative project. The offspring of an Anglo-Saxon Presbyterian mother and a Spanish-Italian South American Catholic father, Pittman like many artists has had to understand his origins in cultural terms—and has come to work with the contraries of rationality and joy, sequential and simultaneous time, compositional structure versus anarchic and sometimes violent contrast.

The critical dilemma that such an artist presents to East Coast criticism must be graphically clear. Pittman has described himself unwaveringly as a Postmodernist painter: he means he has outgrown heterosexual aesthetics and white Ivy League standards of intellectual seriousness. From a perspective outside the region it could well appear that West Coast artists (Bay Area Modernists like Richard Diebenkorn excepted) never understood Modernist painting from Manet on, and never grasped how politics and self-reference were really the work of the signifier, as opposed to the signified—painting and the handling of materials, as opposed to ostensible subject matter or topic. From inside the region, it

seemed that neglect of the signifier was a transgression that no art of quality could ignore. All the more reason then why Angelino curators should want to build on that regional reputation and drive it further and harder toward its limits.

The tendency can be illustrated by the show *Helter Skelter: LA Art in the 1990s*, held in Los Angeles early in 1992, which set out to celebrate what its chief curator, Paul Schimmer, called "the darker side of contemporary life," the visions of "alienation, obsession, dispossession or perversity typical of the City." Often associated enthusiastically with a depraved *fin de siècle*, Los Angeles culture was now represented as in thrall to apocalyptical scenarios of necrophiliac sex, fantasy violence, drug-induced alienation, or plain fear. *Helter Skelter* contained the extraordinary oversize sculptures—that may not be the word—of Nancy Rubins, which piled up mountains of deteriorated cast-off rubbish such as mattresses (a museum installation) or broken lorry and aircraft components, with caravans, fridges, and the like in appalling disarray amid trees and parkland [Fig. 6.12]. In Europe such a work might be regarded as a play of one sculptural aesthetic against another—culture versus nature—or as photo-documentation; yet in the context of West Coast traditions it was understood to "characterise current events, city life, the nightly news, this country's official domestic and foreign policies." Excerpts of new fiction writing by Benjamin Weissman, Dennis Cooper, and Amy Gerstler were interleaved throughout the catalogue to heighten the atmosphere of paranoia and threat. The paintings of an artist like Robert Williams [Fig. 6.13], who worked on hot-rod customizing and *Zap Comix* in the late 1960s before coming to art, can be distinguished from their comic-book sources mainly by their commitment to visual and narrative overload, functioning as a formal counterpart to that disorientation and exoticism that some other West Coast artists have liked to call their own. Other varieties of millennial reflection from the Los Angeles region were represented in *Helter Skelter* by the art of the Philippines-born Manuel Ocampo, the performance and video art of Paul McCarthy, and the cynical collage meditations on the institutionalized violence of corporation, church, and state by Llyn Foulkes.

Let us look briefly at the work of Paul McCarthy, an artist with strong ties to CalArts and its distinctive teaching ethos. McCarthy began doing performances and films in 1967 and has lived and worked in the Los Angeles area since the 1970s; yet all of his work has an existential quality that binds it to far wider reaches of Western culture and thought. A list of his "Instructions" for playfully trangressive actions in the later 1960s and early 1970s had contained items such as:

6.13 Robert Williams
Mathematics Takes a Holiday. Scholastic Designation: The Physics of Relative Motion Brings the Victim to the Bullet as the Ratio of Abstraction Is Always Altered in Favor of Those Who Find It to Their Advantage to Judge the Moon as a Hole in the Sky. Remedial Title: Piss-Pot Pete's Daughter Soils Apache Loincloths on a Jabberwocky Trajectory, 1991
Oil on canvas
40 x 46" (100 x 120 cm)
Collection Robert and Tamara Bane, Los Angeles

6.14 Paul McCarthy
Bossy Burger, 1991
Performance video installation

6.15 Larry Johnson
Untitled Negative (H), 1991
Ektacolor print
5'1" x 7' (1.5 x 2.1 m)

Like Warhol, but with greater menace, Johnson is interested not in emotion but in "the precepts that accompany emotion: the confession, the self-explanation, the release, the testimonial, the testimony, the things that have come to signify what is meaningful" rather than the supposedly meaningful in itself.

Pile Dirt On Your Desk (Spring 1969)
Paint All Rugs In the House Silver (Fall 1969)
Pounding A Line of Holes In the Wall With a Solid Steel Rod (Fall 1970)
Use Your Head As a Paintbrush (Fall 1972)

—actions that ostensibly expressed frustration or rage but in another way evoked a wider sense of the absurdity of existence or the world (Beckett's *Waiting for Godot* has been a reference point for McCarthy). As the artist has said, "the experience of being confronted with my existence was suddenly overwhelming… I was confronted with nothingness, why was there anything, why was there something?" McCarthy's remarkable performances have perpetuated that air of absurdity, that elemental distrust and indeed carnivalization of all that exists. Seemingly half-violent and half-mocking, they perpetually cast a cynical light on the icons, the characters, and the mores of American (and hence global) popular culture. Replete with eating, sex, defecation—all quite artlessly and mockingly simulated—observers have often tried to pose probing questions about the artist's traumatized psyche, his upbringing, and so forth. What personal meanings can be invested in those liquids, those orifices, those masks, that blood-colored ketchup? The performance/video known as *Bossy Burger* of 1991, for example, has the artist dressed up as a burger-bar attendant in the persona of the *Mad Comics* anti-hero Alfred E. Neumann—until the actions become puppet-like, even disgusting [Fig. 6.14]. Filmed on video and exhibited at the Rosamund Felsen Gallery in Los Angeles, *Bossy Burger* was staged on two left-over sets from the discontinued TV sitcom *Family Affair*, in which a burger bar of that very title could still be seen. Rather than the antiseptic jollity of the TV show, McCarthy's on-screen performance has the Alfred E. Neumann character conducting a sham cooking lesson before the camera-audience, splattering ketchup and mayonnaise, stumbling about idiot-style, and howling and babbling in a ghoulish parody of to-the-camera cooking

instructions. A violent shift to the signified it may be—but the matter is never quite so simple if the work is to register effectively as art. Notice, in this connection, that McCarthy shies away from questions about meaning and reference. In keeping with the early smearing performances of Shiraga, Yves Klein, and even Pollock, we find it is mess in and for itself that commands center stage, the "release" of instinctual disorder from the constraining channels of sobriety and decorum. The artist's own psychic investments probably are irrelevant—and he recognizes this. His performances "involve a separation from my personality," McCarthy has said; "the act of creativity itself has to do with the separation from

personality." Second, McCarthy took care to ensure that, while sketches and preparatory material and even the sitcom sets were exhibited alongside the video, *Bossy Burger* as a performance was never experienced live. Formally, the work was a video document of a performance, together with the static remnants of the space in which the performance had taken place.

The ever-present interplay between the materials of the signifier and the real-world events of the signified has formed the crucial critical problem of much modern art: the bearing of the former upon the latter and the latter upon the former constitutes the inner mechanism of even today's seemingly most scandalous work. To European eyes, at least, the altered balance between the two elements is what has given Californian art its adventurous good name. The mawkishly teenage sensibility of much of McCarthy's work (its plasticized Surrealism, its gawky violence and ejaculatory disorder) has formed an interesting leitmotif in a fair amount of West Coast Postmodernism—and in this register returns us to the identity of the regional scene.

We shall review here the work of Larry Johnson, Raymond Pettibon, Jim Shaw, and some aspects of the work of Mike Kelley. To look at Larry Johnson's recent work, to begin with, is to be made aware of various ironic levels of engagement with Hollywood animation language (specifically the Disney tradition) and the use of verbal texts in a superficially beguiling but at the same time deeply inauthentic register [Fig. 6.15]. The verbal rhyming, the graphic banalities, and the visual scenarios of Johnson's scenes all index a sub-teenage world of fantasy adventure, glib jokes, and mindless absorption in advertising messages. Johnson's works in this genre come in sequences, each one apparently more inconsequential than the last. Suffice it to report that Johnson is in favor of art that can be "got" in "about the same time as it takes to read a daily horoscope or beauty tip."

Or take Jim Shaw, who seems to sink back into the *Saturday Evening Post* world of the 1960s: his *My Mirage* narrative of 1987–91 utilized what he called "as many aesthetics of the period as could be crammed in." In the panels that compose the work, Billy the protagonist grows up a Christian, runs the gauntlet of secular temptation, and seeks innocence again in psychedelia, having read about it in *Time* magazine and watched it on CBS. Here we see Billy conjuring up fantasies from the paranoid world of Salvador Dalí [Fig. 6.16]. Elsewhere in the piece, Shaw has teenagers aimlessly speculating about the anti-heroes who absorb their free time: Donovan, Frank Zappa, Timothy Leary, and the like. Having them mildly flirt with involvement in drugs and other minor forms of criminality, Shaw knows (and knows that we know) that his characters are merely acting out rituals of fairly innocuous resistance to the social system to which they belong. In revulsion against his various forms of depravity, Billy becomes a born-again Christian in a ludicrous reach for innocence: an absurd story that parodies in the most obvious way a trashy literature of popular appeal as well as sending up the abrupt arrival of those narratives in art.

Raymond Pettibon, who completes the trio, also lies far to one side of East Coast or European sensibility and stands as further evidence (were it needed) that a "global"

6.16 Jim Shaw
Billy's Self-Portrait No. 3
Panel from *My Mirage* narrative, 1987–91
Oil on canvas
17 x 14" (43 x 35.5 cm)

6.17 Raymond Pettibon
Untitled (He Had Seen), 1998
Pen and ink on paper
16 x 22 ¼" (40.5 x 56.5 cm)

The inscriptions in Pettibon's graphic works can be read in any order and the layered images are not intended to constellate around particular meanings: rather, they combine the seeming randomness of a Dada poem with the prophetic ethos of William Blake—while complicating the traditions of both.

perspective on current art would be a vapid thing, even supposing it were possible at all. Like other Californians, Pettibon's fascination is with the word-image mixtures of popular culture, with faux-naïf effects in both registers, and (most controversially perhaps) with the aesthetic potential of the joke, *manqué* or not. Let us look at his relationship to literature first. Pettibon's method is to take a range of comic-book graphic effects—the excessively crumpled suits, the botched facial expressions, limbs, and anatomies drawn in just the wrong way—and surround them with literary quotations, snatches of conversation, and everyday cliché, except that the different registers collide or intentionally whiz past each other [Fig. 6.17]. The artist has told Dennis Cooper, whose writing he often works out of, that the text-image clashes are characteristically about "making associations… I think when my work is successful… well, one of my standards is to look at the image and consider that this is something no one else in the world could have come up with"—Pettibon refers approvingly to the great *New Yorker* cartoon tradition whose graphic wit has seldom (as I concur) been surpassed. As for the literary quotations and excerpts that populate Pettibon's drawings, they form an incongruous mêlée of portentous nonsense, overheard conversation, and fragments and *bons mots* from Henry James (a particular favorite), Hawthorne, and Ruskin. Mix them together with surfing, baseball, or Batman images drawn finely in black, blue, and brown ink, and you have a species of vacuousness seldom before encountered in the fine arts. Where images and texts collided hypergolically in 1930s Surrealism—on fire with meaning and often armed with menace—Pettibon's disjunctions sail past each other inconsequentially, but they do so, paradoxically, with pride. This is a conclusion that is to be taken straight. For Pettibon has withdrawn from the jaded world he observes, to draw compulsively, as teenagers do in their bedrooms alone.

What does this general enthusiasm for disaffected teenage sensibility signify? The answers are both obvious and obscure. Given that youth culture has constituted one of Western civilization's most potent inventions since the 1950s, it is surprising that its actual mores—as opposed to its advertised qualities—did not surface more fully before. Though its ostensible content is puerilism and miscreancy, the aesthetic strategies of this so-called "bad-boy" or "bad-girl" art are in actuality neither puerile nor miscreant. From the messy adolescent confusions of Jim Shaw's Billy or Larry Johnson's camp nostalgia to other explorations of the genre, such as the painful world of sexual discovery delineated in Larry Clark's photo-essay *Teenage Lust* (1975) or the world of the cowboy junkie in his *Tulsa* (1971), or the transgressive biking and clubland

gangs of Richard Prince's recent work—it cannot be seriously denied that the work of this grown-up adolescent generation in California has established a certain *vérité* in the face of their experiences and their history. And camp is no longer apolitical, even if Warhol might have once claimed it was. Second, the new puerilism signifies effectively how artifice is frequently the key term in dominant constructions of all social and sexual identities. More cynical and worldly than most of Pop art—its protagonists are now well into their thirties or forties—this puerilism must be credited with a thoroughly adult understanding of the ironic tone. It has discovered an unexplored arena of primitivism, eroticism, and literary and graphic perversity all rolled into one. Its attention to adolescence as a transitional phase between childhood and adulthood may even be seen to have prepared the ground for similar incursions into the hidden lifestyle agendas of the middle-aged or the very old.

As for history, Californian Postmodernism has had its own kind of eloquence, the artists of this generation having grown up amid the social wreckage of the Vietnam War, the Manson killings, Patty Hearst, hard narcotics, and the disillusionment of punk. As the critic Robert Storr put it in a fine recent essay on Pettibon, during the youthful careers of this generation, "America veers to the doom-predicting right while the left atomises, liberalism goes weak at the knees and what remains of the counter-culture is bought out by movie moguls." In the difficult task of reading this fallen world, Pettibon is an expert, affirms Storr, even though none of the voices of his texts is in any sense authentically his: "Mixing black humour with chilling pessimism, stock characters out of 1940s and 50s melodrama with first-hand observations of 60s, 70s and 80s hustlers and deadbeats, Pettibon has served up an original mythic version of an internal America that has the creepy ring of truth."

Slackers (and Others)

The concern for displaced or damaged identities described in the last section—much of it located in the image of America as a nation suffering arrested psychological growth—has had certain consequences for the manner in which art is displayed. Pettibon, to mention him once more, often displays his work in random wall displays where dozens of drawings of varying sizes jostle unassertively for the viewer's attention. Display style matters. So it is no surprise to find that "bad-boy" or "bad-girl" artwork has often slipped from the wall-space to the floor, naturally converging with the drastically overused concept of "installation," in which a total space or scene is animated by artistic work. It must be admitted that the installation format has often proved hospitable to the narrating of private, relocated, or imaginary identities, since the installation can fictionalize a space in a way that single objects seldom can.

Installation—the idea descends from Dada and Surrealism and re-emerges in Fluxus, Conceptual art, and other radical movements such as German sculpture of the 1980s—involves guiding attention away from singular objects onto complexes and

6.18 Laurie Parsons
Stuff, 1980
Branches, rocks, debris, etc.
16 x 1200 sq. ft. (40.6 x 365 sq. m.)
No longer extant

Stuff hovers ambiguously between a project that was never finished and a document. Parsons says that "it was just a photograph of an outdoor spread of natural material. I did collect the whole tableau, but then it was inadvertently discarded from the space [where] I had been keeping it." She adds: "Sooner or later I would have done so anyway, I'm pretty sure."

6.19 Laurie Parsons
Bedroom (detail), 1990
(Painting on rear wall by Karl Klingbiel)
In situ

relations within the viewing space, where that space is now taken as a physical context rather than as a hygienically Modernist background for the display of several works. In other cases it is the space itself and its character that become the very topic of the work.

Though prefigured by Michael Asher and Chris Burden in the later 1960s, the newer tendency is well exemplified by the paradoxes presented by the young American Laurie Parsons. She came to attention around 1986 for exhibiting some broken pieces of wood from derelict buildings, neglected items of physical trash, or the results of chance encounters — Japanese mystics would call these *wabi-sabi*, denoting the look of the weathered detritus of the physical world. In some ways Parsons's loose assemblies of cast-off materials take into three dimensions many of the adolescent concerns that the California artists were exploring in two. Photographing random collections of debris or already familiar scenes "as thoughts, forays, whatever," Parsons lodged the resulting slides with her dealer, only sometimes counting them as art [Fig. 6.18]. For a show in New York in 1988 she exhibited her own desk, littered with the usual papers in disarray — but in the back room, not in the gallery space. For a 1990 show at Lorence Monk in New York she exhibited her bedroom and everything in it, including a checkbook lying on the table [Fig. 6.19], while for a second show at the same gallery the space was left empty. That very antithesis tells us something: "I struck upon serving up the objects of my life, parts of myself. But from the start I took it idly, not 100% seriously, because it did not seem like much of a solution to my issues with objects by that point, and exhibiting for that matter. I was generally becoming more interested in considering the frame of these situations, the interaction with personal, as all not simply tangential to a main experience [*sic*]… I'm interested in broad creativity, in fringe activity and inclinations." "My modus operandi is very intuitive," she writes me in another letter; "I don't mind doing nothing, and only 'do' things that feel right, that come compulsively delivered." As the critic Jack Bankowsky has pointed out, it's more or less the world of Richard Linklater's 1991 film *Slacker*, the world of the "pre-semester doldrums of a middle-American university town," in which slackers — drifting student types grouped aimlessly around a series of cultish interests — "worship at their own jerry-built altars and proselytise for a private religion." For such figures, "anarchy percolates… but never exceeds a slow boil." It was in this spirit that a 1991 installation by Jack Pierson entitled *One Man's Opinion of Moonlight* ushered the audience into a simulated bohemian walk-up,

replete with a set of drawers full of what drawers always seem to be full of: empty matchboxes, coasters, a dead battery, pencils, and the like. But if Pierson has lived within the image-system of the aimless bohemian, drinker, or uncoordinated student type, Parsons has cultivated a lifestyle of faux-naïf "honesty" that she wants (occasionally) to have counted as art. Telling us that she wants to make art beyond the gallery, evade the institutions of art, re-encounter the real—all vanguard attitudes of the 1960s, if not before—Parsons has made unsettling but attractive works that offer striking opportunities for negotiating a practice to one side of, but still within, the art institutions she so evidently doubts.

6.20 Karen Kilimnik
Madonna and Backdraft in Nice, 1991
Fog machine, black velvet, fish line, flashlight, fireman's helmet, 2 hats, cellophane, photographs, electric fan, and cassette tapes
Dimensions variable
Installation at the Villa Arson, Nice

A similar appetite for the half-finished within the compass of an adolescent life can be found in the installations of Karen Kilimnik. Her "slack" art has taken the form of specific re-creations of scenarios whose identity is intentionally unclear. One enters a disordered space in which, apparently, something either has just happened or is shortly to happen. Nothing is especially clear. Objects and surfaces are at their neglected, unswept worst. Kilimnik's *Madonna and Backdraft in Nice* combined the imaginary detritus left by the singing star (who had recently been in Nice) with *Backdraft*, a film about firemen: the installation took place at Villa Arson, the reference of whose name is obvious [Fig. 6.20]. Such installations can on the one hand be read autobiographically: "I'm such a slob," says Kilimnik, "everything seems destined to wind up on the floor as though I was too lazy to pick up whatever it is." Better, they can be read as the artist's response to glamor-stars and their super-charged lifestyles—in this case Madonna—from the point of view of someone who has just missed the show. Reality and illusion deftly combine. For to describe Kilimnik's installations this way is to position oneself as a spectator of the static theater presented. It is to accept the objects and remnants displayed at face value, in terms of the story they suggest or the real-life scenario they simulate, but it is also to acknowledge that theatricality—the *bête noire* of formalist Modernists in the 1960s—has developed to the point where narrative is constructed explicitly as illusion, but with all the iconographical richness that a static tableau allows.

Slack art in its generality works against permanence, durability, idealization. Given its preoccupation with the unfinished and the second-hand, it can also be construed as a reworking of the mechanisms of viewer expectation. For slack art works on the basis of a twin strategy of fascination and disappointment: fascination at the prospect of observing someone else's deserted projects or their personal junk (that most intimate of residues), accompanied by disappointment at finding the artistic spectacle so constituted to be seriously degraded or even radically incomplete.

6.21 Cady Noland
The Big Shift, 1989
Mixed media including pole, grille, rings,
flags, bug sprayer, bungee cord, handcuffs
5′6″ x 14′ x 6″ (1.6 m x 4.2 m x 15 cm)
Collection Jeffrey Deitch

In such pieces Noland loosely incorporates
"redneck" objects such as handcuffs and
flags with a deceptive informality suggestive
of what a *New York Times* critic called
"the struggles and emotional vacancy of
the American heartland, especially its
Southern half."

Slack art could also be seen as a rejection of the appropriation aesthetics of Koons, Bickerton, and Steinbach, which had just previously launched a meditation on the commercially and glossily new. The physically disturbing and visually quite threatening tableaux of another American, Cady Noland, though often comprised of new objects, partake of this same critique. When Noland arranges the props and devices of sporting events, police investigations, and nationalist emblems such as the American flag, she evokes a realm of institutionalized violence that seems somehow redolent of the patriotic redneck areas of the Midwestern or Southern states. Yet the effectiveness of her pieces lies in her taking the hard paraphernalia of containment—aluminum, galvanized steel, and iron—and bringing these materials abruptly into (and against) the spatial vehicle of the gallery with a startling confidence that gains from their very unsuitability as art [Fig. 6.21].

In surveying such examples we encounter again and again a feature that has been mentioned already and that in fact has been central to the viewer's response to much of advanced visual culture from the time of Dada: disappointment. For not only is there very often little to see in the sense of articulate formal relations in the work—rhythms, affinities, inversions, and so on—but the materials used are often banal, dirty, broken, or of so personal a nature (Laurie Parsons) as to repel the voyeuristic eye. An earlier aesthetics of disappointment can be found in Robert Smithson's *Artforum* writings of the 1960s. In an essay entitled "Entropy and the New Monuments," Smithson had voiced a pioneering admiration for those "disrupted and pulverized" sites far from the neatly curated spaces of the city center. "Near the super highways surrounding the city," Smithson wrote, "we find the discount centres and cut-rate stores with their sterile façades... the lugubrious complexity of their interiors has brought to art a new consciousness of the vapid and the dull." Such a consciousness was successfully evoked for Smithson in the "monumentally inactive" contemporary works of Robert Morris and Sol LeWitt, only to reappear in the art of the later 1980s and early 1990s American slacker.

In Mike Kelley's installations, too, one is sometimes at a loss to know whether the vapid and dull are interesting at all: that, indeed, may be the very source of their interest. For Kelley belongs to the same generation of middle-aged artists who mobilized an adolescent sensibility to mock middle-class values of religious piety, family, and official history as symptoms of adult rationality. Born in the blighted Midwestern city of Detroit, Kelley trained at CalArts before entering the circuits of West Coast art—he "discovered" Raymond Pettibon's drawings in the later 1970s and has counted Californians Jim Shaw and Paul McCarthy as aesthetically close. A work by Kelley of 1988 entitled *Pay For Your Pleasure* had a series of crudely painted banners depicting forty-two writers, artists, and philosophers (of the order of Baudelaire, Goethe, Degas, Sartre, and Bataille) that bear quotations to the effect that genius is

outside the law. To emphasize the link between creativity and criminality, Kelley then arranged these banners along a corridor that led to a final work by a local criminal-turned-amateur artist: for the Chicago showing, a self-portrait by the Illinois mass child-murderer John Wayne Gacey, dressed as Pogo the Clown; for Los Angeles, the freeway killer William Bonin; for Berlin's *Metropolis*, the murderer Wolfgang Zocha. A collection-box near the door solicited donations for victims' rights groups [Fig. 6.22].

Under even that abbreviated description *Pay For Your Pleasure* can be seen to have embodied a principle that soon became endemic to Kelley's work, that of the inversion of values—the parodying of hierarchies, the replacement of high

6.22 Mike Kelley
Pay For Your Pleasure, 1988
Installation view at the Renaissance Society at the University of Chicago, 1988

with low and of low with high—partly in a spirit of bad-boy pranksterism, but partly in the more serious philosophical register offered by Georges Bataille and his writings on excess, abasement, and abjection of the later 1920s and early 1930s. There, Bataille had fallen away from André Breton's version of Surrealism, had erected a counter-group of his own around his short-lived theoretical and pictorial journal *Documents*, and had worked up a position he called "theoretical heterology," whose project was to collect up the excremental remains in human thought and action, restore them to visibility, and then, finally, to so politicize the processes involved as to bring them into alignment with revolutionary postures and ideas. The most far-reaching and at the same time most generalized concept in Bataille's thinking and writing was that of the *informe*, or formless.

In his *Critical Dictionary*, written in the late 1920s at a time of crisis for Bretonian Surrealism, Bataille had written: "Formless is not only an adjective having a given meaning, but a term that serves to bring things down in the world, generally requiring that each thing have its form. What it designates has no rights in any sense and gets itself squashed everywhere, like a spider or an earthworm." Challenging the rational structures that mask the true essence of reality, Bataille advocated "affirming that the universe resembles nothing and is only formless," saying that to do this would be "like saying that the universe is something like a spider or spit." Recognition of the power of Bataille's thinking now enabled East Coast critics to bring much post-1960s art into alignment with his radical project: Robert Morris's anti-form sculptures, the dripping and splattering of Cy Twombly, Jean Fautrier, and Jackson Pollock, Piero Manzoni's *Achromes*, and much more. Such was the project of Rosalind Krauss and Yve-Alain Bois's important exhibition *L'Informe: Mode d'Emploi* at the Pompidou Center, Paris, in 1996, the accompanying book of which established new standards of subtlety in the conceptualization of postwar art. Mike Kelley, along with Cindy Sherman the youngest

6.23 Mike Kelley
Craft Morphology Flow Chart, 1991
Thirteen groups of tables with 113 soft toys
and black-and-white photographs
Installation at the Carnegie Museum of Art,
Pittsburgh, 1991–92

artist to feature there, showed a group of works that comprised soiled soft toys from the playpen in various guises: stitched into a wall-hung tapestry, mounted against each other in situations of mock violence or playful ambiguity, or simply positioned on a table top in images of gormless neglect [Fig. 6.23]. "I try to present the wear and tear of the prototype and not romanticise it," says Kelley, "because there's nothing I hate more than romantic, nostalgic art… My work is perched between nostalgic assemblage artists on the one side and this classical commodity art on the other side. It's not about idealisation." Of course, it is possible to read Kelley's various tableaux in terms of what they ostensibly refer to: childhood toys as evocations of nursery memories, blankets as reminiscent of the playpen. His work can be understood as an allegory of adult projections embodied in toy manufacture and use. Kelley makes the point that the doll as the perfect image of the child becomes feared and rejected—hence repressed—when dirty. It begins to speak of abuse and neglect, even becoming demonized as an unwanted presence. The myth of childhood innocence lies at the origin of the process: in modern, developed culture, says Kelley, "the doll pictures the person as a commodity more than most. By virtue of that, it's also the most loaded in regard to the politics of wear and tear."

On a second level, Kelley's transgressions are attacks on the taste and assumptions of avant-garde art itself: the Duchampian readymade now deployed with a truly alarming lack of grace. Significantly, too, Kelley rails against the high-mindedness of classic Modernism, especially its irresolvable dichotomy between abstraction (Mondrian) and expressiveness (Matisse), which Kelley transcends elsewhere in his work by appeal to low-art cartooning, grotesquery, and various paradigms of the feminine. Minimalist art—one of Kelley's central targets—is described by him as "reductive, essentially heroic primal forms [which] lend themselves easily to the role of the authority figure. Thus it is only right that we should want to defame them." Minimalist art, he says, is "something that needs to be pissed on." In the context of Bataille's concept of the *informe*, finally, Kelley's remaindered blankets and beaten-up soft toys in all their striking miserableness become defiantly attractive, "attractive because repellent" (Krauss's words), once more high because lower-than-low. The idea of abjection, far from being a "theme" referring to substances and processes (mostly of the body), becomes in Kelley's work a question of classification, a matter of measurement gone awry. In *Craft Morphology Flow Chart*, the project pictured here, Kelley sorted the soft toys according to size, texture, patterning, or some other irrelevant dimension: photographs were provided lining up each shabby specimen alongside a ruler in a grotesque parody of "normalization."

As Robert Morris showed in his *Threadwaste* sculptures of the mid-1960s or as Robert Smithson showed with his entropic "pour" projects of the time, unchecked quantities of garbage, liquid residues, or heterogeneous matter naturally seek the floor—hence lend themselves to the so-called installation idea. Yet my feeling is that

"installation" as a concept fails utterly to designate any aesthetic process apart from this drift to the unstructured, the horizontal, or the fluid material form. If we could legislate, we would abolish it. And yet despite this theoretical vacuity, some such projects have presented striking and significant gains.

Ilya Kabakov had been a leading Moscow Conceptualist in the 1970s. At that time, he composed wry "albums" recording the life-progress of invented characters whose private identities were markedly at odds with their designated social ones. Kabakov was also one of the founders of Collective Actions, which from the mid-1970s performed Minimalist or empty performances in remote locations in reaction against the cultural poverty of life in the major cities.

His first journey outside the Soviet Union took him to Czechoslovakia in 1981, the year of his celebrated essay "On Emptiness," and the beginning of his *Ten Characters* series that would continue for most of the decade. In the spring of 1985 an epochal event was to shake the foundations of Western politics and society. On the death of KGB hard-man and Soviet First Secretary Yuri Andropov, a new appointment was made in the person of Mikhail Gorbachev, who announced a *perestroika*, or reconstruction, of Soviet society along liberal market lines: *glasnost*, or openness, was to characterize that policy in theory. In practice, political prisoners were still being arrested and psychiatrically detained, and statues and other monuments to the Soviet past were still being erected, right up until 1991 when the USSR was formally disbanded as a political entity. In that interval, ambitious and already well-connected artists of the stature of Kabakov were able to emigrate through Israel to New York—in Kabakov's case with the help of the Ronald Feldman Gallery, whose commercial interests were involved. There followed a group of installations such as *The Man Who Flew into Space from His Apartment* (1988), in which Kabakov reconstructed the domestic remnants of a man who confronts an identity crisis by catapulting himself into space through the roof of his cramped quarters in a Soviet-era communal dwelling house. Such works shared with American slack art the ever-interesting, sometimes voyeuristically enticing impression of the authentic human trace, from which any real-life presence has recently departed and from which a nostalgic aura of loss, transience, and material chaos has arisen. In a multi-part work of 1990, Kabakov constructed an explicit story out of the very props and devices of someone's art. The viewer walked into a crowded labyrinthine space inhabited by large-format paintings of "happy" Communist life such as a construction site and a camp for pioneers—painted of course by Kabakov himself. They were placed, however, in "terrible disorder in two rows," Kabakov explained. "On some of them for some reason clothes are hanging— underclothes, socks, shirts: the paintings are partly realistic, and partly depict all kinds of plans and schedules." Texts lay nearby on a table, telling how an inhabitant of a crowded apartment "becomes tormented by the fact that he doesn't fulfil his obligations to do things at a certain time, to meet deadlines. He begins to go crazy, hanging up his clothes on these schedules and regulations, right down to his underwear. He hangs out everything that he has, then runs from his 'Red Corner'

6.24 Ilya Kabakov
He Lost His Mind, Undressed, Ran Away Naked, 1990
Installation

6.25 Jessica Stockholder
Flower Dusted Prosies, 1992
Floor tiles, paper, wool, cushions, newspaper mache, roofing tar
Room: 13 x 64 ½ x 21' (3.96 x 19.6 x 6.40 m)
Installation at the American Fine Arts Co., New York

naked." Kabakov is eloquent on the possibilities of the installation genre. "By its very nature," he says, "it may unite—*on equal terms*, without recognition of supremacy—anything at all, and most of all phenomena and concepts that are extraordinarily far from one another. Here, politics may be combined with the kitchen, objects of everyday use with scientific objects, garbage with sentimental effusions" [Fig. 6.24]. More recently Kabakov has said that the technique of installation art "consists in ensuring that the viewer can never for a single moment grasp whether he is confronted by an image or a thing… in my case the game is played in such a way that the viewer cannot work out whether he is confronted by ethnography or a semiotic system… An installation is a technique of producing a critique, of constant, permanent, criticism!"

One other seminal project in the installation mode bears close examination in the present context. The Canadian-born Jessica Stockholder has built interior gallery structures from the mid-1980s to the present day that achieve a kind of resolution that others have seldom even attempted: a rich melding of painting, sculpture, and architectural work that resonates with the formal values of articulate color as well as an extraordinarily sensitive attitude to process, to building, and ultimately to decay. Through the decade to 1995, after studying both painting and sculpture at Yale, Stockholder would assemble cast-off materials, elementary building components like 4 x 2 timbers, wire, blankets, paper, and plastic fabrics and take the physical and psychological parameters of a given gallery space before "inhabiting" it (she follows Gaston Bachelard's *Poetics of Space*) with combinations both metaphorically and metonymically attuned, yet lacking a clear, formulated, or narrative line in the resulting ensemble. Despite the obvious signs of process in her installations, she has insisted that "narrative" is not the right word: "There is a kind of building or layering of meaning that results from the literary content of the objects I use, but the structure is not linear. There is no beginning, middle or end. My aim is to throw the net as wide as possible, even while there are focused areas of literary meaning that develop here and there." To experience Stockholder's larger installations, then, such as *Flower Dusted Prosies* (1992) is to witness multiple procedures and strategies that trigger remote associations with the history of art as well as forging new material affinities. We see nods and hints toward Russian Constructivism, formalist color painting—some by male and some by female artists—Pop art, even Minimalism in so far as economy and volume come into play [Fig. 6.25]. Lights animate volumes, volumes flatten out to form painted surfaces, flimsy gives way to solid, concave to convex, patterned to plain. To say definitively what the work is about is precisely contrary to the point: "My work has always grown from an attempt to

gain a sense of control of, or at least comfort with, the material world," Stockholder has written. Steering away from literal semantics or narrative, then, the viewer is returned to a purely abstract level of conceptualization around notions of work and material, one that the artist has made articulate in her own way.

Millennial Moods

Despite the prominence enjoyed by installation art of all kinds, it was also to painting in its more or less traditional format that we could refer for signs of a change of tempo—more precisely a change of mood—as the year 2000 approached. From his first paintings in the 1970s, which were unusually long horizontal panels divided into two virtually disconnected sections, the San Diego-born painter David Reed found himself wrestling with the formal problem of combining utterly contrary techniques— gestural and geometrical, monochrome and colored—within some kind of formal unity. His instinct was (and remains) not to choose between counterposed alternatives, but to have them both: deep space and shallow space, fierce improvisation and careful geometry, dramatic lights and darks, cool colors abutting the most sensuous, and so on. Such disobediences within the highly nuanced field of abstract painting took on their own significance during the 1980s when Reed realized not only that these extremities belonged to Baroque art, but that Baroque art seemed relevant again to the sensibility of the century's end. Visits to Italy, leading to a respectable working knowledge of Caravaggio and Rubens, functioned to underline Reed's presentiment that contemporary abstraction had to speak to a violent dissociation between expression and artifice, reality and theater, anguish and control. One other precedent, in the form of Frank Stella's important Norton lectures at Harvard in 1983–84, now informed Reed's evolving interest in the Baroque. When Stella had complained of the tired flatness of Modernist painting, he had pointed precisely to Caravaggio as providing "a working space that is perceived as real and palpably present"—including spatial organization that pushes and pulls, widens and vibrates, jostles and lies still. What Reed found he could achieve in paintings such as *No. 287* of 1989–90 [Fig. 6.26], then, was precisely

6.26 David Reed
No. 287, 1989–90
Oil and alkyd on linen
26 x 102" (66 x 259 cm)

such an unstable dissociation of focus, with inserted rectangular panels abruptly shifting the focus of what you see, launching ambiguities of scale and spatial position into an already lengthways elongation that forces you to look right and left in rapid succession. "The emotions I wanted," Reed has said of his flirtation with the Baroque, "occurred best in that very ambiguous space where you can't locate things—where you don't know if it's physical or an illusion." And yet I suspect that the claims made by Reed's paintings to have achieved contemporaneity would not have struck home without one further association: between Baroque spatial complexity and cinematic vision. For what Reed has begun to realize is that in narrative cinema as much as in seventeenth-century art—especially in cult classics such as Hitchcock's *Vertigo* (1958), filmed in San Francisco, the to-and-fro of emotion is sequenced just like the opening and closing of dramatic space in earlier art. Reed has claimed, in fact, that his Baroque-inspired paintings share a certain structure with the dream-machine of narrative cinema—and should be hung in bedrooms for the best results.

Such critical reflections could only have surfaced on America's East Coast, where despite his origins Reed's reputation as a painter has been made—the same location, in fact, where late Modernist painting has evolved most adventurously. Yet the sense of a millennial ending has been palpable in painting elsewhere. For instance, the mood darkens considerably when we cross the Atlantic to look at the work of the British artist Glenn Brown, who as one of the youngest participants in the 2003 Venice Biennale, and as an increasingly ubiquitous figure these days, may have much to tell us about the current self-understanding of this branch of art. At first glance we see the basic elements of Brown's method, which is to take an existing painting, even an Old Master from the tradition, and repaint it from a color reproduction in a method he has himself described: "I work on the underlying drawing, manipulating it, stretching,

6.27 Glenn Brown
Mark E Smith as Pope Innocent X, 1999
Oil on wood
21 ⅞ x 21 ¼" (55.6 x 54 cm)
Collection of Dallas Price-Van Breda,
Santa Monica

rotating and cropping it as if it were a skeleton of the work or an armature. Onto this I then apply an almost monochromatic base of two or three colours, which I then start working with, sometimes obliterating all the initial painting. In the last month or two of working on the painting, there will be no reference to the reproduction of the original painting." A kind of parodic exercise, then—of a Frank Auerbach, a Francis Bacon, a Dalí, a Rembrandt, a Fragonard—while being nothing less than a virtuoso performance in observation and brush technique: the effect is to painstakingly magnify the sort of expressive swirls that an Auerbach (for instance) might contain. Looking carefully at the series in which Glenn Brown reworked Frank Auerbach's *Head of JYM* of 1973, however, we realize something more: that he has managed to conjure not only the swirling paint but the out-of-focus peripheral forms that a fully sculptural version of the Auerbach might assume [Fig. 6.27]. He paints, that is, not an Auerbach, but a photograph of an Auerbach turned into a sculpture. And this in turn reveals to us that *trompe*

l'oeil is another tradition that Glenn Brown has attempted to join. Or as the artist puts it even more succinctly: "A Modernist way of working would show the underlying structure of something. I don't do that."

The mood is darker still with the Belgian painter Luc Tuymans, an artist of deceptive simplicity and difficult sarcasm. Tuymans came to attention thanks to Jan Hoet's selection for *Documenta 7* (1982) in Kassel: he has been widely discussed since then for the strange aura of detached indifference that seems to hover over his provocative subjects, including the Holocaust (*Gas Chamber*, 1986) [Fig. 6.28], paedophilia (*Child Abuse*, 1989), and ethnic cleansing on the one hand, right through to banal everyday items such as bottles of cleaning fluid, lampshades, or a glove on the other. What has made Tuymans millennial is the very continuity of treatment accorded to the image of a gas chamber and that of a desk-light—the familiar theme, so far, of the banality of evil. But the works engage on a deeper level with the complexity of painting's representational codes, by acknowledging a certain impossibility, a certain historical irrelevance, in the practice of painting itself. The effect that secures this impression for Tuymans is the practice of sketching out each painting in miniature, generally in watercolor or gouache on paper, then enlarging it in the act of painting to a still small-sized panel that contains all the bleached-out, doodled quality of the miniature sketch. In fact, the characteristic acid-greens and depthless pale-blues and pinks of Tuymans's paintings seem to underscore their inauthenticity at every point: we seem to see a washed-out simulacrum of some important image rather than the image itself—seen perhaps as on a badly lit TV screen, or against the light. Tuymans has his personal obsessions, of course—the cult of Flemish national identity, the European Holocaust, scenes of implied violence or criminality: In a recent cycle devoted to the violence of Belgian colonization in the Congo, Tuymans depicts Patrice Lumumba, the first freely elected leader of the independent Congo Republic, whose murder in 1961 with the connivance of the CIA and the United Nations is still controversial today [Fig. 6.29].

Just as that series was being worked on, a further group of Tuymans's paintings was being shown in the millennially titled *Apocalypse* exhibition in London, in which we saw a broad range of subject matter—a deceased woman wearing orange-tinted glasses; a bearded man; a maypole; some cosmetics; and an X-ray of the spine—presenting no unified preoccupation, rather an approach to the internal scale and facture of painting that shifts his project into a register that demands to be looked at with a forensic as well as cynical eye. For that bleached and insubstantial treatment challenges our awareness of how images are made and survive in a world of cinematic mediation, and seems to tell us that behind so many photographic or cinematic documentations of "the real" lies a sinister history of horror and concealment.

The London exhibition, ominously subtitled *Beauty and Horror in Contemporary Art* and scheduled to close only days before the millennial moment of January 1, 2001,

6.28 Luc Tuymans
Gas Chamber, 1986
Oil on canvas
19 ⅔ x 27 ½" (50 x 70 cm)

6.29 Luc Tuymans
Lumumba, 2000
Oil on canvas
24 ½ x 18 ⅛ x ⅞" (62 x 46 x 2.2 cm)

6.30 Maurizio Cattelan
The Ninth Hour, 1999
Mixed media
Lifesize

projected thirteen artists whose sensibilities had been adjudged to be in tune with a prevailing sense of foreboding, summation, and change. It included the Americans Mike Kelley, Richard Prince, and Jeff Koons, while the European affinity with apocalypticism was suggested by (aside from Tuymans himself and the German Wolfgang Tillmans) the Italian artist Maurizio Cattelan and the truly apocalyptic British duo Dinos and Jake Chapman.

Curatorially the show required each artist to occupy one room in the museum, a tactic well suited to Cattelan's characteristically clever installations, which require some degree of connivance between himself and the museum authorities. Cattelan had already experimented suggestively with taxidermy in a series of artworks harking back pointedly to the glories of Italian Renaissance and post-Renaissance culture. As a boy, he had walked every day to school beneath the shadow of Donatello's great equestrian *Gattamelata Monument* (1453) in Padua; as an adult artist he had taxidermized Donatello's magnificent horse in *Novecento* (1977)—and had hung the beast by a leather harness and pulleys from the gallery roof. He had also taxidermized a donkey for *If a Tree Falls in the Forest and There Is No One Around It, Does It Make a Sound?* (1998), in which we were shown the innocent donkey with a new TV strapped to its back, as if transporting the first TV up mountain paths to a remote rural community, hence summoning up a world in which diversity is being eradicated while every experiential and epistemic datum is subordinated to the passivizing regime of news and entertainment. For *Apocalypse* itself, however, Cattelan filled his single room with a work known as *The Ninth Hour* (1999), in which the viewer was affronted by a fully dressed lifesize waxwork of Pope John Paul II, apparently felled to the red carpet floor by a meteorite that had resoundingly crashed through the glass ceiling above [Fig. 6.30]. More startlingly still, Cattelan's Pope seems unaware of the irony of being crushed by a rock at the moment of Christ's death according to the gospels—indeed, from his impassive expression he seems determined to carry on regardless, his grip on his cross still firm.

In the transitional year 2000, a mood could be detected in some places of unease, at best. "Is there a contemporary subject matter that is becoming a new mythology for our time?" rhetorically asked curator Norman Rosenthal in his opening statement to *Apocalypse*. "In what new ways are younger artists accepting and describing contemporary realities that suggest the uncertain and insecure future that has always existed for mankind?" To the latter question, the answer supplied by Dinos and Jake Chapman was unimpeachably clear—and it remains a resonant one for an era dominated by America's belligerent attitude to global cultural change. The background to the Chapmans' prominence in younger British art (they were born in 1962 and 1966 respectively) is worth recounting briefly. Following their graduation from London's

Royal College of Art, they worked for Gilbert and George before turning in 1993 to Goya's gruesome *Disasters of War* etchings as a model for small, painstaking reconstructions using plastic figurines that they skillfully melted, reshaped, and repainted. Arranging these miniature scenes in neat circular formation on fake grass gave Goya's harrowing testimony a suburban pleasantness that suggested how every atrocity or act of violence or onset of disease can become—certainly has become—neutralized by our culture's insensitivity to pain. The following year saw the Chapmans converting one scene, in which Goya has three castrated and mutilated soldiers tied to or hanging from a tree, into their cruelly titled *Great Deeds for the Dead*. It was this work, together with the even more fabulously titled *Zygotic Acceleration, Biogenetic Desublimated Libidinal Model (Enlarged x 1000)* of 1995 that brought them to wide if scandalized attention, when both pieces were exhibited in the Royal Academy of Art's infamous *Sensation* show in late 1997 [Fig. 6.31]. (It later caused a minor scandal when it traveled to New York.) In the latter work the Chapmans presented an impossibly fused ring of show-window child mannequins, naked except for their identically sized Fila trainers, all of them based on an earlier figure-type known aggressively as *Fuck-Face*—in other words, with vaginas for mouths or ears, or a semi-erect penis in place of the nose. Distantly parodying circular Minimalist works of the mid-1960s [see Fig. 1.5], *Zygotic Acceleration* provided a radically dissociated tension between the pull of human sexual curiosity and the repulsion engendered by the illusion of genetically corrupted bodies. It also pointed to a fascination on the Chapmans' part with bodily and psychological

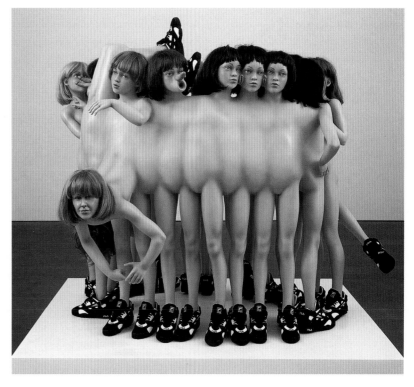

6.31 Jake and Dinos Chapman
Zygotic Acceleration, Biogenetic Desublimated Libidinal Model (Enlarged x 1000), 1995
Mixed media
59 x 71 x 55" (150 x 180 x 140 cm)

extremity as simultaneously entertaining but also fascinatingly morbid conditions. And it was the latter impulse that returned the Chapmans to the theme of war for their contribution to *Apocalypse* in the year 2000. For the massive work known as *Hell*, in preparation for a full two years in advance of the show, the Chapmans created some five thousand miniature painted figures whom the viewer comes to identify as brutalizing Nazi soldiers on one side, pitted in ferocious and bloody combat with naked mutants on the other. Displayed in gory narratives of killing and torture across a total of nine landscapes, the surprise in store for those who can keep on looking is that the Nazis are generally being brutalized by their opponents, though the outcome of the struggle—which contains skeletons coming to life, mutant fish, and cannibalistic scenes—is never clear, and, for the viewer absorbed in child-like fascination with the scene, yet one more trap set to ensnare

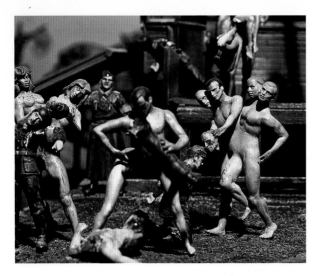

6.32 Jake and Dinos Chapman
Hell (detail), 1999–2000
Glass fiber, plastic and mixed media
Nine parts: 8 parts 8 x 4 x 4' (2.44 x 1.22 x
1.22 m)/1 part: 4 x 4 x 4' (1.22 x 1.22 x 1.22 m)

his or her already battered curiosity [Fig. 6.32]. The Chapmans have said that violence that feeds upon violence is like Nietzsche's "eternal return." As the moment of the millennium approached, their work seemed to evoke both the end of one violent century and the beginning of another.

It remains only to mention a figure whose notoriety on the international scene has set new standards of showmanship and visibility since his emergence as an artist in 1988—and to locate within that career a further instance of the tendency to drift into narrative with which this chapter has been concerned. Damien Hirst first came to attention in the late part of 1988 as the young impresario behind a three-part exhibition known somewhat puzzlingly as *Freeze* (single-word titles for a time enjoyed a vogue in several Western cities). The venue was a vacated Port of London building close to the Thames, with funding from a development corporation for London's up-and-coming Docklands area, once a vibrant shipping center and now a new business district east of Tower Bridge. Hirst, together with fellow students from Goldsmiths' College, by now coming to the peak of its reputation as an innovative teaching center, effectively announced a new orientation in West European art—one driven by a desire to terminate the painting revival of the 1980s and launch a renewed interest in everyday banalities, unashamed sexual innuendo, and the crude realities of life and death. A further feature—massive doses of student-level irony and street humor—made the generation of Richard Patterson, Sarah Lucas, Gary Hume, Ian Davenport, and of course Hirst himself instantly attractive to dealers and of immediate interest to wider international observers. The next year, a similar *esprit* was made available at the Lorence Monk Gallery in New York, and by 1992 "British Art" was appearing under that self-announcing title at Barbara Gladstone. Further warehouse shows in London fanned the excitement, all supported by a new magazine launched in 1991 no less ambiguously entitled *Frieze*. By the mid-1990s, when the advertising mogul-cum-art collector Charles Saatchi had placed himself firmly behind the "yBa" (young British art) phenomenon, and newspaper cartoonists and gossip columnists had had their dig, it was clear that the financial and press leverage of this reckless new manner was a growing force.

But journalistic success by no means equates with critical power. Damien Hirst's own work of 1991, *The Physical Impossibility of Death in the Mind of Someone Living*, quickly became notorious because it suspended a dead tiger shark in a robust Minimalist tank placed at floor level and then filled with formaldehyde: there followed cows divided or sectioned, the formaldehyde preserving the carcass indefinitely while exposing to the fascinated view the organs and bone structures of the dissected cadavers. Among critics, it became customary to say that Hirst was obsessed by death, by the natural world, by violence—and had no qualms about using animal corpses in ways that seemed cynical and philosophical at the same time. In his defense, far older

traditions of animal art were routinely invoked. Hirst's growing public, forever skeptical about his sincerity, soon associated him with wild behavior and recklessly extravagant artworks: the critical "theming" of his work has since dominated the work of Hirst and his generation, and threatens to settle into dogma as the millennial moment passes by.

In practice, critics themselves are divided about how to respond to the foregrounding of violence, mutilation, and (of course) sex within the contemporary work of art. Even though "outrage" remains the routine preserve of tabloid reviewers—generally on the political right—the best artists of this generation have played skillfully with conventions of staging and viewing in full cognizance of the traditional (and largely futile) tension between "content" and "form." The Chapmans' entry for the 2003 Turner Prize—London's annual publicity-fest of the notorious and new—was a case in point. In one room, a flamboyantly gory sculpture entitled *Sex*, depicting an assortment of rotting carcasses *à la* Goya, was paired with a second piece entitled *Death I* [Fig. 6.33], simulating (in finely crafted bronze) a pair of inert plastic sex-dolls in some form of conjunction on a floor-based couch. Once more, the Chapmans openly courted the outrage of the tabloid fraternity—while actually offering to the viewer the challenge of negotiating a position somewhere between prurience and fascination, between the impulse to close inspection and the self-corrections of civilized restraint, an all but impossible balance stimulated by techniques and images internal to the work. Historically minded viewers may also have reflected on an earlier scandal sparked by Carl Andre's more philosophical experiment with firebricks placed on the floor.

Critics are also divided about the qualities of Hirst's production. Just as with Jeff Koons, whose suspended basketballs Hirst undoubtedly saw (in *New York Art Now* at Saatchi's gallery in 1987), they are divided along lines determined by political assumptions about what any surviving avant-garde might or must be. While certain supporters point to the "realism" of the life-and-death thematics of Hirst's art, to its daring elevation of "content" above the demands of material and form, writers for *New Left Review* such as Julian Stallabrass and Kitty Hauser have described it as aesthetically and critically "light"—and, in Hauser's case, as unable to rival the mercurial pleasures of the pop music whose tone and range of address the yBas always purported to admire. As the debate went on, Hirst mounted his first one-person show for almost a decade in 2003. Held in east London at the White Cube Gallery under the characteristically long title *Romance in the Age of Uncertainty: Jesus and His Disciples: Death, Martyrdom, Suicide and Ascension*, visitors saw cabinets filled with redundant laboratory glassware, hammers, axes, and blood-stained coils of plastic tubing, each item denoting the martyrdom of a particular disciple. Meanwhile cows' or bulls' heads submerged in formaldehyde-full vitrines stood for the apostles, while a thirteenth vitrine, empty apart from the

6.33 Jake and Dinos Chapman
Death I, 2003
Painted bronze
28 ¾ x 85 ¹³⁄₁₆ x 37 ⅜" (73 x 218 x 95 cm)

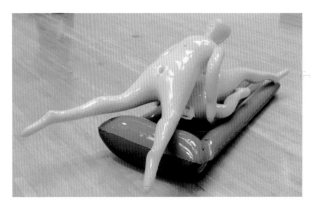

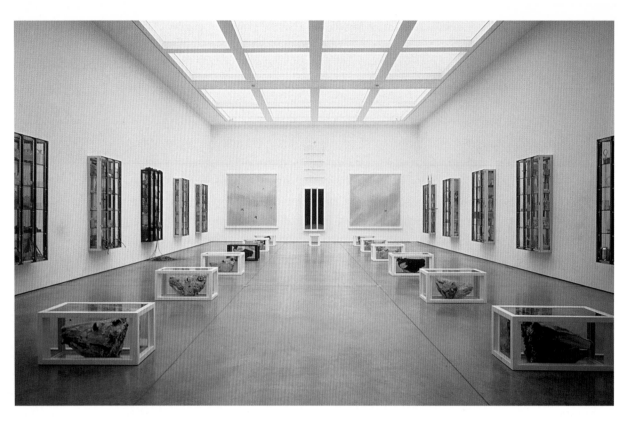

6.34 Damien Hirst
Romance in the Age of Uncertainty
Installation view at White Cube, London,
September 10–October 19, 2003

formaldehyde, stood for Christ [Fig. 6.34]. Professors of theology described the contrivance as "crude, offensive and shocking"; whereas ambitious collectors worldwide rushed in to divest themselves of an astonishing £11 million within the first two weeks of the show. Few reporters noticed, however, that the crisis-laden thematics of *Romance in the Age of Uncertainty* were carried in effect by a formal arrangement that was itself both mocking and heavily symbolic. For with the entire show "installed" like a church, with "chapels" leading processionally to a high altar, the attentive visitor might have enjoyed the reference to that stock-in-trade complaint against the Modernist gallery space, that its ethos is too much like a shrine. In an upstairs room, meanwhile, Hirst presented thirteen black paintings made out of thousands of dead flies soaked in resin, their clogged and malodorous surfaces identical but for small variations in the shapes of the encrusted insectal matter. Named after life-destroying diseases such as malaria, bubonic plague, and ebola, the paintings underscored the apocalyptic mood of Hirst's new show without a trace of the light-hearted cynicism that had previously animated his work. Instead that note was struck by the London *Times* on the day I visited the show: "Ah, the latest Damien Hirst controversy," the leader writer cleverly observed; "how one yearns for something as radical as a spot of landscape or a nice bit of portraiture."

Contemporary Voices

"Talking Failure: Mike Kelley Talking to Julie Sylvester," *Parkett* 31, 1992, pp. 100–03.

"The Arts and Crafts Movement viewed mass-produced objects as being kitsch or poor. I don't think that's the way people view them now. I think they see the manufactured object, by virtue of its 'untouched' quality, as a perfect object. And it is the model for the craft object—rather than something that predated it—all craft objects become failures in respect to it. I'm interested in objects that play up that schism—between the idealized notion behind the object and the failure of the object to attain that. (Adolescence interests me in the same way because it is about enculturation, the point at which it becomes glaringly obvious that we are unnatural and that normalcy is an acquired state. Adolescents, in being 'unsuccessful adults', reveal the lie of normal adulthood)… I like to think that I make my work primarily for those who dislike it. I get pleasure from that idea… The museum can co-opt anything; any object that is put there becomes 'high' by virtue of the context. But I have a problem with the terms 'high' and 'low'—I prefer 'allowable' and 'repressed' as they refer to usage—that is, whether a power structure allows discussion—rather than to absolutes. The museum drains meaning out of things. It's inevitable. But somewhere in their failure is the indicator of success."

Jessica Stockholder, "In Conversation with Lynne Tilman," *Jessica Stockholder*, London: Phaidon Press, 1995, p. 34.

"I have a large interest in garbage (as we all do). I use a lot of garbage in my work because it brings with it a process that continues despite what I might do to it. The work will decay; it is not with us forever despite our desire that art might be. Garbage, on the other hand, is… [yet] my work isn't about junk. This is an issue because some critics have often written about my work that way. It's about things—some of them are junky, some of them are new and some of them are old."

7
Other Territories: 1992–2002

Successive phases of Western capitalism from the seventeenth century to the twenty-first have proved effective in appropriating populations and cultural traditions, first, for reasons of expanding trade and political influence, but second, on the level of the arts, for reasons of gaining access to new technical and cognitive models of making paintings, sculptures, and other artefacts. Western fascination with oriental art during the nineteenth century, or the well-known avant-garde interest in tribal masks and sculptures at the beginning of the twentieth, are examples of this appropriative cast of mind. The great colonial adventures by the European nations—the French in Africa, the British in India, Canada, and Australia—are stories of extraordinary complexity whose multiple victories and disasters form part of the pattern of cultures today. The self-absorbed reflections of European and American artists as the century ended formed but one part of a discernible shift of emphasis in the critical values and inter-ests of art. The Chapmans' robust indictment of European genocide can be read as the scathing endgame of an entire culture. Luc Tuymans's *Congo* paintings, exhibited to acclaim at the Belgian Pavilion in Venice in 2001, can be read as a contribution to the widescale critical debate on post-colonialism that has erupted since the end of apartheid—as a reprise even of Joseph Conrad's indictment of Belgian colonial rule in his great novella *Heart of Darkness* (1899): they and it take us directly outward, or backward, to Europe's inclusiveness of other cultures, and to its invariable mistreat-ment and misunderstanding of them. For example, the end of colonial adventurism has created shifts of consciousness whose implications we have only glancingly recognized so far. A recent great wave of change—beginning with the implosion of the Soviet Union and its client states in Eastern Europe between 1985 and 1991 and the dismantling of the apartheid system in South Africa in 1994—has brought about a far wider kind of inquiry into national cultural identities in their relation to the still economically

Opposite
Kenji Yanobe
Atom Suit Project: Tanks, Chernobyl (detail), 1997
See fig. 7.15

powerful West. Another historic sea change of the last decade of the twentieth century, the rapid expansion of electronic information networks and the spread of global capital, has forced the Western system of culture to revitalize one further time its patterns of investment and display. Neither particular optimism nor particular pessimism seems an appropriate response to these developments. The task, rather, is to understand them.

The Rise of Africa and Asia

Any "foreign" artist working in Western Europe or America during the 1970s and early 1980s would quickly have been made aware of his or her ethnic or racial origins. American treatment of its African and Caribbean underclasses, or European treatment of its Indian and African immigrants—to take some notable examples—resembled acts of internal colonization that further subdued minority populations in terms of education, health, and access to social welfare. For artists from any of these groups to gain access to the elite circuits of gallery display, magazine promotion, and commercial success had always been a struggle, but it now animated the fractured consciousness of the Western democracies with if anything greater urgency than before. The Pakistan-born artist Rasheed Araeen, to take a prominent case, following a brief association with the radical Black Panther group in the late 1960s and early 1970s, and further self-training in the anti-imperialist writings of Frantz Fanon, Amilcar Cabral, and Paulo Freiere, himself composed a "Black Manifesto" for a new journal, *Black Phoenix*, in 1978, which in turn led to the founding of the influential journal *Third Text: Critical Perspectives on Contemporary Art and Culture*, which has been in continuous production since 1987. Araeen's position in the "Black Manifesto" was that "the problems of contemporary art today are the result of colonialism and its present relationship with the West… we must go beyond formal and aesthetic considerations and look into the historical factors which influenced or suppressed artistic developments in the last few centuries… contemporary cultures in the Third World in general and the visual arts in particular remain what could be called the stagnant backwaters of Western Development." Araeen argued that Third World artists' mimicking of Western artistic styles "not only uproots them from the reality of their own culture and history, but leads them to an alienated situation which cannot question the domination of foreign values, thereby also denying them any opportunity to develop their art indigenously." He quotes Fanon's words from *The Wretched of the Earth*: "This European opulence is literally scandalous, for it has been founded upon slavery, it has been nourished with the blood of slaves, and it comes directly from the soil and from the subsoil of that underdeveloped world," leading Araeen directly to his conclusion that colonization "suppressed the development of indigenous art and culture in the Third World by preventing the historical development of the productive forces of its peoples." Araeen's own art of the mid- and later 1970s, meanwhile, attempted to interrupt the

universalism of Western culture through a variant of Minimalist art that used diagonals—and hence looked very unlike the rectilinear forms of Andre or Judd. The diagonals referred, in turn, to dynamic sexual energies as well as to Islamic decorative patterns: the "difference" from Western Minimalism was scarcely noticed at the time.

For the majority of his subsequent paintings Araeen appropriated the manners of Western abstraction, only to challenge them culturally in their own formal language. A floor sculpture entitled *Arctic Circle* (1986–88), formally echoing a stone circle by the land artist Richard Long, was a ring of empty bottles of the kind consumed by Inuit peoples following their introduction to alcohol by Western colonizers. In like fashion *A White Line Through Africa* (1982–88) was a line of bleached animal bones, suggesting the history of bloodshed in that continent that accompanied the period of colonial rule and that has notoriously followed it in the very recent past. In a series of Minimalist-type paintings of the 1980s and 1990s, Araeen went a stage further in his efforts to destabilize the viewer's position in front of the work. In *Green Painting I,* four green panels (the color of the Pakistani flag) were arranged around photos of blood spattered on the floor taken at a Muslim animal-slaying festival that were also to be read as references to organized political violence. Each image was then attached to an Urdu newspaper headline relating to topical stories such as Benazir Bhutto's house arrest or Richard Nixon's visit to Pakistan. In further examples from the *Green Painting* series, Araeen interpellated images of wedding gifts given to his sister, photographs of a young bull prepared for ritual sacrifice with garlands of flowers around its neck in Andy Warhol-like repetition [Fig. 7.1], or drip paintings of the Jackson Pollock type whose drips extrapolated into barbed-wire fragments encroaching upon the Pakistani green. All the works deployed the established grid conventions of Western Modernist abstraction, while at the same time placing its ostensible content just beyond the recognition threshold of most West European viewers. Araeen has said: "It is not a simple juxtaposition of Western and Oriental icons. The nine panels are the result of cutting and rupturing. First I conceive a rectangular Minimalist space or panel which is painted green—an allusion to nature/raw/young/immature/under-developed—which is cut vertically and horizontally, then I move the four panels apart forming the empty space of the cruciform. This cruciform is filled with material which is incongruent to the purity of Minimalism." In thus courting recognition by *both* sets of observers of the *wrong* readings, Araeen points to the hypocritical incorporation by the West of the politics of the other, so-called "third" world. The

7.1 Rasheed Araeen
Green Painting IV, 1992–94
5 color photographs with Urdu texts and acrylic on 4 plywood panels
5'9" x 6'10" (1.75 x 2.08 m)

competent spectator of such works arguably would have no single or simple identity behind which to hide.

As Araeen and other post-colonial theorists have repeatedly argued, the problem lies not with the colonized, but with the colonizers of the white North European and American establishments. Writers from outside the visual arts such as Edward Said, Homi Bhaba, and Gayatri Spivak, whose influential books have launched an entire academic subculture in the West, have contributed to a rich debate on the play of subjectivities and identities in the representations of the "other" by colonized powers, and the transformations brought about by enforced inequality, exile, and migration. Though Edward Said's book *Orientalism*, published in 1978, did not address itself to modern or contemporary art, its implications were clear. Orientalism in one form or another dates from at least the eighteenth century, and resurfaced powerfully in early modern art with the efforts of Gauguin, Picasso, and Expressionists everywhere to enact forms of exoticism and primitivism as routes to a more authentic Western consciousness—a search that provided only further stereotypes of the white mind's desire to escape itself in fantasies of the oriental, the native, and the "natural."

7.2 *Magiciens de la Terre*
Pieces by Jimmy Wululu
Installation at the Centre Georges Pompidou,
Paris, 1989

The concept of cultural hybridity promoted heavily in Bhaba's writings of the 1980s and 1990s has nevertheless met with resistance from Araeen himself, among others. To Araeen, "hybridity" only disguises what it was intended to reveal. He reminds us that artists everywhere have migrated between cultures, not out of coercion or poverty, but to situate themselves at Modernism's center or to make themselves available for careers in the economically dominant system. The least attractive version of hybridity, says Araeen, arises when "post-colonial writers and curators now collaborate with art institutions in the West in the promotion of what can only be described as post-colonial exotica."

It would perhaps be overly cynical to view every act of curatorial assimilation in such a negative light. Several new definitions have to be made. First, not all artists curatorially invited into the Western circuits of display are from former colonies of Europe. Second, the physical migration of an artist from one culture to another is no longer the sole condition of his or her representability within the Western museum curator's mind: one-person shows or lavish magazine illustration can now be accomplished regardless of the living or working location of the artist. And third, increasing numbers of artists at the end of the twentieth and the beginning of the twenty-first century identify themselves with several nations simultaneously, due to the opportunities for travel that now obtain. Nationhood itself is an increasingly fluid idea.

These circumstances can be illustrated in turn. The great curatorial venture of the late 1980s that took as its goal the establishment

of a global vision in which artists of any nation could be celebrated as contemporary was the blockbuster exhibition *Magiciens de la Terre*, mounted by Jean-Hubert Martin and Mark Francis at the Centre Georges Pompidou in Paris in 1989 [Fig. 7.2]. By placing works by artists such as Nuche Kaji Bajracharya from Nepal, Dossou Amidou from Benin, southern Nigeria, Sunday Jack Akpan from Nigeria, the Inuit artist Paulosee Kuniliusee, and the Australian Northern Territory artist Jimmy Wululu next to already legitimated Western figures such as John Baldessari, Hans Haacke, and Nam June Paik, *Magiciens* invited awkward questions about the pursuit of quasi-colonialist agendas in contemporary dress. As Benjamin Buchloh argued in an interview with Martin, the project ran the risk of "cultural and political imperialism… [by] request[ing] that these [remote] cultures deliver their cultural products for our inspection and consumption"; that it fell prey to the "cult of a presumed authenticity which would like to force other cultural practices to remain within the domain of what we consider the 'primitive' and the original 'other.'" Though it resulted in a colorful and much-reviewed spectacle, Martin's declared aim to "show artists from the whole world, and to leave the ghetto of contemporary Western art where we have been shut up over these last decades" courted the familiar danger of wielding modern-art notions forged in the West in order to recover exotic notions of magic perceived to be lacking at home. Notwithstanding, *Magiciens* was a critical success at the time and survives today in the memory in the form of its magnificently lavish catalogue, not to mention the visibility it gave to many artists who had suffered unjustified international neglect.

The trade-off between increased visibility, on the one hand, and the inevitable distortions of meaning that assimilation brings, on the other, is one form of the dilemma that afflicts formerly colonized or displaced populations confronted with Western economic power. The plight of artists from other nations with histories of systematic displacement by whites, such as the First Nations artists of North America, has also been severe. The Cherokee artists Edgar Heap-of-Birds and Jimmie Durham have with difficulty been absorbed into the Western system, but only through the curatorial recycling of those symbols of identity in terms of which they first became visible as artists: in Durham's case, skulls, feathers, fragments of wood and sticks, and self-effacing jokes about the body. Durham was politically involved in the American Indian movement of the 1960s and 1970s, then drifted for a while before being included in a small New York show, *Beyond Aesthetics*, with the Puerto Rican painter Juan Sánchez in 1981. Durham's significance lies in his ability to second-guess the hapless Western curator, who brings concepts of "the authentic" to bear upon cultures he does not know. "Authenticity is a racist concept," says Durham, "which functions to keep us enclosed in 'our world' (in our place) for the comfort of a dominant society"—by which he means a society transfixed by notions of self-presence, ownership, and the supposedly autonomous individual. Yet Durham points out that none of these epithets corresponds to the way American Indians see themselves: "European culture's emphasis on the sovereign subject and its private property is alien to a Native American concept of the self as an integral part of a social body whose history and knowledge are inscribed

7.3 Jimmie Durham
Self-Portrait Pretending to Be Rosa Levy
(detail), 1994
Pencil, acrylic paint, color photograph
20 ¼ x 16 ½" (51.4 x 41.9 cm)

Durham's parodic and laconic works express
not a Cherokee identity, but the identity
offered to the Cherokee by the white settler.
"One of the most terrible aspects of our
situation today is that none of us feel that we
are authentic. We do not feel that we are real
Indians… For the most part we feel guilty,
and try to measure up to the white man's
definition of ourselves."

across a particular body of land." Or again: "We're given authen-
ticity—we have it inflicted upon us—[hence] Indians want to be
authentic, especially for those who see us as authentic." So domi-
nated by white consciousness is the American Indian artist's grasp of
representational practice, then, that he or she collaborates in his own
way in the production of that "nativeness" that white mythology
requires for its own completion. Yet this paradox, combined with the
natural bent of the American Indian for linguistic play—for jokes
and irony—has been turned to good account as one determining
condition for Durham's self-deprecating sculptures and images.
These rub against the grain of Western white expectations, even
within a highly charged aesthetics of double-take and simulation.
Durham's *Self-Portrait Pretending to Be Rosa Levy* of 1994, to take
one example, is rich in Duchampian irony from a position outside the
canonical range of application of Duchampian techniques [Fig. 7.3].
Who is Rosa Levy? Seemingly a Jewish impersonation of Duchamp's
female alter ego Rrose Selavy (a play on the phrase "Eros, c'est la
vie"). But the figure looks and is male, and does not on any level
resemble Marcel Duchamp in drag. "Cherokees are very funny people,"
Durham has said; "we're always using humour. I think it's always
been there… I think it comes as a defence from what we have been
through the last three hundred years." Durham has always called himself a contempo-
rary artist, finally, rather than an Indian one, as part of a self-conscious attempt to
evade the stereotype that "Indianness" is an aspect of a remote or historical culture.

This posture of playful yet sarcastic responsiveness to the identity contexts
supplied by metropolitan Western Modernism has proved virtually definitive of post-
colonial art of recent times: a source of its strength as well as of its legibility to curators
and critics established within the Western system. Actual physical relocation of the
artist to New York or London or Berlin is not (of course) prescribed—though it helps.
In either case the strategy is the same. For example, attempts to salvage a way of
speaking about how dominant discourses have shaped how identity is discussed have
animated marginalized artists in Canada such as the Cree artist Jane Ash Poitras and
the Mohawk artist Shelley Niro. It turns out, for instance, that Niro's work parallels
that of Sherrie Levine and Cindy Sherman, not only strategically, in using the photo-
document to refuse the visual expectations of male culture, and not only formally, in
using photographic languages or references to film discourse, but in ironically
displacing the perceptions in terms of which whites regard groups whose traditions
they have gradually (and usually damagingly) overlain with their own. For her small
hand-painted photo-piece *The Rebel*, Niro photographed her mother reclining sensu-
ously on the mud-spattered trunk of the family car [Fig. 7.4]. Parodying the adver-
tisers' stereotypical image of the model draped on the hood, the piece begins deftly to
undo the dominant culture's cherished concepts of beauty, ownership, and status.

Such gestures lend themselves effectively to the discourses of Western art by adopting their languages and codes—even its avant-gardist ones—to subversive ends. Here, the marginal uses its marginality precisely to occupy, and by occupying to redefine, the center.

The post-colonial dispersal and migration of contemporary artists from oppressed and/or remote cultures to the economically powerful and eclectic metropolises of North America and Western Europe will enter the history books as one of the great cultural shifts of the last twenty years—one whose uneven pattern remains far beyond the resources of a single book or curatorial enterprise to describe. As the last three examples show, the process is as complex as the world political process itself. What single, monolinear understanding of Western modern art could survive it?

Likewise, when we shift our perspective to the East, the Western eye encounters aspects of its own late-Modernist culture whose origins it had either forgotten, or willfully mistranslated, or ignored. When the Japanese artist Yoko Ono sat on stage in Carnegie Hall performing *Cut Piece* in 1964, in which members of the audience were invited to disrobe her by cutting away her dress, the meditative and self-negating qualities of Buddhist traditions may have been far from the occidental viewer's mind. Two opposite but complementary attitudes can be distinguished in Japanese art since that time—at least among those that have been successfully assimilated to the museum circuits of the West. The first, building on the high-tech consumer revolution of Japan in the 1980s, inserts a style of blankness and repetition into the new precision-made media forms. In a large public installation made for an exhibition in the South Korean capital Seoul in 2000—to take but a single example—the Tokyo-born Takehito Koganezawa created a trembling freeze-frame video of two young men staring blandly at the hurried visitor below: The work hovered ambiguously between an advertising video for unidentified goods and a newscast that had very little to convey. At the other end of the technological spectrum, the performances of Osaka-born Chiharu Shiota stage a radical denial of the technological fetish in order to re-engage directly with the lowest forms of physical matter that she can find. In Shiota's work we find an interesting reprise of some of the Gutai performances of the 1950s and early 1960s, in which Shiraga, Yoshihara, Murakami, and others performed directly with raw paint, mud, and paper in a series of randomizing gestures within a time-based structure having no durability beyond the photographic document. Shiota's *Bathroom* performance of 1999 is characteristic. Immersing herself in mud and slime, she emptied bowls of the liquid over her head in slow repetitive movements that not only established a

7.4 Shelley Niro
The Rebel, 1987
Hand-tinted black-and-white photograph
6½ x 9½" (16.5 x 24 cm)
Collection of the artist

7.5 Chiharu Shiota
Bathroom, 1999
Performance, video still

position for herself outside the middle-class hygiene-obsessed culture of her upbringing, but enacted cycles of masking, unmasking, and renewal through self-denying submission to discomfort and the physically low [Fig. 7.5]. Performances such as *During Sleep* and *In Silence*, both of 2000, have helped establish Shiota's credentials as an almost traditional avant-gardist of the displaced Japanese type in the thriving experimental culture of Berlin, where she now lives.

It may be fairly asserted that the idiom of performance that has formed part of Western-type Modernism since the actions of Allan Kaprow and Robert Watts in the later 1950s had its deepest roots not in European Dada but in oriental spiritual practices of bodily negation, self-transcendence, and non-linear structures embracing contradiction and change. The expression of ancient Buddhist, Taoist, or Confucianist attitudes in modernized technical societies is not of course straightforward—and is made more problematic by the overlay of colonial or political repression in modern Asian states. Taiwan, after a long period of Japanese colonization (1895–1945), was subjected to a period of US-supported Kuomintang administration before the imposition of the Nativist movement in the 1970s as a means of "recovering" a lost identity and re-Sinocizing Taiwanese culture and art—a repressive policy intended to resist Westernizing culture, supported by strict martial law that came to an end only in 1987. Only then did more liberal ideas begin to flow: a symptom was the *International Dada* exhibition shown in 1988 at the newly opened Fine Arts Museum in Taipei. The difficult tension between imposed "national" identities and the pull of transnational Western capitalism expressed itself in avant-gardist gestures using extreme physical endurance as a form of political expression—as when in 1983 Lee Ming-Sheng attempted to cover 875 miles (1,400 km) in forty days by walking and running (in fact he failed), or when in 1984 he carried a 6.6 lb (3 kg) bundle strapped to his back with a chain and padlock for 113 days. Lee claimed it was a heavier burden to carry the weight than to overcome the social and political oppression of the government. In 1987, his performance piece *Non-Running, Non-Walking* consisted of participating in the national marathon on his hands and knees, arriving at the finish in front of the Presidential Palace two weeks later to evident police disapproval. Lee's countryman Chen Chieh-Jen, meanwhile, was enacting political protests in the guise of performance art, with an equal measure of personal risk. During the period of martial law, when political demonstrations were outlawed, he staged performances in crowded city streets that were designed to be both "ordinary" activity and politically provocative acts. More recently Chen has worked with digitized photography to produce daring metaphors of political torture

and repression, such as *Rebirth* (2000), in which diseased citizens with contraptions strapped to their genitals lie dying in the cold electric glare of a public subway or hospital corridor [Fig. 7.6]. Expressionist in form and content, they use the utopian inventions of photographic manipulation in a manner that runs dramatically counter to their usual employment in advertising and glossy magazine journalism. Reflecting the onset of epidemic disease, these pieces suggest populations radically alienated from the technologies that were invented to improve and sustain them.

Much of the philosophical content of Taiwanese art—if not its political focus—is to be found in the work of Tehching Hsieh. Initially a painter, Hsieh began a career in performance in 1972 when he leapt from a third-floor apartment in Taipei, an act of such metaphorical and physical absoluteness as to remain in the cultural memory at home even after his illegal emigration to New York in 1974, where he continued a run of bodily extreme performances that passed almost unnoticed until shown in a retrospective in that city in 2001. Hsieh's performances are marked by a highly disciplined attitude to time, and to the interplay of temporal duration with questions of survival, repetition, abstinence, and the loss of conventional forms of pleasure. All of them are specified in advance by a "contract" between himself and his public, and most have run for a whole year. For the whole of *Cage Piece* of 1978–79, the artist confined himself in a barred cell in his apartment without talking, reading, writing, watching TV, or

7.6 Chen Chieh-Jen
Rebirth, 2000
Color photograph
7'4½" x 9'10" (2.25 x 3.00 m)

7.7 Tehching Hsieh
One-Year Performance, 1981–82
Photo document

listening to a radio—an ordeal punctuated only by the daily arrival of an assistant to bring food and remove waste, and the occasional gathering of an art audience to verify the action was taking place. For *Time Piece*, 1980–81, Hsieh punched a time clock every hour on the hour, twenty-four hours a day for a year, with a movie camera verifying each clock-punch with a single-frame photo—the resulting DVD shows the entire year compressed into six minutes. The next year, for *One-Year Performance*, Hsieh spent out-of-doors, not even venturing into a shop interior to buy food [Fig. 7.7]: his only transgression was being dragged into a New York police station for questioning following a street fight. His so far final, thirteen-year-long performance, from 1986 to 1999, consisted of "keeping himself alive" as far as the millennium on December 31, but otherwise producing nothing that could in any sense be counted as "art."

Such performances—now as much part of the mythology of Taiwanese avant-gardism as they are of the multinational art scene in New York—take right up to (and beyond) the limits of artistic expression a number of questions about Conceptualism, documentation, and personal and public politics that will never receive a definitive or final answer. What is the trade-off between personal risk and discomfort and the public expression of ideas? How much or how little documentation is needed to reconstitute the avant-gardist work as a temporal and existential structure in all other respects appearing like a withdrawal from action, form, and construction? What are the limits and boundaries of the folding of art into life, or life into art, and in what circumstances are we willing to concede the probable disappearance of the distinction? In the migration of Tehching Hsieh from faraway Taiwan to anxiety-laden New York, how much of his (non-)activity needs translation, and with what losses and gains? Finally, does our understanding that Hsieh has now renounced even the "time-wasting" art (as he called it) by which he made his name incline us to say that he is no longer an artist—or is that category elastic enough to support even that ultimate negation?

One suspects it probably is. For it must be understood that the more evanescent the physical residues of avant-garde art, the more completely politicized is the body that made it. The interweavings of gesture and object that have marked Western avant-gardism since the time of Gutai or Abstract Expressionism have demonstrated how necessary the two terms have become to each other, even within a given culture. The translation of bodily gestures from culture to culture under conditions of exile or migration only complicates what is already a signal concern of much that we have studied in this book. To look at the most boldly expressive art of mainland China since the failed liberalization movements of the 1980s is to meet these

translation conundrums head-on. "Politicized flesh" is the term given by one critic to the most experimental forms of China's new avant-garde—but what politics, and for whom? Older Chinese traditions were already confounded by the imposition of Communist ideologies of egalitarianism and collectivization at the time of the founding of the People's Republic of China in 1949: ideologies brought to an apogee during the Cultural Revolution of Mao Tse-tung in the later 1960s and early 1970s. This instantly uneasy compromise between Maoism and Buddhism then encountered Western market values during the 1980s, since when China's membership of the global art community has assumed many forms. To look at the range of artistic media displayed at the remarkable *China/Avant-Garde* exhibition at the National Palace of Fine Arts, Beijing, in February 1989—four months before the bloody events of Tiananmen Square in June—was to witness the signs of a culture in rebirth. In effect, *China/Avant-Garde* offered a retrospective account of the work of 180 artists who had achieved prominence in the 1980s for outspoken or provocative work. The show was a triumph of independence over the mechanisms of official control. The group Xiamen Dada laid a rope throughout the whole building with its name attached at one-yard intervals. Wenda Gu, already an immigrant to New York since 1987, exhibited photographs. An entire room was filled with sculptures, installations, and paintings by the Culture Research Group South West, as well as paintings by Wang Yousheng and Liu Xiaodong. Paintings by the student artist Fang Lijun came to public attention for the first time—Fang was soon to achieve surrealistic effects of a humorous and highly disquieting kind [Fig. 7.8]. The editor of China's *Fine Arts* journal, Gao Minglu, wrote in the catalogue that "the soul of modern art is modern awareness, ie. self-knowledge and the new interpretation of existence by people today, their relationship to the world and the universe in which they live." A "No U-Turn" road-sign image made up the poster to the show.

7.8 Fang Lijun
No. 2, 1990–91
Oil on canvas
31½ x 39⅓" (80.2 x 100 cm)

"If the facial expressions are painted very accurately but on the other hand the movements and posture remain indefinable, it appears a little contrived... however, the most realistic portrayal grasps these indeterminate emotions and so develops a space, extending from the concrete to the immeasurable... To paint the human body I use unmixed paint sold by the manufacturer under the name 'flesh-color.' If it appears absurd to the eye, it proves just how absurd we are in many of the ideas we regard as natural."

In more directly performative works, too, the exhibition marked a new beginning. At the opening of *China/Avant-Garde* the artist Xiao Lu fired a shot into a work made by herself and fellow artist Tang Song. The exhibition was immediately closed and the markswoman arrested. Following the events in Tiananmen Square, Chinese performance art went underground. In the early 1990s a so-called East Village group in Beijing created performances at abandoned sites away from police attention, for invited guests only; yet by now the incursion of Western markets into China, and the resulting tensions of consumer consciousness, were also driving artists to acts of sexual provocation and expression that ran directly counter to the "official" policy in favor of traditional art and

latter-day Socialist Realism. The work of Huangshi-born Ma Liuming, now legendary among China-watching Westerners, illustrates the genre. In 1993 he brought into existence an androgynous character, Fen Maliuming (the artist in women's make-up and floral dress), who alchemically combined the sexes by masturbating in front of the invited audience and drinking the semen. In 1998 Ma performed a variant of this act at the scandal-causing *Inside Out* exhibition in New York, where he invited members of his Western audience to sit beside his naked body and be photographed: in this way the artist, who held the shutter cable and controlled the moment of the photograph, became a voyeur of his own performance of cultural migration and (presumably) mistranslation.

Here again, it is the body that migrates between continents and cultures, or between one enclave of the home culture and another; while in the process of cultural translation, the meanings of the original statements can too easily become obscured. Chinese performance artists have acted out at the limits their feelings of anguish at the oppressive acts of their government at home, as well as at the incursions of materialist cultures from abroad (principally the United States). Take Sheng Qi from the 21st-Century Group, who cut off his little finger in protest against the Tiananmen Square massacre, and whose performances of the last few years have included injecting live chickens with Chinese medicines, mutilating them, and urinating on their battered

7.9 Zhang Huan
My America (from the performance *Hard to Acclimatize*), 1999
Seattle Art Museum

bodies—a form of protest against mechanized food production for the fast-food markets of the new China. In Qi Li's *Ice Burial* performance of 1992, performed at the summer solstice, the artist had his body covered with ice with the intention of releasing all his body heat to convert the ice back into water; thus concluding the performance with the end of his own life. In fact, Li was hospitalized before the final moment, his exhibition was closed by the authorities, and the artist survived in limbo for a further six months before committing suicide successfully and in private: the tragedy was subsequently dramatized in Wang Xiaoshuai's film *Frozen* of 1997. To report such events is to become aware not only of the levels of political unfreedom that Asia's younger artists have had to endure—Li's metaphor of "unfreezing" stands clearly for a much-desired cultural thaw—but of the values attached to bodily existence that Westerners in their generality do not and perhaps cannot share. Several other stagings may be taken as symptomatic. Zhang Huan, born in Henan province and also part of Beijing's East Village group, has made works characterized by mass participation and the artist's physical endurance. The latter was demonstrated during a piece entitled *65 Kg* (1994), in which the artist was hung bound and gagged from the ceiling while blood dripped from wounds made in his body by surgical incisions. In the more recent *My America (Hard to Acclimatize)*, performed at the Seattle Art Museum in 1999 (the title recalls Beuys's 1974 work), Zhang sat naked with his feet submerged in water, while naked Caucasian men and women on three levels ran in circles around the artist, pausing only to throw bread at him. Beginning with something akin to a Buddhist prayer ritual and ending with the artist sitting surrounded by bread projectiles, the performance enacted the contradictions between Western veneration for the silence of the orient, the economic dependence between the Eastern and Western worlds, and perhaps the "victim" quality of oriental cultures under threat of bombardment from Western values [Fig. 7.9]. Zhang's recent emigration to live in New York has made larger and more complex performances possible, with the result that Chinese dilemmas have been "translated" into languages approximating those of a much-hoped-for international dialogue.

East European Renaissance

There is little doubt that Western market forces played a significant role in the latest wave of liberalization following the death of Deng Xiaoping in 1997. Powerful Western auction houses like Christie's and Sotheby's have been holding auctions of contemporary Chinese art since the early 1990s, and a handful of traveling exhibitions in Europe and the United States have helped reputations to migrate, if not always the artists themselves. The pattern partially duplicates the progress of contemporary art in post-Soviet Russia and the Eastern bloc countries—the other great geopolitical region once dominated by totalitarian Communism that now also finds itself in a quasi-colonial relationship to Western cultural influence and economic power.

Such a statement can be easily misunderstood. Contemporary artists in Russia are aware of the Westward migrations of Kabakov, Komar and Melamid, Leonid Lamm, Leonid Sokov, and others who now live and work in New York. They are aware too of the bountiful collection of postwar "nonconformist" Russian art now beautifully housed at the Zimmerli Art Museum at Rutgers University, New Jersey, where it serves as a unique showcase to the world. They know something of the Western art magazines that promote discussion and artistic reputations alike; of the private gallery system that risks early shows by unknown talent and feeds an often-vigorous market with examples of new and experimental art. Younger artists from all over the Eastern bloc seek representation in the biennales and triennales that crop up in the capitals of Europe, America, and increasingly Asia and even Australia. Yet a paradox governs this form of consciousness: namely, that even modest reputations established within this international circuit—this "wandering tribe of nomads," to cite a despairing Russian critic—will seldom be matched by an equal regard at home, either in the art journals or on radio and TV. The condition is a painful one. On the one hand, Russia still lacks an infrastructure of art academies, magazines, journals, and public and private galleries committed to contemporary art: within a nation of such prestige and size, one can count no more than a handful of each. Circuits of information and intellectual exchange remain meager and poorly resourced. The majority of Russian cities emerged from the Soviet collapse of 1991 looking damaged and backward, redeemed only by a nostalgic appearance and a photogenic if disastrously disintegrated urban fabric. On the other hand, Russian traditions of Soviet as well as pre-Soviet times contain positions aplenty for the artist: as philosopher, as social shaman, as political figurehead, as magician, as oracle—in short, a figure of unequaled social and moral power. The distance between these traditions and current reality could not be more extreme.

And yet by a different logic contemporary art from Moscow and St. Petersburg has derived certain energies from this conundrum. The critic Ekaterina Degot points out one source of these energies: the fact that progressively since the 1960s scarcely anyone in Russia really believed in Communism, and with few career possibilities open to them turned their energies toward hobbies, private obsessions, arcane "projects," or simply surviving: skills that now surface in a panoply of activities known as "art." Second, Degot reminds us that after the end of the Soviet state in 1991 the country reverted to its old unpredictability and chaos, not as a strategy or by default, but as a right—and that in doing so became *in principle* unintelligible to most observers from the economically stable West. The failed coup of 1991, a series of bungled military adventures in

7.10 Oleg Kulik
I Love Europe and Europe Doesn't Love Me,
1996
Performance, Berlin

In this version of his performance Kulik cavorts naked as a dog, harrying pedestrians and snapping at their clothes, until he is himself surrounded by Polizei officers and their dogs.

Chechnya, street crime and terrorism at home, and the political surrealism of old Communists switching their colors to accommodate quasi-market attitudes—these realities quickly became, in Degot's words, "a total aesthetic project stronger than that which artists could create themselves." The result has been a wave of "Actionism"—the term derives from the 1960s Viennese artists Nitsch and Schwarzkogler—expressing the deepest cynicism toward the formal pleasures of art and the greatest uncertainty with regard to Russia's tentative new identity both in her own eyes and vis-à-vis the West. What Degot calls the "post-traumatic" actions of Aleksandr Brener and Oleg Kulik, for example, have privileged anything and everything that is unsettled, unsystematic, chaotic—and they have been registered with interest in the West. Kulik has postured as an animal making inarticulate sounds, as well as proclaiming himself a candidate for the state presidency. Posing as a dog, barking, defecating, and attacking passers-by in an action of 1994, Kulik quickly attracted the attention of high-profile Moscow newspapers and a local TV channel—and then the art press in Germany, Britain, and the USA [Fig. 7.10]. In another action entitled *Deep in the Heart of Russia*, Kulik simulated sodomy with animals and inserted his head into the vagina of a cow—the political symbolism of enforced political collectivism from the days of totalitarianism was not likely to be missed. Aleksandr Brener, on the other hand, has attempted to reclaim some form of personal bodily identity of the kind ritually proscribed (at least officially) under totalitarianism, in the process demonstrating that the attempt would usually fail. In the mid-1990s he tried to copulate with his wife on a city sidewalk during frosty weather, and on another occasion to give himself a blowjob in public (he failed in both). Elsewhere he attempted to force his way into the Ministry of Defense in Moscow to put slippers on the Minister's feet; and at the height of the war in Chechnya he pranced around Red Square with boxing gloves, announcing that he was challenging Boris Yeltsin to a fight [Fig. 7.11]. Later, in 1996, Brener sprayed a dollar sign on Kasimir Malevich's masterpiece *White Square on a White Background* during an action in the Stedelijk Museum, Amsterdam, for which he was arrested and imprisoned. Avdei Ter-Oganyan, who now runs his own small art school for students seeking a training in provocation, hacked a venerated religious icon to pieces in public with an ax, for which he too was tried and sent to jail. Such catastrophic interactions with everyday routines or cultural icons form part of the agonistic side of contemporary Russian art that has attracted notoriety and even some incomprehension in the West: they are by definition non-transportable and unrepeatable actions that cannot be housed in museum collections but only in the popular memory of dissent. The sharp downturn in the German and Japanese economies, combined with the usual insularity of Western museums, has meant that with a few exceptions Russian contemporary art

7.11 Aleksandr Brener
The First Gauntlet, 1996
Performance, Moscow

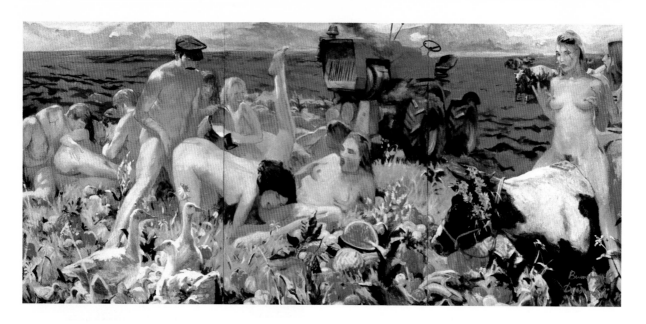

7.12 Vladimir Dubossarsky
Harvest Celebration, 1995
Oil on canvas
6′ 6 ¾″ x 14′ 9 ⅛″ (2..00 x 4.50 cm)

remains an undiscovered territory. The same conclusion applies to most of the art of Central and Eastern Europe.

On the other hand, a spate of adventurous curatorial ventures has recently lifted the lid on virtually unknown historical movements such as Socialist Realism, freshly exposed in the later 1990s in some notable traveling exhibitions. The most elaborate, *Agitation for Happiness*, at the State Russian Museum in St. Petersburg and collateral venues in Finland and Germany, placed on show for the first time for decades the ideologically tendentious art of the Stalin years, with its monumental paintings of cheerful tractor-drivers, bubbling gymnasts, and stern-looking apparatchiks: in itself this was significant for an older audience whose memories of the 1940s and 1950s were thereby revived, but important also for younger artists born too late to have seen many of the works at first hand, who now witnessed for themselves the pictorial power and technical competence of officially funded and rule-governed art. Of course, such exhibitions also provided those artists with a set of models for parody. The painter Vladimir Dubossarsky, for example, took for his prototype the iconic *Harvest Celebration* of 1931 by Aleksandr Gerasimov—and satirized it in his own epic-scaled *Harvest Celebration*, showing instead an orgy of naked sex by the side of a plowed field on a somewhat modernized farm. In the foreground we see happy farmyard ducks and geese, but also those same ripe melons, luscious bananas, and tomatoes that populated the countryside pictures of an earlier time, now performing duty as metaphors for joyous carnality [Fig. 7.12]. Equally parodic are the photographs of the Ukrainian Arsen Savalov, who spent three weeks down a deep mine in the Donbass region and persuaded miners covered in coal dust at the end of a shift to wear ballerinas' tutus and other sartorial signifiers of Russia's traditional culture. The clash of masculine energy and feminine charm had an electrifying and deeply disturbing effect [Fig. 7.13]. Displayed in the reflective spaces of the art museum—I saw Savalov's series in Norway—these oppositions

of work/pleasure, dark/light, politics/culture, and male/female resonated with political and social implications far beyond their obvious humorous qualities.

The immediately pressing question is how far the international community can be persuaded of the importance of this work beyond its national boundaries—the after-shocks of Soviet ideology having been displaced from the world's attention by the terrorist attack on New York of September 2001. Cultural migration is a highly unstable pattern of activity whose determinants lie in much larger movements of political and economic power. For just as we see the opening of a new global agenda centered upon relations between the Muslim and Christian worlds, we see signs that the major preoccupations of post-Soviet Russians could "melt" in significance as normalization in that country takes effect: I am referring to what some call the "boring" period of President Putin's rule, involving the regularization of tax payments, the attempt to eliminate crime, and the democratization of politics (in name at least).

And here is another paradox of our times. For it remains uncertain for the moment whether normalization is actually happening, and at what pace. For the time being, Russian and Ukrainian artists even after the end of "official" culture are continuing to find positions of local relevance that still encounter political power, not in the form of prescriptive regulation but in the form of historical stereotype and cultural intertia. In the new Putinesque atmosphere, Russian artists of diverse persuasions are becoming linked, not by intellectual fashion or stylistic uniformity, but by what Moscow critic Viktor Misiano in a spellbinding recent essay has called the *tusovka*, or "networking," of ideas and practices in an otherwise unplanned and highly labile cultural landscape. The argument goes something like this. *Tusovka* (literally, "shuffling") is a matter of free and willing association between artists, curators, and critics in the absence of state infrastructure. *Tusovka* exists as a series of meetings, projects, and aspirations: it requires no established qualities or virtues, no professional or social standing. Neither a court gathering nor a mafia, to be in *tusovka* you "just need to be there." As Misiano puts it: "*tusovka* is a syndrome whose origins lie in the collapse of a disciplinary culture and social hierarchies." Certain leader figures, such as Osmolovsky and Kulik in Moscow, Novikov and Bugaev in St. Petersburg, Savalov in Kiev, and Roitburd in Odessa, have a role which is to "breed expectation": individuals will act singly or collectively *in extremis* to realize something unrealizable, even utopian in its scale. To lend assistance to *tusovka* is to be capable of internalizing another's obsession, or one's own—accepting all that is different and even contrary. Hence, as Misiano says, "nothing is more archaic and outmoded to *tusovka* than the category of public opinion: *tusovka* is the most obvious symptom of a post-ideological culture." As a personalized form of organization, it

7.13 Arsen Savalov
Donbass Chocolate, from the *Deep Insider* series, 1997
Photograph

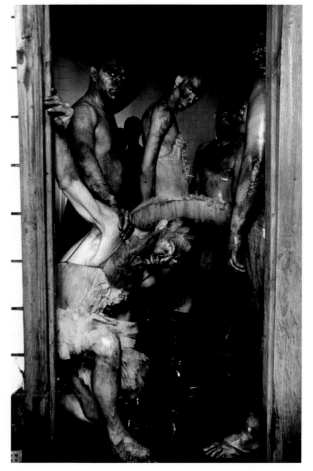

"extols everything individual out of a belief in its demiurgic potential." It exists at a local level, and thinks about global matters only when they become a part of *tusovka*'s localization. The language of these new projects, then, is at one and the same time self-addressed and universal: "this is how the voice of the symbolic order must be," Misiano argues persuasively. "It sends a message but gets no reply." The cognitively loaded assertions and ambiguities of new art accept no contradiction. They induce a kind of paralysis of scandal and desire. Look at the video performances of the group AES (Tatyana Azamasova, Lev Evzovich, Evgeny Svyatsky), which inhabit the dividing line between pornography and boredom. In *The King of the Forest* of 2002, for instance, several dozen young boys and girls from a dance school in the village of Pushkin were filmed on the polished floor of the sumptuous ballroom of the Catherine Palace. As they innocently walked and ran about in their stockinged feet, the camera lingered indelicately on the gym-slipped young bodies and especially on the beautiful young faces of pre-pubescent girls [Fig. 7.14]. *Othello, Asphyxiophilia* (1999) had a naked Othello "strangling" an ecstatic beauty with her own string of pearls. The viewer is invited to add his or her scandalized assent. A network rather than a hierarchy, then, a part of *tusovka*'s new rationale is to distance a younger generation from the exponents of Moscow Conceptualism and its Pop-like successor Sotsart, both of which closely

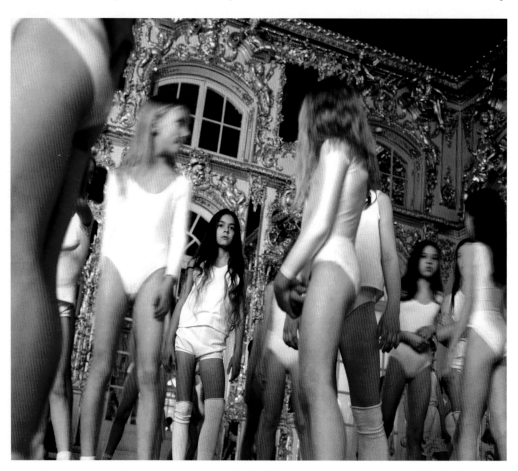

7.14 AES
The King of the Forest, 2002
Video still

shadowed Western ideas and even mimicked some of its styles. The new network of energies—and the statement might apply to other centers of activity in the former East European bloc—is fueled by a potent mixture of euphoric ambition and the frustration that comes from unjustified or disappointed hopes. "And so it is," says Misiano triumphantly, that "having produced nothing tangible and lasting during the 1990s, *tusovka* has made a number of people's fortunes and launched some brilliant careers."

Indeed, as the travails of late-Communist dystopia give way to new uncertainties of the global market system, artists have been able to look again at the Cold War era with fresh despair. Impoverishment and ecological damage alike—the result of the reckless incompetence of the bureaucratic-military-scientific establishments of the late Soviet period—have provided powerful causes to which artists feel they must now respond. Perhaps the Chernobyl nuclear reactor disaster of 1986 remains the foremost symbol of failed utopia, not just in the western Ukraine but throughout the region. As the Slovenian theorist Slavoj Žižek has reminded us, Chernobyl not only made instantly obsolete such notions as "national sovereignty," but raised the possibility that, counterintuitively, "our very physical survival hinges on our ability to consummate the act of… tarrying with the negative." We can make sense then of the daring journey undertaken by the Japanese artist Kenji Yanobe, who penetrated the infected Chernobyl area wearing what he called a "nuclear-safe mobile capsule"—to bring back photographic self-portraits depicting the artist as an apocalyptic explorer returning to an irradiated anthropological ruin, images that viewers will quickly recognize as the very inverse of those of the space-exploring cosmonauts of Soviet Russia's first nuclear age [Fig. 7.15]. Or let us refer to the Kiev-based artist Ilya Chichkan, who confronted the traumatic aftermath of the world's worst scientific disaster by procuring photographs of mutant fetuses from Kiev's medical university, then managed to decorate them with cheap jewelry from a local bazaar before rephotographing the deformed heads and bodies in a gruesome parody of the burial rites of the ancient Scythians who once inhabited the area. As the Ukrainian critic Marta Kuzman reminds us, Chichkan's awful monument to the dead of the nuclear fetish stands in desperate but telling contrast to the stone burial monuments of earlier history.

The photograph is indeed a modern monument of a kind: freezing the evidence of environmental and social disaster has in Chichkan's work succeeded in maintaining the medium's documentary function even at the historical moment of photography's final corruption through digital manipulation. In practice, this documentary function might better be called counter-documentary. For example, the Ukrainian photographer Boris Mikhailov, the oldest and most prominent member of the Fast Reaction Group in Kharkov (other members of FRG are Serhiy Bratkov, Serhiy Solanskiy, Victoria Mikhailova), developed in the later 1960s and early 1970s the practice of collecting

7.15 Kenji Yanobe
Atom Suit Project: Tanks, Chernobyl, 1997
Photograph

7.16 Boris Mikhailov
From the *Case History* series, 1997–98
Photographs

touristic snapshots, usually of the kind that had been kept in the back pocket for years and had acquired creases, breaks, and accidental erasures, and then painting them with garish watercolors in faint repetition of the Ukrainian tradition of painting photos for memorial reasons—the so-called *luriki*. Mikhailov's gesture depended of course upon recognition of the similarity of these amusing parodies to Pop art and specifically to the work of Warhol, but also of the distance of Ukrainian Pop from its New York predecessor. "It was important to me that I had a bad original photograph," explained Mikhailov. "It allowed me to describe the dream, the impossibility, the inability to do anything well, our isolation from cultural traditions." More recently, Mikhailov has established an international career as a result of his ability to bring original perceptions to bear upon street phenomenology, the traumatized condition of the urban underclass, and the humanity of anonymous folk [Fig. 7.16].

Documenta 11

It has become customary to say that there is no better barometer of current art-world opinion than the multimillion-dollar biennales, triennales, and quadriennales that litter the international calendar (though regular attention to the art magazines is not a bad alternative). But which art world? We must remember that art shares with the fashion system its forecasts, its maniacal publicity, its hype. Given the international compass of many of these shows, they can to some degree be taken as definitive (like the fashion forecasts) of what has occurred and what may be around the corner—but we should be cautious about our conclusions.

Take Kassel, Germany, in June 2002, where the eleventh of the five-yearly art extravaganzas that began as a series back in 1955 took place. Kassel is a nondescript former armaments-manufacturing city on the Weser, a provincial center that few people visit between those occasions when it holds the largest contemporary art exhibition in the world. The most celebrated previous show, *Documenta 5* in 1972, had been dominated by German, British, and American Conceptual artists within the purview of its ambitious young curator Harald Szeemann. By 2002 the representation had very significantly shifted. Selected by a team of seven curators under the leadership of the Nigerian-born Okwui Enwezor, it purported to take a "global" vision of art projects expressive of migration, identity, and change: of disputed borders, transplanted or threatened communities, oppressed or neglected regions, new or heterogeneous avenues of knowledge and political awareness. A total of 112 artists (in fact a modest number by *Documenta* standards) was invited to submit projects that collectively would precisely *not* order themselves into a single theme or position. As Enwezor argued, *Documenta 11* would not try to reach conclusions, declare the past to be

bankrupt, or celebrate the endlessly new. "If the animating intellectual and artistic quest of past Documentas has been to prove such conclusions were possible, *Documenta 11* places its quest within the epistemological difficulty that marks all attempts to forge one common, universal conception and interpretation of artistic and cultural modernity… the exhibition could rather be read as an accumulation of passages, a collection of moments, temporal lapses that emerge into spaces that reanimate for a viewing public the endless concatenation of worlds, perspectives, models, counter-models, and thinking that constitute the artistic subject." He further specified that the exhibition would not constitute a closure on the intellectual ambitions of the project: it would be one of five "discursive platforms" taking place in different parts of the world (the others being a lecture series on "Democracy Unrealized" in Vienna, a conference on "Truth and Reconciliation" in New Delhi, another on "Creolité and Creolization" in St. Lucia, and a further philosophical forum on "The City" in Lagos, Nigeria). Cautioning against the twin processes of post-colonial liberation and global capital expansion, Enwezor said that "if the avant-gardes of the past (Futurism, Dada and Surrealism, let's say) anticipated a changing order, that of today is to make impermanence and… aterritoriality the principal order of today's uncertainties, instability and insecurity. Within this order," he supposed, "all notions of autonomy which radical art had formerly claimed for itself are abrogated." After empire, he claims, comes the resistant force of what Michael Hardt and Antonio Negri in their book *Empire* have called "multitude," with its pressing, anarchic demands, its almost unrecognizable forms of subjectivity and position, its freedom from the older and decaying forms of the rigidly territorialized Western nation state. Against these older forms of Western culture has emerged radical Islam and the possibility that the September 11 attacks on New York are a metaphor of antagonistic politics wherever it may appear. Ground Zero—be it in New York, Ramallah, or Jerusalem—is what Enwezor at one point calls "the founding point of the reckoning to come with Westernism after colonialism… the full emergence of the margin to the centre."

In practice, of course, *Documenta 11* was a culturally and geographically specific selection, arranged on view in more or less conventional spaces and dominated by excitement at some of the technologies of the day. Its enormous intellectual ambitions may not have completely registered with the viewer with insufficient time to absorb the lengthy texts, see more than a fraction of all the ancillary films, or attend the many debates, conferences, and platform discussions—a logistically impossible task. Many visitors would have felt let down by the absence or near-absence or artists from Scandinavia, the Baltics, most of Eastern Europe, Australia, and smaller countries such as Switzerland, Wales, Greece, and Vietnam. Some reviewers complained, with justification, of the oppressive aura of political correctness that pervaded the show—as well as of its lack of humor, and its predominantly narrativizing, literary tone. And yet historically, *Documenta 11* will certainly go down as an important effort to break the mold of current disciplinary formats in the organization of massive international shows, and for having addressed at just the right moment the question of what globalization might

7.17 William Kentridge
From *Mine*, 1991
Charcoal on paper
29 ½ x 47 ¼" (75 x 120 cm)

mean in a context of rapid and far-reaching political and economic change.

It was Africa that proved to be the revelation of the show—with some seventeen artists from Benin, the Côte d'Ivoire, South Africa, Uganda, the Democratic Republic of the Congo, Nigeria, Cameroon, and Egypt, only a few of whom we have the space to mention here. Among South Africans, the work of the white artist William Kentridge is untypical in having already reached the international arena and made for the artist a growing reputation. Kentridge was propelled into his current manner by two events: an upbringing as a white child in black South Africa, where he witnessed the humiliation of blacks, and a spell in Paris studying mime at the Ecole Jacques Lecoq before returning to his native Johannesburg. The former context was a shocking revelation to a young child, for as Kentridge recorded in a recent interview: "I had never seen adult violence before seeing a man lying in the gutter being kicked by white men... violence had always been a fiction before that moment." The latter was a lesson in how to marshal the energy of stage performance—to gather energy for one precise movement and to carry it through to the next. As he has reflected more recently: "There were maybe twenty or thirty other exercises [at the Ecole Lecoq] which were used as metaphors for performance or acting, but which were equally appropriate for drawing." For it is drawing—the solitary activity of drawing and redrawing for sequences of animated film—that has established Kentridge as a major figure in contemporary visual art. Accepting first of all that apartheid could not be represented in any conventional way, and perhaps not with conventional artistic tools either, Kentridge has crafted a special hybrid form of "drawing-film" that speaks more eloquently about process than either medium taken singly. The immovable "rock" of apartheid, both before 1995 and afterward, he has described as "possessive, and inimical to good work. I am not saying that apartheid, or indeed redemption, are not worthy of representation, description or exploration: I am saying that the scale and weight with which the rock presents itself is inimical to that task." Kentridge's drawing-films, on the contrary, work on a more formal level as a demonstration of utter fluidity and mutability in the historical process. We typically see white mine-owners working besuited at their managerial tasks, interspersed with moments of privacy in which they imagine the collapse and reorganization of the landscape even as their brutal hegemony continues. Or we see miners at their work [Fig. 7.17]. Rosalind Krauss has written incisively of how the drawing process for Kentridge, in which the artist trudges in solitude backward and forward between the drawing and the movie camera for hours upon end as the animation proceeds, is itself a kind of existential labor that

speaks of a radical economy of means (Kentridge uses only a few sheets of paper for each film) and a radical return to pre-technical methods associated with the mysteries of the palimpsest, where one image peels away to reveal another, and another. "It is just this walking back and forth," says Krauss, "this constant shuttling between the movie camera on the one side of the studio and the drawing tacked to the wall on the other, that constitutes the field of Kentridge's operation. The drawing on which he works is at all times complete and at all times in flux since once he has recorded it from his station at his Bolex, he moves across the floor to make an infinitesimal modification in its surface, only then to retreat once more to the camera." Scenes don't change in Kentridge's films: they bleed endlessly into each other in a perpetual unfolding in which nothing is fixed—in which accidental minutiae in one frame can become something monstrous or fluid in the next, and the next, and so on. In crafting utterly new image-types with the most pre-technological of means (sticks of charcoal and a primitive camera) Kentridge ensures that material as well as overt narrative constitute a work of thoroughgoing and dialectical subversion.

Among black artists from Africa, the career of Bodys Isek Kingelez is perhaps representative. First introduced to the international art circuit by Jean-Hubert Martin for *Magiciens de la Terre* in Paris in 1989, the self-taught Kingelez has been making utopian cities out of assorted bits of packaging, brightly colored papers, and discarded remnants of the consumption cycle, which in all their fantastic excess sit on low floor-plinths rising to perhaps three or four feet in height—hence the viewer looks down upon them appreciatively from above. Kingelez' major project of the 1990s was to refashion the place of his birth, the village of Kimembele-Ihunga in the Bandundu Province of former Zaire, and to make it a shining new twenty-first-century city with boulevards, skyscrapers, stadia, and a monument to the wisdom of his father, Maluba [Fig. 7.18]. Kingelez describes the town itself—renamed by him Kimbéville—in language no less exotic than the buildings themselves. "The overall concept of the town ranks it among the high-calibre, super-multisystem phenomena of futurist architecture," Kingelez says. And he is prepared to confound fantasy and reality with the statement that "these realist buildings, unaffected by the dictates of fashion, represent an unparalleled devotional vision... These boulevards, these lanes with their spotless pavements, hardly ever become congested, blocking freedom of movement; on the contrary, they provide people with pleasant, easy access to all parts of the town." The attractions include "a plethora of services, hotels and restaurants. Sometimes with an American flavour, sometimes Japanese, Chinese or European, not to mention African fare. The town has it all, from sun-up to sun-down, and for forever and a day. Its distinctive features so full of promise, this town should appear on a definitive list of the greatest towns on earth." Boasting openly and

7.18 Bodys Isek Kingelez
Kimbembele Ihunga (Kimbéville), 1994
Plywood, paper, cardboard, various materials
4′3⅛″ x 6′ x 10′6⅛″ (1.30 x 1.83 x 3.00 m)

Mixing self-irony with fantasy, Kingelez has said: "The town of Kimbéville acts as a mechanism for development with a myriad of distinctive features applying as much to the buildings as to the varied elements of its clearly defined landscape which blatantly demonstrates why this town was created. Its creator, the artist Kingelez, a man of high moral fibre, will keep his future promises with this work of art which will accompany him into the 21st century. Kimbéville is a real town which, given time, will exist; it is not an effigy made up of well-known brandnames which is doomed to remain a maquette."

also charmingly of the architect's "fame and international reputation as a highly talented artist," Kingelez and his project translate with the greatest difficulty into the framework of Western aesthetics and critical thought. We recognize his posture as a deft inversion of the relationship of citizen to the failed utopian cities of modernity, as a recasting of the modern world city on a scale that few Western architects in recent memory—save perhaps Venturi for Las Vegas or Koolhaas for New York—have so much as envisaged. Yet we recognize too that Kingelez commands a local context and a traditional pattern of temporalities not yet convergent with Western norms of progress and retreat, new and old, real and imaginary.

That such aesthetic oppositions simply do not hold up for the contemporary African (or Asian, or South American) artists was ably demonstrated at *Documenta 11* by the presence of the original—and in Western terms highly eccentric—artist Georges Adéagbo, a student of law and business in France in the 1970s until news of his father's death returned him to his home village of Cotonu, Benin, to take his place at the head of his family. Refusing that role, he began to assemble installations in his bedroom, then in his yard, in highly hermetic and inscrutable ways: "My only way of communicating with my relations was these short handwritten notes that I put on the ground along with objects I found on walks. I go to the lagoon every morning... to pick up some object and take it home, then I write a note about what it evokes in me, put the note beside the object and wait to see how people react... All I have to do is put down an object and the ideas come flooding in. I work like this every day, even under the hot sun. And every evening I collect everything together in one place." "I am not an artist, I do not make art," protests Adéagbo. "I am just a messenger." And then, in apparent self-contradiction: "Art is what you say to people without winding them up." Thus Adéagbo's installations generally begin from a symmetrical arrangement on the floor and spread out [Fig. 7.19]. They were first spotted by chance by a French curator, and have featured in international exhibitions since. For Kassel, Adéagbo's installation *The Explorer and the Explorers Facing the History of Exploration...! The Theatre of the World* departed from strict symmetry but displayed extraordinary networks of found, commissioned, self-authored texts and images relating to exploration, in a non-narrative, research-like provisionality that resists reduction to "content" or "theme" but imbricated Western and African histories in some startlingly complex ways. Alive to contingency and fragmentation, to the critique of Enlightenment systems in the West, Adéagbo by fortuitous circumstance manages to occupy a place in Western art that defies accurate historical positioning and revels in its exuberant difference even from Western installation genres.

7.19 Georges Adéagbo
The Explorer and the Explorers Facing the History of Exploration...!
The Theatre of the World, 2002
Mixed media
Collection Museum Ludwig, Cologne

Assertng his role as a messenger rather than an artist, Adéagbo says that an artist is "anyone who gets a message through: it is art that makes the artist, not the artist who makes art."

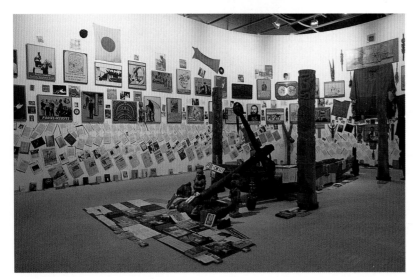

"Africa remains a territory of the imagination," writes Enwezor elsewhere, "contradictorily occupying a place of origin and lack, a forest of excessive and observant signs that troubles the cultural logic of the Modernist project." Young African artists devise "fictive histories which turn their practice into colonies of perversion that are magnified and projected through the peculiar lens of occidental desire and its almost insatiable taste for the exotic." In the work of the best young artists with roots in Africa, "we are jarringly confronted with questions that dance around the possibility of an autonomous post-colonial enunciation." It is a description that fits well a certain sub-category of African art shown to good effect in Kassel, namely the work of Africans who had shifted culture, been born outside the continent, or who had traveled ceaselessly among the contradictions of uneven globalization. For *Documenta 11* the Uganda-born Farina Bhimji (now resident in London) contributed a particular perspective by revisiting Uganda to make a twenty-eight-minute film, *Out of Blue* (2002), concerned with the recent tragic atrocities in her country. Stark as a Minimalist artwork in motion, it joined the other slow-motion film experiments referred to elsewhere in this book.

The artist Yinka Shonibare was born in London of Nigerian parents, before school in Lagos and holidays in London taught him to feel at ease in both cultures, and eventually as a student at Goldsmiths' College to take an interest in the historical and colonial tensions structuring his double world. Speaking Yoruba in Africa and perfect English in his adopted country, Shonibare absorbed Australian and American TV cartoons as a teenager before becoming acquainted with internationally recognized figures such as Cindy Sherman and Rosemarie Trockel, feminist theory, and the ironic tactics of an earlier avant-garde. "I realised," says Shonibare, "that I didn't have to accept my designation as some sort of doomed Other: I could challenge my relationship to authority with humour and parody in mimicking and mirroring." Yet it is not only humor—some of it dark—but an interest in the seductive power of material wealth, not to mention literal sexual seduction, that has animated his most ambitious recent tableaux. For, key to all of Shonibare's tableaux to date is his use of brilliantly colored patterned fabrics known as Dutch Wax—worn by millions of Africans today as a signifier of their identity. The fabrics, it turns out, originated in Indonesia in the nineteenth century, were transported to Holland by Dutch colonizers, and then manufactured at cotton mills in Manchester before being exported to West Africa, where indigenous local manufacture repeated the style. Though appearing superficially "authentic" to Westerners looking at Africa, this fabric, Shonibare observes, is itself an inauthentic cultural hybrid of complex genesis, for when Africans appropriated the designs, they perhaps did not realize that they were already marked by colonialist appropriations and Western capitalism in its pure form. Used to create a tableau of eighteenth-century noblemen abroad, Shonibare's signature fabric in fact provided a prop to signify the lavish adventurousness of Europe in its first encounter with its native or rural other. Thus for Kassel, Shonibare turned to the theme of the European Grand Tour for his installation *Gallantry and Criminal Conversation*, quite specifically themed to

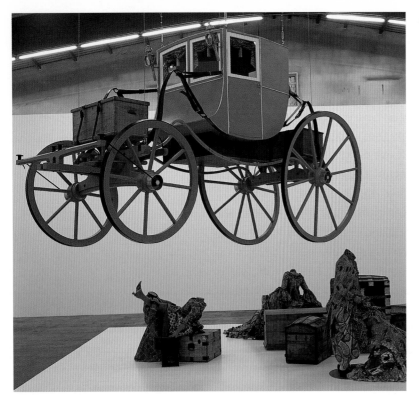

7.20 Yinka Shonibare
Gallantry and Criminal Conversation, 2002
11 lifesize fiberglass mannequins, Dutch wax-
printed cotton, leather, wood, steel plinth
29'7" x 29'7" x 5" (9.00 m x 9.00 m x 12 cm)
approximate carriage measurements;
6'8" x 8'4" x 15'5" (2.00 x 2.60 x 4.70 cm)
Installation at *Documenta 11*, Kassel,
Germany

speak about the sexual adventures of British aristocrats touring Italy in the eighteenth and early nineteenth centuries [Fig. 7.20]. Occupying a large square hall, the installation presented a full-size eighteenth-century carriage, with eighteen headless figures pulling up their garments to engage in sexual exchanges amid the unloaded luggage trunks of their interrupted journey (the terms "gallantry" and "criminal conversation" refer to exactly these encounters).

In the short interval between *Documenta 11* and now, there have been signs that a global agenda has been becoming *de rigueur* for ambitious curators aiming to attract the attention of the roving critic. Take Venice's 50th Biennale, that of 2003. Even this venerable old institution (the first Biennale was in 1895, and there have only been a few breaks in continuity since) has shown signs of a new inclusiveness. Based originally on celebratory shows in the favored national pavilions—Italy, France, the USA, Russia, Germany, Great Britain, and a few others—participation has widened over the last twenty-five years more or less in line with the expansion of travel, the spread of broadly democratic political agendas, and the sheer pressure exerted by the recognition that nations such as Egypt, Romania, Poland, and more recently Korea, Taiwan, China, the Czech and Slovak Republics, all have rich and independent artistic traditions bearing a significant relation to so-called first-world Eurocentered Modernism. In 2003 Kenya became the first East African nation to appear. No less significantly, the overall curator, Francesco Bonami of the Museum of Contemporary Art in Chicago, handed over responsibility for the Biennale's ancillary exhibitions of new art— the "must-see" exhibitions of younger artists—to no fewer than eleven independent curators to do with them as they wished. Refusing the role of grand curator—or rather finding a new way of occupying it—Bonami suggested that the twenty-first-century art extravaganza "must enable multiplicity, diversity, and contradiction to exist." No longer able to depend upon a shared language of artistic form (probably an illusion at the best of times), the Biennale should strive to symbolize "the modern world with its contradictions and growing fragmentation into more and more nations and identities."

But what realities lie behind the new rhetorics of multiplicity and contradiction, the fashionable embrace of uncertainty, mobility, and shifting boundaries? On the one hand, Bonami's other decision to position an exhibition of Western painting (in fact fifty Westerners to one Japanese) at the very heart of a multinational Biennale acted as a provocation to a critical public who probably hoped for a more adventurous avant-

gardist show. Viewed one way, this meant a reaffirmation of the place of Western painting at the center of contemporary aesthetics, or at any rate a posing of the question whether installation and the other "alternative" genres had not lost contact with the traditions of the static painted rectangle. On the other hand, the confinement of *Pittura/Painting: From Rauschenberg to Murakami: 1964–2003* at the Museo Correr, far from either the pavilions or the younger experiments at the Arsenale, would have suggested to some the entrapment of the Western painting tradition within the spatial confines of the museum. A third interpretation is perhaps the most tempting of all: that no real strategic tension exists any more between painting and its ostensible negation in video, installation, and performance. It seems more likely that to the artist as much as to the viewer, all media can claim now to survive—indeed, to flourish—on a plane of equal credibility, with little more than a murmur of those political anxieties that animated the avant-gardes of the 1960s and early 1970s, namely the threat of commodification by the art market and the fetishized durability of the authentically authored work. Furthermore, there is no automatic or neat correlation between recent Western traditions and the painting medium, or between non-Western traditions and the "alternative" artistic media.

That at least is the implication of Bonami's other emphasis, that temporality in art "is never linear," that it is "characterised by repetition and syncopation, detours and delays. Sometimes the real revolutions, political as well as artistic, remain invisible until they have already happened." Bonami spoke too of "the delayed nature of most artistic revolutions, the revolutionary quality of delays," as if to suggest that painting too—its formalities, its restrictions of shape and medium—may paradoxically remain a benchmark for the kinds of work being done in installation or the moving image. Whether Bonami's wisdom was successfully demonstrated by the latest offering in Venice is more difficult to judge. We saw the independent curators taking care of the new globality—in Gilane Tawadros's *Fault Lines* pavilion devoted to contemporary African art, in Hou Hanrou's *Zone of Urgency* devoted to the recent contradictions of rapid modernization in the Asian Pacific region, in Catherine David's *Contemporary Arab Representations*, and in the sprawling shed full of excitations curated by Molly Nesbit, Hans Ulbrich Obrist, and Rirkrit Tiravaniya entitled *Utopia Station*. Suffice it to say that *Utopia Station* corraled the energies of over two hundred artists and architects who built small structures, submitted drawings, or designed posters "to swarm in the space and also beyond it, scattering individually into the city of Venice." In the meantime writers, dancers, and performers were invited "to give Utopia their ideas, radical actions and sounds" under the sign of Adorno's maxim that "whatever can be imagined as utopia, this is the transformation of the totality… what people have lost is very simply the capability to imagine the totality as something that could be completely different."

It was perhaps *Contemporary Arab Representations*, however, that pursued the new internationalism with the greatest vigor. In common with Enwezor's *Documenta 11* and Molly Nesbit's *Utopia Station*, this took the form less of an exhibition than a

project, unbounded by a single time and place of exhibition, but rather extending over several years and consisting of a range of seminars, publications, performances, a mobile set of participants, and several museum administrations. Launched with the aim of "encouraging the production, circulation and exchange between the different centres of the Arab world and the rest of the world," it sought "to look at the complex dimensions of aesthetics in relation to social and political situations [and to] analyse and question unprecedented dynamics, speeds and configurations, in short a phenomenological complexity whose echoes can be heard far beyond the Arab world." From Lebanon alone, first at war with Israel and still under Syrian occupation, have emerged artists such as Tony Charkar and Walid Sadeh, who produce a wide range of work reflecting on the postwar atmosphere; others such as Elias El-Khoury and Mohammed Soueid, who address what they understand to be a continuous state of war [Fig. 7.21]; and yet others who confront the Syrian occupation itself. The Lebanese critic Paola Jacoub expresses the desire to "tear down the vectors of colonialism" in the architectural reconstruction of the country. The recognition of contemporary artistic projects in Egypt, Iran, and especially war-torn Iraq in the wake of the US-led invasion of 2003 promises to become no less important as international art curators address the Middle Eastern scene.

7.21 Mohammed Soueid
Presentation room film program at
Contemporary Arab Representations,
Beirut/Lebanon, Witte de With, Rotterdam,
September 2002

Contemporary Voices

Fang Lijun, cited in the catalogue to *China Avant-Garde*, Berlin: Haus der Kulturun der Welt, 1993, p. 113.

"Why are we a lost generation? This is nonsense, put about by others who want us to think, live and function so well that we satisfy their egoistic needs like their battery hens. But we will not do it. We neither obey the rules of life imposed by them nor collect a salary as public servants do. But we do not starve, we have more money than they do, are more relaxed and happy, have more women and time to have fun or travel. That is why we are called the lost generation. But deep in their hearts the people think that we are a generation which should be shot."

Viktor Misiano, "Russian Reality: The End of Intelligentsia," *Flash Art*, summer 1996, p. 104.

"The current catastrophe influencing art [in Russia] is two-sided: institutional and epistemological. All hopes for the new infrastructure have failed: state institutions of the Soviet age are in ruins and an art market still doesn't exist. At the same time, all models of thought that were formed in the context of opposition to the Soviet regime, and those which mythologized its alternative, have turned out to be totally inadequate to the post-Soviet reality: consciousness hasn't kept pace with the enormous speed of the transformations. Art currently lacks both social and cognitive justification."

Okwui Enwezor, "The Black Box," *Documenta 11: Platform 5*, Ostfildern-Ruit, Germany: Hatje Cantz, 2002, p. 47.

"It may be said—in the sense of the insecurity, instability, and uncertainties it inspires—that the kind of political violence we are experiencing today may well come to define what we mean when we invoke the notion of Ground Zero. Beyond the symbolic dimension of its funerary representation, the notion of Ground Zero resembles most closely Fanon's powerful evocation of the ground-clearing gesture of tabula rasa, as a beginning in the ethics and politics of constituting a new order of global society moving beyond colonialism as a set of dichotomising oppositions, and beyond Westernism as the force of modern integration… Some call [September 11] the clash of civilizations, others the axis of evil, or the battle between good and evil, between the civilized and uncivilized world; others call it jihad, intifada, liberation, etc. In all the jingoistic language that mediates this state of affairs, cultural and artistic responses could, however, posit a radical departure from the system of hegemony that fuels the present struggle."

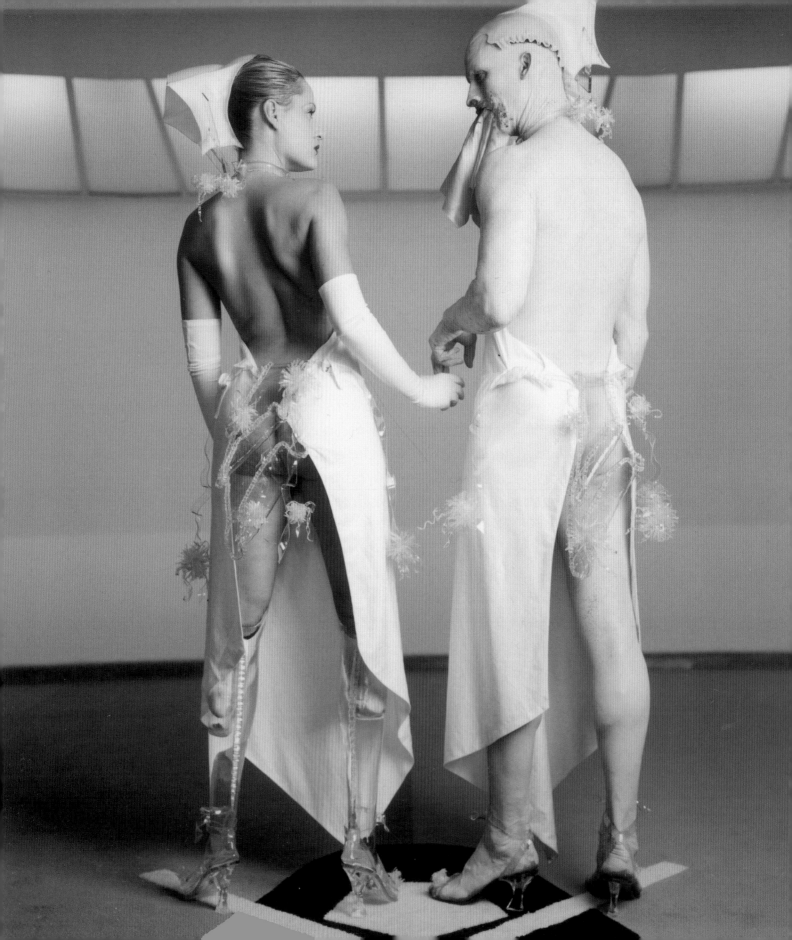

8
A New Complexity: 1999–2004

The sudden recognition by curators of the value of new art from China, Taiwan, South Korea, Africa, the Middle East, the former Russian Republics, and most of Central and Eastern Europe in the last decade or so is a development too recent to fully assimilate. On the one hand, the spread of international dialogue and financial resources has begun to liberate the talents of certain artists working far from the familiar circuits of Western avant-gardism. On the other hand, that same diversity brings with it new pressures on the way we Westerners witness, understand, and write about new art.

One such pressure comes from a seemingly new demand upon the viewer's comprehension. The sudden enlargement of the Western system to embrace most nations of the globe is not only a matter of quantity. As aesthetic systems proliferate and critical positions multiply, judgment becomes more difficult, even within a system that delivers information on new art with ever greater rapidity. Critical judgement must always transcend mere excitement at the sight of something spectacular or phenomenologically new. For example, memorable—for me—at *Documenta 11* were the Moldavian artist Pavel Bräila's forty-minute *Shoes for Europe* (2002), a film about the incompatible rail-gauges at the Moldavian/Romanian border town of Ungheni (a rich metaphor for the politics of Central Europe); the Turkish artist Kutlug Ataman's four-screen DVD projection *The Four Seasons of Veronica Read* (2002) concerning one woman's obsession with the life-cycle of the Hippeastrum bulb; and the magnificent installation *Lines in the Sand* (2002), about the meanings of the story of Helen of Troy, by the veteran American artist Joan Jonas [Fig. 8.1], arguably the formally most audacious work in the show and one that demonstrated a full range of disjunctive spectatorial possibilities through Jonas's virtuoso handling of multi-channel imagery. The suggestion contained within even this short list of preferences (and a different writer would give a different list) is that new material technologies—of the moving

Opposite
Matthew Barney
Cremaster 3 (detail), 2002
See fig. 8.9

image, of the multi-screen projection, of the multi-channel installation—are making superior claims on our attention at this time: superior claims about their spatial complexity, their interweaving of auditory and visual data, about the nature of the new museum space. This chapter will address these symptoms of a replenished visual order, and address the implications of that other ephocal invention, the Internet, for our understanding of art today.

Chaos Theory

Evidence of a jump into various degrees of disorder was in evidence in Kassel in the guise of two very different works situated, not in Documenta's vast indoor spaces, but in the wider spaces of the city. In order to see Thomas Hirschhorn's *Bataille Monument*, for example, one had to walk a mile or so north to the Nordstadt neighborhood, where, on the Friedrich-Wöhler housing estate, one encountered in the middle of the car park a makeshift media center lashed together out of plywood, Perspex, and brown sticky tape. Nearby, disaffected local kids could mingle with an international art audience to rifle through a library of Bataille's writings, inspect maps and biographical data, or lounge in front of Tarkovsky films on TV. The ambience was friendly and conducive—and demonstrated the democratizing power of a project more potent than a mobile library, more engaging than "sculpture" in the form of a commodity praised and prized for its durability, and more inclusive in its definition of an audience than the city-center museums (true to his convictions, the artist was present to chat to locals, welcome visitors, and dilate on the importance and merits of Bataille). Constructed and maintained by young members of a local boxing club, Hirschhorn's *Bataille Monument* convincingly incarnated Bataille's dazzling speculations on the *informe*, on "expenditure," on the bodily low, in something that could be taken as community form. "I wanted every individual to bring himself or herself to the project as a person. Our motto was 'Do not work like me—let's work together.'" Or as Hirschhorn further explained: "Choosing Bataille meant opening up a broad and complex force field between economy, politics, literature, art, erotica, and archaeology... Bataille has nothing to do with Kassel... the *Bataille Monument* is not a contextual work... I am not a social worker... for me, art is a tool to get to know the world... it is made for a nonexclusive audience." As Buchloh said of Hirschhorn's disordered projects as a group, "their structures, procedures and materials seem impoverished in their resources and infantile in design... All of them seem to have been taken from the *non-sites* of consumer culture, the negative ready-mades of containers and wrapping materials in which objects had been packed and shipped, thus salvaging the discarded evidence of an infinite production of waste."

Back in Kassel's impressive seventeenth-century Karlsaue

8.1 Joan Jonas
Lines in the Sand, 2002
Video installation and performance

park, a similar description might have fitted the
very strange world of the German performance
artist John Bock, scarcely out of college yet
already one of the truly recondite figures of the
international art stage. Having trained at the
Hamburg Art Academy under Franz Erhard
Walther and in the company of fellow students
Jonathan Meese and Christian Jankowski (both
performance artists), Bock emerged in the mid-
1990s giving "performance-lectures" of startling
randomness that viewers immediately associated
with Dada, with theater of the absurd, with Vienna
Actionism, and with a parody of science and
aesthetics in all their heterogeneous forms. For
example, in a "lecture" dignified by the title

8.2 John Bock
FoetusGott in MeMMe, 2002
Performance at *Documenta 11*, Kassel,
Germany 2002

LiquiditätsAuraAromaPortfolio of 1998 Bock had divided a performance space into two
levels; the higher one, accessed by a staircase, showing garbage, kitchen equipment,
and various wooden and filmic interventions, each complex suggestive of some
mysterious activity taking place in the realm below. For a MOMA New York show of
2000 Bock performed four lectures, called *Quasi-Maybe-Me-Be Uptown* ("a fashion
show with thirteen females and two male models, showing costumes I tailored from
spaghetti, shaving foam, bubbles, sweaters with long sleeves and a dummy costume"),
Intro-Inside-Cashflow-Box ("in a shed in the garden, where the audience could follow
the action through a glass plane"), *MEECHfeverlump schmears the artwelfareelasticity*
(a video of amateur actors), and *Gribohm Meets Mini-Max-Society* ("I spent three
hours in a box mounted on wheels, producing photograms by laying myself on the
photo-paper and passing them out through a hole in the box, to my assistant"). But
such self-descriptions give no real idea of the richness of the layered interconnections
of arcane philosophy, misquotation from German literature and scientific texts, and
the ludic (if not ludicrous) anarchic play with materials that a Bock "lecture" typically
offers. For Kassel, Bock constructed his own wooden house-theater in which to stage
his strange plays *1,000,000$ Knödel Kisses*, *Quasi Me*, and *Koppel Margherita*, linked to
numerous supplementary actions by himself and others and spanning most of the
duration of the exhibition [Fig. 8.2]. Everything presented seemed to teeter on the
brink between careful control and absolute mess, evoking slapstick, Brecht, the circus,
Paul McCarthy, a sense of narrative quest, and a lexicon of aborted gestures performed
amid and between the elements of his crazily constructed stage. On the one hand, Bock
inhabits a territory seemingly indebted to Dada and in that sense conforming
strategically or otherwise to deeply embedded protocols of the late-Modernist visual
arts. On the other, perhaps, Bock is acting out the alienation of meaning in a world
experienced as repetitive, complex, and terrifying, hence tantalizing his audience/
viewers (which term do we choose?) with a reminder of how Dada first strove to

combine chaos with a sense of the historical and social world.

Two developments in the wider fields of science and technology have stimulated a different kind of debate, one having to do with complexity and its consequences. The first of these stems directly from a 1979 scientific paper by the meteorologist Edward Lorenz entitled "Predictability: Does the Flap of a Butterfly's Wings in Brazil Set Off a Tornado in Texas?" which argued that no humanly finite list of causal variables would enable the scientific community to fully account for massive phenomena of the earth's weather such as tornadoes, nautical storms, or seasonal temperature variations. Explained differently, Lorenz's so-called "butterfly effect" said that large non-linear dynamic systems—the ones we care about because they cause environmental damage or precipitate geological shifts—show excessive but theoretically demonstrable and extremely sensitive dependence on the smallest initial conditions. Chaos theory, the branch of science that gathers intellectual disciplines together to explain dynamic tendencies such as crowd behavior, stock-market trends, and weather, shows how even apparent randomness and ungovernability have deeper and more complex causal roots. The second development of the last ten years is the penetration of ordinary life by exactly such paradoxical concepts as rule-governed disorder, the systemic character of networks articulating the micro with the macro levels, and the fundamentally biological character of everything.

If Clement Greenberg had once defended the Abstract Expressionist painters for having understood what kind of late Modernist painting could put itself into correspondence with what he termed "the most advanced view of the world obtaining

8.3 Julie Mehretu
Retopistics: A Renegade Excavation, 2001
Ink and acrylic on canvas
8'6" x 18' (2.59 x 5.49 m)

at the time," then the signs are that certain contemporary projects of the last few years are laying claim to a similar achievement. Take the new paintings of the Ethiopian-born Julie Mehretu, educated in Addis Ababa and Dakar before moving to the United States, where she now regularly exhibits. A huge canvas such as the 18-foot (5.49 m) long *Retopistics: A Renegade Excavation* (2001) establishes by its scale and its idiom alone a set of counterparts for geography, travel, and biographical diversity, while demonstrating impressive formal command of complex graphic and spatial techniques [Fig. 8.3]. A layered complexity certainly provides the initial appeal: we see ink sketches of familiar buildings, overlain by delicate biological forms and curved lines, overlain once more by splinters of solid, translucent, or architectural fragments rushing into our field of view. As if generated by computer-graphics software and hence able to interpenetrate at will on a TV screen, these spatial elements could also be bridges, buildings, freeways, and floor plans, laid out (as they seem to be) on a provisional perspective ground-plan that is by implication linked to the space of the easily fascinated viewer. The language of this abstraction, however, is far less easy to convey. Reverberating with echoes of Russian Suprematism of some eighty years before (one of Mehretu's canvases is called *Rise of the New Suprematists* [2001]) while at the same time trumping even the grandest mural scale of the American Abstract Expressionists, such paintings demonstrate by visual conviction alone that abstract art as a category is far from dead. It is the Baroque entanglement of the very small with the very large in Mehretu's work that lends it contemporary force: it shows us both that not all computer-generated visual effects are gaudy blandishments for the tired eye, and also that the Baroque as an aesthetic system has assumed new relevance to the experience of life in the teeming cities where most of the world's population now lives.

On a more cosmic scale, the American painter Matthew Ritchie has addressed himself to what a chaos-governed universe might look like, and the appeal of his paintings is to the philosopher and the scientist as much as to the follower of new aesthetic work. Thus far Ritchie has used the flat parameters of wall and floor (and the physical boundary that joins them), and he has clearly studied scientific illustration as well as chemistry, geography, cartography, and physics in order to generate his extraordinary visual and graphic effects. The sheer formal energy of painting's own ordinary resources might well be understood to be the primary effect of Ritchie's work. Yet a complex construction like Ritchie's *The Fast Set* installation [Fig. 8.4], made with acrylic and enamel paints, aided by low-rent marker pens such as a scientist might use

8.4 Matthew Ritchie
The Fast Set, 2000
Acrylic and marker on wall, enamel on Sintra
15 x 24 x 18' (4.57 x 7.31 x 5.49 m)
Installation at the Museum of Contemporary Art, Miami

For *The Fast Set* installation Ritchie provided a text about an imaginary lone astronaut, a time-traveling Golem, Schrödinger's cat, and space-time in a headlong, multilayered style that paid little heed to the reader's psychic comfort. "Painting," Ritchie has said, "is an infinite battery, it violates the laws of thermodynamics, and is never entropic."

on a lecture board, refers in two directions simultaneously: to the mental and social self-representations of fast socialites and careerist professionals whose interlocking horizons career and collide in patterns of unrepresentability, as well as to the mind-bending temporal complexities of the cosmically massive right down to the microscopically small. Some critics, it must be said, have seen in Ritchie's wild lopsided painting-installations a reflection of acid-trip hallucinations or the dark world of voodoo powers: "Kinetic Fragonard" is another term put forward in an effort to describe the Rococo fascination induced by these swirling garlands and gaudy ripples. It has also proved tempting to read Ritchie's works as allegories of the place of human beings in the universe, since close inspection of his patterns reveal small humanoid traces within, successively, electron-microscope views of plasma or protein, and galactic spirals and force fields on the cosmic scale. Caught up within the networks of energy that science is only now beginning to map, Ritchie's installations evoke the cognitive complexities of gambling (another favorite reference of the artist) as well as the much larger metaphysical mix.

Who would have supposed that marker pens and graphic scribbling could

8.5 Sarah Sze
Untitled (St. James), 1998
Mixed media
Dimensions variable
Installation at the ICA, London

constitute the resources of contemporary art? When the Brooklyn-based artist Sarah Sze adorned the architectural ledges of an old warehouse space in Bremen's Lichthaus in 1997 with dime-store purchases, clothes-pins, buckets, matchboxes, plastic pens and the like; when she piled up plastic plates, sponges, bars of soap, books, cookie packets, batteries, desk lamps, and other domestic detritus—not in the gallery space but on a window shelf and on the ceiling high above a gallery floor in a London installation of 1998 [Fig. 8.5]—it would have been fair to associate her with the "slack" art of mock-teenage confusion whose moment had already begun to pass. Yet something else was stirring in Sze's installation art. Beginning at the bottom of the evolutionary ladder with the category-rich confusion of the everyday, she could also be observed piling and connecting her categories in relatively specific ways—specific, that is, to an eye attuned to cosmic discoveries and interstellar connections. That, at least, is the teleology of her recent work. But for its articulation, the key for the moment seems to be architecture and the messy fabric of the city. Familiar with New York and Tokyo, Sze constructs her pieces according to the following procedure: Go to a series of local hardware stores and accumulate clips, wires, plastic consumer goods, and other humble components; and then build—upward from the floor in the case of *Second Means of Egress*, shown at the Berlin Biennale of 1998 [Fig. 8.6]. Formally resembling the high-tower architectural gantries of the great metropolis (the viewer's position is necessarily far below), such an assembly presented manifold intricate joinings and myriad small acts of assembly with ordinary things, the whole edifice elaborated cheekily with lights, fans, the odd house plant, a gas supply, and numerous ascending and descending ladders. "I bring to a given space an amalgamation of my collected objects that I find in the location," Sze has said. "I start by going to 99-cent stores selling everyday items that one might have lying around… I try to bring them to the space in a way that elevates their value from the familiar to the personal and owned. A soap bar in a drugstore is generic. In the context of an installation it finds a specific place—somewhere between being functional and decorative." The critic John Slyce has proposed a reading of Sze's structures according to Fredric Jameson's concept of "dirty realism"—he means that vision of city experience that makes it seem like "one immense unrepresentable container, a collective space where the opposition between the inside and the outside has been annulled." A further metaphoric leap would associate the unrepresentable city with the equally unrepresentable cosmos. As scientists struggle with language and graphic systems to model their ever more baffling speculations on the shape, origins, and structures of the universe, so the artist must be content with an ordering of science's high intellectual endeavors on the plane of phenomenal experience—that is, on the plane of physical matter. In a deft understanding of the connection between

8.6 Sarah Sze
Second Means of Egress, 1998
Mixed media
Dimensions variable
Installation at the Berlin Biennale

"When I install, I move into a specific place as I might move into a home," the artist has said. "I consider each space in terms of the evidence of its use and history, its character and idiosyncrasies. I look at the light, with daylight and tungsten, the air, the temperature, the access to electricity and water, fire extinguishers, exit signs and all the signs of human activity… what did I intend? This is something I begin to realize after a work is made and before I start the next."

miniaturization and the massively large, Sze's work recalls the words of Robert Smithson: "Size determines an object, but scale determines the art. In terms of scale, not size, a room could be made to take on the immensity of a solar system."

Much of the strength of Sze's work derives from its total integration and reconciliation of two normally separated realms of experience —the most private domains of the domestic such as the bathroom shelf or the bedroom drawer, and the great teeming spaces of the late-Modernist city. Landmark films from Ridley Scott's *Blade Runner* (1982) to the Wachowski brothers' *Matrix* (1999) and *Matrix Reloaded* (2003) have in their different ways evoked the technologically futuristic city (it is frequently Tokyo) in which architectural fantasy bleeds confusingly into the stubborn remnants of the working-class ghetto with its abundance of rubbish and unplanned obsolescence. In Sze's installations, similarly, the exterior spaces implode inwards, while the inner memory-attachments of found materials and randomly acquired detritus fold outward to become the articulation of a public realm. Like Schwitters before her (the Hanover Merzbau, or the porridge sculptures of the later years) or the installations of Gordon Matta-Clark, Sze has reanimated the spaces and the material culture of modernity's defining interior and exterior habitations.

Mention of Schwitters brings with it the possibility of a further and more radical gesture that the Dada master was perhaps reluctant fully to embrace. Schwitters's intermittent but long-standing devotion to the Constructivist theology of his day— such as the commitment to architecture, to architectonic and plastic invention in whatever material medium—located him squarely within an aesthetic of the permanent and durable artwork; all the more paradoxical therefore in the light of the obsolescent matter out of which his works and constructions are made. The fragile material condition of Sze's installations, by contrast, make them into a sort of movable feast: each one is dismantled but may be partially resurrected or rearranged for a subsequent show. Out of this material fact alone come two philosophical ideas of general importance. One is that the spaces reanimated by Sze's installations—it may be an upmarket gallery or a disused warehouse space—are subject to the same transitory qualifications as the filigree structures that fill them: "All space is subject to time, isn't it?" Sze has observed. "Because my work is tenuously constructed, the ephemerality of the space becomes compounded: which is to say that the original space is fragile, and the created space does nothing to ground it."

A second and very different theoretical pay-off comes with the almost familial closeness between ephemeral installation and photography. No photographs can claim adequately to capture the full phenomenal richness of a multilayered or delicately mobile piece of installation art. Yet it is in the photographic document, especially the high-resolution color photography of current professional practice, that the only and thus the best record of such a work is to be found. Teamed with the financial investments of ambitious art publishers, the installation genre has since its beginning found its most numerous audience in readers far removed in space and time from the original staging of the work.

Both this and the impermanence of the work—traceable ultimately to the tactics of Minimalist art, but intensified of late—are true of the projects of the Japanese-born Tomoko Takahashi, from 1990 based in London for study at Goldsmiths' College and then quickly absorbed into an international circuit of display. Takahashi's earliest works are indicative of what was to follow: in the absence of a gallery space she would move into friends' homes or workspaces and rearrange their belongings into tableaux that reflected the artist's relationship to them. A librarian's office is transformed into a sea of opened books; a painter's studio is reorganized into structures of propped

8.7 Tomoko Takahashi
Line-Out, 1998
Mixed media
Variable dimensions
Installation detail
Part of *Neurotic Realism* at the Saatchi
Gallery, London, 1999

canvases and personal accouterments and utensils. The method used in Takahashi's gallery works has been the same. Overlapping with the attitudes of the German Büro Berlin group as well as the more recent projects of artists like Jason Rhoades and Karen Kilimnik, Takahashi brings her oriental sensibilities to bear on the material *données* of the space she finds herself in. Living, sleeping, and eating in the gallery for the duration of its radical rearrangement, Takahashi approaches her task with a musical attitude to rhythm and time. Shadowing the free-flowing structures of gamelan music from Java, and no doubt aided by her own developing expertise on the Indian sitar, she generally begins with broader templates of organization but free-forms their intervals with extraordinarily precise arrangements of junk from the neighborhood or from the site. In 1998 the London art dealer and collector Charles Saatchi organized a show of young talent entitled *Neurotic Realism* ("neurotic" was never the right title for the show), in which Takahashi was given a large connecting space between two other galleries. Her project was then to organize disorder on an epic scale. "For *Line-Out*," she tells us, "there are three layers. First a floor drawing underneath the objects composed of dots and lines with black and silver tape—I wanted to become familiar with the base, unfamiliar space. When I started to get used to the scale of the floor, it had a sense of the flow of space as well, then came the objects" [Fig. 8.7]. These objects—a poor word for the remnants and garbage on show—comprised a rather specific phenomenal range that was precisely redolent of the street-life accumulations that Takahashi's adopted city both generates and then casts negligently aside. Just as the refuse-tip caretaker groups his or her acquisitions into rough and sometimes idiosyncratic categories of size, function, age, or state of repair, rising from ankle-level to the harder-to-reach accumulations behind, so Takahashi had old record-players, clocks, kitchen tools, and out-of-date bits of hardware, many of them wired up so that their mechanisms malfunctioned, piled in carefully ascending peaks and troughs, a sort of bric-a-brac hillscape waiting to ensnare the incautious visitor (the title *Line-Out* referred to the wiring plug in the rear of many appliances). And ensnare them they did.

8.8 Tomoko Takahashi
Tennis Court Piece, for Parklight at Clissold Park, 2000
Mixed media
Installation detail

Badly tuned radios, mumbling gramophone turntables, an old hot-plate giving rise to a slow boil—such lash-ups delivered intimations of vagrant occupancy, but with real persons missing. The visitor could not easily escape immersion in the show: the slightest step out of place could tip the incautious onlooker into threatening mounds of machinery. "It was nice to see my objects dominate people and see them not knowing how to behave," Takahashi reflected upon the crowded opening of the *Line-Out* show. "I was really too scared to be there."

Of course, it is true that the ephemerality of much contemporary art since the 1960s has challenged the demand for buy-and-sell durability that has aligned more traditional works of art with other commodities and the market. And like other exponents of junk-related aesthetics, Takahashi's stance toward the market has been negligent, perhaps deliberately obtuse. There is a performative element within her work that renders each installation event-like as opposed to constant over time. Usually living with the installation space in the days, weeks, or even months before a show, she "performs" her accumulations in tune with the approaching deadline of the opening. "If it's 10.00 on Tuesday," she says, "I really do run around the installation until 9.59, finishing on the deadline, on the dot"—as if to cue the arrival of the crowds of viewers in their turn. Her *Tennis Court Piece* took impermanence to an interesting extreme [Fig. 8.8]. Camping on a tennis court in the Clissold Park municipal gardens in the early weeks of June 2000, Takahashi proceeded to borrow (or be given) sports equipment from local schools such as ping-pong paddles, broken hockey sticks, cricket pads, and apparatus for gym, disposing it with formal mastery over the extant marking lines of the tennis court and then opening the installation between the hours of 9.30 p.m. and dawn over four successive nights, before dismantling the work on the fifth and giving the component pieces away. Almost unphotographable and certainly not for sale, the "piece" nevertheless survives its dismantling in forms probably more durable than all others—in images and texts like the ones you are reading now.

The desire of some contemporary artists to have the experience of their work open onto the wider experiential fabric of the city, of the culture, even of the universe; to construct complex analogies between the world of the singular and small and that of the multiple and very large—this gesture has antecedents in the work of sublime landscapists of the past, from the apocalypse-loving John Martin (1789–1854) to the frontiersman Frederic Edwin Church (1826–1900). True sublimity, that is to say, belongs strictly to the early days of European and American travel, and its artists would not have been able to foresee the investments of time, money, and personal welfare that have led an early twenty-first-century generation into the underworld of depleted and for the most part unwanted goods. And yet necessarily, that descent has its own metaphorics. One begins to understand that what career politicians nowadays refer to as the "new global order" is in reality nothing but disorder: ongoing and unremitting disorder on every level from the nation to the nursery, from the continent to the closet and back again. The architect and design theorist Rem Koolhaas, author of *Delirious New York* (1978) and *Great Leap Forward* (2002), has recently evolved the concept of a

city of "Junkspace" that speaks pessimistically but realistically—one might say—to this general cultural condition. The term "Junkspace" comes close to summarizing the new visual-social order based upon consumption, individualization, and banal information. Junkspace, says Koolhaas, "is political: It depends on the central removal of the critical faculty in the name of comfort and pleasure." But also: "Junkspace is both promiscuous and repressive: as the formless proliferates, the formal withers, and with it all rules, regulations, recourse… Junkspace knows all your emotions, all your desires." Koolhaas's language is also metaphorical through and through: "The formerly straight is coiled into ever more complex configurations. Only a perverse Modernist choreography can explain the twists and turns, the ascents and descents, the sudden reversals that comprise the typical path from check-in (misleading name) to the apron of the average contemporary airport. Because we never reconstruct or question the absurdity of these enforced *dérives*, we meekly submit to grotesque journeys, past perfume, asylum-seekers, building sites, underwear, oysters, pornography, cell-phones—incredible adventures for the brain, the eye, the nose, the tongue, the womb, the testicles."

Speaking of testicles—and of complexity—we come finally and in a different register to the extravagant and spectacular work of Matthew Barney, who in his impressive *Cremaster* videos from 1994 to 2002 has captivated and infuriated audiences in more or less equal degree. About Barney, Matthew Ritchie has himself written: "Very rarely do artists appear that are instantly convincing in the role of major players, let alone with a persona so perfectly tailored to our desires. Barney is glamorous in every sense of the word, including its original meaning: a visual enchantment cast by a supernatural agency to make things seem different than they really are." One-time medical student, former Yale football student, fashion model, and sculptor of sorts, Barney launched his twenty-four-year-old self upon the New York art scene with a 1991 video performance entitled *MILE HIGH Threshold: Flight with the ANAL SADISTIC WARRIOR*, in which we saw Barney, wearing a bathing cap, high-heeled shoes, and a titanium ice screw in his anus, climbing across the gallery ceiling in a three-hour endurance test against the forces of gravity and discomfort. Alongside the video, the gallery itself was filled with gym equipment, prostheses, mounds of wax, tapioca, and the synthetic sexual hormone choriotropin—all of which have become standard symbols in Barney's subsequent work. The overt theme of such masochistic performances is evidently the self-disciplinary routines necessary for the training of the athletic body, but also the closure of the sexual orifices, the transmutation of male into female and of female into male, and the motif of quest, or hardship, ritualized in extraordinary, sometimes unbelievable ways—the full materialization of the stoicism of 1970s performance art.

"I came of age on the football field; that's where I started to construct meaning in my life": Barney's interest in prostheses and physical endurance came out of his obsession for the footballer Jim Otto of the Oakland Raiders, the superhero who endured the pain of playing with a series of knee replacements, and whose "00" jersey

8.9 Matthew Barney
Cremaster 3, 2002
Production still

number Barney soon began to see as a testicular metaphor as well as a neat visual emblem of Otto's name. "Cremaster" names the muscle that regulates the ascent and descent of the testicles in response to temperature and sometimes fear. Barney's five epic performances in that series, now legendary in New York and Europe, unravel a symbolism of gender and restraint in a language that is both seductive and arcane. In the earliest, *Cremaster 4* (1994), Barney, dressed in a white suit and with bright red hair, attended by muscular Faeries, tap-dances his way through the floor of a pier on the Isle of Man, drops into the sea, and crawls back to the surface of the land via a long Vaseline-filled tunnel. Meanwhile two motorcycle side-car teams race in opposite directions round the island: an Ascending team dressed in yellow and symbolizing the female ovaries; and a Descending team dressed in blue, who symbolize the testes. The motorcycle teams meet eventually on the pier, and, to the sound of bagpipes and drums, we see a shot of the artist's scrotum covered with yellow and blue threads that stretch to the motorcyclists, who draw them tight. *Cremaster 5* (1997) is set in the Hungarian State Opera and the Thermal Baths, Budapest, and revolves around the life of Ehrich Weiss (a.k.a. the escapologist Harry Houdini), whose career as a magician and stuntman closely mirrors Barney's own. His story is told in something like reverse order amid a retinue of ribboned Jacobin pigeons, prosthetic devices, Hunchbacks, Giants, and Divas. For the final work of the series, *Cremaster 3* (2002), Barney occupied the symbolic center of New York art, the Guggenheim Museum, with perhaps his most lavish mise-en-scène to date [Fig. 8.9]. As audiences wound their way up the infamous ramp amid videos and sculptures of the previous four Cremasters, a fifth video entitled *The Order* was screened, suspended above the rotunda on a massive five-screen Jumbotron, incorporating shots of Barney ascending (like the fearful testicles) the Guggenheim's rotunda and interacting with tap-dancing chorines, battling hardcore bands, a leopard woman, and finally the sculptor Richard Serra in the act of recreating his own early slung lead sculptures, but this time using Barney's Vaseline. No short description can convey the lavishness and interconnectedness of Barney's baroque constructions, or the epic scale on which he likes to operate. The better critics have cautiously and justly celebrated the work; yet one of them, the British writer Norman Bryson, has drawn attention on the one hand to the "troubling" nature of Barney's obsession with the "will to power": his constant self-imposed exertion against a backdrop of Busby Berkeley-like extravagance and symmetry. "The proposition that the human mission is to dominate nature, and constantly break past naturally imposed limitations, is essentially Faustian or Promethean," Bryson observes; "it suggests titanic ambition, and inevitable disaster." On the other hand, the Canadian critic Bruce High Russell has drawn attention to a complementary idea. The care with which Barney conceals the phallus even as he performs near-naked—or else disguises it with prosthetic coverings—cues us, he thinks, to the presence of castration anxiety as the driving libidinal power of the *Cremaster* series. In effect, we are encouraged to imagine the interiorization of the main mark of male sexual differentiation and to toy with the possibility of the absorption of the testes into the body as ovaries. "Barney's

work," says Russell, "evokes the crisis of his generation from the perspective of a presumably heterosexual male artist in an era obsessed by identity politics… its success addresses our own problems." Or, as the less enthusiastic Roberta Smith of the *New York Times* had it: "Now that Barney has gotten *Cremaster* out of his system, anything could happen."

The Art Museum: Emporium or Shrine?

We must now pause to consider the impact of such multi-channel installations—new sensoria of sound, image, and material—on the architecture of the art museum: and of its distinctive spaces upon them. I doubt if the attentive reader could fail to have observed the delicate interplay between the physical ambience of the container and the experiences available from the objects and installations on view; and not only in Matthew Barney's work. We have seen several times how the contemporary curator-impresario binds his viewing audience with ever more daring groupings of artworks, ever more spectacular themes with which to position and attract attention to the new. His or her accomplice is the architect-showman who can transform a city center, a formerly derelict suburb, or a university campus by the supply of major (and photo-attractive) new buildings, themselves symbols of significance in the evolving identities of towns, nations, and communities. In fact, it may be no exaggeration to say that a Western city's vitality is now measurable by the glamor and adventurousness of its art museums; that unlike any other time in modern memory, an architect's reputation (if not notoriety) rests upon his or her museum architecture.

These projects have their own aesthetic ambitions, and the list of recent achievements is already a long and impressive one. Renzo Piano has given us the Cy Twombly Gallery in Houston, Texas (1995), the Brancusi Studio in Paris (1997), and the Beyer Foundation Museum in Basel (1997); Daniel Libeskind the Jewish Museum, Berlin (1998, his first realized building), the Felix Nassbaum Museum, Osnabrück (1998), and plans for the Victoria & Albert Museum, London (shelved at the time of writing). Richard Meier already had three museum projects to his name before embarking on the vast white concourses of the Museum of Contemporary Art in Barcelona (MACBA, completed in 1995). In common with Piano and Rogers's Pompidou Center in Paris in the 1970s, Meier's Barcelona project was built in an inner-city working-class area deemed in need of clearance by the city planning authorities. Entire communities disappeared in both cases, displaced to farther reaches of the city where the new tourists would seldom venture. The Barcelona decision (like Paris) spoke of a city whose identity and priorities would revolve increasingly around international visibility, the celebrity associated with new art, and the aura bestowed by controversial and spectacular design [Fig. 8.10].

8.10 Richard Meier and Partners
Museum of Contemporary Art (MACBA),
Barcelona, Spain, 1995

Interior whiteness and uncluttered, finely articulated space have been the presiding motifs of art-museum architecture since its inception in the heyday of the Modern Movement in the 1920s and 1930s. Nothing short of remarkable has been the durability of this connection, right into, through, and beyond the so-called Postmodernist phase. Yet the official logic of Meier's MACBA design—to introduce light and air into the heart of the dingy Raval district just west of Barcelona's vibrant Las Ramblas—resulted in an open but unstructured piazza (now populated by grateful skateboarders) in front of a gleaming white structure with no visible social or architectural relation to its context, one that includes a sixteenth-century convent and some remaining tenements. MACBA's imposing south-facing façade lets in huge amounts of sunlight that pour first into the long ascending walk-ramps (a reference to Frank Lloyd Wright's rotunda on Fifth Avenue) behind which lie the galleries themselves. It is the civic and aesthetic identities of Meier's masterpiece, however, that have stimulated most critical comment. Now administered by an unsatisfactory consortium of the Catalonia and Barcelona governments and a private foundation that provides funds for acquisitions, MACBA had no identifiable collection at the time of its opening, and no director. Since 1995 its oversized and rather anonymous galleries have been home to international touring exhibitions for the most part having little relation to Spain, Catalonia, or Barcelona. So-called urban regeneration and the satisfaction of tourist needs seem to have outweighed other planning or architectural imperatives. At the same time, Barcelona has sealed its identity as the quintessentially "contemporary" Spanish city with MACBA's imposing help.

Likewise when the Canadian-born architect Frank Gehry won the competition to design a new art museum for the derelict center of the once-prosperous northern Spanish port of Bilbao, his reputation was seen as securing for that city a place on the tourist map and a consequent hike in its economic fortunes. Gehry had cut his teeth with the offbeat geometry of a private house for the artist Ron Davis in Malibu, California (1972), and the equally small Vitra Design Museum in Weil am Rhein, Germany (1989). His long association with art and artists and his understanding of Cubist sculpture led next to the Frederick R. Weisman Art Museum in Minneapolis (1993), before he embarked on the grandest design of his career so far—which would also function as a major outpost of the Guggenheim empire beyond the borders of the USA.

Given that Bilbao is capital of the fiercely independent Basque country, some reference to the traditions or to the modern history of that region might have been expected (these would include the small town of Guernica, some 20 miles

8.11 Frank O. Gehry
Guggenheim Bilbao, 1991–97

For the Guggenheim design in Bilbao Gehry used the computer program CATIA, developed for the design of the Mirage jet by the French aerospace firm Dassault.

[32 km] to the south). But Thomas Krens, ambitious director of the fast-expanding Guggenheim empire, had no such agenda when he invited four prominent architects, Hans Hollein, Arato Isozake, Coop Himmelblau, and Gehry, to sketch out plans for a collaboration between New York and the regional and municipal governments in Bilbao. Completed in 1997 and draped along a narrow ledge above the Nerviòn River, the building loops under a road bridge and soars vertically on the far side [Fig. 8.11]. Approachable from several angles, its silver-gray exterior at once calls to mind a beached whale, an abandoned industrial plant, and pre-eminently the teetering towers and volumes of Russian architecture of the post-revolutionary phase of 1918–21, a time when "architecture" was largely a rhetorical fantasy confined to paper or the vivid imagination (Tatlin's Constructivist tower, for example, was never built). Inside the Bilbao atrium, on the other hand, we are in the world of Fritz Lang's film *Metropolis* (1920) or the futuristic architectural visions of Antonio Sant'Elia. The other conspicuous feature of Gehry's design, the asymmetric volumes and irregular lines and interfaces coming visibly out of the computer programs deployed by the design teams that created them, point not to a revolutionary past but to a revolutionary future. The viewer is absorbed into extraordinary intervals and spatialities, dramatic pulses of light and dark, that collectively signify an order of complexity now commensurate with his or her understanding of the latest electronic age: a kind of art museum, in short, that is of the same creative order as many of the artefacts it might soon be expected to house.

What then of the display spaces, taken room by room? The contemporary curator is inevitably seduced by possibilities not dreamt of in an earlier age: the museum's 450 ft (137 m) long "boat" gallery initially accommodated large Minimalist sculptures by the likes of Robert Morris and Richard Serra, as well as such expansive (but arguably pointless) projects as a mile-long (2 km) painting by the now ageing master of the combine, Robert Rauschenberg. Here then is a paradox. Agent of an unquestioned economic renaissance for a city hit by declining shipping and steel industries, the Bilbao Guggenheim has already opened a window on the wider world of postwar and contemporary culture—except that that culture is the leading hegemonic voice of Western Modernism and its aftermath, specifically the mission of the original Guggenheim Museum to affirm the spiritual and intellectual values of abstract art. Given that the Basque government paid over $150 million to the New York Guggenheim to construct the museum and to provide a rotating display of its holdings, there would seem to be no serious argument about cultural imperialism in any of its cruder forms. Yet the fact remains that the Guggenheim's vision of contemporary art remains only one among many—it is the generation first of Rothko and Pollock, then of Morris, Rauschenberg, Kruger, Serra, Oldenburg, and Andre, amounting to an American-led canon of recent visual art. With further outposts in Venice, Berlin, and lower Manhattan, and negotiations for other spaces ongoing, the global power of the New York Guggenheim seems set to expand even further still.

Rem Koolhaas for his part has generalized his apocalyptic notion of Junkspace

8.12 Herzog and De Meuron
Tate Modern, Bankside, 2000

to cover the art museum. Junkspace "can either be absolutely chaotic or frighteningly aseptic—like a best-seller—overdetermined and indeterminate at the same time… Museums are sanctimonious Junkspace," he has said; "there is no sturdier aura than holiness. To accommodate the converts they have attracted by default, museums turn 'bad' space into 'good' space; the more untreated the oak, the larger the profit centre… Dedicated to mostly respecting the dead, no cemetery would dare to reshuffle corpses as casually in the name of current expediency… Large spiders in the humongous conversion offer delirium for the masses." In fact Koolhaas is here referring in the most unkindly way to Louise Bourgeois's sculpture *Spider*, positioned during the summer of 2000 on the industrial-scale mezzanine floor in London's Tate Modern, Great Britain's most glamorous recent metropolitan art museum, designed by the Swiss architects Jacques Herzog and Pierre De Meuron and opened in the same year [Fig. 8.12]. In reality, Britain's modern and postwar art collection is fairly meager, while its population has maintained for most of the twentieth century a thoroughly skeptical attitude toward the growth of cultural democracy and Modernist culture more generally. Throughout this period the Tate had a late Victorian building at Millbank to house the national collection of British and modern art, and until the later 1980s and the appointment of (now Sir) Nicholas Serota minimal purchasing powers and little enthusiasm for change. The late arrival of Tate Modern at the start of the twenty-first century, some seventy years after the Museum of Modern Art in New York (1929) and a quarter of a century after France's Pompidou complex in Paris (1976), speaks for itself. The transformation of a redundant power station on the south bank of the Thames to expand and revivify the older national museum of art has come then to symbolize this grudging modernity, revealing instead a symptom of something still unfamiliar in the British context: a fascination for all forms of contemporary visual art.

Yet Koolhaas is right in his implication that enthusiasm should be tempered with caution. Before Tate Modern, Herzog and De Meuron had to their name some small-scale projects in or near Basel, Switzerland, as well as the elegantly minimal Goetz Gallery in a suburban Munich garden. Winning the Tate design competition against entries from Tadao Ando, David Chipperfield, Rafael Moneo, Renzo Piano, and Koolhaas himself, they proposed the slightest of exterior changes to the disused power station, significantly preserving the tall central chimney and raising the building height by a single glass story. By this measure they ensured that Tate Modern would compete, through a different symbolism, with the great Wren dome of St Paul's Cathedral across the river to the north. It is for its interior, however, that Tate Modern has attracted particular opprobrium. Having descended an ungainly ramp to bookshop level, the visitor here has to rise through the building on vast elevators more

characteristic of a shopping arcade. The display rooms are mostly small, all of them furnished with conspicuously untreated oak floors, and there are no flexible display screens to modulate interior space: all is fixed, logical, and in some degree derived from the aesthetic systems of the French-Swiss artist Rémy Zaugg [see Fig. 3.2], whose rigorously phenomenological approach, Herzog and De Meuron tell us, "is very close to what we try to pursue in architecture." Each level of the museum repeats itself in disorienting fashion, right up to the overpriced restaurant on top.

Generally unloved by contemporary artists, Tate Modern's central problem, however, has proved to be the vast hall running from floor to roof, formerly occupied by the power-station turbines. Dingy and oppressive despite its enormous size, the so-called Turbine Hall has played host to sculptural projects that have felt the need to "respond" to the hall's interior scale almost in the installation manner. Aside from Bourgeois, Juan Muñoz (in 2002) has also carried out a commercially sponsored project there. The year 2003 saw the latest and most spectacular of all Tate Modern's sculptural works, the *Marsyas* of the Indian-born British sculptor Anish Kapoor, a work long and high enough to fill the huge space from floor to ceiling and from end to end [Fig. 8.13]. Playing subtly with an antithesis of material/immaterial, *Marsyas* allowed views from underneath and into the negative volume enclosed by the 8,372 square yards (7,000 sq. m.) of skin-colored stretched fabric. The dark red color offers a tangential reference to the flaying of Marsyas story in classical mythology, while the trumpet

8.13 Anish Kapoor
Marsyas
Installation at Tate Modern, London, 2003

volumes might be read as the screams of the martyr's pain. Viewed in less clumsily narrative terms, Kapoor's work announced a deeper and more abiding sense of how an art museum like Tate Modern can function vis-à-vis the art of our time. The converted power station presents a deft hybrid of the industrial context of an earlier phase of modernity and the sanctified space of traditional aesthetic experience. Above all pragmatic and functional, the building travels far to meet the needs of a new Postmodern, post-canonical tourist public who escalate or wander in great waves through the interior, while "outside, the architect's footbridge is rocked to the breaking point by a stampede of enthusiastic pedestrians" (Koolhaas again). The balance between emporium and shrine has never proved more difficult to achieve.

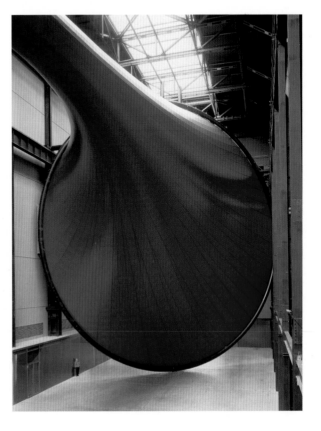

Meanwhile, extraordinary new art museums in wealthy or image-conscious cities seem set to define new standards of glamorous and often sensitive display across the world. The Spanish-born Santiago Calatrava's new design for the Milwaukee Art Museum (2001) graces the terminus of Milwaukee's Wisconsin Avenue as it reaches Lake Michigan with bird-like wings (its brise-soleil) that elevate and deflate in poetic symmetry to change the building's very shape. The attempt to achieve the "Bilbao effect" is palpable: of course we expect Calatrava's local collaborating architect

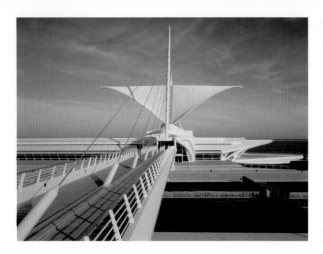

8.14 Santiago Calatrava with Kahler Slater
Milwaukee Art Museum, 2001
Milwaukee

to say that the building "has become a catalyst for renewed vigour in the community—a degree of energy that has not been seen here for a long time." The Director for City Planning in Milwaukee easily agrees, affirming that "the Calatrava building has already raised the bar for what clients and developers are striving for. It has helped reflect a desire to explore more architecturally rich concepts and endeavours" [Fig. 8.14]. Or take the Japanese architect Tadao Ando's more understated Modern Art Museum of Fort Worth, Texas (2002). Fort Worth already combines its Texan ranching ethos with two other major art museums, in the form of Philip Johnson's Amos Carter Museum (1961) and Louis Kahn's Kimbell Art Museum (1972). Sitting uneasily close to Fort Worth's other main visitor attraction, the Cowgirl Hall of Fame, Ando's subtle new melding of polished concrete and reflective water surfaces forms a cultural oasis in an otherwise ramshackle part of the city. Visitors leave quickly, and by car. Is this new collaboration between the architectural genius and the city's civic fathers good for contemporary art? Or do we have to become reconciled to a certain sterilizing, morgue-like quality in some of the shining new spaces of display? We may like to recall that new art on its first arrival is seen in countless less spectacular spaces, small and large, temporary and often poorly appointed, frequently far from the city's center. While the new art museums are symbolically important, it remains the case that anarchy and a certain low-rent bricolage are more fundamental still to the process of creation itself—from which basis larger reputations sometimes grow.

Spaces for Film

Crossovers between video, sculpture, performance, and sound have also made expedient use of the flexible spaces of today's new art museum. In tandem with visual and physical complexity, however, the single most striking presentational change in recent art has been the use of the moving image, either projected like a film or flickering on a small screen within a larger space. It may also be the case that moving pictures have changed the way the viewer looks at static contemporary art. First, consider the play of light. In the familiar Modernist museum the architecture itself guaranteed that carefully monitored levels of natural light would animate the artwork situated in white-cube interior spaces. For contemporary film or video projections, by contrast, exterior light is usually abandoned in favor of dark spaces in which only the image's interior light appears. But second, the absence of fixed seating in the gallery space (not an oversight on the part of the curator, but an aspect of the work) renders the film or video experience quite unlike that of entertainment cinema with its comfortable seating and cocoon-like ambience. In the gallery, the viewer is asked to stand uncomfortably or sometimes sit on the floor in a posture significantly different

from that demanded by the Hollywood film; but also from the contemplative posture normal to the viewing of paintings. A third feature of many film and video installations is that, while the work imposes itself upon the viewer's attention, it does so in the absence of regular cinematic accouterments such as entrance tickets, start times, and endings. The gallery viewer walks into a video installation sometimes at the beginning but frequently halfway through—and may leave early, or stay late, according to the degree of interest aroused. The scheduled viewing time can be as short as two or three minutes, or as long as about an hour. These unfamiliar conditions have the effect of producing an anxiety in the viewer for which there is no obvious or satisfactory solution. As Boris Groys has observed: "Whatever the individual's decision, either to stay put or to keep moving, his choice will always amount to a poor compromise."

From its beginnings in the 1970s counter-culture, artists' video and film has sidestepped the hypnotizing conditions of narrative cinema precisely in order to critique the dominant culture's most thoroughly passivizing entertainment genre. Avoidance of synchronized sound–image combinations—the cardinal reality device of Hollywood film—has also formed part of many an avant-gardist's agenda. Some reminder of the physical and cognitive discomfort involved in viewing paintings and sculptures has been retained by such videos and films, then, seemingly in order to refocus attention upon the visual formalities of the work such as compositional structure, texture, color, rhythm, and scale, and upon the conceptual dimensions of language, style of address, and awareness of audience position. Resistant to the promotional machinery of Hollywood film and TV, artists' films and videos have also quite self-consciously confined themselves to low-budget production, primitive shooting and editing techniques, and a certain homemade hit-or-miss amateurishness that has placed them in a relationship to the style of photography found in Conceptual art, or the flickering video art pieces of the 1970s avant-garde.

Take the London-born black artist Steve McQueen, the best of the younger British video artists, who won the prestigious Turner Prize in 2000 and has reflected entertainingly in his work on the very nature of film as an experimental visual art. Other video artists were at that time deconstructing the tropes, the mechanisms, the very duration of film—such as in Douglas Gordon's well-known *24-Hour Psycho* (1993), which (apparently building on Bill Viola's earlier work) slowed Hitchcock's masterpiece down to two frames a second, hence extending its running length to 24 hours in order for film buffs and lay persons alike (given time and wakefulness) to savor the effect of Hitchcock's famously manipulative classic in all its glorious micro-detail. McQueen himself looks closely at how narrative works, and seems to enjoy some of the absurdity of his own attempts to do so. In his one-minute-long *Exodus* (1992–97), we watch two black men carrying a couple of tall potted plants through the streets of London, weaving through the crowds, and at the end of the film boarding a bus: we suppose we are "following" them surreptitiously, until in the final scene they turn round and wave to us from the back window, instantly changing the direction of the cinematic gaze. Here lies the clue to some of McQueen's most arresting film-as-art. For,

8.15 Steve McQueen
Deadpan, 1997
16 mm black-and-white film, video
transferred to laser disc, silent
4 minutes, 35 seconds

as in *Five Easy Pieces* of 1995, in which McQueen is filmed from below pissing on the camera (the image blurs with the liquid before returning to its in-focus form), and in which hula-hooping black men perform rhythmic gyrations while being filmed from above, Rodchenko-style, until one of them fumbles and the hoop relapses to the floor, we see a pattern emerging of black sexuality transferred into the very materiality of the film. The viewer very soon becomes aware that every superposition and inversion, every rhythm maintained and every tension broken, every relationship between the camera as a looking eye and a black body seen in all its dangerous carnality—each arresting sequence addresses in film terms alone the stereotyping and subject-ivities of the racial body. In *Just Above My Head* (1996), on the other hand, the black body's carnality is represented as simultaneously ethereal and sinking. The camera frames the space above the walking artist's head, sometimes including it along its lower edge, sometimes losing it altogether as the head bobs beneath the camera's gaze: the effect was of a mostly blank screen, with the head visible occasionally as sculpture, bobbing above the line dividing the screen from the gallery floor. In *Deadpan* (1997), McQueen re-enacts in slow motion and with repetitions the famous Buster Keaton gag in *Steamboat Bill Junior* (1927) in which a house façade falls upon an innocent bystander but fails to injure him because his position fortuitously coincides with an unfenestered window. In McQueen's version the artist stands mute and impassive as the house collapses over him [Fig. 8.15]. Playing relentlessly on the viewer's recollection of the Keaton gag, McQueen hypercharges the tension-and-release sequence in seeming to make the phallic body survive its own sexual arousal and discharge.

When we come to the pre-eminent Finnish film artist Eija-Liisa Ahtila—one of the new stars of the international circuit—we see a different deployment of the moving image and a precise technical strategy. Ahtila shoots all her works with a film camera but transfers them to video in order to make them available for art-house cinemas, on CD and on DVD, as well as for the installation setting of the art gallery, for which, incidentally, she often specifies chairs and sofas for the audience. The reason for this concession lies in the complexity of the films themselves, which demand intense concentration on the multiplicity of voices, channels, crisscrossing narratives, and speaking characters that populate her multi-screen projections. Ahtila's celebrated early work *If 6 Was 9* (1995) is scripted to resemble a confessional documentary film in which five teenage girls seated around a table recount their early sexual discoveries and fantasies in three parallel visual tracks [Fig. 8.16]. The difference from traditional

documentary is that the monologues wander from one screen to another and hence from one character to another, producing absurdly humorous but also fantastical hybrids of subjective positions and speaking voices. In the meantime, the Finnish dialogue translated as subtitles presents a strenuous reading test for the curious viewer trying to retain a sense of normalcy within the whole. In fact it is an impossible task. Ahtila's even more narratively impossible *Anne, Aki, and God* (1998) was based on meticulous research into therapy sessions carried out with a real-life schizophrenia sufferer called Aki. Monologues based on Aki's tape-recorded words are then spoken with deadpan seriousness by actors over images that evoke Aki's psychological confusion, as he searches in vain for his girlfriend in a city populated by figments of his vivid imagination. "Aki V resigned from his work as a computer application support worker with Nokia Virtuals, became ill with schizophrenia, and isolated himself in his one-room flat. His mind started to produce a reality of its own in sounds and visions. Little by little this fiction became flesh and blood, the line between reality and imagination became blurred. Fantastical persons and events stepped out of Aki's head… then Aki was informed that his main duty in the future would be being in charge of Hollywood, because Hollywood controlled all emotional fantasies of human beings." Ahtila's three-screen installation *House* (2002) explores a similarly dark continent, showing off the slow but inexorable mental unwinding of a woman enumerating all that is "routine" about her home, her habits, and her garden. But the viewer is obliged to understand that in Ahtila's multi-screen reconstructions form itself plays the major structural role in presenting the permuted subjectivities that the viewer can never quite grasp. Almost fugal in their counterpointed relations, Ahtila uses the format of simultaneous projection to re-establish the power of experimental cinema at the culture's center, no longer content with the margins where the entertainment industry would prefer to leave it.

The relative cheapness combined with the relative newness of film and video art has produced the conditions for many types of innovation within the compass of the international artistic avant-garde—we have seen several already in earlier sections of this book. The spread of the medium has been meteoric. Part of a wider renaissance of

8.16 Eija-Liisa Ahtila
If 6 Was 9, 1995
Production still
35 mm film and DVD installation for 3 projections with sound, chairs/sofa
10 minutes

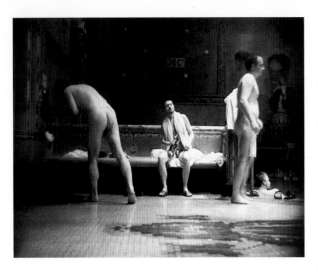

8.17 Katarzyna Kozyra
Bathhouse for Men, 1999
Production still

East European art since the demise of the Communist state, the Polish artist and video-maker Katarzyna Kozyra has produced some striking works that bear directly on the practices and customs of her culture while appealing simultaneously to new international audiences for art. Her direct engagement with the preoccupations of an earlier West European modernity came to light with *Olympia* (1996), a photography-and-video piece in which the artist was showing lying seductively, depilated, on a hospital bed while receiving intravenous treatment for Hodgkin's disease, an elderly female attendant standing nearby. A similar agenda, that of the visibility and concealment of the body within Polish Catholic society, was addressed impressively in Kozyra's *Bathhouse* the following year—in which we saw women attending unselfconsciously to their bodies in a setting devoid of the markers of social glamour, interaction with men, or clothing. Shot with a concealed camera, the video captured moments of unexpected tenderness and empathy, completely asexualized and completely detached from socially legitimated standards of beauty. It was followed in 1999 by *Bathhouse for Men* [Fig. 8.17], for the filming of which Kozyra disguised herself as a man with an artificial penis and beard, and smuggled in a camera through which to observe herself and her fellow "men" from obscure positions, near the floor or through the crack in a door. The result—shown to wide acclaim at the 1999 Venice Biennale—manages to convey the natural bearing and unshapeliness of men in a scene of total privacy. Lacking both sound and narrative order, these works venture toward social documentary but did so while taking care to display the unusual techniques and circumstances of their making. In place of entertainment, the attentive viewer is persuaded to dwell thoughtfully on questions of public and private space, on beauty and ageing, and perhaps above all on the work's relation to scenes of bathing from the West European painting tradition such as Rembrandt's *Susanna in Her Bath*, Ingres's *Turkish Bath*, and Cézanne's numerous *Bathers*.

While Kozyra's work in one sense belongs to the Conceptual and amateur genre—the brute document as brute document, whatever it may show— it can also profitably be considered in relation to what has been called "Third Cinema," the work of politicized artists and filmmakers who straddle in an even more complex way the boundary between documentary and art. Third Cinema is defined as an alternative both to Hollywood and to *cinéma d'auteur* (Antonioni, Godard), as well as to Conceptual film and video made within the artistic avant-garde. Prominent in this domain in recent years has been the work of the Iranian-born Shirrin Neshat. Having left her country in 1974 and studied in California before going to New York, Neshat has revisited her country many times as an artist filmmaker to research and then to confront questions of the fate of women and the direction of Iranian social policy as it emerges slowly from its repressive past. Neshat's films, made in Turkey or Morocco and employing casts of often hundreds of men and women moving about in crowds, have

won near-universal admiration. Winner of the Venice Biennale's Golden Lion award in 1999, her film *Rapture* may be taken as an index of her visual and political concerns since the landslide election of the reforming president Mohammed Khatami in 1997. The film deals allegorically with the likely or possible fate of women in a traditional society in which reforms have been tentative, but measured. On one gallery wall is projected a sequence of images of identically dressed men, moving into and occupying a strong circular fortress of stone, meeting in an impressive shot of concentrically circled figures, ostensibly in possession of traditional power and guardians of their society's future. On the opposite wall we see a projection of a large group of women dressed in traditional black chadors wandering outside the fortress in apparent search of the ocean's edge. Arriving there, they embark six of their number in a rotten hulk of a boat that they push out through the waves at the start of their journey onward. At that moment the men in the fortress ascend to the battlements and stand with hands raised as if in salute to the seafaring female travelers.

The allegorical meanings of the voyage can signify ostracism, a new life, or simply departure, while the gesture of the men can mean farewell, a successful voyage, or a form of victory over a subject class. The implied significations of Neshat's beautifully made films are determined, at best (so she has told us), by how, by whom, and by where the film is seen. That flexible positionality is on one important level the real achievement of her work. What critics have less frequently drawn attention to is the ravishing geometry of most of Neshat's scenes, in which every symmetry and asymmetry is as meticulously handled as in any 1960s Minimalist work. The stark visual alternatives, the inexorable unfolding of the framed image as a flat granular entity, the measured pace, all function as slow-motion abstractions determining the scope and very format of what the viewer sees. Nevertheless, the dominant critical

8.18 Shirrin Neshat
Passage, 2001
Production still

questions have so far concerned the political "content" of Neshat's work. *Passage* (2001), made for a Barbara Gladstone Gallery show, shows a young girl watching a mysterious procession of men cross an open landscape and finally deliver a body to a group of veiled crouching women who inhabit the center of a burning triangular mound [Fig. 8.18]. "It is very melancholic," Neshat has agreed (the music was by Philip Glass). "It is about mourning; it is a tragic death, not a natural death, potentially a young person who was killed. This piece came right after some intense events between Israel and Palestine… it is a mixture of my sister losing a young son, a mixture of very morbid events round my life: a response." Asked about the ubiquitous motif of the veil, at one and the same time a symbol of repression and a form of

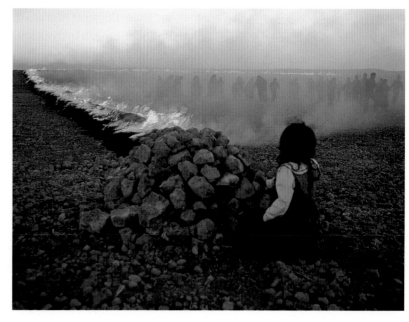

Iranian identity, Neshat offers the following thought: "In some ways there is an incredible resistance against the veil [in modern Iran], but the veil has also become a symbol of resistance against the West. For a lot of women, it became also a system of refusing to be looked at as an object of desire. There are very complex and contradictory reasons and there is no way that I could have presented this icon in a way that gave one particular reading because there is just no way, and even to this day there are divisions [in Iran] between women… As to this idea of the orientalization of these women beyond the veil, I think it is a problem of the West and not the East: the minute they have the veil they become exotic, [but] that is an invention of Westerners, not of Muslims… Women [in Iran] cannot exist without the hijab: For me it has been just part of the reality of the culture I am dealing with."

These examples could be multiplied several times over. Descriptions make for poor reading if they are concerned only with the narrative content of the film: the more important task is to locate the form and structure of the images inside the evolving languages of what has come to be the encompassing category of contemporary visual art. The trouble is, given that artists' film and video is still in its infancy, those languages are in their infancy too, and intelligent discussion of aesthetic value—not to mention the airing of concerns about how such works acquire a place in the market for art, by whom they are circulated, curated, owned, and restored— still seems a long way off. But instinct alone tells us that artists' film that runs counter to the dominant entertainment and advertising genres—or that can exploit filmic resources to aesthetically and semantically subversive ends—promises depths and richness beyond words. And it would be surprising if those depths and that richness did not interact strongly with the aesthetic formulae of painting, sculpture, and installation as counterpart gallery genres. Why? Because film shares with painting its rectangularity and uprightness, if not its illumination conditions and its relationship to viewing time. Because film shares with sculpture its occupancy of gallery space and its dependence upon an institutional setting, if not its three-dimensionality. And because film shares with installation a measure of theatricality, of narrative mise-en-scène. It is in the complex formal similarities between film as a genre of contemporary art and the much longer traditions of painting and sculpture—not to mention the newer installation aesthetic—that its future rewards are to be found.

Digital Images

No account of contemporary visual art would be complete without mention of a further filmic art, one that has made claims on the viewer's attention from the prolific new resources of the World Wide Web. The discovery by scientists in California in the 1970s how to divide the on-screen image into hundreds of thousands of extremely small pixels (or picture elements), then how to associate each pixel with a computer code, was the step that launched the computer revolution that is still in its infancy

today. Having reduced the photographic image to a digital code, the next step was to invent a "mouse" capable of isolating sections of the image and moving it, with a "pointer" capable of zeroing in on individual pixels in order to change their color and brightness. Engineers at Xerox and Apple were soon able to bring the technology within reach of picture editors, artists, and designers. By the early 1980s one could freely speak of "photographs" that had a severely weakened indexical link to the film negative—the image produced by the action of light on a photo-sensitive surface. Photography's apparently veridical link to the real world of places and things had been suddenly attenuated. The age of the digital image had been born.

Two consequences of this revolution may be mentioned now. The first has been an animated debate about the veracity of the photographic still. If photographs are decreasingly the product of negative and developing fluid—if the chemical manufacture of photographs is a thing of the past—then what certifies the image's link to the world of appearances? Photographic critics have been quick to answer that even chemically produced photos were subject to cropping, airbrushing, montaging, and deceptive captioning: that a radical falling short of objectivity has in fact characterized the whole photographic tradition since the 1840s. Spurred on nevertheless by the processing and editing speeds of digitization, editors and artists were quick to unleash the power of the photo-image in its new form. First, *National Geographic* magazine printed a cover picture of the Nile pyramids whose real spatial intervals were digitally

8.19 Jeff Wall
Dead Troops Talk (A Vision After an Ambush of a Red Army Patrol Near Mogor, Afghanistan, Winter 1986, 1992
Cibachrome transparency in lightbox
7′ 6⅛″ x 13′ 8⅛″ (2.29 x 4.17 m)

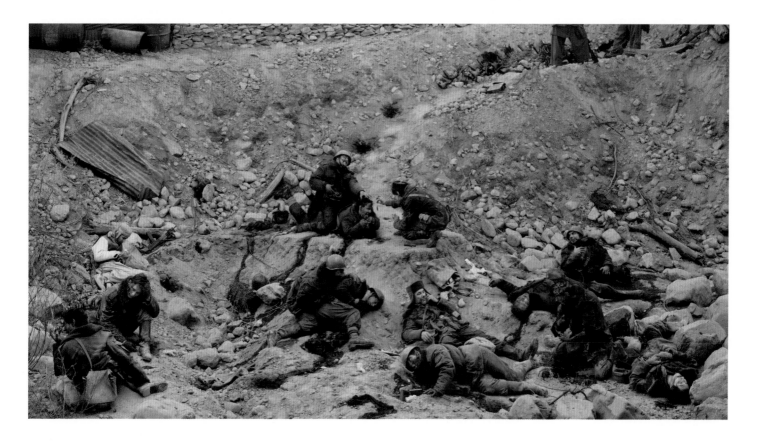

compressed; that was in 1982. Then artists like Nancy Burson applied software to the "condensation" of images into each other, to produce composite heads and faces that corresponded to no living human being. Photo-artists like Jeff Wall had already started directorially arranging scenes so as to capture something that was essentially fictional even while it had the appearance of something real [see Fig. 4.11]; but a step change occurred around 1992 with the introduction of digitization techniques. Now, Wall was able to dispense with directorial mock-ups of his pictorial scenes, and to compose each new work in the studio part by part, character by character, section by section. He could then build them electronically to form an image that corresponded to nothing in reality—while taking care to ensure that his pictorial structures echoed compositional features more familiar to the academic tradition [Fig. 8.19]. The technique had the immediate effect of repositioning the viewer as someone aware that the photograph had re-entered the tradition of contemporary history painting, with all the artifice and trickery that was ever available to the painter's craft. At the same time the viewer continued to "see" in the photographic surface some distinctive claim upon visual appearances and even upon truth. Analogue (that is, chemical) and digital photography seem to invite radically different epistemological responses and hence radically different ways of viewing art. The story of this revolution seems likely to unfold much further and much faster in the years ahead.

Concerning the *moving* image in the recent past, two countervailing forces have played upon artists: First, the demand to show technical awareness of the latest advances in computerized imagery, much of it developed by the military and slowly trickling down at still relatively high costs into the market; and second, the need to establish credible and critically intelligent translations of that technology into the rapidly transforming spaces of the public museum and gallery. The first requirement by itself reminds us of another step change from the relatively simple video technology deployed from the early 1970s on. Artists can now avail themselves of more cheap color video film, higher-resolution editing possibilities, and far more sophisticated projection technology than were ever available in the brave days of yore. Already in the 1980s, multi-image installations by Gary Hill immersed the viewer in extraordinary illusive spaces now rendered dark and mystical—a far cry from the brightly lit arenas of the Modernist white-cube galleries and the Minimalist decor of the new art museums of that day. In the more recent period of digitization, we look to the career of Bill Viola for a level of virtuoso work in the medium, for in his work we have seen how the newest technological advances can be mobilized for reflective and even spiritual ends. Viola has referred constantly to the relevance of the great theological traditions of Europe and the mystical philosophies of the East to the pace and mood of his video works that slow down the filmic image to a register of awareness more in tune with the gallery experience. In his early *Room for St. John of the Cross* (1983) Viola presented the vision of the Spanish mystic and poet who was imprisoned and deprived of sensory stimulation. A decade later he had moved on to more ambitious formats in works like *Stations* (1994) and *The Messenger* (1996), which presented powerful Christian

metaphors (of the Passion and baptism respectively) in wall-sized projections with resonant sound, unfolding in slow repetitions within a darkened gallery space now comparable to the spaces of a chapel or a shrine. Such works could be immediately understood as infusing the far older traditions of European religious art with a tone of contemplative seriousness that contemporary audiences and reviewers (on the published evidence at least) had long wished to see revived. "Don't forget," Viola has warned, "that one of the great milestones of our century has been the transporting of ancient Eastern knowledge to the West by extraordinary individuals such as the Japanese lay Zen scholar D.T. Sukuki and the Sri Lankan art historian A.K. Coomaraswamy, even on a par with the re-introduction of ancient Greek thought to Europe through translations of Islamic texts from the Moors in Spain… It is no longer acceptable to scrutinise things solely from the perspective of our local, regional or even 'Western' or 'Eastern' cultural viewpoints."

Two technical advances have made Viola's recent video installations especially vivid within the gallery space: the flattening of the projection machinery to the 2 or 3 inch (5–7.5 cm) thickness of a traditional altar painting, resulting in a joining of the moving image to the tradition of religious depiction on wood or canvas; and the digital slowdown of real-life gestures to a speed where jumps between film frames are no longer visible—to the point where the artist can re-create, for instance in a recent work such as *The Greeting* [Fig. 8.20], the dramatic gestures of the painting *The Visitation* (1528–29) by the great Florentine Mannerist Jacopo Carrucci da Pontormo. In the more abstract language of the gallery, we are now able to say that new video art has proved successful in negotiating possession of a space *between* the explosive picture–sound co-ordinations of Hollywood's entertainment screen, and the traditionally static images and forms belonging to both Old Master and Modernist periods of art. To Viola, the visual attractions of the first can be made almost compatible with the formal challenges and visual dividends of the second.

For some, the politics of the electronic image have presented a challenge to be confronted directly. The artist Tony Oursler has said: "How we make video is our only hope of remaining vital in this culture." That was back in 1995, when statistics of TV watching suggested it to be the most pervasive (and passive) activity on the planet. "It's pretty much a death trip to sit there, watch television and not make it," suggested Oursler. By 1995, making it was Oursler's art form: he was already known for his "talking head" video sequences projected onto bent or articulated surfaces. The heads appeared as abbreviated or swelling facial features burbling with séance-like non-sequiturs—sometimes indicating constraint, or pain, or distorted through obscurity, discontinuity, and repetition. One would see mouths or eyes without faces, speaking out from everyday physical surfaces, from under furniture—even from rubber dolls, in the manner of the caricature, the fairground freak, or the ventriloquist's dummy. More widely, fragmentation and reframing—devices invented in the early days of Modernism by the Russian avant-garde of the revolutionary period—have provided Oursler with techniques for crafting sexual innuendo and popular jokes as well as

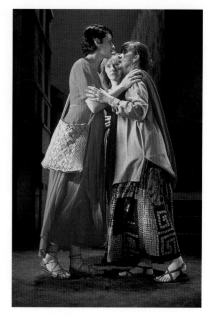

8.20 Bill Viola
The Greeting, 1995
Video/sound installation
Dimensions variable
Whitney Museum of American Art

8.21 Tony Oursler
Influence Machine, 2000
Video and sound projection
Madison Square Park, New York

for a broader display of semantic, acoustic, visual, and phonemic dislocation. In another format, Oursler took a wall of unevenly spaced Plexiglas bricks the height of a tall gallery wall and projected onto it the head of a woman talking. Oursler's collaborator Constance DeJong read a cut-up script, intoning "I am, I am not" in a voice fractured in its tonal and semantic registers, while the image wobbled across the bricks like a ghostly spirit. One had the sense that Oursler's speaking heads were trapped in their spectral locations on account of their having been projected from very far away, from the airwaves, from the ether, even from the Internet. For as has become clear more recently, Oursler's technically projected ghosts resemble the babbling spectra that conduct ceaseless conversations in the chatrooms of the World Wide Web. As the Modernist art historian T.J. Clark has surmised, the characters cannot stop talking. "The face's main problem is the Internet. The face is a ghost, or a soul, or a spirit seeking rest after death… and rest has become impossible. For some reason the Internet has invaded the world of these spirits and taken over their wavelengths. So they are coming back to do battle with the digital enemy." The installation referred to is Oursler's *Influence Machine* (2000), projected on Hallowe'en in Madison Park, New York, where a cacophony of spectral texts and looming faces were beamed onto trees, clouds of steam, and old skyscrapers, each resembling a séance sent via satellite and cable from some nether electronic world [Fig. 8.21]. Faces undulated, grew and disappeared on the wind. One heard voices of nineteenth-century mystics attempting to contact the spirit world, radio static that occasionally resembled voices, then the uncanny correspondences between these and the ghosts that populate the shift from physical to virtual—or vicarious—experience. "To me," says Oursler, "the body is being dematerialised and rematerialised all the time. Technology alters life. Technology is an amplifier of instinct. That list was probably the same a million years ago, only now it's a little more dangerous."

But if Oursler's disembodied speaking heads, projected onto vapor clouds in a city park at night, expose the paradoxes of the new technology in a medium (and in a setting) understood to belong to art, then the use by other artists of digital technology as a medium of art looks like a technically utopian choice. The rise of what is now known as "digital art" or "Internet art" reaches beyond the Modernist world of form and matter, of form organized as matter, to organize and occupy the space of the screen itself. The screen is matter too, obviously, but the characteristics of the screen experience are so different from painting, sculpture, installation, or video film (at its best a parody of TV), and its operations so unfamiliar, as to bend the language needed to describe it and certainly the criteria needed to appraise it. To Modernists enamored

of the contexts of matter, space, and color, much of this—perhaps all of it—will fail and fail miserably to pass the "test of form" (T.J. Clark).

By contrast, Postmodernists, defined as those who believe a corner has been turned, a fence crossed in the balance between the verbal and the visual, will enthuse over the new awareness and the new languages that the World Wide Web has ushered forth. On-screen space will be said to collapse into "territory waiting to be mapped": for a feature of the new images has been the movement of visual data as it layers, coalesces, and self-modifies in a more or less ceaseless flow. In the digital work, said one expert recently, "the spaces that are being mapped can range from computer networks and the Internet itself, as one vast communication territory, to a specific database and data set, or the process of networked communication," allowing the "digital" artist to transcend the conventional ways that information is organized in preconfigured corporate portals, and allowing the user to experience the Internet in new and potentially radical ways. That at least is the claim of Mark Napier's *Riot* [Fig. 8.22], a cross-content web browser that blends major websites such as CNN, the BBC, and Microsoft, and by collapsing domains and web pages together offers an experience of the Internet relatively free of institutional boundaries or corporate control.

Readers will be anxious to gain a purchase on the question of whether the rise and rise of the Internet is likely to change the infrastructure of contemporary visual art—its organization and its economy—as it stretches across the globe. If information about new art can travel internationally and without reference to national boundaries, if artists, curators, and investors can surf the airwaves unhindered, what consequences will this have upon the way "the contemporary" is figured upon the international stage? In practice, however, the "globalization" of art is already a kind of illusion peculiar to the West. *National Geographic* (and it should know) told us recently that a mere 15 percent of the world's population, most of them in the wealthiest countries, has access to over 96 percent of computers with Internet connections. In the five years from 1997 to 2002 Internet use in Asia rose by a multiple of 16, well over twice the speed of increase in the rest of the world; yet in 2002 the uptake in Asia was still only one six-hundredth of that in the United States. The information super-highway does not travel everywhere. And if it did, would that make advanced art a global phenomenon? Would its character be everywhere the same?

That seems to me to be another illusion peculiar to our situation in the West—and for several reasons. Linguistic barriers divide nations and groups from each other and give them the local identities they need. Let us also not forget that art still arises within local communities whose aesthetic traditions we often do not and perhaps cannot fully understand. Further, what we call the

8.22 Mark Napier
Riot, 2000
Cross-content web browser

modernization of consumption is not an even process, and takes place in local economic, social, and historical conditions that are by no means homogeneous. In any case, and as more and more people are arguing, consumption as we know it in the West is a disputed and sometimes valueless gain: the globalization of the market is a "good" mainly espoused by the large corporations of Europe and the USA.

We might want to remind ourselves too of the geography of cultural power still concentrated in the West: the concentration of creative, editorial, and financial power within a small number of centers. I refer once more to the pull exerted by New York, which now as formerly can best be described in terms of sheer critical mass—given that more artists, critics, magazine editors, gallerists, and above all collectors of art are to be found concentrated here than in any other city on the globe. Now as in the 1950s, a unique blend of ambition, money, and influence is enabling opinion-formers to make and break reputations with a speed and finality seldom experienced elsewhere. In recent times, too, New York has taken the lead in promoting interchanges between the arts that look altogether new. The designation "artist" has acquired new connotations, as we see painters directing films, sculptors crossing over to do architectural work, fashion designers installed in the art museum, Internet artists colonizing the galleries. Statistics on the movement of artists are also revealing. In contrast to Szeemann's male-dominated *Documenta 5*, *Documenta 11* in 2002 contained thirty-one women to eighty-two men: a significant increase. But despite the ostensibly globalizing agenda of Enwezor and his team, it turned out that over two-thirds of all *Documenta 11* artists of both genders lived and worked in New York (the largest slice) and other NATO capitals, even if roughly half were migrants from non-Western countries in search of opportunity and recognition—while the other half were born or educated in that city. By this measure too, New York remains the center of the expanded field of the contemporary visual arts, even as it reaches further around the globe. Finally, it would seem that all of the media—music, video, performance, publishing, and the Internet— are beginning to join hands with architecture, fashion, and the fine arts in a networked system of mutually reinforcing, polymathic collaborations that find echoes in cities as diverse as Brussels, São Paolo, London, and Sydney. Editorially "soft" journals devoted to mixtures like "Interviews, Architecture, Art, Fashion, Entertaining, and Travel" have positioned new readers and lookers over against the "tough" critical and theory journals, the full spectrum of which could not be more different from where we began a generation or two ago. The information revolution, of which the digital image is just a primitive beginning, is a feature of our society not only to be used, but to be understood and argued with, as in the best traditions of the avant-garde. Art today and tomorrow has the challenge of this technology to meet.

Contemporary Voices

Thomas Hirschhorn, "Beyond Mission Impossible: Thomas Hirschhorn and Marcus Steinweg interviewed by Thomas Wülffen," *Janus* 14, 2003, p. 28.

"*Utopia does not interest me. Utopia is only meaningful when I try and put it into practice and when I have the courage to surrender to potential failure and not run away when confronted with the fear of disaster. I think Utopia has to be created in the here and now. I have never been interested in the Utopia of the past. And it must not become trendy either. Utopia must never be left in the hands of politicians and sociologists. As an artist I want to try and accept responsibility for this in and through my work… It is not a question of being responsible for a success or a failure, but of taking responsibility for the desire for Utopia. If I am filled with this desire and acknowledge it then you cannot speak of failure, regardless of the result. Failure in this case would be a lack of desire.*"

Rosalind Krauss, *"A Voyage on Art in the Age of the North Sea": Art in the Age of the Post-Medium Condition*, London and New York: Thames and Hudson, 1999, p. 56.

"*One description of art within this regime of Postmodern sensation is that it mimics just this leaching of the aesthetic out into the social field in general. Within this situation, however, there are a few contemporary artists who have decided not to follow this practice, who have decided, that is, not to engage in the international fashion of installation and intermedia work, in which art essentially finds itself complicit with a globalisation of the image in the service of capital.*"

Timeline

	Politics	Other events	Visual arts
1972	Bombing of North Vietnam continues Richard Nixon elected president for second term (USA)	Terrorist attack on Olympic Games at Munich (Germany) Apollo 16 lands on moon Pocket calculator invented	*Documenta 5* (Kassel)
1973	USA declares end of involvement in Vietnam War between Israel and Arab states Salvador Allende ousted by military coup (Chile)	First color photocopier marketed (Japan) Oil price rises of 70% announced (Arab states)	Death of Picasso First *Sydney Biennale*
1974	Labour government elected after miners' strike (UK) Nixon resigns following Watergate hearings (USA)		
1975	General Franco dies (Spain) North Vietnamese capture Saigon	First joint space mission between US and USSR F-16 fighter developed (USA)	*The Fox* journal published (New York)
1976	Jimmy Carter elected president (USA) Harold Wilson succeeded as prime minister by James Callaghan (UK) Death of Mao Tse-tung (China)	Olympic Games held at Montreal (Canada) US space-probe Viking I lands on Mars	*The Human Clay* (London) *October* journal launched (New York) Death of Max Ernst
1977	Democratic elections take place in Spain Steve Biko dies in police cell (South Africa)	Apple II microcomputer marketed (USA)	*Documenta 6* (Kassel) *Pictures* (New York) Pompidou Center opens (Paris) *Heresies* magazine published (New York)
1978	Pope John Paul II succeeds Pope Paul VI	First test-tube baby born (UK)	Death of Giorgio de Chirico Death of Harold Rosenberg
1979	Ayatollah Khomeini takes power in Iran US Embassy hostages taken (Iran) Margaret Thatcher becomes prime minister (UK)	Walkman radio introduced Compact disc developed	
1980	Ronald Reagan elected president (USA)	Ozone depletions cause concern Olympic Games held at Moscow	*Picasso's Picassos* (New York) Baselitz and Kiefer sensations at Venice Biennale
1981	François Mitterrand elected president (France) Ayatollah Khomeini releases hostages (Iran)	Fax machines enter widespread use	*A New Spirit in Painting* (London) Barthes's *Camera Lucida* published *Westkunst* (Cologne) Death of A.H. Barr
1982	Solidarity trades union outlawed in Poland Leonid Brezhnev dies; Andropov becomes president of USSR Kohl elected chancellor (West Germany) Falklands War between Great Britain and Argentina	Cruise missiles adopted by US Airforce	*Zeitgeist* (Berlin) *Documenta 7* (Kassel)
1983	Thatcher wins second term as prime minister (UK) Anti-nuclear protests take place in UK, France, Germany	First US woman travels in space AIDS virus isolated (France)	Baudrillard's *Simulations* published
1984	Reagan wins second term (USA) Yuri Andropov dies; Chernenko becomes president of USSR Ethiopian Civil War intensifies	Top quark discovered (Geneva) Olympic Games held at Los Angeles First Apple Mac computer available	MOMA (New York) extension opened *Primitivism in 20th-Century Art* (New York)
1985	Mikhail Gorbachev becomes president of USSR Gorbachev and Reagan agree to reduce arms African famine continues		Saatchi Gallery opened (London) *Renoir* exhibition (London and Boston) breaks attendance records Death of Marc Chagall
1986	Ferdinand Marcos ousted (Philippines)	Challenger spacecraft explodes (USA) Chernobyl nuclear reactor explodes (Ukraine)	*Damaged Goods* (New York) Ludwig Museum opened (Cologne) Musée d'Orsay opened (Paris)
1987	Irangate inquiry criticizes Reagan (USA) Conservatives win third election in succession (UK)	Compact video disc introduced Montreal Protocol on CFC emissions published Stock markets crash on Black Monday	*Documenta 8* (Kassel) Death of Andy Warhol *Third Text* journal launched

Timeline

	Politics	Other events	Visual arts
1988	George Bush elected president (USA) Mitterrand re-elected president (France)	Olympic Games held at Seoul (Korea) Drought hits USA Transatlantic fiber-optic cable laid	*American/German Art of the Late 80s* (Düsseldorf and Boston) *Freeze* (London)
1989	Tiananmen Square demonstrators massacred (China) Death of Ayatollah Khomeini (Iran) Democratic elections take place in USSR Berlin wall opened (Germany)	San Francisco experiences earthquake disaster Cordless telephone becomes widely available 10,000,000 fax machines are in use worldwide Stealth bomber makes maiden flight	NEA attacked by fundamentalists (USA) *China Avant-Garde* (Beijing) Serra's *Tilted Arc* destroyed 150th anniversary of photography
1990	Nelson Mandela released (South Africa) US troops sent to Gulf John Major appointed prime minister (UK) Helmut Kohl elected chancellor of unified Germany	Global warming threat recognized Adobe Photoshop software launched	*Between Spring and Summer* (Washington) Tate Gallery reopened (London)
1991	Gulf offensive launched against Iraq Coup against Gorbachev fails (USSR) Formal dissolution of USSR takes place Civil war begins in Yugoslavia	BCCI banking scandal uncovered Tomahawk missile used in Gulf War 10,000,000 cases of HIV estimated worldwide	*Metropolis* (Berlin) MOCA Frankfurt opened *Frieze* magazine launched
1992	Conservatives win fourth term (UK) Bill Clinton elected president (USA) Maastricht Treaty on European Union signed	Olympic Games held at Barcelona (Spain) COBE satellite explores cosmic background (USA) Digitized video launched Riots erupt in Los Angeles (USA)	*Helter Skelter: LA Art in the 90s* (Los Angeles) SoHo Guggenheim opened (New York) *Documenta 9* (Kassel) Death of Francis Bacon
1993	Palestinian self-rule agreed Vaclav Havel elected president of Czech Republic GATT trade agreement concluded	Concept of "information super-highway" promoted (USA) Internet system links 5,000,000 users	*Abject Art* (New York) Marcel Duchamp retrospective (Venice)
1994	Nelson Mandela sworn in as South African president Genocide in Rwanda	Discovery of Chauvet caves, France, containing paintings over 30,000 years old	*Bad Girls* (New York and Los Angeles) Matthew Barney, *Cremaster* series opens Death of art critic Clement Greenberg
1995	Israeli President Rabin assassinated in Jerusalem	Federal building in Oklahoma City, USA, destroyed by a car bomb	Charles Saatchi heavily promotes "yBa" artists (London) *Brilliant!* (Walker Art Center, Minneapolis) MACBA Barcelona (Meier)
1996	The Taleban take power in Afghanistan	European Union countries impose ban on British beef owing to mad cow disease	Aleksandr Brener arrested following Stedelijk Museum action
1997	Agreement to let Palestinians control Hebron Massacre in Algeria led by Islamic militants Tony Blair become prime minister (UK)	Kyoto Protocol on climate change Scottish researcher creates clone lamb from adult sheep DNA Beginning of Asian economic crisis	*Documenta 10* (Kassel) Vienna (Judenplatz) Holocaust Memorial *Sensation* (London) Guggenheim Museum Bilbao (Gehry) completed
1998	President Clinton impeached (USA) Iraq bans UN weapons inspectors	Email becomes popular, use of the Internet grows exponentially First nuclear tests in India and Pakistan	Jewish Museum, Berlin (Libeskind)
1999	Czech Republic, Poland, and Hungary join NATO	First round-world balloon flight completed	*Sensation* exhibition sparks controversy (New York)
2000	George W. Bush elected president (USA) Milosevic removed from power in Serbia	DNA sequencing of human genome completed Dot.com businesses face sharp decline	Tate Modern, London (Herzog and de Meuron) *Apocalypse* (London)
2001	Attack on the World Trade Center, New York	Taleban destroy Buddha statues in Afghanistan Enron Corp. bankruptcy scandal	Milwaukee Art Museum (Calatrava)
2002	UN Security Council sends weapons inspectors to Iraq	Euro currency introduced in Europe Pollution cloud over South Asia causes half a million deaths	Modern Art Museum, Fort Worth (Ando) Matthew Barney, *Cremaster* series closes *Documenta 11* (Kassel)
2003	US leads coalition forces into Iraq North Korea abandons nuclear non-proliferation treaty	SARS (severe acute respiratory syndrome) spreads from Asia	*October* journal 100th issue 50th Venice Biennale
2004	Conservatives win election in Iran Ten countries join European Union	Madrid train bombings	

References and Citations

The anthologies listed below provide comprehensive further readings in the art of the period. The chapter references that follow refer to quoted passages in the order in which they appear, or suggest further reading on the artists concerned. Those chapter references that can be found in the anthologies are marked with a capital letter (or letters) in square brackets.

Anthologies

H. Foster (ed. and intr.), *The Anti-Aesthetic: Essays in Postmodern Culture*, Washington: Bay Press, 1983 [H]

C. Harrison and P. Wood (eds.), *Art in Theory 1900–2000: An Anthology of Changing Ideas*, Oxford: Blackwell, 2003 [HW]

L. Lippard, *From the Center: Feminist Essays on Women's Art*, New York: Dutton, 1976 [L]

U. Meyer, Conceptual Art, New York: E.P. Dutton and Co., 1992 [M]

H. Robinson (ed.), *Feminism — Art — Theory*, Oxford: Blackwells, 2001 [R]

J. Siegel (ed.), *Art Talk: The Early 1980s*, New York: DaCapo Press, 1988 [S]

K. Stiles and P. Selz (eds.), *Theories and Documents of Contemporary Art: A Sourcebook of Artists' Writings*, Berkeley, Cal., and London: University of California Press, 1966 [SS]

B. Wallis (ed.), *Art After Modernism: Rethinking Representation*, New York: New Museum of Contemporary Art, 1984 [W1]

B. Wallis (ed.), *Blasted Allegories: An Anthology of Writings by Contemporary Artists*, New York and Cambridge: New Museum of Contemporary Art and MIT Press, 1987 [W2]

Chapter 1: Alternatives to Modernism

C. Greenberg, "Avant-Garde and Kitsch," *Partisan Review*, 1939 [HW]. C. Greenberg, "Modernist Painting" (1960), in J. O'Brian, *Clement Greenberg: The Collected Essays and Criticism*, Vol. 4, Chicago: University of Chicago Press, 1993. W. Hopps and S. Davidson (eds.), *Robert Rauschenberg: A Retrospective*, New York: Guggenheim Museum, 1997. J. Yoshihara, "The Gutai Manifesto," *Genijutsu Shincho*, Dec. 1956 [SS]. P. Manzoni, "Free Dimension" (1960) [HW]. G. Celant, "Arte Povera," in *Arte Povera*, Milan and New York: 1969 [HW]. M. Merz, "Untitled Statements: 1979, 1982, 1984," in G. Celant, *The Knot: Arte Povera at PS1*, New York: PS1, 1985 [SS]. R. Morris, "Notes on Sculpture, Part I," *Artforum*, Feb. 1966 [HW]. R. Morris, *Continuous Project Altered Daily: The Writings of Robert Morris*, MIT Press, 1993. D. Judd, "Specific Objects," *Arts Yearbook 8*, New York, 1965 [HW]. M. Fried, "Art and Objecthood," *Artforum*, summer 1967 [HW]. R.H. Fuchs, *Richard Long*, New York: Guggenheim Museum, 1986. M. Heizer, D. Oppenheim, and R. Smithson, "Discussion," *Avalanche* 1, fall 1970 [SS]. S. LeWitt, "Paragraphs on Conceptual Art," *Artforum*, summer 1967 [HW]. R. Barry, "Interview with Ursula Meyer, 12 October 1969" [M]. V. Acconci, "Step Piece" [M]. L. Lippard and J. Chandler, "The Dematerialization of Art," *Art International*, Feb. 1968. C. Schneemann, "The Notebooks" (1962–65), in Schneemann, *More Meat Than Joy: Complete Performance Works and Selected Writings*, ed. B. McPherson, New York, 1979. AWC, "Statement of Demands," *Studio International*, Nov. 1970 [HW]. B. Reise, "Which Is In Fact What Happened: Thomas Messer in an Interview with Barbara Reise," *Studio International*, July–Aug. 1971. B. Reise, "A Tale of Two Exhibitions: The Aborted Haacke and Robert Morris Shows," *Studio International*, July–Aug. 1971. D. Buren, statement on Guggenheim, *Studio International*, July–Aug. 1971. D. Buren, D. Waldman, T. Messer, and H. Haacke, "Gurgles Around the Guggenheim," *Studio International*, June 1971. H. Haacke, "Untitled Statement" (1969) [SS]. H. Haacke, "Museums, Managers of Consciousness," in R. Deutsche *et al.*, *Hans Haacke: Unfinished Business*, New York: New Museum and MIT Press, 1986. C. Duncan and A. Wallach, "The Museum of Modern Art as Late Capitalist Ritual: An Iconographic Analysis," *Studio International* 1, 1978.

Chapter 2: Victory and Decline

H. Szeemann, *Documenta 5*, Kassel, 1972. F. Ringgold, "Interview with Eleanor Munro" (1971) [SS]. L. Nochlin, "Why Have There Been No Great Women Artists?," *Art News* 1971. L. Alloway, "Women's Art in the 1970s," *Art in America*, May–June 1976. L. Benglis, "Statement," in Susan Keane (ed.), *Lynda Benglis: Dual Natures*, Atlanta: High Museum of Art, 1991. J. Chicago, *The Dinner Party: A Symbol of Our Heritage*, New York, 1979 [SS]. L. Lippard, "Jackie Winsor," *Artforum* 12: 6, Feb. 1974 [L]. E. Hesse, "Untitled Statement," (1969), reprinted in Lucy Lippard, *Eva Hesse*, New York: Da Capo Press, 1976 [SS]. L. Lippard, "Rosemary Castoro: Working Out," *Artforum* 13: 10, summer 1975. C. Duncan, "Virility and Domination in Early 20th-Century Vanguard Painting," *Artforum* 12: 4, 1974. L. Lippard, "Mary Miss: An Extremely Clear Situation," *Art in America* 62: 2, March–April 1974. M. Rosler, "The Bowery in Two Inadequate Descriptive Systems," in *Three Works*, Halifax: Press of the Nova Scotia College of Art and Design, 1981. M. Kelly, *Post-Partum Document*, London: Routledge & Kegan Paul, 1983. C. Schneemann, "The Notebooks" (1962–63), in Schneemann, *More Meat Than Joy: Complete Performance Works and Selected Writings*, ed. B. McPherson, New York, 1979. C. Schneemann, "Women in the Year 2000" (1975), in *ibid.* C. Iles (ed.), *Marina Abramović: Objects, Performance, Video, Sound*, Oxford: Museum of Modern Art, Oxford, 1995. H. Cotter, "Rebecca Horn: Delicacy and Danger," *Art in America*, Dec. 1993. C. Burden, "Untitled Statement," *Arts* 49: 7, March 1975. J. Harris, "Valie Export: Frau Export," *Artext* 70, Aug.–Oct. 2000. V. Export, *Valie Export*, Vienna: Museum Moderne Kunst Stiftung Ludwig, 1997. K. Silverman, "Speak Body," in *Split Reality: Valie Export*, Vienna and New York: Springer Verlag/Museum Moderner Kunst, Vienna, 1997. L. Lippard, "The Pains and Pleasures of Rebirth: Women's Body Art," *Art in America*, May–June 1976. *Gina Pane*, Southampton: John Hansard Gallery, University of Southampton, 2002. B. Buchloh, "Beuys: The Twilight of the Idol: Preliminary Notes for a Critique," *Artforum*, Jan. 1980. E. DeAk and W. Robinson, "J. Beuys: Art Encagé," *Art in America*, Nov.–Dec. 1974. J. Roberts, "Stuart Brisley," in *Stuart Brisley*, London: ICA, 1981. "Michael Snow: De Là 1969–1972," in S. Delahanty, *Video Art*, Philadelphia: ICA, University of Pennsylvania, 1975. M. Le Grice, "Statement," in *Arte Inglese Oggi*, Milan: Electa Editrice, 1976. C. Welsby, "Statement," in *Arte Inglese Oggi*, Milan: Electa Editrice, 1976. R. Serra, "Prisoner's Dilemma," *Avalanche Newspaper*, May 1974. "Ant Farm," in P. Gale (ed.), *Video by Artists*, Toronto: Art Metropole, 1976. D. Graham, "Excerpts: Elements of Video/Elements of Architecture," in P. Gale (ed.), *Video by Artists*, Toronto: Art Metropole, 1976. D. Graham, "Homes for America," *Arts Magazine*, Dec. 1966–Jan. 1967. C. Gintz, "Beyond the Looking Glass" (Dan Graham), *Art in America*, May 1994. T. Crow, *The Rise of the Sixties: American and European Art in the Era of Dissent 1955–69*, London: Weidenfeld, 1996. D. Graham, "Video Piece for Showcase Windows in

Shopping Arcade" (1974), in A. Alberro (ed.), *Two-Way Mirror Piece: Selected Writings by Dan Graham on His Art*, MIT Press and Marian Goodman Gallery, New York, 1999. C. Diserens (ed.), *Gordon Matta-Clark*, London: Phaidon, 2003. M. Asher, *Writings 1973–1983 on Works 1969–1979*, ed. B. Buchloh, Nova Scotia College of Art and Design and the Museum of Contemporary Art, Los Angeles, 1983. C. Gintz, "Michael Asher and the Transformation of 'Situational Aesthetics,'" *October* 66, fall 1993. *Shifting Ground: Selected Works of Irish Art 1950–2000* (Patrick Ireland), Dublin: Irish Museum of Modern Art, 2000 . Marie Judlová (ed.), *Ohniska Znovuzrození: České umění 1956–1963* (Beran and others), Prague 1994. C. Ratcliff, *Komar and Melamid*, New York: Abbeville, 1988. M. Tupitsyn, "Kollektivivnye Deistvia (K/D): Trips Beyond the City," in D. Ross (ed.), *Between Spring and Summer: Soviet Conceptual Art in the Era of Late Communism*, Cambridge, Mass.: MIT Press, 1990.

Chapter 3: The Politics of Painting

A. Caro, "A Discussion with Peter Fuller," *Art Monthly*, 1979 [SS]. F. Ingold, "The Speaking Image: Pictorial Perception and Pictorial Constitution in the Work of Rémy Zaugg," *Parkett* 19, 1989. R. Zaugg, untitled text, in *Voir Mort: 28 Tableaux*, Lucerne: Mai 36 Galerie, 1989. R. Barthes, "The Wisdom of Art," in H. Szeemann (ed.), *Cy Twombly: Paintings, Works on Paper, Sculpture*, Munich: Prestel Verlag, 1987. *Cy Twombly: A Retrospective*, New York: Museum of Modern Art, 1994. C. Owens, "The Allegorical Impulse: Towards a Theory of Postmodernism," *October* 12, spring 1980. T. Adorno, *Aesthetic Theory* (1970), Minneapolis: University of Minnesota Press, 1977. P. Leider, "Stella Since 1970," *Art in America*, March–April 1978. F. Stella, *Working Space*, Cambridge, Mass. and London: Harvard University Press, 1986. L. Lippard, *9th Paris Biennale*, Paris: Musée d'Art Moderne de la Ville de Paris, 1975. R.B. Kitaj, "Pearldiving," in *The Human Clay*, London: ACGB, 1976. L. Freud, "Some Thoughts on Painting," *Encounter* 111: 1, July 1954 [SS]. D. Grefenkart (ed.), *Georg Baselitz: Paintings 1962–2001*, Milan: Serbelloni Editore. F. Clements, "Interview with Robin White," *View* 6, Nov. 1981. "Ten Unusual Questions for Sandro Chia: An Interview with Wolfgang Fischer," *Sandro Chia*, London: Fischer Fine Art, 1987. C. Joachimedes, N. Rosenthal, and N. Serota (eds.), *A New Spirit in Painting*, London: Royal Academy, 1981. C. Joachimedes and N. Rosenthal (eds.), *Zeitgeist: International Art Exhibition*, Berlin, 1982. R. Rosenblum, "Thoughts on the Origins of 'Zeitgeist,'" in *ibid*. C. Joachimedes, "Achilles and Hector Before the Walls of Troy," in *ibid*. R. Pincus-Witten, "Entries: Rebuilding the Bridge: Hödicke, Joachimedes and Berlin in the Early 80s," *Arts Magazine*, March 1980. B. Brock, "The End of the Avant-Garde? And So the End of Tradition. Notes on the Present 'Kulturkampf' in West Germany," *Artforum*, 19: 10, June 1981 [W1]. D. Kuspit, "The New(?) Expressionism: Art as Damaged Goods," *Artforum*, Nov. 1981. R. Krauss and A. Michelson, "Editorial," *October* 1, spring 1976. D. Kuspit, "Flack from the 'Radicals': The American Case Against German Painting," in J. Cousart (ed.), *Expressions: New Art from Germany*, St. Louis Art Museum, 1983 [W1]. D. Crimp, "The End of Painting," *October* 16, spring 1981. B. Buchloh, "Figures of Authority, Ciphers of Regression: Notes on the Return of Representation in European Painting," *October* 16, spring 1981 [W1]. G. Richter, "Notes 1966–1990s," in *Gerhard Richter*, London: Tate Gallery, 1991. J. Thorn-Prikker, "Gerhard Richter, 'Ruminations on the October 18, 1977 Cycle,'" *Parkett* 19, March 1989. *Gerhard Richter: 18 Oktober 1977*, Krefeld: Museum Hans Esters, 1989. B. Buchloh, "Interview with Gerhard Richter," in *Gerhard Richter*, Chicago: Chicago Museum of Contemporary Art, 1987 [HW]. M. Foucault, "Photogenic Painting" (1975), in A. Rifkin (intr.), *Gérard Fromanger*, London: Black Dog Publishing, 1999. G. Deleuze, "Cold and Heat" (1973), in A. Rifkin (intr.), *Gérard Fromanger*, London: Black Dog Publishing, 1999. Art and Language, "Portrait of V.I. Lenin in the Style of Jackson Pollock," *Artforum*, Feb. 1980. C. Harrison, *Essays on Art and Language*, Oxford: Blackwells, 1991. *Art and Language*, Paris: Galerie Nationale du Jeu de Paume, 1993. T. Crow, "Unwritten Histories of Conceptual Art: Against Visual Culture," in *Modern Art in the Common Culture*, New Haven and London: Yale University Press, 1996. D. Kuspit, "Golub's Assassins: An Anatomy of Violence," *Art in America*, May–June 1975. L. Golub, "The Mercenaries," interview with Matthew Baigel, *Arts* 9, May 1981 [SS]. C. Greenberg, "Modernist Painting" (1961), in J. O'Brian (ed.), *Clement Greenberg: The Collected Essays and Criticism, Vol. 4*, Chicago: University of Chicago Press, 1993. B. Buchloh, "Parody and Appropriation in Francis Picabia, Pop and Sigmar Polke," *Artforum*, March 1982. "Poison Is Effective: Painting Is Not: Bice Curriger in Conversation with Sigmar Polke," *Parkett*, 1990. G. Politi, "Julian Schnabel," *Flash Art* 130, Oct.–Nov. 1986. C. Christov-Bakargiev, "Interview with Carlo Maria Mariani" (Schnabel), *Flash Art* 133, April 1987. T. Lawson, "Last Exit: Painting," *Artforum*, 1981 [W1]. *David Salle*, Fruitmarket Gallery, Edinburgh, 1987. W. Robinson, "Slouching Toward Avenue D" (East Village Art), *Art in America*, summer 1984. B. Blinderman, "Keith Haring's Subterranean Signatures," in *Arts Magazine*, Sept. 1981 [S]. C. Owens, "Commentary: The Problem with Puerilism," *Art in America*, summer 1984. "The Other Face of Banality: Gérard Garouste Interviewed by Jérome Sans," *Artifice*, Dec. 1985–Jan. 1986. *Milan Kunc*, Galeria di via Eugippio, San Marino, 2001. *Ken Currie*, Third Eye Centre, Glasgow 1988. G. Lukács, *Realism in Our Time: Literature and Class Struggle*, New York and Evanston: Harper & Row, 1962. *Ree Morton: Retrospective 1971–1977*, New Museum, New York 1980. J. Perrault, "Issues in Pattern Painting," *Artforum*, Nov. 1977. *Rooms* (Richard Artschwager, Cynthia Carlson, Richard Haas), Hayden Gallery, Cambridge, Mass., 1981. M. Shapiro and M. Meyer, "Waste Not Want Not: An Inquiry into What Women Saved and Assembled—FEMMAGE," *Heresies* 4, winter 1977–78 [SS]. V. Jaudon and J. Kozloff, "Art Hysterical Notions of Progress and Culture," *Heresies* 4, winter 1977–78 [R]. *Philip Taafe*, IVAM Centre de Carmen, Valencia 2000. G. Hilty, "Snakes and Daggers" (Philip Taaffe), *Frieze* 41, June–July 1998.

Chapter 4: Images and Things

B. Buchloh, "Detritus and Decrepitude: The Sculpture of Thomas Hirschhorn," *Oxford Art Journal* 24, 2001. M. Duchamp, *Dialogues with Marcel Duchamp*, London: Thames & Hudson, 1971. R. Lebel, *Marcel Duchamp*, New York: Grove Press, 1959. *Ger Van Elk*, Amsterdam: Stedelijk Museum, 1974. *Boyd Webb*, London: Whitechapel Art Gallery, 1987. D. Crimp, "Pictures," *October* 8, spring 1979 [W1]. *Pictures: An Exhibition of the Work of Troy Brauntuch, Jack Goldstein, Sherrie Levine, Robert Longo, Philip Smith*, Artists Space, New York, 1977. C. Sherman, "Untitled Statement," *Documenta 7*, Kassel, 1982 [SS]. S. Levine, "Five Comments" (1980–85) [W2]. C. Greenberg, "Four Photographers," *New York Review of Books*, 23 Jan. 1964, in J. O'Brian (ed.), *Clement Greenberg: The Collected Essays and Criticism*, Vol. 4, Chicago: University of Chicago Press, 1993. J. Paoletti, "Victor Burgin's *Office at Night*: Between Image and

Interpretation," *Arts Magazine*, September 1986. V. Burgin (ed.), *Thinking Photography*, London: Macmillan, 1982. R.L. Pincus, "Sophie Calle: The Prying Eye," *Art in America*, Oct. 1989. G. Danto, "Sophie the Spy," *Art News*, May 1993. J. Siegel, "Barbara Kruger: Pictures and Words," *Arts Magazine* 61, June 1987 [SS]. C. Owens, "The Discourse of Others: Feminists and Postmodernism" (1983) [H]. W. Benjamin, "The Work of Art in the Age of Mechanical Reproduction" (1936) [HW]. J. Baudrillard, "The Precession of Simulacra," in Baudrillard, *Simulations*, New York: Semiotexte, 1983. K. Linker, "From Imitation to the Copy to Just Effect: Reading Jean Baudrillard," *Artscribe*, April 1984. M. Winzen (ed.), *Thomas Ruff: 1979 to the Present*, Cologne: DuMont, 2001. M. Hermes, "Doppelgänger" (Thomas Ruff), *Artscribe International*, March–April 1988. A. Pohlen "Deep Surface" (Thomas Ruff), *Artforum*, April 1991. M. Gisbourne, "Struth," *Art Monthly*, May 1994. D. Dannetas, "Interview with Christian Boltanski," *Flash Art* 124, Oct.–Nov. 1985 [SS]. R. Barthes, *Camera Lucida: Reflections on Photography*, London: Cape, 1982. B. Jones, "False Documents: A Conversation with Jeff Wall," *Arts Magazine*, May 1990. T.J. Clark, S. Guilbaut, and A. Wagner, "Representation, Suspicions, and Critical Transparency: An Interview with Jeff Wall," *Parachute* 59, July–Sept. 1990. T. Cragg, "Untitled Statement," *Documenta 7*, Kassel, 1982 [SS]. *Bill Woodrow: Sculpture 1980–86*, Fruitmarket Gallery, Edinburgh, 1986. R. Newman, "From World to Earth: Richard Deacon and the End of Nature," in S. Bann and W. Allen (eds.), *Interpreting Contemporary Art*, London: Reaktion Books, 1991. M. Fried, "Art and Objecthood," *Artforum*, summer 1967 [HW]. H. Steinbach, J. Koons, S. Levine, P. Taaffe, P. Halley, and A. Bickerton, "From Criticism to Complicity," *Flash Art*, summer 1986 [HW]. J. Koons, "Full Fathom Five," *Parkett* 19, 1989 [HW]. T. Kellein (ed.), *Jeff Koons: Pictures 1980–2002*, Cologne, 2002. *Jeff Koons*, San Francisco: San Francisco Museum of Modern Art, 1992. *Toward the Future: Contemporary Art in Context* (Tasset), Chicago: Museum of Contemporary Art, 1990. R. Wiehager (ed.), *Sylvie Fleury*, Ostfildern-Ruit: Cantz Verlag, 1999. E. Hayt, "Sylvie Fleury: The Woman of Fashion," *Art and Text* 49, Sept. 1994. *Jack Goldstein*, Grenoble: Centre National d'Art Contemporain de Grenoble, 2002. P. Halley, "The Crisis in Geometry," *Arts Magazine*, summer 1984. P. Halley, "Notes on the Paintings," in *Collected Essays 1981–87*, Bruno Bischofberger Gallery, Zurich, and Sonnabend Gallery, New York, 1988. T. Crow, "Ross Bleckner, or the Conditions of Painting's Reincarnation" (1995), in Crow, *Modern Art in the Common Culture*, New Haven and London: Yale University Press, 1996. L. Wei, "Talking Abstract: Ross Bleckner," *Art in America*, July 1987. J. Siegel, "After Sherrie Levine," *Arts Magazine*, June 1985 [S]. "Sherrie Levine Plays with Paul Taylor," *Flash Art* 135, summer 1987. B. Dimitrijević, *Tractatus Post-Historicus*, Tübingen: Edition Dacic, 1977. M. Tupitsyn, "U-Turn of the U-Topian" (Mukhomory), in D. Ross (ed.), *Between Spring and Summer: Soviet Conceptual Art in the Era of Late Communism*, Cambridge, Mass.: MIT Press, 1990. *Modernism and Post-Modernism: Russian Art of the Ending Millennium* (Yurii Albert and others), Yager Museum, Hartwick College, Oneonta, New York, 1998.

Chapter 5: In and Beyond the Museum

G. Debord, *The Society of the Spectacle*, 1967, English edition, Detroit, 1970. E. Sussmann (ed.), *On the Passage of a Few People Through a Rather Brief Moment of Time: The Situationist International 1957–72*, Institute of Contemporary Arts, Boston, and MIT Press, Cambridge, Mass., and London, 1989. D. Buren, "Site Work," *Artforum*, March 1988. D. Buren, O. Mosset, M. Parmentier, and N. Toroni, "Statement" (1967), *Studio International*, Jan. 1969 [HW]. J. Siegel, "Real Painting: A Conversation with Niele Toroni," *Arts Magazine*, Oct. 1989. I. Blazwick (foreword), *Alan Charlton*, London: ICA, 1991. "For Me It Has to Be Done Good: An Interview with Alan Charlton," *Arts Magazine*, May 1990. "A Quite Different Coldness: Gerhard Merz Interviewed by Thomas Dreher," *Artscribe International*, Nov.–Dec. 1988. C. Harrison, *Essays on Art and Language*, Oxford: Blackwell, 1991. T. Atkinson, "Disaffirmation and Negation," *Mute*, London: Gimpel Fils, 1983. T.J. Clark, "Clement Greenberg's Theory of Art," in F. Frascina, *Pollock and After: The Critical Debate*, London: Harper and Row, 1985. D. Kuspit, "Interview with Anselm Kiefer" (1987), in J. Siegel (ed.), *Art Talk: The Early 80s*, New York: Da Capo Press, 1988. R. Storr, "Louise Lawler: Unpacking the White Cube," *Parkett* 22, 1989. *Louise Lawler: An Arrangement of Pictures*, New York: Assouline, 2000. M. Buskirk, "Interviews with Sherrie Levine, Louise Lawler, and Fred Wilson," *October* 70, fall 1994. Y.-A. Bois, "Susan Smith's Archaeologies," in S. Bann and W. Allen (eds.), *Interpreting Contemporary Art*, London: Reaktion Books, 1991. *John Armleder*, Fréjus: Le Capitou, 1994. J. Saltz, "History's Train" (Mucha), *Art in America*, Jan. 1994. P. Monk, "Reinhard Mucha: The Silence of Presentation," *Parachute* 51, June–Aug. 1988. S. Sonmidt-Wulffen, "Models," *Flash Art* 121, March 1985. T. Wullfen, "Berlin Art Now," *Flash Art*, March–April 1990. G. Celant, "Stations on a Journey" (Mucha), *Artforum*, Dec. 1985. P. Bömmels, "Auto-Americanism" (Büro Berlin), *Artscribe*, April 1987. Büro Berlin, "dick, dunn," in *Büro Berlin: Ein Produktionsbegriff*, Berlin, 1986. *Imi Knoebel*, Eindhoven: Van Abbemuseum, 1982. "Albert Oehlen im Gespräch mit Wilfred Dickoff und Martin Prinzhorn," *Kunst Heute* 7, Cologne, 1991 [HW]. J. Koether, "Interview with Martin Kippenberger," in *B: Gespräche mit Martin Kippenberger*, Ostfildern: Cantz, 1994 [HW]. *Freitreppe: Olaf Metzel*, Munich 1996. *Olaf Metzel*, Nice: Villa Arson, 1999. C. Joachimedes and N. Rosenthal (eds.), *Metropolis*, Stuttgart: Edition Cantz, 1991. K. Ottmann, "Rosemarie Trockel," *Flash Art* 134, May 1987. J. Koether, "Interview with Rosemarie Trockel," *Flash Art* 134, May 1987. D. Drier, "Spiderwoman" (Rosemarie Trockel), *Artforum*, Sept. 1991. C. Blasé, "On Katharina Fritsch," *Artscribe International*, March–April 1988. T. Fairbrother et al., *BiNational: American and German Art of the Late 1980s*, Boston: ICA, 1988. *Magiciens de la Terre*, Centre Georges Pompidou, Paris, 1989. *Krzysztof Wodiczko: Critical Vehicles: Writings, Projects, Interviews*, Cambridge, Mass.: MIT Press, 1999. *Richard Serra: Writings and Interviews*, Chicago: University of Chicago Press, 1994. C. Weyergraf-Serra and M. Buskirk (eds.), *The Destruction of Tilted Arc: Documents*, Cambridge, Mass.: MIT Press, 1991. J. Lingwood (ed.), *House: Rachel Whiteread*, London: Phaidon, 1995. J. Young, *The Texture of Memory: Holocaust Memorials and Meaning*, New Haven and London: Yale University Press, 1993. *Jochen Gerz: Res Publica 1968–1999*, Ostfildern: Cantz, 1999. M. Welish, "Who's Afraid of Verbs, Nouns and Adjectives?" (Holzer), *Arts Magazine*, April 1990. J. Siegel, "Jenny Holzer's Language Games," *Arts Magazine* 60: 3, Nov. 1985. S. Bann, "The Inscription in the Garden: Ian Hamilton Finlay and the Epigraphic Convention," *Apollo* n.s. 134, Aug. 1991. D. Eichler, "The Last Resort" (Genzken), *Frieze* 55, Nov.–Dec. 2000. *Isa Genzken*, Chicago: Renaissance Society at the University of Chicago, 1992. "Thomas Hirschhorn: Energy Yes, Quality No," *Flash Art*, Jan.–Feb. 2001. "Thomas Hirschhorn and Marcus Steinweg," *Janus* 14, 2003. B. Buchloh, "Detritus and Decrepitude: The Sculpture of Thomas Hirschhorn," *Oxford Art Journal* 24, 2001.

Chapter 6: Marks of Identity

J. Salz, "Strange Fruit: Robert Gober's *Untitled*, 1988," *Arts Magazine*, Sept. 1990. C. Greenberg. "Where Is the Avant-Garde?," *Vogue*, June 1967, reprinted in J. O'Brian (ed.), *Clement Greenberg: The Collected Essays and Criticism, Vol. 4*, Chicago: University of Chicago Press, 1993. L. Steinberg, *Other Criteria: Confrontations with Twentieth-Century Art*, Oxford: Oxford University Press, 1972. G. Osterman, "Mixed Gay Chorus" (B. Harris), *Women Artists News* 16–17, 1991–92. P. Hodges, "Robert Mapplethorpe, Photographer," *Manhattan Gaze*, Dec. 10, 1979. S. Dubin, "The Trials of Robert Mapplethorpe," in Elizabeth C. Childs (ed.), *Suspended License: Censorship and the Visual Arts*, University of Washington Press, 1997. D. Wojnarowicz, *Memories That Smell Like Gasoline*, California: Art Space Books, May 1992. W. Bartman (ed.), *Felix Gonzales-Torres*, New York: Art Press, 1993. "Art or The Caress: A Project for *Artforum*" (Morgana), *Artforum*, Dec. 1990. A. Chave, "Minimalism and the Rhetoric of Power," *Arts Magazine*, Jan. 1990. S. Tallman, "Kiki Smith: Anatomy Lessons," *Art in America*, April 1992. K.B. Schliefer, "Inside Out: An Interview with Kiki Smith," *Arts Magazine*. *Bad Girls* (Williams, Smith), London: ICA, 1993. J. Salz, "Twisted Sister" (Williams), *Arts Magazine*, May 1990. D. Hickey, untitled, in *Vanessa Beecroft Performances: VB08-36*, Ostfildern: Hatje Cantz, 2000. S. Koestenbaum, "Bikini Brief" (Beecroft), *Artforum*, summer 1998. G. Dubois Shaw, "Final Cut" (Walker), *Parkett* 59, 2000. E. Janus, "As American as Apple Pie" (Walker), *Parkett* 59, 2000. *Lari Pittman: Paintings 1992–1998*, Cornerhouse, Manchester, 1998. *Nancy Rubins*, Museum of Modern Art, New York 1995. *Helter Skelter: LA Art in the 1990s*, Los Angeles Museum of Contemporary Art, 1992. *Paul McCarthy*, London: Phaidon Press, 1996. T. Myers, "Hard Copy: The Sincerely Fraudulent Photographs of Larry Johnson," *Arts Magazine*, summer 1991. D. Rimanelli, "Larry Johnson: Highlights of Concentrated Camp," *Flash Art* 155, Nov.–Dec. 1990. J. Saltz, "Lost in Translation: Jim Shaw's Frontispieces," *Arts Magazine*, summer 1990. R. Rugoff, "Jim Shaw: Recycling the Subcultural Straightjacket," *Flash Art*, March–April 1992. *Just Pathetic*, curated by R. Rugoff, Los Angeles: Rosamund Flesen Gallery, 1999. *R. Pettibon: The Pages Which Contain Truth Are Blank*, Museion, Bolzano 2003. *Larry Clark*, Groningen Museu, Groningen 1999. "Laurie Parsons," *Artforum*, Oct. 1990. "Betriebsystem Kunst: Eine Retrospektive" (Laurie Parsons), *Kunstforum International*, 1991–92. J. Bankowsky, "Slackers," *Artforum*, Nov. 1991. N. Bourriaud, "Karen Kilimnik: Psycho-Splatter," *Flash Art*, March–April 1992. J. Deitch, *Strange Abstraction* (Cady Noland, Robert Gober, Phillip Taaffe). R. Smithson, "Entropy and the New Monuments" (1966), in J. Flam (ed.), *Robert Smithson: The Collected Writings*, Berkeley, Cal., and London: University of California Press, 1996. L. Nesbit, "Not a Pretty Sight: Mike Kelley Makes Us Pay For Our Pleasure," *Artscribe*, Sept.–Oct. 1990. T. Kellein, *Mike Kelley*, Kunsthalle Basel, 1992. G. Bataille, *Visions of Excess: Selected Writings 1927–39*, University of Minnesota Press, 1985. R. Krauss and Y.-A. Bois, *Formless: A User's Guide*, New York: Zone Books, 1997. I. Kabakov, "On Emptiness" (1981), in D. Ross (ed.), *Between Spring and Summer*, Cambridge, Mass.: MIT Press, 1990. A. Wallach, *Ilya Kabakov: The Man Who Never Threw Anything Away*, New York: Harry N. Abrams, 1996. B. Groys and I. Kabakov, "A Dialogue on Installations," in N. von Velsen (ed.), *Ilya Kabakov: The Life of Flies*, Ostfildern: Edition Cantj and Cologne Kunstverein, 1992. *Jessica Stockholder*, London: Phaidon, 1995. B.A. MacAdam, "A Minimalist in Baroque Trappings" (Reed), *Art News*, Dec. 1999. T. Bell, "Baroque Expansions" (David Reed), *Art in America*, Feb. 1987. *Glen Brown*, Centre d'Art Contemporain, Kerguéhemec, 2000. L. Loptman, "Luc Tuymans, Mirrorman," *Parkett* 60, 2000. Luc Tuymans, London: Phaidon, 1996. N. Rosenthal (ed.), *Apocalypse: Beauty and Horror in Contemporary Art*, Royal Academy, London, 2000. M. Maloney, "The Chapman Brothers: When Will I Be Famous," *Flash Art*, Jan.–Feb. 1996. *Chapmanworld: Jake and Dinos Chapman*, ICA, London, 1996. S. Dubin, "How 'Sensation' Became a Scandal," *Art in America*, Jan. 2000. D. Hirst, *Romance in the Age of Uncertainty: Jesus and His Disciples: Death, Martyrdom, Suicide, and Ascension*, White Cube Gallery, London, 2003. F. Bonami, "Damien Hirst: The Exploded View of the Artist," *Flash Art*, summer 1996.

Chapter 7: Other Territories

R. Araeen, "Black Manifesto," *Studio International* 988, 1978 and *Black Phoenix* 1, Jan. 1978. E. Said, *Orientalism*, London: Penguin, 1978. H. Bhabha, *The Location of Culture*, London: Routledge, 1991. Gayatri Spivak, *In Other Worlds: Essays in Cultural Politics*, New York: Methuen, 1987. *Magiciens de la Terre*, Paris: Centre Georges Pompidou, 1989. "The Necessity of Jimmie Durham's Jokes," *Art Journal*, fall 1992. "Jimmie Durham: Attending to Words and Bones: An Interview with Jean Fisher," *Art and Design*, July–Aug. 1995. L. Wong, "Shelly Niro: Mohawks in Beehives," *Fuse*, summer 1992. N. Nurgesser, "Chiharu Shiota," *Kunstforum International* 156, Aug.–Oct. 2001. M. Hsu, "Close to Open" (Chieh-Jen Chen), *Flash Art* 208, Oct. 1999. J. Johnston, "Tehching Hsieh: Art's Willing Captive," *Art in America*, Sept. 2001. *Translated Acts: Performance and Body Art from East Asia 1990–2001*, Berlin: Haus der Kulturen der Welt, 2001. Fang Lijun, untitled statement, in *China Avant-Garde*, Berlin: Haus der Kulturen der Welt, 1993. H. van Dijk, "The Fine Arts After the Cultural Revolution" (Gao Minglu), *China Avant/Garde*, 1993. Q. Zhijian, "Performing Bodies: Zhang Huan, Ma Liuming, and Performance Art in China," *Art Journal*, summer 1999. E. Degot, "Moscow Actionism: Self-Consciousness Without Consciousness" (Kulik, Brener), in H.G. Oroschakoff (ed.), *Kräftemessen: Eine Austellung Östlicher Positionen Innerhalb Der Westlichen Welt*, Ostfindern: Cantz Verlag, 1995. V. Misiano, "Russian Reality: The End of Intelligentsia" (Brener), *Flash Art* 189, summer 1996. A. Osmolovsky, "Russian Inertia: Vladimir Dobusarsky and Alexander Vinogradov," *Flash Art* 210, Jan.–Feb. 2000. V. Misiano, "An Analysis of 'Tusovka': Post Soviet Art of the 1990s" (Dubossarsky, Savalov), in G. Maraniello (ed.), *Art in Europe 1990–2000*, Milan: Skira Editore, 2002. *Agitation for Happiness: Soviet Art in the Stalin Era*, St. Petersburg: State Russian Museum, 1994–95. S. Zizek, *Tarrying with the Negative: Kant, Hegel and the Critique of Ideology*, Durham: Duke University Press, 1993. S. Milevska, "AES Does the Big Apple," *Flash Art*, Jan.–Feb. 2000. M. Kuzma, "Defining Mutable Moments and Perfect Worlds: Beyond the Yalta Club" (Chichcan, Mikhailov), in G. Maraniello (ed.), *Art in Europe 1990–2000*, Milan: Skira Editore, 2002. A. Schwarzenblock (ed.), *Boris Mikhailov: Case History*, Zurich: Scalo, 1999. O. Enwezor, "The Black Box," in *Documenta 11. Platform 5: Exhibition*, Ostfildern: Cantz Verlag, 2002. R. Goldberg and W. Kentridge, "Live Cinema and Life in South Africa," *Parkett* 63, 2001. W. Kentridge, statement, in C. Christov-Bakargiev, *William Kentridge*, Brussels: Palais des Beaux Arts, 1998. R. Krauss, "William Kentridge's Drawings for Projections," *October* 92, spring 2000. F. Bonami, "Bodys Isek Kingelez," *Journal of Contemporary African Art* 10, spring–summer 1999. Georges Adéagbo, in *Big City: Artists from Africa*, Serpentine Gallery, London, 1995. P.

Holmes, "The Emperor's New Clothes" (Shonibare), *Art News*, Oct. 2002. O. Oguibe, "Finding a Place: Nigerian Artists in the Contemporary Art World," *Art Journal*, summer 1999. F. Bonami, "Introduction," in *50th Venice Biennale, Dreams and Conflicts: The Dictatorship of the Viewer*, Venice, 2003. F. Bonami, "Pittura or Painting," in F. Bonami (ed.), *50th Venice Biennale, Dreams and Conflicts: The Dictatorship of the Viewer*, Venice: La Biennale di Venezia, 2003. M. Nesbit, "Utopia Station," in *ibid*.

Chapter 8: A New Complexity

Joan Jonas, "Lines in the Sand: Notes," in *Documenta 11. Platform 5: Exhibition*, Ostfildern: Cantz Verlag, 2002. *Joan Jonas: Works 1968–1994*, Stedelijk Museum, Amsterdam 1994. B. Buchloh, "Detritus and Decrepitude: The Sculpture of Thomas Hirschhorn," *Oxford Art Journal* 24, 2001. Y. Dziewior, "John Bock: Receiver's Due," *Artext* 68, Feb.–April 2000. A. Schlegel, "John Bock: Some Inside Output of the Quasi-Me," *Flash Art* 215, Oct. 2000. E. Lorenz, "Predictability: Does the Flap of a Butterfly's Wing in Brazil Set Off a Tornado in Texas?" American Association for the Advancement of Sciences (address), 1979. C. Berwick, "Excavating Ruins" (Julie Mehretu), *Art News*, March 2002,. P. Ellis, "Matthew Ritchie: That Sweet Voodoo That You Do," *Flash Art* 215, Nov.–Dec. 2001. J. Kastner, "The Weather of Chance: Matthew Ritchie and the Butterfly Effect," *Art/Text* 61, 1998. J. Kastner, "Sarah Sze: Tipping the Scale," *Art/Text* 65, 1999. J. Slyce, *Sarah Sze*, London: ICA, 1998. F. Jameson, *Postmodernism, or the Cultural Logic of Late Capitalism*, London: Verso, 1991. C. Bishop, "Tomoko Takahashi: Accumulation of Memories," *Flash Art* 211, March–April 2001. Dick Price (essay), *The New Neurotic Realism*, London: Saatchi Gallery, 1998. R. Preece, "Tomoko Takahashi: In the Eye of the Tornado," *Sculpture*, Nov. 1999. R. Koolhaas, "Junkspace," *October* 100, 2003. Matthew Barney, *Cremaster 4*, Artangel, London, 1995. N. Bryson, "Matthew Barney's Gonadotrophic Cavalcade," *Parkett* 45, 1995. B. High Russell, "Matthew Barney's Testicular Anxieties," *Parachute* 92, Oct.–Dec. 1998. R. Smith, "Matthew Barney: *The Cremaster Cycle*," *Artforum*, May 2003. "Meier, Barcelona," *Architectural Record* 1154, April 1993. G. Mack, "The Museum as Sculpture: Interview with Frank O. Gehry," in G. Mack, *Art Museums into the 21st Century*, Basel: Birkhäuser, 1999. R. Moore and R. Ryan, *Building Tate Modern: Herzog and De Meuron Transforming Giles Gilbert Scott*, London: Tate, 2000. *Anish Kapoor: Marsyas*, London: Tate, 2002. *Santiago Calatrava: Wie ein Vogel/Like a Bird, Kunsthistorisches Museum*, Vienna 2003. M. Hardt and A. Negri, *Empire*, Cambridge, Mass., 2000. B. Groys, "On the Aesthetics of Video Installations," in *Stan Douglas: Le Détroit*, Basel: Kunsthalle Basel, 2001. *Spellbound: Art and Film* (McQueen), London: Hayward Gallery, 1996. M. Durden, "Steve McQueen," *Parachute* 98, April–June 2000. M. Stjernstedt, "Eija-Liisa Ahtila: The Way Things Are: The Way Things Might Be," *Flash Art*, summer 2000. M. Vetrocq, "Eija-Liisa Is Not Going Crazy," *Art in America*, Oct. 2002. B. Ruf, "Hybrid Realities: Eija-Liisa's Ahtila's 'Human Dramas,'" *Parkett* 55, 1999. A. Szylak, "The New Art for the New Reality: Some Remarks on Contemporary Art in Poland" (Kozyra), *Art Journal*, spring 2000. D. Elliott, "Hole Truth" (Kozyra), *Artforum*, Sept. 1999. J. Krysa, "Poles Apart" (Kozyra), *Make* 86, Dec. 1999–Feb. 2000. F. Solanas and O. Getino, "Towards a Third Cinema" (1969), in M. Martin (ed.), *New Latin American Cinema, Vol. 1*, Detroit: Wayne State University Press, 1997. N. Leleu, "Shirrin Neshat: La Querelle des Images," *Parachute* 100, Oct.–Dec. 2000. R. Jones, "Sovereign Remedy" (Shirrin Neshat), *Artforum*, Oct. 1999. M. van Hoof, "Veils in the Wind" (Shirrin Neshat), *Art Press* 279, May 2002. *Bill Viola*, New York: Whitney Museum of American Art, 1997. Bill Viola, *Writings 1973–1994*, ed. Robert Violette, with an introduction by J-C. Amman, London, 1995. M. Ritchie, "Tony Oursler: Technology as Instinct Amplifier," *Flash Art* 186, Jan.–Feb. 1996. *Tony Oursler, Influence Machine*, London: Artangel Trust, 2000. E. Horn, "Knowing the Enemy: The Epistemology of Secret Intelligence" (Tony Oursler), *Grey Room* 11, spring 2003. T.J. Clark, "Modernism, Postmodernism, and Steam," *October* 100, 2002. C. Paul, *Internet Art* (Napier), London: Thames & Hudson, 2003.

Website Addresses

Journals and Magazines

Art Asia Pacific www.artasiapacific.clm
Artchronika www.artchronika.ru
Artext www.artext.org
Artforum www.artforum.com
Art in America www.artinamericamagazine.com
Art India www.artindiamag.com
Art Journal www.collageart.org
Art Monthly www.artmonthly.co.uk
Art News www.artnewsonline.com
Art Nexus www.artnexus.com
Artpress www.artpress.com
Flash Art www.flashartonline.com
Frieze www.frieze.com
Fuse Magazine fusemagazine.org
Nu: The Nordic Art Review www.nordicartreview.nu
October www.mitpress.edu/october
Parachute www.parachute.ca

Museums of Contemporary and Modern Art

Boston ICA www.icaboston.org/
Documenta, Kassel www.documenta.de
Georges Pompidou Center, Paris www.cnac-gp.fr
Guggenheim Museum, Bilbao www.guggenheim.org
Guggenheim Museum, New York www.guggenheim.org
MACBA, Barcelona www.macba.es
Martin-Gropius-Bau, Berlin www.gropiusbau.de
Milwaukee Art Museum, Milwaukee www.mam.org
Museum of Contemporary Art, Los Angeles www.moca-la.org
Museum of Modern Art, Frankfurt www.mmk-frankfurt.de
Museum of Modern Art, New York www.moma.org
State Russian Museum, St. Petersburg www.rusmuseum.ru
Tate Gallery, London www.tate.org.uk
Venice Biennale, Venice www.labiennale.org
Walker Art Center, Minneapolis www.walkerart.org
Whitney Museum of American Art, New York www.whitney.org

Picture Credits

1.1 Courtesy the artist. © Robert Rauschenberg/VAGA, New York/DACS, London 2003. 1.2. Courtesy Jirō Yoshihara. 1.3 Courtesy Galerie Marie-Puck Broodthaers, Brussels © DACS 2003. 1.4 Courtesy Barbara Gladstone Gallery. 1.5 Dallas Museum of Art, general Acquisitions Fund, and a matching grant from the National Endowment for the Arts. © ARS, NY and DACS, London 2003. 1.6 and page 8 Courtesy Moderna Museet, Stockholm © Donald Judd Foundation/VAGA, NY/DACS, London 2003. 1.7 courtesy Barford Sculptures and the artist. Photo: John Riddy. 1.8 Courtesy the artist and Haunch of Venison. 1.9 Courtesy the artist. © M. M. Heizer, 1969. 1.10 Courtesy the artist. 1.11 Courtesy the artist. 1.12 Courtesy the artist. Photo: Tony Ray-Jones © ARS, NY and DACS, London 2003. 1.13 © The Solomon R. Guggenheim Foundation, New York; photo: Robert E. Mates and Paul Katz. © ADAGP, Paris and DACS, London 2003. 1.14 Courtesy the artist © DACS 2003. 2.1 Courtesy Cheim & Read © DACS, London and VAGA, New York 2003. 2.2 Courtesy Cheim & Read © DACS, London and VAGA, New York 2003. 2.3 Gift of the Elizabeth A. Sackler Foundation. Photo © Donald Woodman. Courtesy Through The Flower © ARS, New York and DACS, London 2003. 2.4 Courtesy Paula Cooper Gallery, New York. Photo: Efraim Lev-Er. 2.5 © Estate of Eva Hesse. Galerie Hauser & Wirth, Zurich. 2.6 Courtesy the artist. 2.7 Courtesy the artist. 2.8 Courtesy the artist. 2.9 Courtesy the artist. 2.10 Courtesy the artist © ARS, NY and DACS, London 2003. 2.11 Courtesy the artist. 2.12 Courtesy Sean Kelly Gallery, New York © DACS 2003. 2.13 Courtesy Klemens Gasser & Tanja Grunert Inc. 2.14 Courtesy Galerie Stadler, Paris. 2.15 Courtesy Ronald Feldman Fine Arts, New York. Photo: Caroline Tisdall © DACS 2003. 2.16 Courtesy the artist. Photo: Janet Anderson. 2.17 photo © National Gallery of Canada. 2.18 Courtesy the artist. 2.19 and page 26 Courtesy the artist. 2.20 Courtesy the artist © ARS, NY and DACS, London 2003. 2.21 Courtesy Electronic Arts Intermix. 2.22 Courtesy the artist and Marian Goodman Gallery, New York. 2.23 Courtesy the Holly Solomon Gallery © The Estate of Gordon Matta-Clark © ARS, NY and DACS, London 2003. 2.25 Courtesy the artist. 2.26 Photograph © 2003 National Gallery, Prague. 2.27 Courtesy Ronald Feldman Fine Arts, New York. 2.28 Victor and Margarita Tupitsyn Archive, New York. 3.1 Courtesy Barford Sculptures and the artist. Photo: John Riddy. 3.2 Courtesy the artist. 3.3 and page 58 Courtesy Anthony D'Offay, London. 3.4 Courtesy Leo Castelli Gallery, New York © ARS, NY and DACS, London 2003. 3.5 Bridgeman Art Library. 3.6 Courtesy Gallery Bruno Bishofberger, Zurich © Sandro Chia/VAGA, New York/DACS, London 2003. 3.7 Collection of the Modern Art Museum, Fort Worth, Museum Purchase, The Friends of the Art Endowment Fund. 3.8 Courtesy the artist. 3.9 Courtesy the artist. Private Collection. 3.10 Courtesy the artist. 3.11 Courtesy the artist. 3.12 Courtesy Lisson Gallery, London. 3.13 Courtesy the artist. Photo: David Reynolds, New York © DACS, London/VAGA, New York 2003. 3.16 Courtesy Anthony Reynolds Gallery, London. 3.17 Courtesy Waddington Galleries, London © David Salle/VAGA, New York/DACS, London 2003. 3.18 Keith Haring artwork © The Estate of Keith Haring. 3.19 Courtesy Leo Castelli Gallery, New York. 3.20 © ADAGP, Paris and DACS/London 2003. 3.21 Courtesy the artist and Edward Totah Gallery, London © DACS 2003. 3.23 Whitney Museum of American Art, New York. Gift of the Ree Morton Estate 90.2a-ii. Photo by Geoffrey Clements. 3.24 Courtesy the artist. 3.25 Courtesy DC Moore Gallery, New York. 3.26 Courtesy Gagosian Gallery, New York. 3.27 Courtesy Sidney Janis Gallery, New York © Valerie Jaudon/DACS, London/VAGA, New York 2003. 3.28 Courtesy Max Protetch Gallery. Photo: Steven Sloman. 4.2 Courtesy Anthony D'Offay Gallery, London. 4.3 Courtesy Metro Pictures, New York. 4.4 Courtesy the artist. 4.5 Courtesy John Weber Gallery, New York. 4.6 Courtesy of the Paula Cooper Gallery, New York © ADAGP, Paris and DACS, London 2003. 4.7 Courtesy Thomas Ammann, Zurich. 4.8 Courtesy the artist. 4.9 Courtesy the artist. 4.10 Courtesy Galerie Ghislaine Hussenot, Paris © ADAGP, Paris and DACS, London 2003 . 4.11 and page 90 Courtesy the artist. 4.12 Courtesy the artist. 4.13 Courtesy Lisson Gallery, London. 4.15 Courtesy Lisson Gallery, London. 4.16 Courtesy Sonnabend Gallery, New York. 4.18 Courtesy the artist. 4.19 Courtesy the artist. 4.20 Courtesy the artist. 4.21 Courtesy Postmasters Gallery, New York. Photo: Tom Powel. 4.22 Photo Courtesy: © Jack Goldstein and 1301PE, Los Angeles. 4.23 Courtesy the artist. Photo: Steven Sloman. 4.24 Courtesy Mary Boone Gallery, New York. 4.25 Courtesy the artist. 4.27 Victor and Margarita Tupitsyn Archive, New York. 5.1 Courtesy the artist © D.B – ADAGP, Paris and DACS, London 2003. 5.2 Courtesy Galerie Buchmann, Basel. 5.3 Courtesy the artist. 5.4 Courtesy Galerie Philomene Magers, Cologne © DACS 2003. 5.5 Courtesy Lisson Gallery, London. 5.6 Courtesy Anthony d'Offay Gallery, London. 5.7 Courtesy of the artist and Metro Pictures Gallery. 5.8 Courtesy the artist and Margarete Roeder Gallery, New York. 5.9 Courtesy the artist. Photo: Tom Warren.

5.10 Photo Florian Kleinefenn, Paris. 5.11 Courtesy the artist. 5.12 Courtesy the artist © DACS 2003. 5.13 Courtesy DIA Center for the Arts, New York. Photo: Nic Tenwiggenhorn © DACS 2003. 5.14 Courtesy Galerie Maz Hetzler, Berlin. 5.15 Courtesy the artist. 5.12 Courtesy the artist © DACS 2003. 5.16. Museum of Modern Art, Frankfurt. Photo: Rudolf Nagel. 5.17 © Rosemarie Trockel, Courtesy Spruth/Magers Gallery, Cologne © DACS 2003. 5.18 Courtesy the artist © DACS 2003. 5.19 Courtesy Hal Bromm Gallery, New York. Photo: Lee Stalsworth. 5.20 Courtesy Pace Gallery, New York. Photo: Kim Steele © ARS, New York and DACS, London 2003. 5.21 Work commissioned by Artangel and Becks. Courtesy of Artangel, London. Photo: Sue Ormerod. 5.22 Courtesy Luhring Augustine, New York. 5.23 Courtesy Galerie Crousel, Paris © DACS 2003. 5.24 © Barbara Gladstone Gallery, New York. Photo: David Regen © ARS, NY and DACS, London 2003. 5.25 Courtesy Galerie Daniel Buchholz. 5.26 and page 122 © Thomas Hirshhorn, Courtesy Barbara Gladstone. 6.1 Courtesy Daniel Weinberg Gallery, San Francisco. 6.2 © The Robert Mapplethorpe Foundation. Used with permission, Courtesy A+C Anthology. 6.3 Courtesy Paula Copper Gallery, New York. Photo: Andrew Moore. 6.4 Courtesy P.P.O.W., New York. Photo: Adam Reich. 6.5 © The Felix Gonzalez-Torres Foundation. Courtesy of Andrea Rosen Gallery, New York. 6.6 Courtesy the artist. 6.7 Courtesy Metro Pictures, New York. 6.8 Courtesy Regen Projects, New York. 6.9 and page 150 © Vanessa Beecroft. Courtesy Deitch Projects, New York. Photo by Mario Sorrenti. 6.10 Courtesy Brent Sikkema, New York. 6.11. Los Angeles County Museum of Art, Purchased with funds provided by the Ansley I. Graham Trust. Photograph © 2004 Museum Associates/LACMA. 6.12 Courtesy of Paul Kasmin Gallery and the artist. 6.13 Courtesy Robert Bane Editions, Los Angeles. 6.14 Courtesy Luhring Augustine, New York. 6.15 Courtesy 303 Gallery, New York. 6.16 Courtesy Feature Inc., New York. 6.17. Courtesy Regen Projects, Los Angeles. 6.18 Courtesy the artist. 6.19 Courtesy the artist. 6.20 Courtesy 303 Gallery, New York. 6.21 Installation view, Touko Museum, Japan. Courtesy Paula Cooper Gallery, New York. 6.22 Courtesy of Mike Kelley studio, © the artist. 6.23 © the artist/Metro Pictures, New York. Photo: Richard Stoner. 6.24 Courtesy Ronald Feldman Fine Arts, New York. Photo: © 1990 D. James Dee. © DACS 2003. 6.25 Courtesy the artist and Gorney Bravin + Lee, New York. 6.26 Courtesy Max Protetch Gallery. 6.27 Courtesy of the artist, Jerwood Space, London and Patrick Painter Inc., Santa Monica. 6.28 Courtesy Zeno X Gallery, Antwerp. Photo: Ronald Stoops. 6.29 Courtesy Zeno X Gallery, Antwerp. Photo: Felix Tirry. 6.30 Courtesy the artist and Marian Goodman Gallery, New York. 6.31 © the artist. Courtesy Jay Jopling/White Cube (London). Photo: Diane Bertrand. 6.32 © the artist. Courtesy Jay Jopling/White Cube (London). Photo: Norbert Schoerner. 6.33 © the artist. Courtesy Jay Jopling/White Cube (London). Photo: Stephen White. 6.34 © Damien Hirst. Courtesy Jay Jopling/White Cube (London). Photo: Stephen White. 7.1 Courtesy the artist. 7.2 Courtesy Centre Pompidou, Paris. 7.3 © Jimmie Durham, Courtesy Nicole Klagsbrun Gallery. 7.4 Courtesy the artist. 7.5 Courtesy the artist. 7.6 Courtesy the artist. 7.7 Courtesy the artist. 7.8 Courtesy Max Protetch Gallery. 7.9 Courtesy Zhang Huan studio. 7.10 Courtesy XL Gallery. 7.12 Courtesy Flash Art. 7.11 Courtesy XL Gallery. 7.13 Courtesy the artist and Orel Art Presenta. 7.14 Courtesy AES. © ARS, NY and DACS, London 2003. 7.15 and page 184 Courtesy Rontgen Kunstraum and Yamamoto Gallery. Photo: Russell Liebman. 7.16 Courtesy the artist. 7.17 Courtesy the artist and Marian Goodman Gallery, New York. 7.18 © C.A.A.C. – The Pigozzi Collection, Geneva. Photo: Claude Postel. 7.19 Courtesy Stephan Koehler. www.jointadventures.org. © ADAGP, Paris and DACS, London 2003. 7.20 Courtesy Stephen Friedman Gallery, London. Photo: Werner Maschmann. 7.21 Witte de With, Rotterdam. Photo © Bob Goedewaagen. 8.1 Courtesy Electronic Arts Intermix. 8.2 Courtesy Klosterfelde, Berlin. 8.3 Courtesy The Project, New York. 8.4 © Matthew Ritchie, 2000. Courtesy Andrea Rosen Gallery, New York. 8.5 Courtesy Marianne Boesky Gallery, New York. 8.6 Courtesy Marianne Boesky Gallery, New York. 8.7 Courtesy of Hales Gallery and the artist. Photo: Peter White. 8.8 Courtesy of Hales Gallery and the artist. Photo: Peter White. 8.9 and page 214 © 2001 Matthew Barney, Courtesy Barbara Gladstone Gallery. Photo: Chris Winget. 8.10 Museu d'Art Contemporani de Barcelona (MACBA), Photo © Raimon Sola. 8.11 © FMGB Guggenheim Bilbao Museoa, photo: Erika Barahona Ede. All rights reserved. 8.12 © Tate, London 2003. 8.13 © Tate, London 2003. 8.14 Courtesy Milwaukee Art Museum. Photo: Timothy Hursley. 8.15 Courtesy the artist and Marian Goodman Gallery, New York. 8.16 © Crystal Eye Ltd., Helsinki. Courtesy Klemens Gasser & Tanja Grunert Inc., New York. 8.17 Courtesy Zacheta Gallery, Warsaw. 8.18 © Shirin Neshat, Courtesy Barbara Gladstone. 8.19 Courtesy the artist. 8.20 Whitney Museum of American Art, New York. Partial and promised gift of Marion Stroud in honor of David A. Ross 95.261. Photo: Kira Perov. 8.21 Courtesy the artist and Metro Pictures Gallery. Photo Aaron Diskin, Courtesy of Public Art Fund. Rauschenberg/VAGA, New York/DACS, London 2003.

Index

Figure numbers are given in **bold**